in Chinese Cinema

To Dawen and Huihua, my parents

— Y. Z.

To Grace, Lily, and Stacy at the East Asian Studies Center,
University of Southern California

— S.R.

Art, Politics, and Commerce in Chinese Cinema

Edited by **Ying Zhu** and **Stanley Rosen**

香港大學出版社
HONG KONG UNIVERSITY PRESS

Hong Kong University Press
14/F Hing Wai Centre, 7 Tin Wan Praya Road,
Aberdeen, Hong Kong
www.hkupress.org

© Hong Kong University Press 2010

Hardcover ISBN 978-962-209-175-7
Paperback ISBN 978-962-209-176-4

This digitally printed version 2010.

Contents

List of Tables

Acknowledgements

The genesis of this book dates back to 2005, the year commonly acknowledged as the centenary of Chinese cinema. In China and around the world, the occasion was marked with tributes to Chinese cinema's canonic texts. In New York, the Film Society of Lincoln Center, in collaboration with the City University of New York and the Asia Society, put together a high profile Chinese Cinema Retrospective in October, honoring the occasion with a three-week series that traced the history of mainland Chinese film through many of its celebrated texts. Filmmakers in attendance included the late Xie Jin (*Hibiscus Town*, 1986), the Fifth Generation filmmaker Huang Jianxin (*The Founding of a Republic*, 2009), and the new generation filmmaker Lu Chuan (*Nanjing! Nanjing!*, 2009). Embedded within the larger public celebration was an international by-invitation academic symposium sponsored by the College of Staten Island, the City University of New York. Significant themes and selected papers emerged from the symposium, which form the foundation of our edited volume. A second conference to finalize the chapters with additional contributors was organized by the East Asian Studies Center at the University of Southern California and held on that campus in April 2008. In addition to all the authors, invited attendees included industry professionals from China and Hollywood, and film directors Feng Xiaogang (*If You Are the One*, 2008) and Li Yang (*Blind Shaft*, 2003).

The journey, from the Centenary of Chinese Film Retrospective to the publication of this academic volume, has been a long yet inspiring one. We wish to take this opportunity to highlight the key people involved in this undertaking. Obviously, Richard Pena made it possible for the film retrospective to take place at the Lincoln Center in New York. Richard Pena's role goes beyond lending the prestige of his institution as he has been thoroughly invested in Chinese cinema and took a personal interest in co-curating the film series with Ying Zhu. We are amazed by the breadth of Richard's knowledge on Chinese cinema, and for that matter, on whatever film series he happens to be working on. The Film and Television School at Shanghai University was a key collaborator and our special thanks go to Professor Jin Guanjun, the former executive dean of the Film and Television School at the Shanghai University and the former deputy dean, the renowned film scholar Chen Xihe, for assembling a group of seasoned Chinese

x *Acknowledgements*

filmmakers and critics for the New York event. With the endorsement from the Chinese State Administration of Radio, Film, and Television, China Film Archive generously supplied film prints for the New York Retrospective. The participation of CUNY-TV and the Asia Society was instrumental in making the event a success.

Ying Zhu wishes to shine the spotlight to her crack team at CUNY's College of Staten Island for its contribution in orchestrating the public and academic events. The College of Staten Island's former president, Dr. Marlene Springer, encouraged the adoption of Modern China Studies as one of the College's academic priorities and allocated substantial funding to support the Chinese Film Retrospective in New York. CSI's former dean of humanities and social sciences, Dr. Francisco Soto, embraced the retrospective idea with an open mind. Elaine Bowden, our extraordinary conference planner, labored tirelessly over the implementation of the project. Special gratitude goes to Ying's esteemed colleague in the Department of Media Culture, Dr. Mirella Affron. A former provost at CSI and a renowned film scholar herself, Mirella was undaunted by the potential scale of the undertaking and the intricacies of a multiple partnership. Working with Mirella is a constant reminder that a successful execution of any project requires a mind that combines a grand vision with attention to details. Finally, Ms. Geraldine Kunstadter, Albert Kunstadter Family Foundation, warrants special recognition for her generous contribution.

Stanley Rosen would like to acknowledge the support of the College of Letters, Arts and Sciences and the Residential Life program at the University of Southern California for financial support to travel to Beijing, Shanghai, and Hong Kong to conduct research and gather materials for this book. He would also like to thank the staff of the Universities Service Centre for China Studies at the Chinese University of Hong Kong for their help on his frequent visits to that wonderful library for contemporary materials on China, as well as his staff at USC's East Asian Studies Center — in particular Associate Director Grace Ryu, Program Specialist Lily Glenn, and Program Assistant Stacy Orozco — for being so efficient that he could spare the time to work on this project. They were also the key organizers for the April 2008 USC film conference noted above. At USC as well, the School of Cinematic Arts, directed by Dean Elizabeth Daley and Associate Dean Michael Renov, generously shared their state-of-the-art facilities for the screening of the Feng Xiaogang and Li Yang films during the conference.

Although there are many people in Beijing, Shanghai, and Hong Kong who could be thanked individually, he would prefer to single out the staff of the China Film Promotion International in Beijing for inviting him to attend and speak at the annual Beijing Film Screenings in 2008 and 2009, at which he was able to watch the most recent Chinese domestic films, and to collect the most recent academic and industry publications on Chinese film. He would also like to thank Shanghai University for hosting him and giving him the opportunity to speak on several occasions at the School of Film & TV Art and Technology.

Finally, we wish to thank our contributors, the various outside reviewers, and the people at Hong Kong University Press who have contributed, directly, to the final shape of the volume. Michael Duckworth has been an ardent supporter of this volume. Ying

would always remember her initial conversation about the volume with Michael over a simple lunch at the Hong Kong Baptist University's Ng Tor Tai International House in January 2008. More insights about the book were exchanged over the subsequent Sushi outing, which helped to solidify our collaboration. Dawn Lau, our HKUP's project editor at the last stage, helped to expedite the seemingly ever-delayed project. Obviously, Katherine Chu warrants our special acknowledgement for compiling the bibliography, filmography, and index.

Contributors

Katherine Chu is a Ph.D. candidate in politics and international relations at the University of Southern California. She is writing a dissertation on the role of nationalism in Chinese films. She obtained her M.A. in East Asian area studies from the University of Southern California and her B.A. in Chinese language and literature from the Chinese University of Hong Kong. She is the author of "Co-opting the Wolves: National Film Industry Reform in China after 1978," *Asian Politics & Policy* (forthcoming in 2010).

Paul Clark is professor of Chinese in the School of Asian Studies, The University of Auckland, New Zealand. A specialist in Chinese film and popular culture, his Harvard doctoral thesis pioneered the academic study of Chinese film. It was published as *Chinese Cinema: Culture and Politics since 1949* (1987). Other books include *Reinventing China: A Generation and Its Films* (2005), a study of the Fifth Generation drawn from years of acquaintance with many of the directors and others, and *The Chinese Cultural Revolution: A History* (2008), a cultural history of the era. He is currently completing a book on Chinese youth cultures in 1968, 1988, and 2008. A future project involves a social history of Beijing since 1949.

Shuqin Cui is associate professor of Asian studies at Bowdoin College. She is the author of *Women through the Lens: Gender and Nation in a Century of Chinese Cinema* (2003). She has also authored many journal articles and book chapters on various topics in Chinese cinema. Her research and teaching interests include but are not limited to cinema, gender, and literature studies. She is currently working on a manuscript tentatively titled, "The Absence of Presence: An Exploration of Women's Experimental Art in Contemporary China."

John A. Lent has been teaching at the college/university level since 1960, including stints as founder and lecturer of journalism courses at De La Salle College (Philippines) while a Fulbright scholar; founder and coordinator of Universiti Sains Malaysia communications program; Rogers Distinguished Chair at University of Western Ontario. He was visiting professor at Universiti Kebangsaan Malaysia; at Shanghai University, Communication University of China, Jilin College of the Arts Animation School, and Nanjing University of Economics and Finance, all in China; and now professor at Temple University (1974–present). Professor Lent pioneered in the study of mass communication and popular culture in Asia (since 1964) and Caribbean (since 1968), comic art and

animation, and development communication. He has authored or edited seventy books. Additionally, he edits *International Journal of Comic Art* (which he founded) and *Asian Cinema*, and chairs the Asian Cinema Studies Society, Asian Popular Culture of the Popular Culture Association, and Comic Art Working Group of IAMCR.

Seio Nakajima is assistant professor of sociology at the University of Hawai'i at Mānoa. His main research interests lie in the organizational analysis of Chinese film industry as well as ethnography of Chinese film audiences and consumption. His research has appeared in *From Underground to Independent*, ed. Paul G. Pickowicz and Yingjin Zhang (2006), *Reclaiming Chinese Society*, ed. You-tien Hsing and Ching Kwan Lee (2009), and *The New Chinese Documentary Film Movement*, ed. Chris Berry, Lu Xinyu, and Lisa Rofel (forthcoming). Based on a comprehensive quantitative database he has constructed on the film studios between 1979 and 2008, he is currently working on a project that analyzes the changes in the network structure of film studios that have participated in Chinese film co-productions.

Liyan Qin teaches at the Institute of Comparative Literature and Culture in Beijing University. She got her Ph.D. degree in comparative literature from University of California, San Diego in 2007. She specializes in Chinese cinema and literature, and the relationship between Chinese and English literature. She has published both in the United States and in China, including her article "The Sublime and the Profane: A Comparative Analysis of Two Fictional Narratives about Sent-down Youth" in *The Chinese Cultural Revolution as History*, ed. Joseph Esherick, Paul Pickowicz, and Andrew Walder. She has also translated several English books into Chinese, including J. Hillis Miller's *On Literature* and Yingjin Zhang's *The City in Modern Chinese Literature and Film*. Besides, she writes a column commenting on recent films, both Chinese and otherwise, for the Chinese journal *Writers* (*Zuojia*). She has taught courses on such topics as the history of Western literature, the relationship between Chinese and English literature, and the poetry of Dickinson, Yeats, and Frost.

Bruce Robinson is an Austin, Texas–based editor of scholarly works on subjects in communications and Asian studies and is pursuing his own research and writing about Chinese popular culture.

Stanley Rosen is the director of the East Asian Studies Center at USC's College of Letters, Arts and Sciences, and a professor of political science at USC specializing in Chinese politics and society.

Stephen Teo is currently associate professor in the Wee Kim Wee School of Communication and Information, Nanyang Technological University, Singapore. Before NTU, he was research fellow at the Asia Research Institute, National University of Singapore, from 2005–2008. Teo is well-published in the field of Asian cinema. He is the author of *Hong Kong Cinema: The Extra Dimensions* (1997), *Wong Kar-wai* (2005), *King*

Hu's A Touch of Zen (2007), *Director in Action: Johnnie To and the Hong Kong Action Cinema* (2007), and *The Chinese Martial Arts Cinema: The Wuxia Tradition* (2009).

Shujen Wang is associate dean of the School of the Arts at Emerson College. She is also research associate in the Fairbank Center for Chinese Studies at Harvard University and former president of the Chinese Communication Association. Author of *Framing Piracy: Globalization and Film Distribution in Greater China* (2003), Wang has contributed chapters to several anthologies. Her work has also appeared in such journals as *Film Quarterly, positions, Cinema Journal, Theory Culture and Society, Asian Cinema, Public Culture, Global Media Journal, Harvard College Economic Review, East Asia: An International Quarterly, Policy Futures in Education, Journal of Communication Inquiry, Text, Visual Anthropology, Gazette, Asian Journal of Communication*, and *Media Asia*. Her work has been translated into Chinese and Portuguese.

Zhiwei Xiao is associate professor of history at California State University. His research focuses on Chinese film history.

Ying Xu was a researcher at China Film Archive from 1985 to 2003. She now works as assistant and production editor for *International Journal of Comic Art* and *Asian Cinema*. She has published more than 100 articles about Chinese cartooning, animation, and cinema, as well as foreign films and animation, in English-language journals and major Chinese film newspapers and magazines, such as *Asian Cinema, World Cinema, Film Review, New Film, Contemporary Cinema, Contemporary Television*, and *Film*. In 1999, she received a Canadian government scholarship to research Canadian animation in Montreal, Toronto, and Vancouver for over a month. From her observations and interviews, she published articles in *World Cinema* and *World Affairs Pictorial*, and introduced Canadian animation master Frédéric Back to the Chinese readers in the animation journal *A Touch* in 2003. Xu Ying has attended and presented papers at film, cartoon, and animation conferences in the United States, Canada, South Korea, China, Sweden, France, Egypt, Taiwan, and Italy, and has written reports about these activities for Chinese newspapers and journals.

Yingjin Zhang, director of Chinese Studies Program and professor of comparative literature, cultural studies, and film studies at University of California-San Diego, is the author of *The City in Modern Chinese Literature and Film* (1996), *Screening China* (2002), *Chinese National Cinema* (2004), and *Cinema, Space, and Polylocality in a Globalizing China* (2009); co-author of *Encyclopedia of Chinese Film* (1998); editor of *China in a Polycentric World* (1998) and *Cinema and Urban Culture in Shanghai, 1922–1943* (1999); and co-editor of *From Underground to Independent* (2006). Additionally, he has published six Chinese books and over 100 articles in Chinese and English.

Ying Zhu is professor of media culture and the co-coordinator of the Modern China Studies Program at the College of Staten Island, City University of New York. Her

publications have appeared in leading media journals and various edited book volumes. She is the author to *Chinese Cinema during the Era of Reform: The Ingenuity of the System* (2003) and *Television in Post-Reform China: Serial Drama, Confucian Leadership and Global Television Market* (2008); and co-editor of *Television Drama: A Chinese and US Perspective* (2005), *TV Drama in China* (2008), and *TV China* (2009). Her upcoming books include *The Transformation of China Central Television*. She is the recipient of the American Council of Learned Societies Fellowship (2007–08) and of the 2006 Fellow of National Endowment for the Humanities. She served as a Chinese media expert and contributor for the *New York Times* "China Studies" website.

Introduction

Ying Zhu and Stanley Rosen

Although motion pictures were exhibited and shot in China by foreigners within months of the first screenings in Europe and the United States, 1905 is the first year for which there is concrete evidence of films made in China by the Chinese themselves. In the decades that followed, Chinese cinema has been buffeted in response to the political and cultural upheavals of a Chinese society in transformation. With the founding of the People's Republic of China (PRC) in October 1949, the mainland Chinese film industry was consolidated and nationalized by the early 1950s under Communist Party directives. Film production in China from then until the mid-1980s imitated Soviet-style centralized planning, with state-ownership and subsidized production, turning out propaganda-driven films according to the state's production targets. The end of the Maoist era brought a remarkable outpouring of Chinese cinema from the late 1970s to the mid-1980s. Popular political melodramas by the Shanghai-based veteran director Xie Jin co-existed with experimental art films by the Fourth and Fifth Generation filmmakers as critics and film practitioners earnestly debated the nature and functions of cinema. The art films created a buzz overseas, quickly becoming a critical revelation that put Chinese cinema forcefully onto the world map. Chinese cinema has made critical waves ever since, winning awards at international film festivals, big and small, with celebrated films such as *Yellow Earth* (*Huang tudi*, Chen Kaige, 1984), *Raise the Red Lantern* (*Dahong denglong gaogao gua*, Zhang Yimou, 1991), *Platform* (*Zhantai*, Jia Zhangke, 2000), *Blind Shaft* (*Mang jing*, Li Yang, 2003), and *House of Flying Daggers* (*Shimian maifu*, Zhang Yimou, 2004), landing in the critical and sometimes even popular pantheon of world cinema.[1] Meanwhile, filmmakers such as Zhang Yimou, Chen Kaige, and Jia Zhangke, at different times and for different reasons, have become the darlings of media critics in the United States, Europe, and Asia. A cottage industry of Chinese cinema studies subsequently emerged in the world of academia, and scholarship on Chinese cinema has rapidly proliferated in recent years, resulting in a succession of books and journal articles that cover a variety of topics from political economy to the style and authorship of Chinese cinema.

The Burgeoning Literature in Chinese Cinema Studies

In line with the increasing emphasis on globalization, a number of significant works encompass Greater China (the Mainland, Hong Kong, and Taiwan), ranging from those

that seek to be comprehensive[2] to studies which are more tightly focused.[3] What these books share, as a springboard, is a conceptual framework in their mapping of Chinese cinema that is inclusive of Chinese language and culture within the Greater China, reflecting the established mode of inquiry in Chinese cinema studies pioneered by several major anthologies over a decade ago.[4] Such an all-inclusive approach has certainly enriched our understanding of Chinese cinema both as a conceptual grid and a diverse area of inquiry, yet it leaves little room for an in-depth examination of any particular production center of Chinese cinema, especially given the three centers' distinctive political and economic systems as well as shifting cultural climates.[5] While the cinema of Taiwan has only recently been addressed in book-length monographs, Hong Kong cinema has been more readily treated as an independent entity.[6]

In light of the success of Chinese film abroad and the interest in the subject in the wider field of cinema and cultural studies, research monographs and edited volumes that focus exclusively on the cinema of the PRC have become more common; however, they most often concentrate on certain historical periods, cinematic movements, or specialized issues. One must start with Paul Clark's then-landmark work published in the late 1980s, *Chinese Cinema: Culture and Politics since 1949*, which offered a widely read account of film production in the PRC from the late 1940s to the mid-1980s.[7] Indeed, for a number of years this was the one standard must-read work for anyone interested in an overview of PRC film history. Clark's more recent *Reinventing China: A Generation and Its Films* narrows the focus to the post–Cultural Revolution Fifth Generation directors whose pioneering work brought Chinese cinema to the attention of international audiences.[8] Several volumes examine the effects of recent market reforms on Chinese cinema, with an increasing focus on younger directors whose work has been featured at international film festivals and art house cinemas outside China, and often through "unofficial" distribution sources within China.[9] Arguably, studies on these younger directors — sometimes labeled as the "Sixth Generation" to distinguish them from their more established predecessors from the Fifth Generation — have begun to dominate the field.[10] In addition to volumes that concentrate on particular periods of PRC film history, there are also those that either examine only one aspect of Chinese cinema, albeit in considerable depth, or seek to put Chinese film studies into a larger context, including those which focus on gender issues or cultural theory.[11]

Despite this burgeoning literature, however, systematic studies of the cinema of the PRC based on recent and comprehensive research examining the three major aspects of art, politics, and commerce that must be considered for a comprehensive understanding of a nation's film industry have yet to emerge.[12] Our volume, *Art, Politics, and Commerce in Chinese Cinema*, attempts to fill this void by providing an up-to-date study focusing exclusively on the evolution of film production and consumption in mainland China, while noting the influence of Mainland cinema beyond its immediate borders. Such an extensive treatment of mainland Chinese cinema is particularly relevant, indeed long overdue, as Chinese cinema crossed its centenary threshold in 2005 with the film industry struggling, more than ever, to adapt to an increasingly globalized film practice driven by commercial imperatives.

Chinese Cinema with "Mainland Characteristics"

Given the transnational nature of virtually all cinema today — even the vaunted Hollywood model — and the obvious importance of Greater China in the production and distribution of virtually all successful "Mainland" films, it is useful to explain why we still feel it is necessary to maintain a Mainland focus in our volume. Indeed, the issues of "national cinema" and "Chinese-language cinema" are highly contested ones and many of the best recent studies have wrestled with the meaning of these expressions.[13]

First, the political system in the PRC remains Leninist in the control exercised by the party-state, led by the Chinese Communist Party. Thus, despite the many obvious changes during China's reform period, "Socialism with Chinese characteristics" still mandates an important propaganda role for film, leading to tight censorship over controversial topics. Filmmakers who have violated directives, instructions, or guidelines established by the State Administration of Radio, Film, and Television (SARFT) have been punished by fines and outright bans, not just on the individual films guilty of the violation, but on the filmmaker him or herself. Recent examples include Jiang Wen's *Devils on the Doorstep* (2000) and Lou Ye's *Summer Palace* (2006), with the filmmakers banned for a number of years from making new films in China.[14] Indeed, in a recent volume in which they interviewed twenty-one of China's leading young film directors, Shaoyi Sun and Xun Li focus extensively on the censorship system, suggesting that it may be "the last obstacle to a healthy film industry."[15] Perhaps the most celebrated earlier case was Tian Zhuangzhuang's *The Blue Kite*, an award-winning film from 1993 that received universal critical acclaim outside China, but has never been officially allowed distribution rights within China.[16]

The three films mentioned above are examples of a common problem faced by Chinese filmmakers who touch on "forbidden zones." Before any film is allowed to be sent for exhibition abroad — including participation in an international film festival — the film must be cleared by state censors. Since film festivals have tight deadlines, and official clearance of any film with subject matter or individual scenes which are "controversial" is a complicated affair, filmmakers must carefully weigh the importance of entrance to a major international film festival such as Cannes, Venice, Berlin, or Tokyo against the predictable repercussions likely to follow from the Chinese film authorities. For art films with limited box-office prospects either in China or abroad, international exposure and acclaim are often essential to generate the level of interest that might lead to overseas distribution, and to provide the necessary funding for the filmmaker's next project; indeed, most such films are co-productions relying on support from outside China, with the expectation that the film will find an international audience. It is in such dilemmas that we see the interplay of art, politics, and commerce most clearly, and this dilemma is likely to remain an important feature of mainland Chinese cinema for the foreseeable future. As a consequence of the concern with politics that all mainland Chinese filmmakers must entertain, a mindset that Perry Link has described as "enforced self-censorship" has developed, which occurs when a writer or filmmaker decides to avoid sensitive subjects or scenes, or alters such scenes in anticipation of

punishment.[17] Although a variety of constraints confront filmmakers everywhere, this type of political relationship between the artist and the state does not really apply in Hong Kong or Taiwan.

Nevertheless, despite the continuing importance of the restrictions imposed by the Leninist system, the changing patterns under which films are produced and consumed, in which producers who are concerned with international distribution and the bottom line now play a more important role, have led to a far more complicated set of interactions between the Chinese state and its increasingly independent filmmakers. In the absence of the familiar state subsidies of the Maoist era, media and cultural units in postsocialist China are judged by their commercial success in a very crowded marketplace. State authorities and regulators fully understand this, even when the primary (political) values of the authorities are incongruent with the (commercial) values of the units they supervise. This has led to a system marked by *negotiation*, sometimes tacit and sometimes public, where cultural units may include their audience as a means of pressuring the authorities to exercise restraint in their control and regulation. After thirty years of reform, state-society relations are no longer a one-way street. Society has developed a momentum of its own and the state has to be concerned with and even to accommodate public opinion. What often occurs, therefore, is the government expressing an opinion (*biaotai*) against something, yet allowing the banned phenomenon, if it is popular enough, to exist despite the ban. There is a clear concern that policies that deviate too far from public expectations might affect the overriding value, which is promoting social stability. This is why you see the ebb and flow of policy, often with a lack of consistency.[18] However, at the same time there are limits — often not clearly defined — beyond which state tolerance will be withdrawn.

The recent fate of Li Yu's *Lost in Beijing* (*Pingguo*, 2007) — well documented in the Hollywood trade papers, the Western media, and on Chinese blogs — offers a useful illustration of perhaps the major theme of our volume, i.e. the continuing evolution of the relationship among the forces of commerce, art, and politics and the expansion of the number of players — domestic and international — who are now involved in this process.[19] When *Lost in Beijing* was shown at the Berlin International Film Festival in February 2007, Li Yu and her producer Fang Li brought two versions — the uncensored director's cut and a "censor-friendly" cut in which fifteen minutes had been removed — and then Li and Fang proceeded to engage in complex negotiations with Chinese film bureaucrats. In striking contrast with past practice, a good deal of the negotiation seemed to take place in public, with the filmmakers detailing the "debate" over the film to the world press. First, Li and her distribution and marketing partners made it clear that they would show the director's cut at a "market screening" for potential buyers, ingeniously reasoning that since the screening was not open to the general public it would not violate the Film Bureau's directive mandating the cuts that had to be made to receive official approval. Second, Li made it clear that the final decision on which version to screen for film festival audiences would be left to producer Fang Li. In the end, Fang opted to show the uncut version, arguing that he had "simply run out of time" to finish subtitling a sanitized version in German and English. Ironically, Fang and Li suggested that they

did not expect to be punished for defying the censors, telling a reporter that the film was fortunate not to win a prize. Such success would have been "a catastrophe," since a prize-winning film would provoke "the prime minister or someone on that level ... to discover what the fuss is about...." The censors did win out over the Chinese title of the film, which was changed to "*Apple*" after the Film Bureau found "*Lost in Beijing*" "too sensitive." Among other issues, reportedly there was at least some concern, with the Olympics coming up in August 2008, that foreigners might think that Beijing was a difficult city to navigate.

But that was not the end of this complicated story. After several delays, the film was allowed to open on the Mainland in November 2007 in a 97-minute version — the Hong Kong and international version ran 114 minutes — and brought in about 17 million yuan in its first month. However, and inevitably, given the nature of information dissemination in China today, the seventeen minutes of footage of rape and class conflict from the original version was widely posted on the Internet. As a result, public screenings were summarily banned, and the producer and his production company were barred from making films for two years. Thus, the truncated film was only removed from theaters after its relatively successful run and, although SARFT had banned the film's broadcast and circulation online, the authorities reportedly only *suggested*, rather than ordered, a ban on the distribution of the DVD. Producer Fang Li felt quite comfortable telling the press that "there has been little impact. Ticket sales are good so far."[20] Significantly, although a senior SARFT official had criticized the film for chasing international awards and insulting Chinese people instead of "consciously defend[ing] the honor of the motherland,"[21] as he suggested that film directors should do, it was only when unnamed netizens posted the censored scenes online that the authorities felt compelled to act.

An examination of the saga of Ang Lee's *Lust, Caution* in the Mainland reveals an even more complicated relationship among Chinese film authorities, who sought to co-opt a world-class Chinese director, China's online nationalists (who objected to the film's "glorification of traitors and insult to patriots"), youth and middle middle-class filmgoers, bloggers, newspaper critics, and liberal intellectuals. Theatrical screenings were initially permitted in the Mainland in a sanitized version prepared by Lee himself, at the same time that the uncut version was available for those who could travel to Hong Kong. The contention over *Lust, Caution* highlights the "pluralization of interests" involved in cultural policy in China today.[22]

Second, a focus on mainland China is justified because in many ways the Mainland has become the focus of global commercial film interests, not just from Greater China, but from Hollywood as well. Following upon the omnipresent publicity given to "the rise of China" or "the Chinese economic miracle," there is great anticipation that a rising middle class of Chinese filmgoers with disposable income will be the salvation of the declining Hong Kong film industry and will be the new frontier for Hollywood's expansion. Indeed, Hong Kong film producers have openly admitted that 80 percent of their market is mainland China and that no film can be made without consideration of its prospects up north. The Closer Economic Partnership Arrangement (CEPA), signed between the governments of Hong Kong and the PRC on June 29, 2003, under which

Hong Kong films can enter the Mainland as co-productions without being subject to the quota restrictions foreign films are, has made the Hong Kong industry more dependent than ever on Mainland film authorities. In 2005, for example, five of the top six and seven of the top ten Chinese-language box-office hits in mainland China were Hong Kong films.[23] In 2007, nine of the top ten domestic films at the box office were co-productions, most with a strong Hong Kong component.[24] Given its new orientation, the decline of the Hong Kong film industry as a source of popular entertainment in Asian markets outside the Mainland has been frequently noted by Western critics.[25]

Third, there is a strong historical dimension to our volume. Many of the chapters cover a broad swath of Mainland film history, when other Chinese-language cinemas were simply not relevant. Some of these chapters trace the evolution of Mainland cinema and the costs and benefits of moving from the isolation of the past to the global embeddedness of the present. Thus, a Mainland-centered approach can more clearly reveal the sometimes stark changes as we move through each of the periods considered.

Fourth, unlike many other studies of Chinese cinema, which quite understandably and appropriately offer a concentration on filmic textual analysis, we are interested not only in the "art" and aesthetics of film, but also in politics and commerce, as our subtitle notes. We see this approach as our "comparative advantage." Had we focused solely on the art of film, the inclusion of Taiwan, for example, would make excellent sense since some of the world's leading filmmakers, including Hou Hsiao-hsien, Tsai Ming-liang, and the recently deceased Edward Yang, are associated with that small island. In terms of film markets, however, Taiwan has been completely dominated by Hollywood and filmmakers from Taiwan must rely on success at international film festivals as the primary venues for their works. In short, when one considers the trinity of art, politics, and commerce together, a focus on mainland China becomes more understandable, indeed imperative.

Fifth, as if to validate the argument of the last paragraph, recent comments from those engaged in the Chinese film industry, from officials to filmmakers, have explicitly spoken of the importance of the commerce-art-politics nexus and its changing context. It is clear that the overseas box-office successes of *Crouching Tiger, Hidden Dragon*, *Hero*, and *House of Flying Daggers* have fueled the ambitions of virtually everyone in the film community, from creative artists to industry bureaucrats, though their visions not surprisingly reflect their place within this community. For example, director Feng Xiaogang — whose work is addressed in several chapters in this volume — told *The New York Times* during the filming of *The Banquet* how his films were changing to reflect the times as we now live in an era where people are looking for more leisure and entertainment. As he put it, "Now China has gradually adopted a market economy…. Movies have changed from a propaganda tool to an art form and now to a commercial product. If someone continues to make movies according to the old rules, he'll have no space to live in today's market."[26]

High-ranking film officials have addressed the commerce-art-politics relationship as well. Significantly, however, they have reversed the order of importance. Unlike Feng,

who sees not only propaganda but apparently also art as out-of-date, Jiang Ping, vice president of the Film Bureau under SARFT, spoke in February 2007 on the need for a new kind of producer in China's new era. In his formulation, China "now urgently |needs| film producers who are politically sensitive, aesthetically sophisticated and have a flair for marketing."[27] It was therefore not surprising that Yi Li's *Zhang Side*, a biopic about a celebrated Chinese soldier who was immortalized in a "constantly read essay" by Mao Zedong, won most of the major Chinese film awards (best picture, director, and actor) in 2006, beating out such larger commercial successes as Stephen Chow's *Kung Fu Hustle*, Feng's *A World Without Thieves*, and Ronny Yu's *Fearless*. Significantly, most of the nominated stars and filmmakers, such as Chow, Feng, and Zhang Yimou did not bother to attend the event.[28] As suggested above in the comments by producer Fang Li of *Lost in Beijing*, however, new-era producers are more likely to emphasize "a flair for marketing" and the kind of political sensitivity that enables them to understand how to work the system successfully rather than promoting the values favored by film bureaucrats.[29]

The Genesis and Organization of the Volume

In 2005, the celebration of the centenary of Chinese cinema was marked with tributes to Chinese cinema's canonic texts in China and the rest of the world. In New York, the Film Society of Lincoln Center put together a high profile Chinese Cinema Retrospective in October, honoring the occasion with a three-week series that traced the history of mainland Chinese film through many of its celebrated texts. In attendance was the legendary filmmaker, Xie Jin, whose film career embodied the very dynamics of art, politics, and commerce that this volume seeks to explore. Embedded within the larger public celebration was an international by-invitation academic symposium sponsored by the City University of New York that provided an opportunity for in-depth exchanges among distinguished experts on the history and current state of Chinese cinema. The symposium featured eight roundtable discussions, covering topics ranging from history and the historiography of Chinese cinema, to the question of Chinese cinema and Chinese-language filmmaking, to Chinese documentary filmmaking, an area of inquiry long neglected. Specialists on Chinese cinema shared with each other their new research and discoveries. Significant themes and selected papers emerged from the symposium, which form the foundation of our edited volume. The volume further commissioned new papers to cover topics either not touched upon or that emerged during the symposium. A second conference to finalize the chapters was organized by the East Asian Studies Center at the University of Southern California and held on that campus in April 2008. In addition to all the authors, invited attendees included industry professionals from China and Hollywood, and film directors Feng Xiaogang and Li Yang.

It is indicative of the nature of contemporary Chinese film studies that our contributors represent a variety of disciplines and methodologies within the humanities and social sciences, including film/media studies, Asian studies, history, political science, sociology, communications, comparative literature, and Chinese language. Reflecting the

broad focus which encompasses aesthetics, politics, and the market, the chapters vary from close textual readings of the key films of individual filmmakers, to the changing dynamics of film culture and the politics of film in different historical periods, to statistical analyses of box-office results and home video markets.

Specifically, the volume is organized around three large areas of inquiry: the Chinese film industry and its local and global market; film politics, including major genres and their reception; and film art, focusing on style and authorship. Each chapter within a particular area builds upon, reflects on, and updates previous scholarship on mainland Chinese cinema while at the same time placing the current transformation within a larger framework. Part 1 of the book focuses on Chinese cinema as an industry and its domestic and global markets. Ying Zhu and Seio Nakajima's chapter "The Evolution of Chinese Film as an Industry" charts the changing nature of film production in China from its inception in 1905 to current practices in the mid-2000s. The development of the industry is broadly divided into three periods: a commercial industry prior to the PRC era, a centralized and state-subsidized industry during the Maoist era, and a decentralized and marketized industry during the era of reform. The major emphasis is an examination of the decentralization and commercialization of the Chinese film industry in the era of marketization and its struggle under the shadow of Hollywood imports. As the trends of privatization, marketization, and globalization continue to strengthen, the Chinese film industry has moved closer to a Western-style industrial structure, management model, and market mechanism. The authors suggest that the adoption of the Hollywood institutional model alone will not be sufficient to enable the Chinese film industry to survive the increasingly competitive market environment in the WTO era; the future of the Chinese film industry rests upon the ability of its practitioners to make films that will resonate with its domestic audiences.

Examining the reception of Chinese films in the notoriously parochial American market, Stanley Rosen's "Chinese Cinema's International Market" assesses the Chinese film industry's efforts to promote its films globally, seeking to counter Hollywood's triumphant re-entry into the Chinese film market since the mid-1990s. The author suggests that despite some obvious successes, notably with the hybrid multinational films *Crouching Tiger, Hidden Dragon*, *Hero*, and *House of Flying Daggers*, Chinese cinema's international venture appears to have fallen somewhat short of expectations. At the same time, he notes the limitations faced by *any* foreign language film, particularly in the highly competitive North American home market of Hollywood, where subtitled films, particularly those from more "exotic" markets such as Asia, have historically never fared well. Rosen reminds us that Hollywood's vast distribution networks, production and marketing costs, and control of upscale screen venues will continue to sustain its ability in producing brand name (*pinpai*) blockbusters. Examining box-office data more closely, however, he notes that Chinese films in fact have in recent years fared better than those of any other nation, although the range of such successful films has been limited, in part by audience and critical expectations. By examining the reasons for the successes and failures of Chinese films, the chapter offers some suggested strategies

Chinese filmmakers might employ to enhance box-office success in the United States and the rest of the world.

Complementing Rosen's chapter, in "American Films in China Prior to 1950," Zhiwei Xiao provides a case study of American films' reception in China during the Republican period (1911–1949). As the author reminds us, the cinematic style and narrative strategy of the native film productions were developed as a conscious effort to compete with Hollywood imports for the domestic market. Consequently, our knowledge of the reception of American films will provide insights into the historical legacy of the Chinese native filmmaking. Xiao's chapter offers a corrective to what the author sees as a tendency in Chinese film studies to overlook the issue of film distribution/exhibition and the historical context of film practices.

Shujen Wang's chapter, "Film Piracy and the DVD/VCD Market: Contradictions and Paradoxes," maps the dynamic landscape of piracy and the DVD/VCD market in China. Incorporating theoretical and historical inquiries of network, globalization, and space, this chapter also explores the effects of technological changes and regulatory expansion and their impact on the Chinese film market. As the author notes, China has been celebrated as "the world's fastest growing theatrical market" for Hollywood films but at the same time is castigated for having the world's highest film piracy rate. Indeed, the Chinese film market at the turn of the millennium is marked by paradoxes and contradictions: state monopoly intersecting consumer capitalism, post-WTO transnational trade and intellectual property governance cutting across nationalist sentiments and local resistance. The boundaries between state and market, commerce and art, and art and politics, are increasingly blurred. Digital technology further heightens the tension between the licit and the illicit amid shifting balances of power and control among different networks and actors. The author argues that these paradoxical developments are symptomatic of complex underlying forces of globalization, digital technology, policy, and the changing state. With its implications for global capitalism and transnational politics, piracy in particular serves as a lens through which some of these issues are manifested.

Part 2 of the volume is devoted to film politics, broadly defined, and focuses on a number of popular and emerging film genres in Chinese cinema, including martial arts, animation, and documentary, and their reception. However, the section begins with an intriguing reassessment of a key turning point in Chinese film culture. Paul Clark's chapter, "The Triumph of Cinema: Chinese Film Culture from the 1960s to the 1980s," takes us back to an era when Chinese audiences eagerly flocked to cinema houses to watch any films available for public screening. Clark links together three time periods that have previously been treated separately, revealing the continuities and persistence of Chinese film culture (going to the movies and the impact of movies on audiences' attitudes and tastes) prior to the Cultural Revolution, during the ten years of so-called "catastrophe," and ending with the early 1980s. He argues that film occupied a central position in Chinese cultural life from the mid-1960s until the rise of the Fifth Generation filmmakers in the mid-1980s. As Clark elaborates, after their victory in 1949, the Communist Party leadership recognized the potential of film to create a new mass culture and present messages in identical form across the nation. In the 1950s, film-going

became a regular experience for urban Chinese, often organized by work units, so that this activity should not be viewed as strictly recreational. Because of a relatively low production level, there was space for imported films: indeed, studios supplemented their revenue by dubbing foreign films, often using actors who appeared on screen in local features. Clark makes the compelling point that, given the limited cinematic exposure, the standard treatment of transitions of time and location had to be learned by audiences new to cinema, which partly explains the relative simplicity and obviousness of many of the films from Chinese studios after 1949.

Stephen Teo's chapter, "The Martial Arts Film in Chinese Cinema: Historicism and the National," traces the evolution and current transformation of the Chinese genre with the highest profile, the martial arts film. Teo argues that, from the beginning, the martial arts genre imbibed influences from Hollywood and European genres while at the same time drawing from the fountain of China's history and folkloric past. The genre was perceived as a signifier of Chinese national identity and cultural form that could be distinguished from the Westernized or Europeanized form. However, the success of *Crouching Tiger, Hidden Dragon* at the start of the twenty-first century has made martial arts a transnational form. The author argues that recent films such as Chen Kaige's *The Promise* (2005), Feng Xiaogang's *The Banquet* (2006), and Zhang Yimou's *Curse of the Golden Flower* (2006) are further demonstrations of the increasing transnationalization of martial arts. They could even be described as allegories of globalization.

John A. Lent and Ying Xu's chapter, "Chinese Animation Film: From Experimentation to Digitalization," traces the history of Chinese animation from the earliest works of the Wan brothers and lesser-known pioneers, through the lull of World War II, the golden eras of the Shanghai Animation Film Studio, the reorganization under a market economy, and the present state of astronomical expansion. As is evident in Lent and Xu's account, during its eighty-year history, China's animation has persisted and excelled under various types of political, economic, and socio-cultural conditions, including military invasions, civil war, dictatorships, and both planned and market economies. Despite at times formidable obstacles and unstable states of existence, China in the past produced some of the world's most exquisite animation, and currently promises to be a global behemoth in production quantity.

Yingjin Zhang's chapter, "Of Institutional Supervision and Individual Subjectivity: The History and Current State of Chinese Documentary," is a critical survey of Chinese documentary filmmaking. It provides an historical overview of the rise of documentary filmmaking in early twentieth-century China and its development under direct state supervision through the socialist period. Special attention is given to the so-called "new documentary movement" in mainland China since the late 1980s. The chapter samples subjects (e.g., migration, prostitution, sexuality), styles (e.g., expository, observational, participatory, reflexive, performative), and special functions (e.g., educational, propagandist, alternative, oppositional, subversive) of new documentaries and situates this new trend of filmmaking in the context of transnational cultural politics (e.g., domestic marginalization, international film festivals, global media, and foreign

investment). The author argues that, overall, the recent documentary trajectory moves away from an obsession with grand history (war, revolution, or modernization) and toward a multitude of simultaneous images of fast-changing landscapes and mindscapes in contemporary China.

Part 3 moves to the third aspect of the volume, film art, focusing on style and authorship. Ying Zhu and Bruce Robinson's chapter, "The Cinematic Transition of the Fifth Generation Auteurs," takes us back to the early 1990s by tracing the Chinese Fifth Generation filmmakers' cinematic transition from New Wave art film to post–New Wave classical film. The chapter addresses economic and textual strategies the Fifth Generation filmmakers, chiefly Chen Kaige, Tian Zhuangzhuang, and Zhang Yimou, utilized to compete with Hollywood for both global and domestic market shares. The authors argue that the core element of the Fifth Generation's transition from art cinema to popular cinema is its reprising of a continuity narrative strategy. Zhu and Robinson discuss stylistic principles of post–New Wave and its cultural/cinematic heritage through textual analyses of the Fifth Generation films from the late 1980s to the mid-1990s, examining Chen Kaige's *Farewell My Concubine* (1993), Tian Zhuangzhuang's *The Blue Kite* (1993), and Zhang Yimou's films as a group during this period. The chapter also links the transition of the Fifth Generation with Chinese cinema's general trend of commercialization during that time. Finally, the chapter discusses post–New Wave's domestic bent since the late 1990s as the domestic market began to demonstrate its profit potential for films with popular appeal.

Liyan Qin's chapter, "Transmedia Strategies of Appropriation and Visualization: The Case of Zhang Yimou's Adaptation of Novels in His Early Films," tackles the issue of film adaptation, an important topic given the close kinship between literature and film in Chinese cinema. After a brief overview of the past century of Chinese film adaptation, Qin focuses on the adaptation practice of Zhang Yimou, who has always preferred literary sources to original scripts. What interests the author is Zhang's remodeling of novels into what became a trusted international brand: "the Zhang Yimou film." What patterns underlie the alterations Zhang introduced? Why were these changes made? What image of China emerges from these films? How has this image itself changed over time? Qin examines Zhang's early adaptation films from three intertwined angles: the "cultural" images he adds, the patriarchs and young lovers he represents, and the communist history he chooses to engage or ignore.

Shuqin Cui's chapter, "Boundary Shifting: New Generation Filmmaking and Jia Zhangke's Films," moves on to spotlight the film practices of the post–Fifth Generation, what has commonly been labeled as the "independent generation." The author argues that the desire to remain independent and the difficulty in doing so has caused these filmmakers to move between the margins and the mainstream and to make films both inside and outside the system. Cui's chapter further highlights the film practice of one of the most influential post–Fifth Generation filmmakers, Jia Zhangke, to illustrate the point that the new generation has never ceased to negotiate a space between the periphery and the center, the local and the global. Finally, Cui reveals how, as the director interprets local space to reveal the abrupt dislocations in China's

socio-economic landscape, he furthers his investigation by focusing on various forms of popular culture.

Ying Zhu's chapter, "New Year Film as Chinese Blockbuster: From Feng Xiaogang's Contemporary Urban Comedy to Zhang Yimou's Period Drama," shifts gears to look at domestic films and filmmakers who have garnered a large audience within China. The chapter discusses Chinese New Year film (*hesui pian*) as a domestic blockbuster genre and the role the popular TV practitioner-turned-filmmaker Feng Xiaogang has played in cultivating the lucrative Chinese New Year market. The only formidable force in making popular New Year films up until 2002, Feng's dominance was challenged when Zhang Yimou's martial arts debut *Hero* rapidly ascended to the top of the box office. With the success of his subsequent epic dramas, *House of Flying Daggers* and *Curse of the Golden Flower*, Zhang has clearly overtaken Feng as the domestic king of the box office. Zhu argues that the success of Zhang's big-budget, epic-scale period drama, aided by a Hollywood-style marketing campaign, has transformed the Chinese New Year film from moderately budgeted urban comedies into massive period spectacles. It is worth noting that *House of Flying Daggers* was released to theaters in July and August of 2004, and thus sought to cultivate the Chinese summer season previously associated with animated films intended for children. Zhu's chapter traces the evolution of the Chinese New Year film from its origins in Feng's modest urban comedies to Zhang's Hollywood-style high concept blockbuster films.[30] It further explores the successes enjoyed by Feng's New Year films among Chinese audiences, and then compares Feng's textual strategies to those of Hollywood's high concept films and Zhang's period dramas. It seeks to illustrate and explain the gradual erosion of Feng's New Year film formula and its replacement by textual and marketing strategies imported from Hollywood.[31]

It goes without saying that the evolution of Chinese cinema manifests the general pattern of China's socio-economic development, which has been driven by an overriding nationalism both in times of crisis and buoyancy. Nationalism in the forms of patriotism and "anti-foreignism" was the key force in Chinese cinema's early expansion, contributing to the rise of Chinese cinema's first entertainment wave and the industry's initial institutional restructuring.[32] As noted by several authors in this volume, nationalism in times of buoyancy is reflected through the industry's push for the globalization of Chinese cinema, in particular the obsessive desire for the recognition of Chinese cinema in the U.S. film market, what we consider the "Hollywood complex." "Going global," however, is nothing new. Zhou Jianyun, a pioneer of Chinese cinema, argued as early as 1925 that internationalization would solve the crisis of Chinese cinema and that the development of the Chinese film industry must follow the direction of Western cinemas by moving beyond the boundaries of the nation-state.[33] The current push for going Hollywood, therefore, derives less from a sound marketing strategy and appears to be more closely related to the nationalistic sentiment that measures the success of Chinese cinema in terms of the degree of recognition and confirmation from Hollywood, the center of the cinematic universe.

From film industry to film representation, film culture, and finally to topics of emerging interest, we have attempted to provide a comprehensive reappraisal of the state

of Chinese cinema as a research subject. We approach Chinese cinema from a variety of perspectives rooted in cinema studies, classical and contemporary. Chinese cinema is treated as an art form (style and narrative), an ideology (representation and culture), and a revenue-generating industry (finance and market). Highlighted are the issues of genre and authorship rooted in traditional film theory and criticism as well as issues of cultural industries and reception, which have emerged in contemporary cinema studies. Several chapters in the book situate the development of Chinese cinema within a comparative framework that accentuates Chinese cinema's interaction with other national and regional cinemas, with the greatest attention given to the role Hollywood has played in shaping the evolution of Chinese cinema.

We acknowledge that limited space for a single volume prevents an exhaustive coverage that would otherwise provide a more balanced picture of the influence upon Chinese cinema of other national and regional film cultures. Moreover, while animation, adaptation, and documentary are singled out as new research avenues, other subjects equally worthy of attention have been omitted. For example, the issue of sexuality and the new DV (digital video) movement is regrettably left untouched, owing not only to space limitations, but also because this emergent area of research is only just beginning to attract adequate scholarly attention. What await our further attention are the popular domestic films that have long been the bread and butter of Chinese filmmakers and the staples of Chinese audiences. Produced and distributed through regular studio channels, these "conventional heartwarming melodramas" address topical issues in contemporary Chinese society.[34] The moral tales they conjure up resonate with the majority of the moviegoers in China. Granted that feature films are increasingly eclipsed by television dramas as the most mundane popular entertainment vehicle, future coverage of Chinese cinema will benefit from coming to terms with the vernacular domestic films that Chinese audiences routinely encounter.[35] In this regard, the recent death of highly popular and critically acclaimed director Xie Jin on October 18, 2008 at the age of eighty-four has already begun to generate renewed debate over the "Xie Jin model," which some scholars have termed "the golden formula that guarantees ticket sales."[36] With an academic conference held in June 2009 at Shanghai University that focused on Xie's work in the context of art, politics, and commerce, we look forward to scholarship from China that emphasizes, as we have in this volume, the interplay among these three key components of Chinese cinema.[37]

Part 1

Film Industry:
Local and Global Markets

The Evolution of Chinese Film as an Industry

Ying Zhu and Seio Nakajima[*]

In the age of steamships and trains, already worldly Shanghai was among the earliest destinations of a new medium that would eventually establish popular culture as both a global commons and a site of international commercial, cultural, and ideological competition. On August 11, 1896, the first film in China was screened at the Xu Garden (Xu yuan) in Shanghai as an attraction in a variety show. It was less than a year after the Lumière Brothers had first screened their short "actualities" to paying patrons in a room at the Grand Café in Paris on December 28, 1895.

Over a century later, 2005 marked a high point in the recent history of the Chinese film industry. The number of films produced reached 260, a 22.6 percent increase over the 212 films produced in 2004.[1] Box-office receipts also reached a record high of two billion yuan in 2005, an increase of one-third over the previous year.[2] Moreover, in 2005, for the second straight year the box-office share of domestic films surpassed that of imported blockbusters in the Chinese domestic market.[3] The top box-office hit of the year was the Chinese film *The Promise* (*Wuji*, dir. Chen Kaige, 2005), which reaped a handsome 170 million yuan, almost twice as much as *Harry Potter and the Goblet of Fire* (dir. Mike Newell, 2005), the top import of the year.[4] Overseas, the box office for Chinese films reached 1.65 billion yuan in 2006.[5] From 2006 to 2007, Chinese film production increased 21.8 percent.[6] The top-grossing film in China in 2007 was another domestic production, *Curse of the Golden Flower* (dir. Zhang Yimou). Also released in the mainstream North American and European markets, *Curse* grossed $76 million worldwide.[7] These figures suggest that the Chinese film industry is poised to become a key player on the international stage.

Our chapter charts the industrial evolution of Chinese film over more than a hundred years, dividing it into five distinct periods: 1) a nascent film industry from the turn of the twentieth century to the mid-1920s, when Chinese cinema developed in the shadow

[*] This chapter is an update to the institutional evolution of Chinese cinema discussed in Ying Zhu's book, *Chinese Cinema during the Era of Reform: The Ingenuity of the System* (Westport, CT: Praeger, 2003). The update reflects new developments in the Chinese film and media industries since the early 2000s.

of imports; 2) a viable commercial industry prior to the PRC era from the mid-1920s to the late 1940s, characterized by vigorous efforts to build a profitable and patriotic industry; 3) a centralized and state-subsidized industry during the Maoist era from the early 1950s until the initiation of the economic reform policy in the early 1980s; 4) the emergence of a decentralized and marketized industry, particularly in the mid-1980s to the early 1990s; 5) the decade (and running) of globalization and expanded Hollywood imports beginning in the mid-1990s.

The development of the Chinese film industry has been far from linear and smooth, regularly rocked by wars, revolutions, and contending ideologies. It has also been affected by significant cultural traditions and predilections, and seen its share of unintended, sometimes ironic consequences of shifting policy directives. All of these have produced an industry quite distinct from the Hollywood model — an industry with its own tensions, drives, and limitations.

Threaded throughout the historical account of an evolving industry detailed below, certain of these tensions, drives, and limitations emerge as the following major themes. First, there is the subordination of film, indeed all cultural forms, to larger purposes, primarily political but also in the broadest sense, societal. Confucian tradition commands art to be moral, edifying, uplifting. Mao, in his famous Yan'an address on literature and art in 1942, similarly insisted that art should be subordinate to political purposes and should serve the masses with positive messages. China's Communist Party leadership has never wavered from this principle, and it is probably fair to say that the Chinese "masses" have come to expect positive messages, particularly about themselves and about their nation, from their own cultural industries. Hence, both official and popular expectations about the socializing function of film are constantly present in tension with the commercial/entertainment imperatives of the industry.

This tension is present, for instance, in the question of the "masses" themselves. Mao's masses were China's vast rural peasantry, and they are still around. In a commercial entertainment industry, however, "audiences" are paying customers, and in both pre–Revolutionary China and post-Tiananmen, globalized China, the "masses" that count tend to be urban, which nowadays includes overseas and non-Chinese-language audiences.

That the evolution of the film industry in each period has depended on larger political developments is another, concomitant theme. Film practice and policy in China have evolved in response to Western imperialism, Japanese invasion, revolution, reform, the convulsive Tiananmen crackdown, China's accession to the World Trade Organization, and so on. State oversight of the industry, meanwhile, has engendered a long series of cultural openings and crackdowns, as, for instance, when Mao made his first call to "Let one hundred flowers blossom, one hundred schools of thought contend" in 1956. The films that "blossomed" in the year following Mao's liberalization proved to be too colorful for comfort and led to the Anti-Rightist suppression of 1957, followed by another period of "thaw," then the ultimate cultural crackdown of the Cultural Revolution, then a new "spring" at the end of the Cultural Revolution, a new crackdown after Tiananmen, and on and on.

A final theme that emerges from the historical narrative is that unanticipated outcomes occasionally result from the state's best efforts to manage the film industry. One example is the rude "blossoming" just alluded to, but another, more significant, is the advent of China's "Fifth Generation" of filmmakers, whose work in the early 1980s "earned Chinese film international recognition ... fired important public debates . . . and aggressively insisted on the uncomfortable, untidy, and long un-faced issues that plague the Chinese people."[8]

With those major themes in mind, we begin our survey more than a century ago, when steam engines first imported electric shadows to China.

A Nascent Film Industry: From the Turn of the Century to the Mid-1920s

Early Chinese cinema developed in the shadow of imports. The earliest imports were from Europe, mostly France, with foreign merchants acting as distributors and exhibitors. The dominance of foreign distributors and imported films was perceived as a new imposition of Western imperialism, provoking Chinese nationalists and early Chinese filmmakers who hoped that cinema could become a tool for social reform and building a stronger China, following the Confucian tradition of entertainment for enlightenment. So, right from the start, feelings of nationalism, resentment of cultural and economic subordination, and a tradition of putting pedagogy over profit in the arts were present. These would not immediately come into play however, as early domestic operators mostly reacted to the new cultural prodigy on its initial terms as an imported, universalizing commercial entertainment form.

Little domestic film production occurred before the fall of the Qing dynasty in 1911. Native exhibitors did not emerge until 1903 and the first domestic production did not appear until 1905.[9] The lack of domestic capital investment left the field mainly to direct and indirect foreign control, with most investments in film stemming from foreign banks, including major firms headquartered in the United States, Britain, France, Germany, Spain, and Portugal. Foreign merchants also built the first real movie theater, Ping'an Theater, in Beijing in 1907, with screenings intended only for foreign patrons.

Twenty years later in 1927 there were still only 100 theaters, but by 1930 there were 250.[10] Yet the rapid theater expansion was driven mostly by the demand for imports.[11] An American merchant, Benjamin Brodsky, founded the first production company in China, the Asia Film Company, in Shanghai in 1909. In 1913 a young theater lover named Zhang Shichuan, along with some friends, founded Xingming, a director-unit style production company that contracted with Asia Film. The same year the wealthy Li brothers founded Huamei in Hong Kong. Sadly, both Xingming and Huamei were short-lived. The outbreak of World War I soon cut off the companies' supply of film stock, shutting them down for good.[12]

At the same time, the war also distracted the European powers from their activities in China, leaving room for domestic investors immediately after the war when an economic recovery freed up more domestic capital. This opening resulted in a surge of

domestically financed, small-scale production companies. The early 1920s saw several waves of speculative film finance in China, but the new companies were again short-lived. The investors' "small investment, fast turnaround, and marketable products" strategy did little to advance the domestic industry. It did, however, establish a pattern in the developing film industry of regular reversals on the radical swings of China's twentieth-century experience.

As Hollywood-style feature-length movies became the global prototype for narrative films, Chinese film pioneers began to experiment with long features in the early 1920s in an effort to compete with Hollywood for the domestic market.[13] Some of the long narratives became box-office hits, offering hope that domestic films might succeed against Hollywood-led imports.

To compete better with imports, Chinese filmmakers made an effort in the early to mid-1920s to consolidate capital and human resources.[14] This industrial consolidation reached its peak in 1927, reducing the number of production companies from well over a hundred to only thirty-two, dominated by an oligopoly of three: Mingxing (Bright Star, Star), Dazhonghua-Baihe (The Great China-Lily), and Tianyi (First Under Heaven). This is probably the earliest moment at which we can point to Chinese film and properly call it an "industry."

Up to this moment, early domestic films were mostly co-productions, dependent upon foreign capital and technology, limiting the early film industry to the treaty ports where these foreign supports were most accessible, especially Shanghai. In fact, the early industry developed to an important extent in Shanghai's cosmopolitan image, with films made by and for urban "petit bourgeois," and as a commercial medium seeking to imitate and compete with imports. But the commercial, urban, Hollywood-driven character of China's "intro to cinema" era had already been rocked by war and already contained the seeds of an altogether differently purposed cinema.

Building a Profitable and Patriotic Industry: From the Mid-1920s to the Late 1940s

Chinese cinema from the mid-1920s to the early 1930s witnessed, simultaneously, a commercial entertainment wave and a series of institutional restructurings. Profitability and nationalism became the bywords of Chinese film during the period, which established the fundamental philosophical struggle that continues to underlie Chinese cinema to this day.

From the start, Chinese cinema has been distinguished in part by a particularly close connection with indigenous literature, hence with writers. In the 1920s this meant literature and writers associated with the May Fourth movement and various other progressive and/or revolutionary writers' groups and societies, including those who would join together to form the League of Left-Wing Writers in 1930. Many of these earnest writers were initially repelled by film's economic imperative to provide popular entertainment. Events conspired, however, to involve writers and filmmakers alike in a more activist and nationalist cinema as "unfair trade practices and other attempts at

colonization by Europe and the U.S. and then by Japan militated against an escapist cinema," and especially after the Japanese bombing of Shanghai in 1932 brought new patriotic purpose to the industry.[15]

On the practical side, a consolidation of domestic transportation in the late 1920s boosted economic development and brought substantial industrial investment to China's coastal cities. However, Hollywood's dominance in the Chinese market continued throughout the 1920s, occupying 90 percent of screen time,[16] largely because foreign capital had effectively monopolized the distribution and exhibition sectors. Film exhibition in the 1920s and 1930s adhered to a two-tiered colonial structure. Upscale theaters in big cities all had exclusive contracts with Hollywood, and heavy fines were imposed when such theaters screened Chinese films. Domestic productions were shut out of these larger markets, relegated to smaller exhibitors in the second tier.

Chinese film practitioners were keenly aware that they needed their own theater chains. Battles over film distribution and exhibition were waged against the Western monopoly, with Star taking the lead in cultivating a market for domestic productions. Imitating Hollywood's vertically integrated studio system, the company founded its own distribution network and its own theater chains, including its Central Theater in Shanghai — a palace built for domestic films. Star also bought foreign run distribution and exhibition networks, cooperating with other local companies to establish the United Film Exchange (UFE), exclusively screening films made by the affiliated companies.[17] From 1928 to 1929, UFE also published a fan magazine, *Film Monthly* (*Dianying yuebao*), to promote its pictures. Sadly, an internal power struggle eroded its financial strength, triggering its closure in July 1929. UFE's theater chains went their separate ways, forming various small production companies. Furious competition among the small independents ensued, creating chaos in the domestic film market and inciting calls for an integrated national film industry. Though a latecomer, the United China Film Company (Lianhua, UC) emerged as a formidable production company that would lead the way.

Luo Mingyou, who owned a chain of theaters located in northern cities, formed the United China Film Company in 1930 through a series of vertical and horizontal integration initiatives. Luo too recognized the importance of integrated structures to Hollywood's global success, and sought to imitate it. But it was the advent of synchronized sound that gave Luo his chance to venture into film production.[18] Synchronized sound raised new cultural and linguistic barriers to imported film. Foreign "talkies" did not fare as well as their silent predecessors. Meanwhile, Hollywood had stopped exporting silent pictures, leaving many theaters in China desperate for something to screen.

Anticipating the inevitable demand for domestic talkies, Luo courted various production companies, including Great China-Lily and Star, to join together under the United China umbrella. With financial support from family and friends, Luo acquired shares of each company by purchasing their equipment and signing exclusive contracts to screen their films in his theater chains. Meanwhile, he advocated constructive cooperation rather than destructive competition among studios. He encouraged studios to support theaters showing Chinese films by supplying them with first-run quality films.

Finally, he advised theater owners to consolidate their chains and to liquidate foreign-run theaters.

With Star, Great China-Lily, Shanghai Cinema and Drama Company, and the Hong Kong Film Company signed up, United China was officially launched in March 1930, setting up offices in Hong Kong and Shanghai. UC also consolidated theaters in Hong Kong, Shanghai, Guangzhou, and northeast China to establish a distribution-exhibition network. Finally, Luo started a technicians' training program in Beijing and a performer's school in Shanghai. UC's nationalistic aspirations and professional management skills attracted many of the top talents in Shanghai, boosting the company's image as a haven for quality productions.

From 1932 to 1934, UC went through a period of crisis brought on by both external and internal pressures, only managing to overcome its financial difficulties by injecting new talent into its production team, including Tian Han (*Three Modern Women* [*San ge modeng nüxing*], 1933) and Sun Yu (*Wild Rose* [*Ye meigui*], 1932), left-wing filmmakers whose socially realistic pictures achieved both critical acclaim and popular success.

The operation of the film industry was disrupted again by the outbreak of the Second Sino-Japanese War in 1937.[19] As the wartime situation stabilized, film production resumed, but on a much different footing. Wartime films in the unoccupied areas focused on nationalism and Chinese resistance, while films in the occupied areas were forced into politically neutral subjects and Japanese propaganda. In the occupied areas, Shanghai and Changchun stood out as centers of film production. In 1942, the Japanese established the China United Film Production Corporation (Zhonglian) to take control of all film production in Shanghai. In Changchun, the Japanese founded Manchurian Motion Pictures (Man'ei) in August 1937 as the production center for wartime propaganda films. In the unoccupied areas, Central Film Studio became the center, first in Nanjing, then moving to Wuhan as the Japanese advanced, and finally to the wartime capital of Chongqing. After the war, the Nationalist government confiscated production equipment from United and Manchurian. In 1943, a new organization, Central Film Services, was founded and began controlling film distribution and exhibition channels. As the Chinese civil war resumed after the Japanese defeat, the four-year period from 1945 to 1949 saw an unprecedented consolidation and centralization of the film industry in the hands of the Nationalist government, including the state-sponsored Central Film Studio. Still, a number of private companies also flourished during the civil war period, including Wenhua, Lianhua, and Kunlun. The private companies produced such enduring wartime classics as *Spring in a Small Town* (*Xiao cheng zhi chun*, dir. Fei Mu, 1948), *The Spring River Flows East* (*Yi jiang chunshui xiang dong liu*, dir. Cai Chusheng, 1947), *Myriad of Lights* (*Wanjia denghuo*, dir. Shen Fu, 1948), and *Crows and Sparrows* (*Wuya yu maque*, dir. Zheng Junli, 1949).

By the end of this period, Chinese cinema had become a contested strategic ground, largely controlled by external events and agents, and internally divided between experienced commercial filmmakers, May Fourth progressives, and ideologues and nationalists from both sides of China's revolutionary divide.

The Era of Centralization: From the Early 1950s to the Early 1980s[20]

Some of the crucial steps toward establishing a socialist-style centralized film management system were taken even before the official founding of the PRC in 1949. The foundations of the Changchun, Beijing, and Shanghai Film Studios were laid in the late 1940s. On October 1, 1946, the Communist Party established the Northeast Film Studio (renamed Changchun Film Studio in March 1955) using equipment abandoned by Manchurian Motion Pictures.[21] Beiping Film Studio (renamed Beijing Film Studio on October 1, 1949) was established on April 20, 1949.[22] The Shanghai Film Studio was officially established on November 16, 1949, taking under its wing several of the city's Nationalist-controlled studios. In 1952, the remaining independent studios in Shanghai merged to form Shanghai United Film Studio.[23] In February 1953, Shanghai United Film Studio merged with the Shanghai Film Studio. Central oversight of the film industry also began before the PRC founding, with the Central Film Bureau established under the control of the Propaganda Department of the Chinese Communist Party in March 1949. After the establishment of the PRC on October 1, 1949, the Film Bureau moved to the jurisdiction of the Ministry of Culture.[24]

At the same time, new theaters and mobile projection units were employed on a massive scale to bring film to the rural masses for the purpose of educating them in Party ideology. Film's new role as socio-political tutor to the masses would entail regulation of content and meaning in accord with the Party's goals and its perception of rural audiences' requirements for simple plots and clear meaning.

The nationalization of the Chinese film industry in 1953 came under the direct guidance of Soviet film experts. China's Soviet-style command economy prevailed from the early 1950s to the early 1980s. In the command economy, investment in production responded to government planners rather than markets, and so it was in film production too. The film "industry" consisted of a nationalized studio system under which the films produced were dictated by the central government's political agenda. Film functioned to disseminate communist ideology and bolster the Party's leadership. Production resources and quotas, film licensing, film distribution and exhibition, and film export were all planned annually according to the Party's propaganda targets, with the Ministry of Culture's Film Bureau in charge of the planning. The Bureau was also responsible for regulating film studios and related institutions, and allocating production quotas among the various studios. The largest ones, including Changchun, Beijing, Shanghai, and August First, were the most favored. Production funding and targets were allocated according to each studio's production capacity and specialties, with the targets specifying not only the gross number of films, but also which types of film would be produced.[25] Each studio maintained a full staff of actors, writers, directors, cinematographers, and technicians. Most were overstaffed, following the general pattern of Chinese state-controlled enterprises.[26] Studios were generally well equipped with 35 mm equipment, and larger studios even built their own exterior "back lot" generic street, the Chinese equivalent of the frontier towns in American Westerns.

A system for licensing approved films was also promulgated in the mid-1950s, with both domestic and imported films requiring Film Bureau approval for exhibition. The Bureau's Film Exhibition Management Department initially oversaw film distribution and exhibition. A national distribution network was established in 1950, in the form of regional film management companies in the Northeast, Beijing, and Shanghai, and in the South-central, Southwest, and Northwest military administrative regions.[27] The National Film Management Company was formed in Beijing in February 1951 to take over film distribution. Acting as a central distribution agency overseeing film distribution at the national level, the company purchased complete film prints from studios at rates based more on length than on the production quality or expected market value of the prints. At the provincial level, local film bureaus established their own management organizations to control film distribution and exhibition. Central control over local activities was not always strong, and local exhibitors sometimes altered the length of exhibition cycles according to the popularity of individual films. For instance, a few cinemas in Changsha gave politically charged Soviet films short runs while granting entertainment-oriented domestic comedies longer runs.[28]

Its long-term damage to the future development of the film industry notwithstanding, the nationalized studio system provided immediate shelter to both veteran and newly established studios from the mid-1950s to the early 1960s. It consolidated film technology and capital, and nourished film talent in a production environment free from financial constraints for a generation of filmmakers. The government's protectionist film policy, fashioned more out of political than economic concerns, kept Hollywood and West European imports at bay, maintaining China's large film market exclusively for the domestic industry. Under these conditions, Chinese cinema witnessed a period of prosperity that lasted until the outbreak of the Cultural Revolution in the mid-1960s.

This was also a period during which a relationship between the state and the film industry as well as habits of mind and purpose in Chinese cinema were consolidated, and would stick through any future developments. Mao's 1956 invitation to "Let one hundred flowers blossom, one hundred schools of thought contend," began a series of political openings and crackdowns in the industry that has continued down to the present, establishing a pattern of regulation that helped to ingrain habits both of socially purposeful filmmaking (whether politically controversial or not) and self-censorship that also continue, and which now affect Chinese cinema's "brand" and competitiveness in the global market.

Although the Cultural Revolution virtually shut down film production, as Paul Clark notes in his chapter, certain films were still available to the public at this time, including some foreign productions.[29] With the end of the Cultural Revolution in the late 1970s the centralized studio system resumed its function, marked by continued political control and financial subsidies from the state. The system remained intact until the mid-1980s when China's economic reform began to alter these relationships.

China's economic reform began in the late 1970s with a reorientation of the government's development strategy, shifting away from heavy industry toward light industry and agriculture, the basics of people's daily consumption.[30] As consumption

became the new driving force of economic growth, the film industry responded by shifting its focus from production to exhibition. Recognizing film exhibition as the key to boosting film consumption, the State Council approved a joint petition by the Ministry of Culture and the Ministry of Finance in August 1979 to give exhibition companies a greater profit share toward future expansion. Theaters were allowed 80 percent of box-office profit as an investment fee for renovation and expansion. In the next three years, the exhibitors invested more than 50 percent of profits in renovating old theaters and building new ones, as well as updating equipment and recruiting more projectionists and other technicians.[31]

Meanwhile, the China Film Corporation (China Film, successor to the China Film Distribution and Exhibition Company) had been purchasing original prints from studios at a mandatory price of 9,000 yuan per print, regardless of each film's individual market value.[32] China Film contracted for a studio's entire production output, enabling studios to sell unpopular films on the strength of the popular, or even in the absence of popular films. Such a distribution system resembled the block-booking practice of the Hollywood majors during the height of the studio era except that in China the studios did not need to exert any pressure on the distributor. This cozy production and distribution practice, together with the lack of competition from imports and the era's limited entertainment options, contributed to the success of domestic films, regardless of quality, from the late 1970s to the mid-1980s.

Encouraged by the popularity of cinema and the growing wealth of the newly reformed distribution-exhibition sector, the studios lobbied for an extension of the profit-sharing policy to the production sector. The Ministry of Culture responded with a memorandum in 1980 directing China Film to settle accounts with the studios according to the number of prints made for distribution rather than by paying a flat fee for original prints.[33] However, the new regulation was a modification rather than a radical change from the flat-rate purchase system. The regulation stipulated a fee schedule that allowed the amount paid for a film to fluctuate only within a narrow range of 90,000 to 108,000 yuan. The new accounting rule provided studios an opportunity to earn some extra cash, but not enough to act as a financial incentive to make more marketable films. Still mostly disconnected from the market, the studios continued to pay little attention to their films' box-office performance. This arrangement would hurt the overall financial well-being of the industry in the long run, but it did provide studios the freedom to indulge in the kinds of cinematic exploration that would characterize a New Wave of Chinese filmmakers. Ironically, a centrally planned system with little concern for the market helped to produce China's "Fifth Generation" of filmmakers and put Chinese cinema forcefully onto the world map.

The Era of Marketization: From the Mid-1980s to the Early 1990s

Economic reforms that took hold in the second half of the 1980s played a significant role in determining the parameters and possibilities of Chinese cinema as both an economically viable and a culturally motivated institution. With its emphasis on the

financial accountability of individual production units, the new policy shook the very foundation of Chinese cinema. The problems of low productivity and inefficiency in the state-run enterprises had become apparent by the mid-1980s, brought to light by a financial crisis in the state-run film industry. During the first half of the 1980s, Chinese cinema had witnessed distressing declines in both box-office receipts and the flow of capital and creative forces into film. In 1984, only 26 billion tickets were sold, down 10 percent from 1980.[34] In the first quarter of 1985, the moviegoing audience was 30 percent smaller than in the previous year. The result was a loss in revenue of 9.36 million yuan ($1.17 million), which compelled the state to implement a number of important policy changes in the hope of resuscitating the industry.

Growing out of a Planned Economy: The Second Half of the 1980s

Film reform began in the distribution sector, with new rules giving local distributors more economic autonomy and responsibility. Under the planned economy, the state-controlled China Film Corporation (CFC) had acted as the central distributor, responsible not only for distributing films to theaters but also for paying fees to the studios, footing the bill for promotion and extra film prints. Local distributors only passed along film prints to the theaters and turned over the box-office revenue to the CFC. With no financial responsibilities, but sharing profits with the CFC, local distributors often requested more prints from the CFC to support multiple screenings for more profit. Under the new rules promulgated in 1984, local distributors were required to pay for extra prints, in exchange for a greater share of profits.

Encouraged, studios demanded further distribution reform that would allow the production sector to share profits. Under the old system, studios sold film prints outright to the CFC for a flat fee. Studios' profits depended on the number of prints the CFC ordered. The first two studios to challenge this system were the Shanghai and Xi'an Studios, negotiating with the CFC in 1986 to stop selling prints outright and instead to share in box-office receipts.

Film industry restructuring during the first half of the 1980s was haphazard, without a coherent, long-term strategy, and reflected a passive and partial reaction to China's overall economic reform. Focusing on the distribution-exhibition sector, it left film finance and production untouched.

In January 1986, a structural overhaul at the state level put the Film Bureau, previously under the control of the Ministry of Culture, under the leadership of the Ministry of Radio, Film, and Television (RFT). The restructuring attempted to consolidate and coordinate the three major sectors of China's audiovisual industry. However, because this state-level institutional restructuring was not carried out at the provincial level, where power struggles and bureaucratic bickering kept the local Film Bureaus under the control of the local Culture Departments, many organizational and managerial glitches resulted.

In 1987, both the studios and the local distribution companies demanded further autonomy from the CFC in production planning and film distribution. In their mutual attempt to dismantle the CFC's monopoly, the studios and the distribution-exhibition

companies courted each other, agreeing to collaborate in film distribution. Proposals were made to allow studios to cultivate their own production-distribution-exhibition networks and to grant local distribution companies the autonomy to purchase film prints of their own selection. However, the proposals were deemed too radical at the time and were rejected out of hand.

Still in 1987, the Ministry of RFT issued "Policy Document 975," dismantling the mandatory price limits at both the high and low ends and allowing studios to share box-office profits with distributors. In 1988, a symposium on "Strategic Planning for the Film Industry" resulted in a decision to further relax price controls on film exhibition, allowing a limited hike in ticket prices at some upscale film theaters in big urban centers. In sum, film reform in the 1980s focused mostly on the distribution-exhibition sector, granting the distributors and exhibitors a better share of the profits and more managerial autonomy. This partial reform reflected policy makers' unwillingness to come to terms with the inefficiencies of the state-run studio system, which had long been out of touch with the market. Still apprehensive about market-driven economics, the Chinese film industry was one of the most conservative state-run sectors in China by the end of the 1980s.

Towards a Market Economy: The Early 1990s

The standstill in the film industry was broken in the aftermath of 1989's Tiananmen debacle when the state sought to redirect public attention and distance the event by redoubling its reform efforts. Especially after Deng Xiaoping's Southern Tour early in 1992, the newly energized economic reform program moved to the state level and propelled a thorough structural overhaul of the film industry. Film industry restructuring in the 1990s, including reforms in film production, reflected the general trend of in-depth state-run enterprise reform, ownership reform, and marketization. Distribution reform in the 1990s sought to eliminate the multi-layered distribution process, dredging the previously clogged distribution channel, and encouraging competition not only among the distributors and exhibitors but also among the studios. Distribution reform reached a new peak in 1993 when the Ministry of RFT issued "Policy Document No. 3 — Suggestions on the Deepening of Institutional Reform in the Chinese Film Industries," and a further policy document ensuring the implementation of the Document 3 suggestions.[35] Much of the reform progress through 1997 can be attributed to "Policy Document No. 3" and its follow-up document. The supplemental document connected print prices and ticket prices directly to the market, decisively dismantling China Film's distribution monopoly. It also proposed measures for production reform, allowing studios to negotiate directly with local distributors on profit-sharing and multiple distribution arrangements. The same year, a film exchange market was established in Beijing to host an annual production-distribution conference, simplifying distribution by bringing producers and distributors together in one place. The exchange market functioned as a kind of film festival to pretest the market value of films.

A shortage of production capital continued to plague the industry, limiting both the quantity and quality of films. With the studios' financial crisis exposed, a

consensus emerged that Chinese cinema's state-run studio system was long overdue for a structural overhaul. Reform measures were to be similar to those carried out in other state-run industrial sectors. While the Ministry of RFT maintained its control over film importation and annual production targets, individual studios implemented various strategies, including organizational restructuring, opening to private investment, horizontal integration arrangements, and international co-production deals. Different studios applied different measures to different extents.

Production reform brought to light the studios' inflated overheads, low productivity, and lack of creativity operating in a financially egalitarian and ideologically authoritarian environment. A series of policy amendments at the state level were implemented to grant more economic and creative autonomy to the studios. But the studios' problems could not be solved by a few policy adjustments. While the mandatory profit-sharing quota could be adjusted through tax reform and marketization at a macro level, the problems with egalitarian pay scales and overstaffing could not be amended easily, since they cut deeply into ideological, cultural, and political norms. The problems of overstaffing, especially of administrative personnel, and the aging of creative personnel and production equipment, persisted.

In response, using whatever limited leeway they had in these areas, the studios adopted a number of measures, including downsizing, internal restructuring, talent outsourcing, and linking bonuses with profits. Experiments with horizontal integration in the form of ventures into other audiovisual-related businesses were also undertaken. Some studios even went so far as to expand into alternative businesses such as restaurants and discotheques. Horizontal integration, or the cultivation of multiple revenue streams, was particularly effective at utilizing extra equipment, technology, talent, and sometimes even studio back lots for extra profits. This cultivation of alternative revenues also included the production of television commercials.

The Era of Globalization: From the Mid-1990s to the Mid-2000s

Production reform in the early 1990s did not lead to better box-office performance. Chinese cinema continued to lose audience, revenues remained slim, and production money remained meager. Hoping to improve the situation, the Ministry of RFT issued yet another policy revision in early 1994, approving the importation of ten international blockbusters annually, primarily big-budget Hollywood films. Hollywood's re-entrance to the Chinese market would profoundly shape the course of Chinese cinema from this point forward. Still in the midst of its marketization effort, Chinese cinema would now engage with globalization as well, and the trend would accelerate after China's accession to the World Trade Organization in December 2001.[36]

Hollywood Reacquainted

The Ministry of RFT required imported blockbusters to represent the state-of-the-art in global cultural achievement, and to display excellence in cinematic art and technique. In practice, cultural achievement and artistic and technological excellence were apparently

measured by a prospective film's budget, its star power, and/or its box-office returns. Thus, as much or even more than ideology, economics determined the selection of imports. As a result, since 1995, star-studded, big-budget, and high-tech blockbusters such as *Natural Born Killers* (dir. Oliver Stone, 1995), *Broken Arrow* (dir. John Woo, 1995), *Twister* (dir. Jan De Bont, 1997), *Toy Story* (dir. John Lasseter, 1995), *True Lies* (dir. James Cameron, 1995), *Waterworld* (dir. Kevin Reynold, 1995), *The Bridges of Madison County* (dir. Clint Eastwood, 1995), and *Jumanji* (dir. Joe Johnston, 1995) have played to Chinese audiences. The imports generated huge box-office revenues, totaling 70–80 percent of the total box office in 1995. As intended, the ten big imports restored Chinese audiences' theater-going habit. "Going to the movies" once again became a leading entertainment choice, clearly benefiting Chinese cinema as well. The returning Chinese audiences began to take notice of domestic films, discovering some of China's own big-budget and high-tech entertainment pictures, what the Chinese called "domestic big-pictures" (*dapian*). These included international co-productions with majority creative contributions from the domestic partners. The domestic big pictures all became blockbusters in 1995,[37] with *Red Cherry*'s box office even topping the big imports.[38] Under this new regime, Chinese cinema made a quick recovery, with total box-office returns in 1995 15 percent higher than in 1994.[39] With ten big imports and ten big domestic pictures, 1995 became known as "the year of cinema."[40]

Chinese critics attributed Chinese cinema's renewed popularity to the film industry's new "big-picture consciousness," meaning a revelation about budgets and quality.[41] Hollywood's high-cost production values became the standard of quality for both Chinese audiences and film practitioners. Domestic big pictures imitated their foreign rivals.[42] In 1995, with budgets over 10 million yuan ($1.25 million) each, four films, *In the Heat of the Sun* (*Yangguang canlan de rizi*, dir. Jiang Wen), *The King of Lanling* (*Lanling wang*, dir. Hu Xuehua), *Red Cherry* (*Hong yingtao*, dir. Ye Daying), and *Shanghai Triad* (*Yao a yao, yao dao waipo qiao*, dir. Zhang Yimou), set Chinese film investment records.[43] The ten big imports also introduced Western-style distribution to China, dividing profits as well as the losses between the producer, the distributor, and the exhibitor. Under this system, the producer is forced to confront the market directly, while the distributor and exhibitor must make every effort to promote the films. The Chinese film industry began to experiment with this new distribution method in the mid-1990s.

The film industry's replication of Hollywood's blockbuster practice does not by itself explain Chinese cinema's sudden recovery in the mid-1990s. Another policy change at the beginning of 1995 was to have important consequences. In January, the Ministry of RFT relaxed its production licensing policy, extending the right to produce feature films from the sixteen state-run studios to include thirteen provincial-level studios. Furthermore, investors outside the film industry who would cover 70 percent of the production cost were allowed to co-produce with a studio. Previously, since only the sixteen state-run studios were allowed to produce films and distributors could only distribute studio films, an outside investor had to become attached to a studio in order to participate in film production and distribution. The new policy allowed studios to collect a flat "management fee" of around 300,000 yuan ($37,500) regardless of the film's profitability. If the film

was profitable, studios would bargain with the investors for a cut of the profits, usually 40 percent. Although this practice was termed "co-production," in effect the studios were "selling" production rights, under the rubric of a "management fee," to wealthy investors. The investors typically borrowed the host studio's talent, equipment, and interiors, which helped to cover overhead and equipment maintenance fees.

Hollywood Emulated

By the end of 1995, it seemed that the imports, by triggering policy changes and restoring the theater-going habit, had coincidentally restored Chinese domestic film production. However, a closer examination reveals that the domestic box-office success mostly came from productions involving private investment. The majority of the state-run studios continued to fall behind in making marketable films. Two-thirds of the domestic films produced in 1995 were cheap knockoffs of Hollywood and Hong Kong–style entertainment films. The majority were box-office "turkeys" made either by the financially ailing state-run studios or profit-conscious private investors inexperienced in film production and distribution.

The proliferation of low-budget and low-production-value entertainment pictures failed to generate profits and instead provoked tough sanctions from the government. As risqué literature, politically explicit and exploitative artwork, and pirated rock music proliferated in the increasingly commercial cultural markets, a campaign to criticize "spiritual pollution" was launched in 1996 to rein in these markets. In March, the Ministry of RFT held a national film workers' conference in Changsha addressing the Ministry's concerns about the quality of Chinese cinema, particularly low-budget entertainment films featuring gratuitous sex and violence. At the "Changsha Meeting," cinema's pedagogical function and social impact were once again foregrounded. Policy makers demanded that the industry produce and promote ten quality domestic pictures a year for the next five years. What qualified as "quality" remained vague, prompting considerable discussion among industry practitioners. As usual, the studios practiced self-censorship, slating predominately safe, mainstream propaganda films.

Not surprisingly, Hollywood-influenced Chinese audiences were unenthusiastic about Chinese cinema's renewed passion for the socialist genre. The propaganda films were able to claim box-office success only because the government organized, sponsored, and paid for public viewings. Film revenue fell, and the number of films produced also decreased.[44] Thus, there was yet another downturn in Chinese cinema in 1996, leading to serious doubt that the film market could survive without the big imports. The danger of a domestic film market dependent on foreign imports propelled the state to adopt protectionist policies mandating that two-thirds of the films distributed and exhibited must be domestic productions, and two-thirds of screening time must be reserved for domestic pictures. The state's conservative turn steered many private investors away from film and toward investing in the more profitable field of television drama production.

Harried by financial insecurity, studios lobbied for the right to distribute foreign films — a sure means of generating profit. In 1996, the Ministry of RFT issued a document that gave shares of the profit from distributing imports to studios that produced "quality

domestic pictures." As a reward for producing popular quality films, studios would be given the right to distribute the big imports approved by the China Film Corporation. The quota was a one-to-one exchange: one big import for one quality domestic film. In 1996, three major studios — Beijing, Changchun, and Shanghai — won distribution rights to imports on the strength of the domestic hits they had produced in the previous year. Among the twenty-four total Hollywood imports that year, the three biggest, *Toy Story* (dir. John Lasseter, 1995), *Waterworld* (dir. Kevin Reynolds, 1995), and *Jumanji* (dir. Joe Johnston, 1995) were distributed directly by the three studios, which shared the box office with Hollywood and the participating theater chains.

Chinese cinema's complex development in the mid-1990s showed that opening the market to the imports could stimulate domestic competition, and indeed help to expose Chinese audiences to domestic pictures. However, it also revealed that while domestic films still had box-office potential, only films with relatively high production values would have any chance at all. Meanwhile, the state's ideological impositions restricted film practitioners' creative imagination and range, contributing to Chinese cinema's lackluster image both at home and abroad. Furthermore, after being subsidized by the state for decades, an entire generation of filmmakers remained inexperienced in alternative approaches to film production. Even when shifting film policies granted filmmakers more control over their creative processes and products, they still found it difficult to make the transition from a cinema of propaganda and positive purposefulness to a cinema of popular appeal and commercial entertainment. In this important sense, the Chinese cinema's crisis could not be resolved by simply reforming the mode of production.[45]

In the late 1990s Chinese cinema witnessed yet another downturn. While ten domestic blockbusters accounted for $3.1 million at the box office in 1995, the remaining 135 Chinese films produced that year earned an average of only $15,000 each.[46] At the same time, while the ten big imports (six from Hollywood) accounted for just 3.3 percent of the 269 films exhibited in Beijing in 1995, they took in 40 percent of Beijing's box-office receipts of 92.6 million yuan ($11.4 million).[47] Hollywood blockbusters continued to dominate the Chinese market throughout the late 1990s, owing primarily to the performance of *Titanic* (dir. James Cameron, 1997) and *Saving Private Ryan* (dir. Steven Spielberg, 1998), which together accounted for about one-third of the total box office in Beijing and Shanghai. *Titanic*, which set a box-office record in China, accounted for 21 percent of Shanghai's total (38 million yuan) and 28 percent of Beijing's total (36 million yuan).

One response to the industry's downturn, as noted above, was a limit on the exhibition of foreign films.[48] In addition, the Chinese Film Distribution and Exhibition Association launched a national level theater chain ("China Theater Chain"), consolidating three hundred theaters in big urban areas to guarantee quality domestic films the most favorable screen times.[49] In May 1997, the Film Bureau issued yet another measure to reinforce the simultaneous opening of quality domestic films nationally at first-run theaters. The Chinese Internal Revenue Service also got involved, reducing the tax on exhibition income.[50] Meanwhile, in an attempt to improve production quality, the

average budget for a domestic feature was increased from 1.3 million yuan in 1991 to 3.5 million in 1997.

Not surprisingly, with no concessions on the point of creative freedom, the protective measures did not boost the attendance for domestic pictures; rather, it cut into overall revenue by reducing the profit margin of the big imports in 1998.[51] The box office for the periods during which only domestic films could be shown was consistently lower than during open screening periods. Many in the distribution-exhibition sectors expressed doubts as to whether such an anti-market practice was feasible in the long run.

Nonetheless, the Film Bureau and the Film Distribution and Exhibition Association continued to restrict the release of Hollywood films in 1999.[52] The entire months of May, June, September, and October were blacked out. The occasions cited for the blackouts were the tenth anniversary of the June 4, 1989 Tiananmen Square crackdown and the fiftieth anniversary of the PRC's founding on October 1, respectively. An official decision also stated that any Hollywood films released in 1999 would only be permitted "low-key" promotional campaigns, while distributors would be required to aggressively promote domestic films, particularly films made to commemorate the PRC's fiftieth anniversary.

Obviously, the protectionist measures chiefly benefited state-supported propaganda films, what the Chinese film community calls "main-melody films" (*zhuxuanlü dianying*), achieving the ironic result of effectively "re-nationalizing" Chinese cinema in the age of globalized markets, sending "hyper-nationalist" productions out to compete against the wide world of glittering escapist entertainment. The vast majority of domestic pictures, most of them mediocre entertainment pictures, were left to fend for themselves. Pushed against the wall, the film industry initiated a new round of vertical and horizontal consolidation to reorganize and expand the motion picture business.

Industrial integration in the late 1990s and beyond followed the New Hollywood model, ushering the Chinese film industry into the age of conglomerates. The 1980s had witnessed media mergers in Hollywood that put studios under the control of mega-media conglomerates that provided long-term financial stability for the studios and prioritized films that fit a narrow logic of multiplying revenues. Hollywood in the 2000s has been increasingly consolidated into larger media firms and the cinema experience has been expanded beyond the confines of theaters. The Chinese audiovisual industry, directed by the Chinese state, has opted to follow the same strategy, and it has already begun to bear fruit. In 2004, for the first time in decades, China produced more than two hundred movies and total industry revenue increased 66 percent to almost $435 million. Feng Xiaogang's *A World Without Thieves* (*Tianxia wuzei*, 2004), Zhang Yimou's *House of Flying Daggers* (*Shimian maifu*, 2004), and Stephen Chow's *Kung Fu Hustle* (*Gong fu*, 2004) all earned handsome profits. Most significantly, domestic film receipts exceeded foreign film receipts for the first time since 1994, despite a doubling of the number of foreign movies allowed into China each year. This trend of expansion has continued to the present. In sum, the Chinese film industry has now firmly entered the era of globalization, growing by way of increasing film imports and exports, conglomeration

into larger media organizations, and a trend toward international co-productions pursued by the new Chinese media conglomerates.

At the same time, it is the state that created China's media conglomerates, most notably the China Film Group (CFG),[53] and it has endeavored to use their market power as a new mechanism of its cultural control regime, a market-based means of managing market share and market entry as cultural markets gradually become more "open" in response to China's increasing global engagement and its participation in international organizations like the World Trade Organization.

Another important measure that the Chinese state has taken to bolster the film industry is the Closer Economic Partnership Arrangement (CEPA) with Hong Kong. Implemented late in 2004, CEPA essentially saved a dwindling Hong Kong film industry by reclassifying its productions as domestic. Previously treated as imports, Hong Kong films had been largely shut out of the huge Mainland market. CEPA also provided for Mainland–Hong Kong co-productions in terms that opened a back door for more international participation in co-productions organized through Hong Kong. At the same time, this new access comes with the usual restrictions on style and content applied to domestic film, and there has been some concern that Hong Kong cinema would lose its identity in the process of re-engineering its products for Mainland censors. A frequently cited example is the third installment of the hit Hong Kong trilogy of *Infernal Affairs* films. The film's morally ambiguous ending was changed for the Mainland release, so that Mainland audiences got a clear resolution with good guys triumphing over bad. Of course, Hong Kong filmmakers could simply go on producing multiple versions of their films for different markets, but it seems just as likely that they will also inculcate the same habits of self-censorship as Mainland filmmakers are used to.

The Chinese state has managed the marketization of the Chinese film industry with two goals utmost in mind: making the industry competitive in globalized markets while also maintaining the state's grip on culture. It has managed quite well, partly on the strength of China's market size and growing prominence in the global political-economy, partly on the strength of effective policy-making, and partly on the strength of native cultural expectations about the nature and uses of cultural products like film. Still, Hollywood's constant popularity, and the constant necessity of holding it back with import quotas even after the Chinese industry has learned to match its production values, suggest that Chinese audiences are a lot like global audiences. Critics like Zhang Xudong now argue that China's cultural politics have changed so much with "the rise of an extremely uneven and heterogeneous socioeconomic, political, and daily reality in the 1990s" and beyond that the Chinese "masses" no longer cohere.[54] Finally, though, it has to be remembered about China that it invented the "cultural revolution" — the notion that culture could and *should* be massively reinvented toward a designed social outcome. Today's Chinese cinema is still constrained and still constrains itself in the tradition of culture by directive, but ultimately audiences will set the limits as China converges with the global commons that film first served.

Chinese Cinema's International Market

Stanley Rosen

From autumn 2004 to mid 2005, as *Newsweek* magazine noted at the time, Chinese films took off internationally, even conquering the notoriously parochial American market where filmgoers "historically have avoided movies with subtitles as if they were homework."[1] The *Newsweek* report referred specifically to the box-office success of such films as *Hero* (*Yingxiong*), *House of Flying Daggers* (*Shimian maifu*), and *Kung Fu Hustle* (*Gongfu*), as well as the luminous star power of Zhang Ziyi.[2] Indeed, both Zhang and fellow actress Gong Li appeared in high profile American films from 2005 to 2007, with Zhang starring in the plum role of Sayuri in the Steven Spielberg–produced filmization of the bestselling 1997 novel *Memoirs of a Geisha*, and Gong not only appearing in that film as Zhang's rival, but also in two other blockbuster Hollywood films: Michael Mann's *Miami Vice*, starring alongside Colin Farrell and Jamie Foxx, and *Hannibal Rising*, the fifth installment of the Hannibal Lecter franchise. Moreover, in two of these films Gong played a Japanese woman suggesting, unsurprisingly, that star power and box-office appeal are more important to Hollywood than authenticity.[3]

Ever since the introduction of Hollywood films into the theatrical market in China, beginning in 1994 with *The Fugitive*, Chinese film officials and filmmakers have sought a measure of "reciprocity," seeking to promote the success of Chinese films not only domestically — in competition with Hollywood *within* China — but also internationally. Most recently, with the Chinese emphasis on expanding its "soft power" and promoting Chinese culture around the world, film has become an important component in a "go abroad" strategy, supported by leading political officials.[4] However, given the realities of international film markets — to be addressed below — a persuasive case could be made that China's "Hollywood complex" has more to do with a nationalistic need for confirmation and recognition of its film industry than with any realistic expectation of long-term box-office success against the Hollywood juggernaut, although it is also undeniable that Chinese film officials are motivated by this competitive impulse.[5] Indeed, there was a flurry of Western reporting following the success of *Crouching Tiger, Hidden Dragon* (*Wohu canglong*) in 2001, which roughly parallels the more recent enthusiasm, including the same effusive praise for the charms of Zhang Ziyi.[6]

Are these acknowledged successes of a handful of Chinese films and Chinese film stars a harbinger for the future, representing the entering wedge that will usher in a larger wave of Chinese films, and perhaps other Chinese cultural products, or are these

successes misleading aberrations, unrepresentative of Chinese film production more generally? Three separate questions are important here. First, looking beyond the hype, how successful have Chinese films been in international markets? Second, is the recent "success," however measured, sustainable over time? Third, is the Chinese strategy for penetrating overseas film markets conducive to success? To answer these questions I will look at the larger picture of international box-office trends and the place of Chinese-language films — and, indeed, all films that Hollywood refers to as "foreign-language films" — over time, examining not only recent history but also investigating likely future trends.

This chapter will focus primarily on the formidable obstacles to Chinese success. While some of these obstacles can be seen as self-imposed, and reflect the role of film in Chinese politics, culture, and society more generally, the main obstacles are *structural*; in other words, there are clear limitations on how successful *any* country can be in competing with Hollywood outside (and in most cases inside as well) that country's home market. The chapter will present box-office and other statistical data to document the dominance of Hollywood not just domestically in the United States, but also internationally. Indeed, as will be shown below, Hollywood's success increasingly depends on overseas markets.[7] On the other hand, there are strong indications that Chinese films have been among the most successful foreign language films not only in the American market, but also in at least some other overseas markets. Complicating the picture, recent trends suggest that the outlook for Chinese films has become somewhat less encouraging, as the Chinese "formula" for overseas box-office success faces new challenges. The chapter will be divided into two parts. The first part will present an overall picture of film markets in the United States and overseas, while the second part will narrow the focus to examine the success of "foreign language" (i.e., languages other than English), particularly Chinese-language films, in these markets. I will then conclude with the lessons China might learn from the data presented in the chapter.

Film Markets in the United States and Overseas

Even a cursory examination of global box-office revenues reveals several interesting findings. First, although the North American (United States and Canada) share of the total box office has clearly been declining in recent years, North America is expected to remain the leading consumer market for theatrical films (and home video as well). Out of total revenue from theatrical releases of close to US$21 billion in 2004, 45.8 percent of the total ($9.53 billion) came just from the United States, followed by Japan (9.4 percent), France (6.9 percent), the United Kingdom (6.8 percent), and Germany (5.3 percent).[8] By the first four months of 2008, however, as much as 71 percent of the market for theatrical films was being generated outside North America.[9]

Second, while industry insiders have been debating whether such recent data represent an anomaly or a nascent trend, the data also conveniently highlight another of Hollywood's advantages: the ability to maintain flexibility and to adjust to changing global markets. Indeed, Hollywood studios anticipated the increasing importance of the

international market decades ago and by 2004 Motion Picture Association (of America) (MPA) studios were making 51.6 percent of their total theatrical revenue overseas.[10] An examination of the most successful films of all time at the box office suggests just how complete Hollywood domination has been. Of the top hundred films (global box-office receipts of $390.5 million and above), the vast majority were distributed by MPA studios. None of the top twenty films earned less overseas than domestically, while the most successful films — *Titanic*, *The Lord of the Rings* trilogy, the *Harry Potter* franchise, the last two *Pirates of the Caribbean* films, and the Jurassic Park films — all earned over 60 percent of their income abroad, led by *Harry Potter and the Chamber of Secrets*, which earned over 70 percent abroad.

However, examining the top 100 films gives only a partial picture of Hollywood's dominance. When one looks at the top 346 films — those which earned at least US$200.5 million in worldwide grosses — the dominance is even more striking. The large majority of the 346 films were funded, marketed, and distributed (in whole or part) by MPA member studios.[11]

MPA studios, however, have not only concentrated on blockbusters; another aspect of Hollywood's global strategy is co-optation. When it was clear that low-budget, character- or plot-driven independent films had both a critical and popular market — not a single wholly studio-backed project captured a top prize at the Academy Awards in 2005 — the Hollywood majors began to pay more attention. Indeed, the rise (and co-optation) of the "independent" film over the last twenty years has been a frequent topic in the recent literature on the changing patterns of American film production.[12] Moreover, instead of being consigned to small art houses, these movies now play in multiplexes, side by side with expensive blockbusters.[13] This co-optation extended overseas as well. As Richard Fox, executive vice president, International for Warner Bros., noted: "Local language productions are the linchpin of our global growth strategy."[14] Thus, although there have been an unprecedented number of popular local films in recent years, in many cases these "local" films were either produced or released by U.S. distributors.[15] As I note below, this was also the case with Chinese-language films.

Closely related to this localization strategy is Hollywood's co-optation of any foreign stars or directors with a regional or international audience, as demonstrated by the careers of Jackie Chan, Jet Li, Chow Yun-fat, John Woo, Ang Lee, and many others. Indeed, after Chow Yun-fat dropped out of John Woo's $80 million Chinese-language blockbuster *Red Cliff* — which the Chinese government viewed as a showcase for Chinese history, with Part One released prior to the 2008 Beijing Olympic Games — there was concern "whether a local son has forgotten his roots now that he's a Hollywood star."[16]

Perhaps the most obvious plank in Hollywood's strategy for success is the "brand name," "tentpole," or "franchise" film. Such films have established a track record, producing a recognizable name based on prior success, one that will continue to draw filmgoers into the theaters. Sequels have made up around 25 percent of the total box-office in the United States in recent years,[17] although the percentage has been rising, with sequels making up no less than ten of the twenty biggest hits in 2007, and five of the top ten in 2008.[18] When one includes brand name franchises familiar from other media,

such as *The Simpsons Movie* and *Transformers*, the number is even higher. Indeed, we may have reached the era of the "endless sequel." For example, plans were made for the fourth installments of *Spider-Man*, *Pirates of the Caribbean*, and *Shrek* even before their success in the summer of 2007.[19]

Because the studios have a lot riding on these franchises, their production and advertising budgets have continued to rise. In 2007 the reported average cost of an MPA film was $106.6 million, including $70.8 million in negative costs and $35.9 million in marketing costs (including specialty divisions).[20] However, this does not include the tens of millions of dollars spent by outside partners to co-finance dozens of potential blockbusters, where production and marketing outlays on a single title such as *Spider-Man 3* can total more than $400 million. The studios spent more than $1 billion to make and market the third iterations of *Spider-Man*, *Pirates*, and *Shrek*.[21] Even the specialty divisions of the major studios have increased their costs, with the average negative costs going from $23.5 million in 2005 to $42.9 million in 2007, and marketing costs reaching $26 million in 2007, a 44 percent increase from 2006.[22] However, by early 2009, amid studio cutbacks, there were new concerns being raised about the industry still being "recession-proof," particularly in competition with the new, more mobile media.[23]

We can get a more complete picture of the importance of the franchise film and the international box office by looking at the hundred most successful films of all time *outside* the United States, from *Titanic*, which made almost $1.235 billion dollars, to *The World Is Not Enough*, which made $225.1 million.[24] A number of points are worth highlighting. First, fifty-six of the top hundred films based on performance outside the United States are franchise films, including twelve of the top thirteen and nineteen of the top twenty-five. The most striking exception of course is *Titanic*, which presented sequel difficulties even for Hollywood. Second, certain franchises are "can't miss." Five of the top thirteen are *Harry Potter* films; three of the top twelve are *Lord of the Rings* films; and two of the top six are *Pirates of the Caribbean* films. Third, fourteen of the top hundred are animated films. Fourth, the only films from outside Hollywood are Miyazaki's *Spirited Away* (*Sen to Chihiro no kamikakushi* at no. 73) and *Howl's Moving Castle* (*Hauru no ugoku shiro* at no. 95). Needless to say, if one added the domestic U.S. market to these totals Hollywood would be even more dominant. As documented below, Chinese films as well rely on "brand names" (*pinpai*) to succeed overseas.[25]

The Prospects for Chinese Film Internationally

Given the daunting realities of the Hollywood machine discussed above, is there any reason to be sanguine about the prospects for the Chinese film industry in its attempts to make inroads into the international marketplace, particularly the most lucrative one in North America? It is helpful to begin by looking more broadly at the market for Asian films in the United States before the recent successes of 2004–2005 noted above. Table 2.1, covering 1990–2003, provides some helpful information, with several points worth noting. First, *Crouching Tiger, Hidden Dragon*, as a box-office phenomenon, has not been repeated. Indeed, similar to the *Titanic* phenomenon in 1998, *Crouching Tiger*

seems to have been the right film at the right time. Needless to say, an outstanding marketing campaign by Sony — discussed briefly below — contributed greatly to the film's success. Second, despite the surprising mega-success of *Crouching Tiger*, subtitled films, particularly from what are considered to be more "exotic" markets like Asia have not, with rare exceptions, fared well in the United States. Of the top ten films on the list, five of them were dubbed Jackie Chan films, and one was a dubbed Japanese film.[26] The Japanese film *Shall We Dance?* (1997), which made US$9.5 million in the United States, was remade with Richard Gere and Jennifer Lopez and did much better domestically and in foreign markets than the original Japanese version (see below).

Table 2.1 Top 10 Asian Films in the U.S. 1994–2003

	Film/Year	Country	Total U.S. Gross
1	*Crouching Tiger ...* (2000)	HK/China/Taiwan	$128.lm
2	*Rumble in the Bronx* (1996)*	Hong Kong	$32.4m
3	*Supercop* (1996)*	Hong Kong	$16.3m
4	*Jackie Chan's First Strike* (1997)*	Hong Kong	$15.3m
5	*Iron Monkey* (2001)	Hong Kong	$14.7m
6	*Mr. Nice Guy* (1998)*	Hong Kong	$12.7m
7	*Legend of Drunken Master* (2000)	Hong Kong	$11.6m
8	*Operation Condor* (1997)*	Hong Kong	$10.4m
9	*Spirited Away* (2002)*	Japan	$10.0m
10	*Shall We Dance?* (1997)	Japan	$9.5m

Source: Liz Shackleton, "East Meets Midwest," *Screen International*, October 3, 2003, 19.
Note: *film dubbed into English.

This leads directly to a third issue, the remake of Asian films in the United States. It has become quite common for Hollywood studios to buy the rights to an Asian film which has been successful in Asian markets and then remake it in English, with well-known stars, to be distributed in the United States and internationally.[27] In addition to *Shall We Dance?*, this has been done, for example, with the Japanese films *Ringgu*, remade as *The Ring*, and *Ju-On*, remade as *The Grudge*. All of the English-language remakes were far more successful than the originals, not only in the U.S. market, but abroad as well.

The American version of *The Ring* had a production budget of US$48 million and an estimated marketing budget of $35 million, indicating that DreamWorks treated the film not just as a niche art film, but a potential franchise. The results justified this optimism, with *The Ring* achieving a theatrical box office just short of $250 million, divided almost equally between domestic and foreign markets. This was followed by *The Ring 2*, directed this time by the original Japanese filmmaker, Nakata Hideo. Released on March 18, 2005, the film grossed over US$160 million, with international figures

slightly exceeding the domestic box office. Thus, *The Ring*, whose Japanese version had not been released theatrically in the United States, has become a highly popular franchise, with a box-office take that has already surpassed $400 million.[28]

The Grudge, although not quite as successful — albeit with a much smaller production budget of US$10 million — has also done very well, with a total box office of over $178 million. In this case, however, 62 percent of the total came from the American market. *Grudge 2*, released on October 13, 2006, added $70 million, with 55 percent from the American market. It is interesting to note that the original Japanese version, *Ju-On*, was released in the United States, and brought in about $325,000, far below the overseas take of $2,679,000. *Shall We Dance: The Remake*, on a production budget of US$50 million, brought in close to $150 million, with about 61 percent coming from overseas markets. *The Grudge* is also a good example of another difficulty faced by subtitled films, since they are virtually always relegated to niche, art house theaters, primarily in the largest American cities. For example, the Japanese version of the film played in only eleven theaters in its widest release. By contrast, the American version played in 3,348 theaters when in wide release, while *The Ring* played in 2,927 theaters and *Shall We Dance* reached 2,542 theaters.[29]

Interestingly, Hollywood had been concentrating primarily on Korean and Japanese films for its remakes, although the recent transformation of the very successful Hong Kong film franchise *Infernal Affairs* into *The Departed*, with a star director and an A-list cast, altered that pattern. Nominated for five Academy Awards, the film received four, including the awards for best picture, director, and adapted screenplay. It was also a worldwide box-office success, bringing in $290 million, with 54 percent coming from foreign markets. Within the United States it became the second most successful Asian remake of all time, trailing the 1998 *Godzilla* by only $4 million. On the other hand, the original version of *Infernal Affairs*, released in the United States in 2004, played in only five theaters and brought in less than $170,000. It had made over $7 million in Hong Kong, dwarfing the $1 million *The Departed* had generated in that market.[30] However, in yet another example of Hollywood's "pull," the recognition given to *Infernal Affairs* enabled its director, Andrew Lau, to launch a Hollywood career with *The Flock*, his American debut film starring Richard Gere and Claire Danes.[31]

Chinese-Language Films

Turning more directly to Chinese-language films, it is helpful to examine their international and American fates in comparison to other foreign language films, and to see whether we can discern any clear trends over time. Table 2.2, which compares data on the top ten foreign language films in the United Kingdom from 1990 to 2000 and from 2001 to 2005, suggests that the impact of Chinese films on international markets has been developed in recent years. Several points are worth noting. First, the British appetite for foreign films has increased since 2001, with *Crouching Tiger, Hidden Dragon* often given credit as the breakthrough film. As one observer noted, in the eleven years prior to the January 2001 release of *Crouching Tiger*, just six foreign-language titles had passed the US$1.9 million mark in the United Kingdom. Since the

Ang Lee film, ten further subtitled films have crossed that mark, with five released in 2004. Second, as Table 2.2 reveals, three of the top five foreign-language titles were *wuxia* (martial heroic) films, with *Hero* and *House of Flying Daggers* also doing very well. To appreciate fully the impact of *Crouching Tiger*, it is important to note how revolutionary that film was in terms of distribution strategy. Prior to its release, it was common to open foreign language titles on single-figure or, at most, low double-figure sites. Released at eighty-eight sites, considered a huge gamble at the time, *Crouching Tiger* surpassed the previous U.K. foreign-language record-holder *Life Is Beautiful*, which had opened at only ten sites in 1999, and reached seventy-six sites in its widest

Table 2.2 Top 10 Foreign-Language Films, United Kingdom (1990–2000)

No.	Title (Year/Distributor)	Opening Sites	Gross
1	*Life Is Beautiful* (1999/BVI)	10	$5.8m
2	*Cyrano de Bergerac* (1991/Artificial Eye)	8	$4.7m
3	*Il Postino* (1995/BVI)	6	$2.4m
4	*All About My Mother* (1999/Pathe)	22	$2.2m
5	*Farewell My Concubine* (1994/ Artificial Eye)	8	$2m
6	*Cinema Paradiso* (1990/Palace)	1	$1.9m
7	*Buena Vista Social Club* (1999/FilmFour)	7	$1.8m
8	*Three Colors: Red* (1994/Artificial Eye)	9	$1.6m
9	*Tout les Matins du Monde* (1993/Electric)	6	$1.5m
10	*Ridicule* (1997/Alliance)	10	$1.4m

Top 10 Foreign-Language Films, United Kingdom (2001–2005)

No.	Title (Year/Distributor)	Opening Sites	Gross
1	*The Passion of the Christ* (2004/Icon)	46	$21m
2	*Crouching Tiger* ... (2001/Col TriStar)	88	$17.7m
3	*Amelie* (2001/Momentum)	82	$9.5m
4	*Hero* (2004/BVI)	254	$7.2m
5	*House of Flying Daggers* (2004/Pathe)	206	$6.8m
6	*The Motorcycle Diaries* (2004/Pathe)	80	$5.2m
7	*City of God* (2003/BVI)	76	$4.5m
8	*Y Tu Mama Tambien* (2002/Icon)	38	$3.1m
9	*Talk to Her* (2002/Pathe)	57	$2.8m
10	*Bad Education* (2004/Pathe)	45	$2.6m

Source: Robert Mitchell, "Out of Hiding: Foreign Films Flying in UK," *Screen International*, March 11, 2005, 25.

release. The marketing strategy included a sizable budget of $770,000, plenty of time to prepare, and a series of multiplex trailers which made "no overt reference to the fact it was in a foreign language."[32] Ten Oscar nominations, effusive praise from critics, and visits to London by the director and screenwriter also helped. In the United States, Sony Pictures had hired New York publicists Peggy Siegel and Lizzie Grubman, who used a "grassroots stealth marketing campaign" to create a "buzz" that propelled the film "from art house obscurity to breakout film."[33] Siegel was hired because of her 20,000-name database of people in the New York film and media community. Grubman was hired because of her connections to the "hip-hop" community. Among other marketing efforts, she arranged for the rap group Wu-Tang Clan to host two screenings of the film at Sony's headquarters in New York.

Turning more specifically to the American market, Table 2.3 provides a list of the top twenty-five foreign-language box-office successes since 1980. In addition to *Crouching Tiger*, far and away at the top of the list, there are five other Chinese-language films that made the cut, all of them released after *Crouching Tiger*'s success, including *Hero* at no. 3, *Jet Li's Fearless* at no. 6, *Kung Fu Hustle* at no. 10, and *House of Flying Daggers* at no. 21. This data suggest several noteworthy conclusions. First, Chinese-language films have been even more popular in the American market than those from any of the European countries, traditionally the source of the most successful art house films. Second, the most successful Chinese films have all been martial arts films, where language — and the disadvantages associated with subtitles — is less important than the action on the screen. Indeed, one might also include *The Protector* (*Tom yum goong*), no. 16 on the list, a Thai martial arts film in Thai, Mandarin, and English, in which star Tony Jaa channels the exploits of his boyhood idol Bruce Lee.

Third, and perhaps most significant, Chinese films have a higher "penetration" rate than other foreign films, in that they have been given a much broader release in American theaters. Indeed, all six Chinese films on this list, as well as *The Protector*, had a wider release than any film in any other foreign language, with *Kung Fu Hustle* playing simultaneously in 2,503 theaters in its broadest release. This is particularly important since it strongly suggests that Chinese films — with the important proviso that they be martial arts action films — have been the only foreign language films to break out of the art house ghetto.[34] Of the other films on this list — and this would apply even more strongly to foreign films outside the top twenty-five — only *Life Is Beautiful* and *Pan's Labyrinth* played on more than 1,000 screens.

Fourth, since the Chinese successes have all occurred recently, in the wake of the *Crouching Tiger* phenomenon, the prognosis for future Chinese films in this genre would appear to be very positive although, as I will note below, there are some storm clouds already visible on this bright horizon. Chinese martial arts films that are associated with "brand name" stars or directors such as Ang Lee, Jet Li, Zhang Yimou, or Stephen Chow are developing the credentials essential to sustain a franchise.[35] In the future, martial arts films by any of these filmmakers might be expected to do reasonably well, either in the increasingly important opening weekend — now a staple of Hollywood's marketing and distribution strategy — if the decision is made to open the film widely,

Table 2.3 **Foreign-Language Films in the U.S., 1980–Present (as of June 16, 2008)**

Only overseas-produced features counted. Re-issues excluded.

Rank	Title	Studio	Lifetime Gross / Theaters	Opening / Theaters	Date
1	*Crouching Tiger, Hidden Dragon* (China/Taiwan)	Sony Pictures Classics (SPC)	$128,078,872 / 2,027	$663,205 / 16	12/8/00
2	*Life Is Beautiful* (Italy)	Miramax	$57,563,264 / 1,136	$118,920 / 6	10/23/98
3	*Hero* (China)	Miramax	$53,710,019 / 2,175	$18,004,319 / 2,031	8/27/04
4	*Pan's Labyrinth* (Mexico)	Picturehouse	$37,634,615 / 1,143	$568,641 / 17	12/29/06
5	*Amelie* (France)	Miramax	$33,225,499 / 303	$136,470 / 3	11/2/01
6	*Jet Li's Fearless* (China)	Rogue	$24,633,730 / 1,810	$10,590,244 / 1,806	9/22/06
7	*Il Postino* (Italy)	Miramax	$21,845,977 / 147	$95,310 / 10	6/16/95
8	*Like Water for Chocolate* (Mexico)	Miramax	$21,665,468 / 64	$23,600 / 2	2/19/93
9	*La Cage aux Folles* (France)	MGM	$20,424,259 / –	$18,709 / 5	3/30/79
10	*Kung Fu Hustle* (Hong Kong/ China)	SPC	$17,108,591 / 2503	$269,225 / 7	4/8/05
11	*The Motorcycle Diaries* (Multi-Country, in Spanish)	Focus	$16,781,387 / 272	$159,813 / 3	9/24/04
12	*Iron Monkey* (Hong Kong)	Miramax	$14,694,904 / 1,235	$6,014,653 / 1,225	10/12/01
13	*Monsoon Wedding* (India)	Focus	$13,885,966 / 254	$68,546 / 2	2/22/02

Rank	Title	Studio	Lifetime Gross / Theaters	Opening / Theaters	Date
14	*Y Tu Mama Tambien* (Mexico)	IFC	$13,839,658 / 286	$408,091 / 40	3/15/02
15	*Volver* (Spain)	SPC	$12,899,867 / 689	$197,703 / 5	11/3/06
16	*The Protector [Tom yum goong]* (Thailand)	Weinstein /Dragon Dynasty	$12,044,087 / 1,541	$5,034,180 / 1,541	9/8/06
17	*Cinema Paradiso* (Italy)	Miramax	$11,990,401 / 124	$16,552 / 1	2/2/90
18	*Das Boot* (Germany)	Columbia	$11,487,676 / 2	$26,994 / 2	2/10/82
19	*The Lives of Others* (Germany)	SPC	$11,286,112 / 259	$213,589 / 9	2/9/07
20	*Brotherhood of the Wolf* (France-Canada)	Universal	$11,260,096 / 405	$100,839 / 37	6/1/01
21	*House of Flying Daggers* (China)	SPC	$11,050,094 / 1,189	$397,472 / 15	12/3/04
22	*La Vie en Rose* (France)	Picturehouse	$10,301,706 / 178	$179,848 / 8	6/8/07
23	*Shall We Dance?* (Japan)	Miramax	$9,499,091 / –	n/a	7/11/97
24	*Talk to Her* (Spain)	SPC	$9,285,469 / 255	$104,396 / 2	11/22/02
25	*My Life as a Dog* (Sweden)	Skouras	$8,345,266 / 1	$11,667 / 1	5/1/87

Source: www.boxofficemojo.com/genres/chart/?id=foreign.htm

or in the kind of high profile limited release that has worked so well for a number of the Chinese blockbusters.[36] The importance of branding can be seen in the attachment of Jet Li's name to the title *Fearless*, without which the film would not have done as well at the box office.

However, the fate of China's most recent blockbusters on the U.S. market, and a backlash against such films *within* China, have raised concerns that even those films which do well domestically will face diminishing returns overseas. Although I will

explore this theme again below, it is helpful here to note the performances of Chen Kaige's *The Promise*, Feng Xiaogang's *The Banquet*, and Zhang Yimou's *Curse of the Golden Flower*, since they reveal quite clearly the basis of these concerns.

The Promise (*Wu ji*), with a reported budget of $42 million (making it the most expensive Chinese film up to that time), a cast of international Asian stars, a Golden Globe nomination, and China's entry for the best foreign film Oscar in 2005, seemed highly promising. Chen Kaige openly promoted his commercial aspirations for the film, fuming when a Chinese reporter asked him at the premiere in Beijing how he would react if the box-office results were unsatisfactory.[37] Although setting some box-office records in China, it bombed badly with critics and audiences in the United States, bringing in only $669,625, a mere 2 percent of its worldwide gross. By unfavorably comparing it to previous martial arts successes such as *Crouching Tiger*, *Hero*, and *House of Flying Daggers*, American critics were noting the high bar that has now been set for aspiring Chinese blockbusters. Many reviewers, particularly in the trade papers of Hollywood, pointed to its high cost, its "cheesy" CGI (computer-generated imagery) work, music more "Western" than "Eastern," "cartoonish" martial arts fighting, and its general incoherence, at least in the truncated American release.[38]

If anything, Feng Xiaogang's *The Banquet* was even less successful, again despite its box-office success in China ($16.6 million, second only to *Curse of the Golden Flower* in 2006). As with Chen Kaige, Feng was very specific about the importance of the overseas market, stating that "when the budget has reached a certain scale, investors aren't willing to invest without the North American market ... where they need things to be more straightforward. They hope the story and narrative are even simpler, the relationships between characters aren't that complicated."[39] He also noted how a foreign language Oscar would create a great marketing buzz for the film. Indeed, as Ying Zhu notes elsewhere in this volume, beginning with the recent *A World Without Thieves* and certainly including *The Banquet*, Feng has moved in the direction of Hollywood's preferred "high concept" film, which emphasizes simple and definable storylines as a key to box-office success.

However, *The Banquet* was unable to obtain a North American release and the response from film festivals and critics again suggests that Western audiences have set certain expectations for Chinese blockbusters. At its premiere at the Venice International Film Festival, the critics complained that it was "disappointingly Western," noting that "we hope to see a Chinese movie with Chinese style or taste here in Italy.... If the background was cut out, we could hardly tell this was a Chinese movie."[40] Subsequent critical commentary suggested that the market had become over-saturated with this type of Chinese blockbuster. As one commentator put it, "*Banquet* is another *wuxia* epic with a love triangle. There's one in *Hero*, *House of Flying Daggers*, *Seven Swords*, and *The Promise*.... But enough is enough already. Doesn't China have any other types of stories to tell?"[41] Another echoed that sentiment, complaining that *The Banquet* was a member of "that suddenly popular Asian cinema genre: the indulgent, overproduced costume epic aimed at a completely non-Chinese audience many thousand miles away ... polished and programmed for international acclaim."[42] The trade papers were no

kinder, with *The Hollywood Reporter* beginning its review by asking, "What if someone threw a fabulous banquet and forgot the food?"[43]

Expectations were highest for Zhang Yimou's *Curse of the Golden Flower*, the $45 million official Chinese entry for the foreign film Oscar for 2006 (*The Banquet* was relegated to Hong Kong's entry), and up to that time the biggest *Chinese* box-office hit ever to play in China's domestic market. Its $32 million gross was second only to *Titanic*, which had set the record — now surpassed — at $44 million in 1998. Indeed, *Curse* was far more successful in the United States than *The Promise* or *The Banquet*, pulling in $6.5 million, and ranking no. 36 on the list of the most successful foreign language films of all time in the United States (see Table 2.4). However, given expectations and Zhang's publicly stated desire to appeal to foreign audiences,[44] *Curse* proved to be a disappointment. Around 92 percent of its worldwide gross of $68.5 million came from foreign markets, with half the total from the Mainland and Hong Kong. Interestingly, while critics in such "high end" outlets as *The New York Times* and *The Washington Post* offered very favorable reviews, those in the trade publications which focus on the bottom line more than art noted that *Curse* would be unlikely to approach the success of Zhang's previous blockbusters because of a reduction in the action sequences, the dehumanized CGI battle sequences, and the "bad soap opera" elements in the story.[45] The critic for *Entertainment Weekly* went further, asserting that Zhang's shift from humanistic dramas like *To Live* to action spectaculars was "his response to a government crackdown," suggesting that Zhang may be the modern equivalent to Dmitri Shostakovich, the Russian composer "who spent decades to write music that placated the Soviet government." *Curse*, in his view, was the first film to indicate that Zhang "is growing bored with the strategy."[46] As I note below, Zhang has been particularly and very publicly critical of such political interpretations of his film projects and his alleged relationship to the Chinese government.

Ironically, given the criticism in the West that Zhang has "sold out" to the Chinese government, *within* China Zhang has also faced withering attacks for *Curse*. A signed article in a periodical published by the Central Committee's Party School (*zhongyang dangxiao*) noted that "watching [*Curse*] makes one nauseous. This is a bloodthirsty movie."[47] The author broadened his attack, also lambasting the recent blockbusters of Chen and Feng for transgressing "the moral limits of Chinese art." Within the film community as well there has been a backlash against such films, attacking their attempts to imitate Hollywood films at the expense of Chinese culture and tradition. Leading Sixth Generation filmmaker Jia Zhangke — the subject of Shuqin Cui's chapter in this volume — has objected to the "money worship" attitude in producing blockbusters, warning that the fixation on these films could erode creativity in China's film industry. Jia went further, threatening to sue because the domination of digital screens by the martial arts epics prevented *Still Life*, his award-winning film, from finding a theater.[48]

While Chinese films have at least until very recently fared well at the top of the foreign film food chain, it is necessary to examine additional data on the fate of those Chinese films below the top twenty-five before drawing any conclusions on the future prospects for Chinese-language films in the American market. Table 2.4 extracts the 64

Table 2.4 Top Grossing Chinese-Language Films in the U.S., 1980–Present (as of June 16, 2008)

Rank	Title	Studio	Lifetime Gross / Theaters	Opening /Theaters	Date
1	*Crouching Tiger, Hidden Dragon*	SPC	$128,078,872 / 2,027	$663,205 / 16	12/8/00
3	*Hero*	Miramax	$53,710,019 / 2,175	$18,004,319 / 2,031	8/27/04
6	*Jet Li's Fearless*	Rogue	$24,633,730 / 1,810	$10,590,244 / 1,806	9/22/06
10	*Kung Fu Hustle*	SPC	$17,108,591 / 2503	$269,225 / 7	4/8/05
12	*Iron Monkey*	Miramax	$14,694,904 / 1,235	$6,014,653 / 1,225	10/12/01
21	*House of Flying Daggers*	SPC	$11,050,094 / 1,189	$397,472 / 15	12/3/04
28	*Eat Drink Man Woman*	Goldwyn	$7,294,403 / 217	$155,512 / 14	8/3/94
33	*The Wedding Banquet*	Goldwyn	$6,933,459 / 113	$134,870 / 7	8/6/93
36	*Curse of the Golden Flower*	SPC	$6,566,773 / 1,234	$478,771 / 60	12/21/06
52	*Farewell My Concubine*	Miramax	$5,216,888 / 3	$69,408 / 3	10/15/93
56	*Lust, Caution*	Focus	$4,604,982 / 143	$63,918 / 1	9/28/07
99	*In the Mood for Love*	USA	$2,738,980 / 74	$113,280 / 6	2/2/01
102	*Raise the Red Lantern*	Orion Classics	$2,603,061 / 40	$22,554 / 1	3/13/92
109	*To Live*	Goldwyn	$2,332,728 / 67	$32,900 / 2	11/18/94
125	*Shanghai Triad*	SPC	$2,086,101 / 43	$209,098 / 22	12/20/95
135	*Ju Dou*	Miramax	$1,986,433 / 39	$10,300 / 1	3/6/91
140	*The Story of Qiu Ju*	SPC	$1,890,247 / 35	$25,785 / 1	4/16/93
172	*2046*	SPC	$1,362,110 / 61	$113,074 / 4	8/5/05
188	*The Road Home*	Sony	$1,280,490 / 37	$40,557 / 6	5/25/01
190	*The Emperor and the Assassin*	Sony	$1,267,239 / 37	$47,295 / 7	12/15/99

Rank	Title	Studio	Lifetime Gross / Theaters	Opening /Theaters	Date
202	*Shower*	Sony	$1,157,764 / 46	$40,125 / 6	7/7/00
204	*Together*	UA	$1,151,941 / 47	$69,209 / 6	5/30/03
211	*The King of Masks*	Goldwyn	$1,113,103 / 23	$51,539 / 16	5/14/99
213	*Temptress Moon*	Miramax	$1,100,788 / 46	$66,471 / 5	6/13/97
237	*Xiu Xiu: The Sent Down Girl*	Stratosphere	$1,010,933 / 22	$23,880 / 3	5/7/99
305	*The Promise*	Warner Inter-National (WIP)	$669,625 / 213	$272,838 / 213	5/5/06
306	*Balzac and the Little Chinese Seamstress*	Empire	$666,327 / 22	$16,694 / 1	7/29/05
319	*Chungking Express*	Rolling Thunder	$600,200 / 20	$32,779 / 4	3/8/96
321	*Not One Less*	Sony	$592,586 / 24	$50,256 / 6	2/18/00
333	*The Eye*	Palm	$512,049 / 23	$62,062 / 13	6/6/03
336	*Shaolin Soccer*	Miramax	$489,600 / 14	$39,167 / 6	4/2/04
411	*Riding Alone for Thousands of Miles*	SPC	$252,325 / 13	$28,223 / 5	9/1/06
419	*Happy Times*	SPC	$240,093 / 14	$31,084 / 6	7/26/02
433	*CJ7*	SPC	$207,378 / 30	$49,770 / 19	3/7/08
436	*Postmen in the Mountains*	Shadow	$203,975 / 7	$2,334 / 1	12/25/03
442	*What Time Is It There?*	Wellspring	$195,760 / 4	$27,936 / 4	1/11/02
446	*Eros*	WIP	$188,392 / 16	$53,666 / 12	4/8/05
453	*Infernal Affairs*	Miramax	$169,659 / 5	$25,680 / 5	9/24/04
461	*Three Times*	IFC	$151,922 / 5	$14,197 / 3	4/26/06
468	*Days of Being Wild*	Kino	$146,310 / 4	$18,090 / 1	11/19/04
472	*Kekexili: Mountain Patrol*	IDP (Goldwyn /Roadside)	$143,383 / 11	$16,915 / 4	4/14/06

Rank	Title	Studio	Lifetime Gross / Theaters	Opening /Theaters	Date
473	*Zhou Yu's Train*	SPC	$142,562 / 12	$22,933 / 6	7/16/04
530	*Warriors of Heaven of Earth*	SPC	$82,936 / 9	$13,721 / 4	9/3/04
542	*Three … Extremes*	Lionsgate	$77,532 / 19	$36,414 / 19	10/28/05
543	*Still Life*	New Yorker	$75,985 / 2	$12,744 / 1	1/8/08
551	*Mongolian Ping Pong*	First Run	$71,223 / 5	$3,252 / 2	4/21/06
559	*Beijing Bicycle*	SPC	$66,131 / 9	$23,251 / 6	1/11/02
564	*The World*	Zeitgeist	$64,123 / 3	$5,390 / 1	7/1/05
577	*Triad Election*	Tartan	$55,758 / 3	$10,811 / 1	4/25/07
589	*Exiled*	Magnolia	$51,957 / 7	$15,502 / 2	8/31/07
616	*Goodbye, Dragon Inn*	Wellspring	$35,120 / 3	$5,322 / 1	9/17/04
644	*Tuya's Marriage*	Music Box	$25,491 / 3	$2,619 / 1	4/4/08
653	*Sunflower*	New Yorker	$23,919 / 1	$4,195 / 1	8/17/07
661	*Yang Ban Xi*	Shadow	$21,244 / 2	$2,875 / 1	2/8/06
669	*I Don't Want to Sleep Alone*	Strand	$18,361 / 1	$4,377 / 1	5/9/07
673	*Purple Butterfly*	Palm	$17,790 / 1	$6,970 / 1	11/26/04
688	*Formula 17*	Strand	$15,427 / 1	$5,124 / 1	8/26/05
692	*Millennium*	Palm	$14,904 / 1	$4,619 / 1	12/31/03
701	*Blind Mountain*	Kino	$13,164 / 2	$3,676 / 1	3/12/08
712	*Lost in Beijing*	New Yorker	$11,163 / 2	$4,337 / 1	1/25/08
725	*As Tears Go By*	Kino	$9,436 / 1	$4,279 / 1	5/2/08
738	*Electric Shadows*	First Run	$7,129 / 2	$784 / –	12/16/05
751	*Flash Point*	Third Rail Releasing	$5,151 / 10	$3,271 / 10	3/14/08
757	*Beauty Remains*	Emerging Pictures	$4,298 / 2	$3,248 / 2	9/21/07

Source: http://www.boxofficemojo.com/genres/chart/?pagenum=3&id=foreign.htm
Notes: * Among all foreign films. ** In the original source, *Curse of the Golden Flower* had not been included, so it is added here, with the rankings appropriately adjusted.

Chinese-language films from a larger list of the 801 foreign language films that have fared best at the box office. The most striking observation is the limited number of filmmakers who have the reputation, and arguably the skill, virtually to guarantee an audience for their films. Zhang Yimou is at the top of the list, having directed 12 of the 62 films. Zhang's most successful works have been his recent martial arts films. These films followed a rather fallow period — at least in terms of box-office success — in which the efforts from what A. O. Scott called Zhang's second, "neo-realist phase" did not match the results of his previous efforts.[49] Of those released theatrically in the United States, his least successful film was *Happy Times* (*Xingfu shiguang*), which opened in the summer of 2002 and played in a mere fourteen theaters, taking in US$240,000. *Not One Less* (*Yige dou buneng shao*), from the year 2000, fared only a bit better, bringing in US$592,000.

Zhang's most successful period, before his recent successes with *Hero* and *House of Flying Daggers*, occurred between 1991 and 1995. Five of his films from this period make the list (at nos. 102, 109, 125, 135, and 140), with remarkably consistent box-office returns ranging from *The Story of Qiu Ju* (*Qiu Ju da guansi*), which made US$1,890,000 to *Raise the Red Lantern* (*Da hongdenglong gao gao gua*), which brought in $2,603,000. Interestingly, the Zhang Yimou "brand" has changed from the lush, historical epics emphasizing tensions within the family and between family and society in twentieth-century China, to the martial arts historical epics depicting an earlier China during imperial times. While both variations have been successful, his films addressing contemporary urban and rural life — with the important exception of *The Story of Qiu Ju* — have not performed well at the box office. If one adds his other contemporary films that did not even secure a North American release — i.e., *Keep Cool* (*You hua, hao hao shuo*) and *Codename Cougar* (*Daihao meizhou bao*), and the recent *Riding Alone for Thousands of Miles* (*Qianli zou danji*) — the discrepancy is even more striking.

Two other brand name directors have more than four films on the list. Chen Kaige is represented by *Farewell My Concubine* (*Bawang bieji*) (no. 52), *The Emperor and the Assassin* (*Jinke ci qinwang*) (no. 190), *Together* (*He ni zai yiqi*) (no. 204), *Temptress Moon* (*Feng yue*) (no. 213), and *The Promise* (no. 305). Wong Kar-wai, a critical and art house favorite, has made the list with *In the Mood for Love* (*Huayang nianhua*) (no. 99), *2046* (no. 172), *Chungking Express* (*Chongqing senlin*) (no. 319), *Days of Being Wild* (*Afei zhengzhuan*) (no. 468), and *As Tears Go By* (*Wangjiao kamen*) (no. 725).

However, Ang Lee — whose success with Chinese-language films has been limited primarily because of his crossover to more mainstream English-language films — is even more bankable than Zhang Yimou. Lee has scored with *Crouching Tiger* (no. 1), *Eat Drink Man Woman* (*Yin shi nan nu*) (no. 28), *The Wedding Banquet* (*Xi yan*) (no. 33), and *Lust, Caution* (*Se, Jie*) (no. 56).[50]

The few additional films that have done well all have "hooks" of some kind. *Iron Monkey* (*Tie ma liu*) (no. 12), a 1993 Hong Kong martial arts movie, was marketed in 2001 in the wake of *Crouching Tiger*'s performance. In Miramax's effort to duplicate Sony's success, they marketed the film as the "real thing" to those who loved *Crouching*

Tiger. The Ang Lee film, it was suggested, was merely an imitation. The director of *Iron Monkey*, Yuen Woo-ping, had done the now famous "flying" martial arts fight choreography for *Tiger*; in the United States, he was best known for similar work on *The Matrix*. *Iron Monkey* was "presented" — and certified for authenticity — by Miramax icon and Asian film fanboy Quentin Tarantino.[51] Critical acclaim and validation also helps. For example, Chen Kaige's *Farewell My Concubine* shared the Palme d'Or at the Cannes Film Festival in 1993 and was nominated for an Academy Award for best foreign film. Wong Kar-wai's *In the Mood for Love* produced the best actor (Tony Leung) at Cannes in 2000, and won many international and American awards, including the designation "best foreign language film" by both the New York and National Society of Film Critics.

Lessons for China: The Limits of Success

This chapter has suggested that it is unrealistic for China, or any other country, to expect to match Hollywood's box-office success in North America or in the international market. Yet I have also suggested that China (including Hong Kong) has probably done at least as well as any other nation in terms of box-office success outside its home market. How successful, then, is China likely to be in the future; what advantages and disadvantages does China have in this competition; and what strategies have been and are likely to continue to be more or less successful?

First, there needs to be a realistic assessment of what "success" means. Michael Barker, a co-founder of Sony Pictures Classics, used an analogy from American baseball to describe his company's strategy, indirectly contrasting it to the strategy Miramax initially adopted when they tried to emulate *Crouching Tiger*'s breakout success: "Too many companies are looking for the home run. We're very happy with a base hit or a double"; ironically, Sony's Chinese-language production unit in Hong Kong has produced only one film since 2003, Stephen Chow's *CJ7* in 2007.[52] Asian-themed films do have a market internationally, but the most successful films are more likely to be English-language films that have an Asian component, including remakes of Asian movies, than the original work. When one looks at the 346 films that have made at least US$200.5 million worldwide (as of June 15, 2008), the top four Asian-themed films are Hollywood products, starting with *The Last Samurai* (no. 76 on the list), which made more than 75 percent of its gross outside the United States.[53] Perhaps not surprisingly, given the subject matter and a massive marketing campaign, *The Last Samurai* made more in Japan than in the United States.[54] Next on the list is the 1998 rendition of *Godzilla* (no. 106), which made 64 percent internationally, followed by *Rush Hour 2* (no. 141) and *Mulan* (number no. 176).[55]

The first "real" Asian film on the list is *Spirited Away*, the Japanese anime that comes in at no. 210. Significantly, over 96 percent of its box office of US$274.9 million came from outside the United States. The next Asian films on the list — *Howl's Moving Castle* (no. 272, with only 2 percent of its box office from the U.S. market) and *Crouching Tiger* (no. 315) — came in behind *The Departed* (no. 195), *The Ring* (no. 248), and *Rush Hour* (no. 258). These figures for *individual* films can be contrasted with China's

total overseas box office of around $260 million in 2007, up from $244 million in 2006 (which was up 16 percent from 2005), based on the sale of seventy-eight films, among which forty-seven were co-productions.[56] China has plans to release at least twenty new films on the overseas market every year, although as with the Miyazaki films mentioned above, the primary market is likely to be within Asia. The most recent example of this phenomenon is the release of *Red Cliff Part II*, which topped the international box-office chart by pulling in over US$15 million for the January 9–11, 2009 weekend, despite opening only in China and Singapore. Additional January openings were announced for Hong Kong, Taiwan, and South Korea, followed by Japan on April 10.[57] At the same time, Chinese film officials have justifiably been proud of the nation's success in winning festival awards. In 2006, twenty-seven China-made films won forty-four prizes at twenty-two international film festivals, an increase over the thirty-two prizes won by eighteen films in 2005.[58]

Second, there are certain expectations for Asian films when they play abroad. As was noted above, Zhang Yimou has succeeded best when he has tapped into these expectations, most recently with his martial arts films, and earlier with his "visually glorious tales of historical turmoil and forbidden love like *Raise the Red Lantern* and *Ju Dou*."[59] Indeed, in his assessment of the failure of *Crouching Tiger* in its home market of China, John Pomfret, the former Beijing bureau chief of the *Washington Post*, bluntly asserts that "almost every major cultural export from China over the past 25 years that has made it in the West has flopped in China, from the early movies of director Zhang Yimou, to Jung Chang's autobiography, *Wild Swans*; to Ha Jin's award-winning novel, *Waiting*; to the Nobel Prize–winning work of author Gao Xingjian." Pomfret further argues, more controversially, that *Crouching Tiger* took off in the United States because it was very Chinese, while it failed in China because it was *too* Chinese.[60] While one can certainly take issue with Pomfret's reasoning — arguably, a far stronger case could be made that films such as *Crouching Tiger* and *Mulan* failed in China because they were *not* seen as authentically Chinese by local audiences — it is striking that China, Japan, and Hong Kong accounted for only three percent of *Crouching Tiger*'s global sales.[61]

I have already discussed the problem such expectations have posed for high profile films like *The Promise*. Less publicized action films from China are also subjected to comparisons with the familiar. For example, when *Warriors of Heaven and Earth* (*Tiandi yingxiong*) played in the West reviewers immediately compared it (unfavorably) both with Chinese successes such as *Crouching Tiger* and *Hero*, and with more familiar fare such as Sergio Leone's Italian Westerns and John Ford's American Westerns, Kurosawa and Japanese samurai films, American B-movies, historical and other action films such as Mel Gibson's *Braveheart*, to mention only the most common references. The reviewers then concluded that the film is a "derivative mishmash of genre tropes,"[62] with "battle scenes [that] are strictly generic — like a polo match with swords — contain[ing] none of the fancy footwork and flying swordsmen seen in *Hero* or *Crouching Tiger, Hidden Dragon*."[63]

If action movies from China face such invidious comparisons, comedies have even less of a chance to be successful. Even art house favorite Zhang Yimou's *Keep Cool* had

no chance at distribution in the West. However, the classic case of a popular Chinese filmmaker whose films have not been able to travel to the West is Feng Xiaogang. *The Banquet* was only Feng's most recent attempt to penetrate Western markets. Earlier, Sony Pictures, through its Columbia Pictures Film Production Asia subsidiary, tried to promote Feng's work with *Big Shot's Funeral* (*Dawan*), an enormous hit within China, and a film that included well-known actors from mainland China, Hong Kong, and the United States.[64] Columbia optimistically planned on spending quite heavily on marketing in various territories — the marketing campaign in China cost three million Chinese yuan (about US$367,000), a lavish amount for China — but there were early concerns from Chinese reviewers that Feng's satirical style would not survive cultural and language barriers.[65] Ominously, the film did not do well in Hong Kong[66] and proved even less successful in the West despite fairly extensive advance coverage in high profile publications such as *The New York Times*, *Variety*, and the *Wall Street Journal*.

The film was distributed by Sony Classics in the United States, opening on January 17, 2003 in two theaters and closing at the end of the week on January 23. The total box-office gross was an alarmingly low US$820![67] The reviews suggested some of the likely reasons for the failure of such a cross-cultural hybrid, cobbled together to satisfy both the Chinese and Western markets. To begin with, the dialogue was stilted, "presumably for ease of translation," as one reviewer put it.[68] Moreover, the film offered "a vastly different view of Chinese society than most Western moviegoers [were] used to seeing." As one critic put it, "Chinese films that make it abroad are often set in the harsh climate of the countryside or austere surroundings lent by a certain dynastic period. They also tend to be helmed by art house directors like Chen Kaige or Zhang Yimou. In contrast, *Big Shot* is a comedy set in modern day Beijing and directed by one of China's most successful commercial directors."[69] This suggests another problem, the "complete lack of marketing templates for mainstream China-set comedies."[70] Although Feng's lack of name recognition certainly did not make it easy for the marketing people, even Zhang Yimou's name, as noted above, was insufficient to sell his urban comedy *Keep Cool*.

A third problem, also related to audience expectations, has to do with the perception of Chinese politics and its relation to film. It is not uncommon for critics and audiences to read politics — either positively or negatively — into Chinese films. For example, when *Postmen in the Mountains* (*Na shan, na ren, na gou*) opened in New York, one reviewer, who actually found the film "endearing" and "likeable," also noted in the same sentence that "its benign surface may cover some subtle propaganda on behalf of China's centralized government." The film, he suggested, idealized the postman as a state official always ready to listen and sacrifice himself for the betterment of the masses, while the villagers were always portrayed as smiling and content, with the lyrical landscape studies foregrounded and the region's desperate poverty played down.[71] By contrast, the top feature award at the 2005 TriBeCa Film Festival in New York went to Li Shaohong's *Stolen Life* (*Sheng si jie*), which Li noted had been banned in China. In accepting the award, the report quoted Li as hoping that her success would help the movie get "greenlighted so that my people in China can watch this film soon."[72]

This emphasis on discovering the political message of Chinese films in some cases, or the use of film festival awards to aid in promoting the work of banned filmmakers in others, became most obvious when Zhang Yimou withdrew his films *Not One Less* and *The Road Home* from the Cannes Film Festival in April 1999. In a letter to Cannes festival directors that he astutely also sent to the *Beijing Youth Daily*, Zhang wrote that he was withdrawing the films "because I believe you have a serious misunderstanding about the movies.... Everyone has their own opinion about whether a film is good or bad. But what I cannot accept is that the West has for a long time politicized Chinese films. If they are not anti-government, they are just considered propaganda. I hope this bias can be slowly changed."[73] Few accepted Zhang's action at face value, however, with some observers suggesting that he was merely saving face and avoiding an official rejection notice when it became clear that neither of his films were going to make it into the official competition. According to this scenario, Zhang may have been further motivated when he learned that *The Emperor and the Assassin* (*Jinke ci qinwang*), a film by his "rival" Chen Kaige, was accepted into the competition.[74] On the other hand, Zhang is correct in noting that it is not uncommon for Western critics to assume government intervention or at a minimum self-censorship in a film's production. One critic of *The Banquet*, in which the "bad characters" all duly receive their just desserts, suggested that "at some point, they should start giving screenplay credit to Chinese censors."[75]

The situation for films outside the Hollywood mainstream will not be getting any easier. The latest trend by the American majors is to release their blockbuster films nearly day-and-date around the world — in part of course to prevent piracy — and to do so with ever larger print runs and marketing budgets, while at the same time spreading out release dates more evenly to guarantee strong titles in major theaters every weekend. At the same time, as one media critic put it, the real story of today's movie business is not about movies but the brands, noting that fifteen of 2004's twenty-five top-grossing films were projects based on books, comics, old movies and TV shows, or sequels to previous films, with 2005 following a similar pattern.[77] Indeed, in summer 2007 *The Simpsons Movie* made headlines because it deliberately limited the number of tie-ins. Given this situation, the most effective Chinese response — if one goal is to compete with Hollywood at the box office — would be to continue to do co-productions and to partner with Hollywood distributors to promote their films globally, with wide releases, and to develop franchise titles through sequels of successful films. Indeed, nine of the top ten domestic films at the Chinese box office in 2007 were co-productions. The alternative — certainly more aesthetically pleasing — would be to reduce censorship and political considerations and promote the artistic visions of talented directors for a healthier domestic market. The likelihood is that both strategies will be employed as China seeks box-office success *and* artistic recognition in foreign markets.

American Films in China Prior to 1950

*Zhiwei Xiao**

Hollywood's overseas operations have been receiving a great deal of scholarly attention in recent years. For many film historians, the performance of American films outside the U.S. border has a profound impact on how films are made inside the United States. From this perspective, a better understanding of the American films has to take into consideration their reception abroad. As film historian Ruth Vasey has observed, during much of the first half of the twentieth century the foreign markets contributed 35 percent to Hollywood's gross revenue, and according to one scholar, the percentage today is even higher. For this reason, the foreign audience's reactions to American films function as "an active and systematic influence upon the treatment of motion picture material" in Hollywood.[1] Indeed, from the slapstick comedies to the action-oriented Westerns, the two staples of American film exports in the early twentieth century, Hollywood has been consciously focusing on films' "universal appeal" at the expense of intellectual sophistication and cultural nuance due to the concern about the presumed foreign audience's unfamiliarity with American culture and society.

For other scholars interested in the international dimension of the United States' history, Hollywood's overseas expansion is intimately connected to the rise of the United States as a global superpower. In many ways American popular culture, particularly film's penetration of the world, paves the way for American economic, military, and political dominance. In this context, the U.S. government's support for the motion picture industry is tied to its broader objectives of promoting and championing American values and way of life. Understandably, the question of "cultural imperialism," however ill defined the term may be, takes central stage among these scholars.[2]

One of the major weaknesses in the current literature on Hollywood's overseas expansion is the disproportionate attention to the European experience of American films. Conspicuously missing are detailed case studies of American film's encounters with people from the non-Western parts of the world.[3] To what extent are the patterns of Hollywood's operations in Europe observable in non-Western societies, such as China? In what ways do the "theories" about cross-cultural interactions that are generated from studying Hollywood's encounters with European countries apply to the colonial settings of African

* A different version of this chapter was published in *Chinese Historical Review*, 12: 1 (2005 Spring).

and Latin American countries or in the case of China, which was not fully colonized, but neither fully sovereign during much of the first half of the twentieth century? This chapter is a tentative step in this direction. By providing a case study of American films' reception in China during the Republican period (1911–1949), this project engages the recent scholarship that examines American films from a global perspective.

At the same time, this study also addresses a key question in Chinese studies. The old "Western impact versus Chinese response" model may be outdated today, but the essential elements of that model are nevertheless retained in many of the newer theoretical constructs. In many ways, the critical inquiry into the Chinese reception of American films owes an intellectual debt to these recent studies and hopes to add more empirical data to the study of interactions between Western and Chinese cultures in the first half of the twentieth century. It goes without saying that the Chinese response to American films was diverse and varied and it would be a mistake to speak of the Chinese reception in singular and uniform terms. One of the objectives of this chapter is to explain a seeming contradiction and paradox — namely, American films were at once embraced and rejected by the Chinese film audience.

Finally, this study hopes to offer a corrective to a tendency prevailing in Chinese film studies that is more preoccupied with film production than distribution/exhibition on the one hand and with the filmic text than with the historical context on the other hand. Given the fact that American films made up more than 85 percent of the cinema programs during the Republican period, a fuller understanding of Chinese film history will have to consider the Hollywood dimension. The cinematic style and narrative strategy of the native film productions were developed in a conscious effort to compete with American films for the Chinese audience. Hence, acknowledgement of the reception of American films becomes a prerequisite for critically assessing the native filmmaking legacy and provides insights into Chinese cinematic aesthetics.

The Popularity of American Films

There is no doubt that American films were extremely popular with the Chinese audience, especially in major cities such as Shanghai, Guangzhou, Beijing, and Tianjin where most of the first-run cinema houses showed only foreign films. After the outbreak of World War I, American films made up the majority of the film programs in China. According to Richard Patterson Jr., president of Peacock Motion Picture Corporation, there were 450 foreign films shown in China in 1926, of which 90 percent, or roughly 400 titles, were manufactured in the United States. Data published by the Chinese censors in 1935 suggest that there were a total of 412 foreign films shown in China in 1934, of which 364 were American, or 88 percent of the imported films.[4]

During the period between 1937 and 1945 when China was at war with Japan, U.S. film exports to China were first reduced and then brought to a halt after the Japanese attacked Pearl Harbor in December 1941. But even during the Japanese occupation when many cinema houses could no longer show American films, they continued to display the portraits of Hollywood stars in their lobbies to cater to their patrons' nostalgia for

American films. The public manifestation of infatuation with Hollywood became such an irritant to the Japanese military authorities that they issued an order to the cinemas, banning them from glorifying American film culture.[5] As soon as the war ended in 1945, American films reappeared on the screen in "liberated" areas even before the Nationalist army or U.S. Marines arrived. With a huge backlog from the wartime period, the number of American films brought to China in the postwar era reached an all-time high, totaling 881 titles in 1946.[6]

The popularity of American films is not only reflected in their quantity, but also in box-office receipts. As a 1935 survey of Shanghai's entertainment establishments indicates, there were thirty-six movie houses, eight opera houses, six variety show centers, seventeen dance halls and nineteen big restaurants. Apparently, movie-going led to other forms of entertainment.[7] According to statistics collected in Beijing in 1928, of the top ten box-office hits that year, five were American films, four of which led all domestic films both in ticket sales and profits.[8]

Another indication of Hollywood's popularity is the fact that cinema houses would compete for the privilege of premiering any new release. Indeed, a movie theater's status and standing in the exhibition industry was often measured by its ability to win a contract with Hollywood for new releases. To secure their supplies of new films, many first-run theaters signed contracts with particular studios. For example, the Grand Theater (Da guangming), one of the best equipped and most prestigious in Shanghai, signed contracts with both MGM and Paramount, while Nanjing Theater signed contracts with Twentieth Century Fox, Warner Bros., and First National. When MGM granted Nanjing Theater the right of first release in 1934, it was widely viewed in the exhibition business as a major setback and loss of face for the Grand Theater.[9] To some extent, the high demand for American films allowed Hollywood's representatives in China to impose harsh terms on Chinese exhibitors and enforce these terms by threatening the theaters that any violation of the terms would result in an interruption in the supply of films.

It is obvious that Hollywood's popularity was not limited to those of a particular class or educational background. Whether rich and poor, well educated or illiterate, all enjoyed the spectacles and thrills on the screen. If the more privileged satisfied their appetite for American films through private screenings at home by a personal projection team, the less fortunate could always afford a matinee at second- or third-run cinemas. Despite being culturally and economically segregated, the Chinese Hollywood fans shared a fascination as well as a familiarity with American movie idols. Some advertisers took that familiarity for granted and found ways to exploit it. In 1930s Shanghai, an escort service agency promoted its talent pool by advertising its "girls of the Mae West type, Jean Harlow type and Clara Bow type." Apparently, customers' familiarity with these movie stars and the feminine ideals these stars represented was simply assumed.[10]

In print media, news items about Hollywood constituted the staple of published stories which ranged from snapshots of film productions in progress to the trivial details of American movie stars' private lives. A large number of film magazines were exclusively devoted to such stories. Typical of the stories published in these journals were the details of Hollywood stars' private lives. As the editor of *Haolaiwu zhoukan*

(*Hollywood Weekly*) noted, the publication and expansion of this magazine was an attempt to meet the increasing demand from readers, and that the magazine would make a concerted effort to bring together the most interesting information from the leading fan magazines published in the United States, including *Photoplay, Motion Picture, Modern Screen, Picture Play, Screen Book*, and *Hollywood Film*, so that its readers could save the cost of subscriptions.[11] In fact, when the magazine occasionally published news items about Chinese films, its readers protested, which is suggestive of the devotion readers gave to American film and indirectly to this magazine.[12]

In film criticism, Hollywood was often used as a yardstick to measure the quality of domestic productions. Indeed, reading film-related publications from the pre-1949 period, the pervasive references to Hollywood which shaped the Chinese discourse on film are striking. For instance, in commenting on the accomplishments of Chinese actresses, critics would refer to them as the "Greta Garbo of the Orient," "Mae West of the East," or as in the case of a child actor, "the Chinese Jackie Coogan."[13] Or when making remarks about the facial features of Jin Yan, one of the most popular Chinese male movie stars from the 1930s, one critic compared Jin's eyes to that of Rudolph Valentino's and found a resemblance between the two.[14] As another film star from the 1920s and early 1930s would recall, Valentino's sideburns became so fashionable in China that they were widely imitated by Chinese men, who thought that adopting Valentino's hairstyle was essential to winning women's hearts.[15]

In 1939, a journalist in Shanghai interviewed the managers at major cinema houses in the city and reported that according to these managers, Errol Flynn was one of the most popular American actors in China, followed by Clark Gable. Of the actresses, Deanna Durbin and Norma Shearer were two of the most popular stars. One distributor printed 10,000 photos of Durbin, which were sold out within three days. The same report also mentions that Shirley Temple had many Chinese fans and almost every one of her films played to a packed house. As for films, *Snow White and the Seven Dwarfs* was one of the most popular American films of 1937. Other box-office hits mentioned in the report include *The Adventures of Robin Hood* (dir. Michael Curtiz and William Keighley, 1938), *The Dawn Patrol* (dir. Edmund Goulding, 1938), and *Marie Antoinette* (dir. W. S. Van Dyke, 1938).[16] Clearly, Hollywood was well received in Shanghai.

In the 1940s, Chinese film producers and distributors deliberately tried to capitalize on the popularity of Hollywood hits and exploited the publicity generated by well-known American films to promote their own releases. For example, the advertisements for Chinese films would often use phrases such as "Chinese Tarzan," "Chinese Snow White," and "Chinese Robin Hood."[17] After the outbreak of the Pacific War, American films disappeared from the cinemas in Japanese-occupied areas, but some Chinese theatrical groups continued to bank on the popularity of American films by staging theatrical performances based on well-known Hollywood films. For instance, a Beijing Opera group in Tianjin adapted a Hollywood action film, *The Adventures of Robin Hood*, into a traditional opera. Encouraged by the experiment's spectacular success at the box office, the group went on to adapt *The Thief of Baghdad* (dir. Ludwig Berger et al., 1940) into a Beijing opera.[18]

Cultural Appropriation and the Role of Agency

In his study on American films' reception in Europe, Ulf Hedetoft emphasized the mediating role of the local agency in framing the films for national publics.[19] In the case of China, the reception of American films there was mediated through several layers of agency. It is not an exaggeration to say that the popularity of American films in China was both genuine and manufactured. The collaboration between the Chinese exhibitors and American distributors was crucial to the reception of American films in China. On the American side, the U.S. film industry leaders followed the motto attributed to Samuel Goldwyn faithfully, "If the audiences don't like a picture, they have a good reason. The public is never wrong."[20] With the help of U.S. consulate officials, Hollywood paid a great deal of attention to what the Chinese audiences liked and disliked, and tried to cater to the Chinese market. One consular report dated 1917 mentioned that the type of film most in favor with the Chinese was the detective drama, but films of adventure were also in large demand. He also noted that films depicting cowboys had oversupplied the market and were no longer popular.[21] A similar report dated 1923 stated

> Up to the present time serial films have been very popular with the Chinese, but since they have lost popularity in the United States and Europe and are not being produced to the extent to which they were formerly, the proprietors of theaters in South China have instituted a campaign to educate the Chinese to an appreciation of a different type of film.[22]

Clearly, deliberate attempts were made to market and promote American films by both American distributors and their Chinese business partners. A Chinese film fan magazine editor lamented that Hollywood did such a good job at generating publicity for their films that even before its films were put into production, thousands of miles away people in China were already bombarded by information about these productions and made well aware of the details about these films down to cast and costs. He saw that insufficient publicity for domestic productions was one of the reasons that they could not compete with Hollywood.[23]

With the backing from studios in the United States, American film distributors had a competitive edge when it came to promotion and publicity. Subsidizing film fan magazines, providing star photos and other publicity materials to Chinese publication venues, and sponsoring fan magazines' promotional activities were some of the ways through which they marketed their films. Entertainment magazines frequently ran quizzes based on their readers' knowledge of American films. In some cases, the magazines promised rewards to those who could answer all the questions correctly. Obviously, only those readers who watched a lot of American films could stand a chance to win and those who did not would be enticed to watch more.[24] Not infrequently, fan magazines would sponsor "public voting" for the best American films and film stars and those readers who voted for the winners would be given prizes. Undoubtedly, these activities not only promoted the sales and subscriptions

for the magazines themselves, but also served as publicity campaigns to manufacture popularity for American films.[25]

Furthermore, when certain American films ran into trouble with the Chinese government censors, the U.S. diplomats would come to their rescue by applying pressure on the Chinese government.[26] Indeed, one Hollywood insider asserted that the strong support from the U.S. government was a key factor in Hollywood's dominance in world markets and the distinctive feature that set the American film industry apart from the rest of the world, especially from the nascent Chinese film industry.[27] That observation has since been echoed in numerous scholarly studies of Hollywood and its successful global expansion.[28]

On the Chinese side, the Nationalist government's policy to sanitize American films through the mechanism of censorship actually helped polish Hollywood's image. Although one of the initial purposes of film censorship was to curtail Hollywood's dominance in China, by barring films offensive and hence alienating to the Chinese audience, the government inadvertently made Hollywood more endearing to the Chinese film audience. Sometimes, such efforts on the part of the Chinese government were deliberate and taken for political reasons. For example, in 1948 the Nationalists and Communists were locked in a deadly civil war and many in China saw the U.S. support for the Nationalist cause as partially responsible for the military confrontation between the two parties. As a result, anti-American sentiment was running high. At this critical juncture, an American film entitled *Major Google* (dir. Billy DeBeck, 1936) was re-released in Shanghai. Because the film cast the Chinese characters in a rather negative light, the Nationalist government decided to make a number of cuts to the film, lest it would spark an anti-U.S. protest. In this case, the government censors made deliberate attempts to prevent the film from being used by their political opponents and thus causing public ire toward the United States.[29]

Just as officials resorted to political power to manipulate public opinion, film distributors and theater owners collaborated to package Hollywood's products in ways that would attract the potential audience by emphasizing a film's sex appeal in publicity campaigns. In some cases, the language used in movie ads did not accurately reflect what the film was about. One commentator pointed out that most Chinese could not fully grasp the true meaning of American films and would have appreciated some guidance on the part of the theaters. However, instead of helping audiences to understand the narratives of the films, some cinema houses deliberately misled their patrons in publicity materials by both focusing on and exaggerating the sexual themes of the films scheduled for exhibition so as to attract more patrons.[30]

One of the frequently used strategies by Hollywood's distributors and Chinese exhibitors to appeal to the potential audience was to manipulate the translation process. Since the title of a film provided the first clue to the film's content, it played a critical role in a film's reception. In 1933, the RKO production *The Silver Cord* (dir. John Cromwell) was brought to China. The film's narrative focuses on a young man's struggle to free himself from his domineering mother. The film's narrative condemns the mother as a manipulative, controlling, and vicious character and endorses the son's search for

independence. But such a theme did not sit well with traditional teaching in China that emphasized filial piety. Even in the most iconoclastic May Fourth literature, it is usually the patriarchy as represented by a father figure that was attacked. The mother figure, in contrast, remained an all-loving and sacrificing ideal and was worshiped as such. A film critical of a maternal figure risked alienating the audience and suffering box-office failure. Not surprisingly, the RKO representative in China used a Chinese idiomatic expression as the film's Chinese title: *Kelian tianxia fumu xin* (Poor parents!). That expression is usually used to refer to parents willing to do anything for their children's best interests, often at the expense of their own. By using this phrase as the film's title, the distributor greatly reduced the critical thrust of the film and channeled the audience toward an understanding of the film that was compatible and congruent with the moral tenets of the locals.

Similarly, Paramount changed the Chinese title of one of its films from *Xiaozi shifu* (A filial son kills his father) to *Tiechuang qinglei* (Tears from behind bars) and Peacock Motion Picture Co. changed the Chinese title for its *Keep'em Rolling* (dir. George Archainbaud, 1934) from *Zhuzhang tianma* (Riding the flying horse) to *Hongfen shenju* (The woman and the magic horse). In the original Chinese text, the former title is somewhat ambiguous as to whether the story is about the horse being in charge or the horse being tamed. By contrast, the latter title implies that the story centers on a beautiful woman and a magic horse.[31]

The Impact of American Films

Before proceeding to a discussion of the impact of American films on Chinese culture and society in general and the film industry in particular, it is important to bear in mind that Hollywood came to China in the context of the Western conquest of the world and colonial expansion in Asia. The United States, in particular, was viewed as a model by the Chinese in their aspiration for modernity. Though more visible and more accessible to the general public than other cultural products, the impact of American films must be considered in connection with other colonial enterprises in China. To put it more bluntly, Hollywood's influence on China occurred against the backdrop of an overall Western economic, political, and military dominance over China.

It should also be noted that the number of people actually exposed to American films was comparatively small. According to one estimate, there were no more than 10,000 people attending the cinema on a daily basis in 1920s Shanghai, which had a population of 1.2 million.[32] In other words, only 1 percent of the city's population was exposed to film. One editor of a film fan magazine confirms the percentage, but disagrees on the specific number. According to him, Shanghai's population stood at 3 million and had about 30,000 regular moviegoers. He cited a cinema house manager as saying: "we see faces old and new, but not one that we don't know" and argued that the key to further development of the film industry was to expand its clientele base.[33] Apparently, the difference between these two estimates lies in the base number for the city's population. To date, historical research has lent support to the magazine editor's estimate.[34]

For the 1930s, one source suggests that nationwide, there were no fewer than 500,000 people attending movie houses on daily basis.[35] It is interesting to note that in Shanghai, the ratio of moviegoers to the city's overall population was 1 percent, whereas nationwide it was 0.1 percent.

For the 1940s, survey data suggest that for the month of April 1949, the attendance for American films in Shanghai was 1,027,596, which translates into a daily average of 34,086.[36] This number is consistent with the 1920s data, but it was collected on the eve of the Communist victory, when attendance for American films was at its lowest point. As such, it must be read as an extremely conservative estimate. However, since Shanghai was the most important film market in China, with the largest number of cinema houses in the country, there is some question about how useful the data collected there are in assessing film attendance for foreign films elsewhere in the country. Complicating the situation further, there clearly were cases where attendance in less obvious film markets actually exceeded the audience in Shanghai. For example, in Wuhan, a city in central China, two American films, *Love Parade* (dir. Ernst Lubitsch, 1929) and *The Bathing Beauties* (dir. George Sidney, 1944), each recorded an audience of 200,000, far above their performance levels in Shanghai.[37]

Furthermore, the Chinese audience for American films was highly stratified along economic, educational, gender, age, and occupational lines. One observer noted that men generally liked sensuous and sexy pictures, women preferred romance, and children enjoyed comedies and farce.[38] Although overlapping certainly existed, there definitely seemed to be a divide between those who frequented American films and those who preferred Chinese films. The former tended to come from the upper strata of Chinese society.[39] Because the admission price for foreign films was usually higher and familiarity with Western culture and social conventions was critical to understanding these films, going to see foreign films became associated with class, social status, financial means, and cultural sophistication. For many, showing up and being seen at the first-run cinemas for foreign films served purposes other than watching the films.[40]

The divide between the two audiences — one for foreign films and one for domestic productions — was further complicated by another source of competition, namely, traditional theatrical performances which drew a large crowd away from both foreign and domestic films. There was some cross-over, to be sure, but the basic divide along the lines of foreign film, domestic film, and traditional opera remained consistent, so much so that Fei Mu, one of the leading film directors of the 1930s and 1940s, suggested that it would be strategically critical for native filmmakers to focus on winning over both those who frequented foreign films and those who patronized traditional theaters.[41] Another observer disagreed with Fei by suggesting that during hard economic times attendance for American films was less affected because Hollywood fans tended to come from the economically well-to-do social strata. Hence, the decline in attendance for domestic productions did not have much to do with the competition from foreign films and everything to do with the dire economic situation of the domestic moviegoers.[42] Either way, both commentaries confirm the divide among Chinese moviegoers: one for foreign and one for domestic films.

Film historian Ruth Vasey has argued that because of the importance of the foreign markets to Hollywood's revenue, American filmmakers made conscious and deliberate efforts to cater to their international audiences.[43] In the Chinese case, any discussion of Hollywood's impact there must take into consideration the dialectic dynamics in which local taste in China impacted the way certain films were made in America. For instance, mindful of the Chinese sensitivities to American films dealing with Chinese subjects and the periodic protests/boycotts resulting from their sensitivities, Hollywood hired a Chinese who formerly served on the Nationalist government's film censorship board as a consultant to make sure their "China pictures" would not offend the Chinese. In the case of *The Good Earth*, MGM carefully considered "the Chinese angle" by studying a Chinese film dealing with rural life, soliciting opinions from Chinese cultural elites, and making a number of adjustments to the film's plot and characterization based on the Chinese feedback.[44] This was by no means an isolated or exceptional example. Indeed, the Hays Office, which was in charge of sanitizing films produced by Hollywood, constantly reminded its member studios of "foreign sensitivities." A significant proportion of its correspondence with studio executives was concerned with the Chinese protests against offensive films. These internal memos had a direct bearing on the way certain films dealing with Chinese subjects were made in the United States.

At a minimum, the selection of American films to be distributed in China was dictated by concerns over local conventions, values, tastes, and linguistic barriers. Since foreign films were not dubbed before 1949 and only a pamphlet with a brief synopsis of the film program was issued to patrons upon entering, it must have been difficult for the majority of the audience to understand foreign films fully. A former theater manager recalled that foreign films with too much dialogue were usually not well attended and the theaters always tried to pick films with as little dialogue as possible so that they would be easier for the audience to understand.[45] A film critic observed in 1927 that D. W. Griffith was more popular than Ernst Lubitsch with Beijing's moviegoers because his films were more action-oriented whereas Lubitsch's were more subtle and nuanced, hence, more difficult for the Chinese audience to grasp.[46] Obviously, the Chinese preference for certain directors had nothing to do with aesthetics or directing styles, but everything to do with the accessibility of their films. The language barrier continued to be an obstacle to the Chinese appreciation of American films until 1940 when the first simultaneous translation through earphones was installed in the Grand Theater in Shanghai, but even then such equipment was not available to the majority of the movie theaters and the Chinese film audience had to continue to rely on printed programs for guidance to follow the story unfolding on the screen.[47]

Nevertheless, despite the cultural and linguistic barriers, Chinese moviegoers embraced American films and evidence of their fascination with American values and norms of behavior was everywhere. In the 1930s, when a Chinese movie actress broke up with her boyfriend, she justified her decision on the grounds that he was not as romantic as Caucasian men.[48] Her public statement suggests that new norms of courtship and a new basis for sexual relationships were emerging in Republican China. Needless to say, American films played a critical role in transmitting those new moral values and behavioral

norms which were apparently gaining social acceptance in China, or she would not have justified her decision in those terms.

As mentioned earlier, Hollywood stars such as Mae West, Jean Harlow, and Clara Bow were used as common denominators of certain feminine types and ideals.[49] One contributor to *Furen huabao* (*Women's Pictorial*) observed that the ideal of feminine beauty had undergone transformation in China, and that transformation was largely attributed to the influence of foreign films. The author used two specific English terms — "Hollywoodism" and "screen face" — to identify the sources from which Chinese women had developed their modern notion of femininity.[50] And it was not just the traditional Chinese notion of the feminine ideal that was challenged, but their ideas about masculinity, too, were redefined by Hollywood. A survey conducted by a women's magazine found that there were two qualities in men that its women readers desired most: physical fitness and being romantic,[51] neither of which seemed to constitute the most important criterion for women to choose a mate in traditional China. Now, however, they were placed above other considerations.

Numerous commentators have noted the connection between notions about modernity in China and the influences of foreign films.[52] For example, many of the changes in behavioral norms and social etiquette in twentieth-century China are linked to exposure to foreign films. In an article entitled "A guide for courtship" (*Nannü qinghua zhinan*) the author specifically suggested to his readers that they watch American films for demonstrations of appropriate ways to conduct oneself when courting the opposite sex.[53] A commentator lamented that most Chinese did not know how to kiss their sexual partners properly and advised them to watch American films for good demonstrations.[54] In both cases, Hollywood representation was looked at as a truthful reflection of how people in the West would conduct themselves in real life and as a visual source of examples to be emulated by people elsewhere aspiring to be "modern." While it is arguable whether kissing in public and/or featuring the naked human body in art are signs of modernity, their social acceptance in China was undoubtedly attributed to the popularity of foreign films.[55]

While many of China's modernizing elite viewed the changes in social norms and sexual mores as liberating, they were alarmed by the alleged connection between the increase in the crime rate and the influence of American films. In an essay published in *China Weekly Review*, the author complained about the bad influence foreign films had on Chinese society. He noted that the numerous court proceedings about kidnapping cases in China revealed that the perpetrators of those crimes got their ideas from watching American films.[56] His observation was echoed by many. Cheng Bugao, a well-known film director from the 1930s, made a similar observation that criminal elements in China took some ideas from watching American films,[57] and Zhou Shixun, a film producer and magazine publisher who also starred in a number of films, linked a notorious train robbery case to the influence of Hollywood detective thrillers.[58] The fact that so many Hollywood productions dealt with crime, promiscuity, and violence worried many expatriate Americans who were concerned about the damage those films did to the prestige of the Westerners in China.[59]

Less dramatic and sensational, Hollywood definitely helped shape the consumer culture and consumption patterns in twentieth-century China. Its function as an advertising tool for U.S. manufactured goods was one of the reasons that the Department of Commerce of the U.S. government set up a Motion Picture Division to support the film industry's overseas expansion. Dr. Julius Klein, an official of the Department of Commerce, noted in the 1920s that the increase in demand for American manufactured goods in a dozen countries was due to the influence of films. He specifically linked American films and the expansion of U.S. trade in the Far East.[60] A contributor to *Harper's Monthly Magazine* confirmed Klein's statement with the example of sewing machine sales. He pointed out that the Chinese demand for this modern invention was largely due to their exposure in American films.[61]

More specifically, Hollywood provided an important source of inspiration as well as materials for the Chinese film industry. For instance, a film critic of the 1930s pointed out the parallel between the plot of *Shizu hen* (*Regrets*, dir. Dan Duyu, 1932), a United Photoplay (Lianhua film studio) production and the story of D. W. Griffith's *Way Down East* (1920).[62] Indeed, as Leo Ou-fan Lee has argued, when looking at Chinese films made in the 1930s, "it is difficult not to see ample traces of Hollywood influence."[63] While some Chinese credited American filmmakers for initiating the Chinese into the art of filmmaking,[64] others linked the emergence of certain filmic genres in Chinese filmmaking to the influence of Hollywood. When *The Moral Fairies* (*Renjian xianzi*), a Chinese musical,[65] was released, critics immediately pointed out its affinity with Hollywood musicals. Zheng Junli, one of the most accomplished filmmakers from the pre-1949 period, observed in his *Zhongguo dianying shilue* (An outline of Chinese film history) that even the Chinese filmmakers' attempt at glorifying national culture by making genuinely indigenous films based on folklore and traditional materials, such as the costume drama genre, was a direct response to the trend in American filmmaking that promoted Americanism.[66] At a technical level, Wu Yonggang, another well-known film director whose work includes such classics as *Goddess* (*Shennü*, 1935) and *Two Skeletons* (*Langtaosha*, 1936), also pointed out that some of the earlier successes in domestic filmmaking can be attributed to skillful imitation of Hollywood. He also admitted that he himself was inspired by Griffith's films in the earlier days of his film career.[67]

Indeed, many Chinese critics viewed the widespread imitation of Hollywood by Chinese filmmakers as the root cause of the domestic film industry's problems. As these critics pointed out, many Chinese actors copied their Hollywood counterparts not only in mannerism, but even in fashion.[68] Consequently, their popularity with the Chinese audience seemed to hinge on how closely they approximated the Hollywood stars. In that context, it is ironic that the highest honor for some Chinese actresses was to be called the "Greta Garbo of the Orient" or the "Mae West of the Orient."[69] Directors also studied American films carefully and applied the techniques and approaches of American directors in their own films.[70]

It is hardly an exaggeration to say that almost everything that happened in Hollywood would be echoed in China. When some Chinese moviegoers formed a fan

club, the organizer appealed to the potential participants by claiming that they were inspired by similar organizations in the United States and that the club would be formed in the same fashion as it would be there.[71] Some Chinese theater owners decided to add a Sunday morning movie show for school children because their American counterparts did so.[72] Similarly, the Catholic Church's crusade against Hollywood in the United States prompted some Chinese to attempt a similar campaign to sanitize the Chinese film industry.[73] Sometimes blind imitation of things Hollywood degenerated from the laughable to the farcical. Wang Hanlun, one of the best known female stars from the 1920s, set up a film producing company of her own in the late 1920s and used the image of a cat's head as its company logo. In an apparent imitation of MGM's trademark of the roaring lion, she had her cat meow three times at the beginning of every film produced by her company.[74]

Criticisms and Resistance

As happened elsewhere in the world, Hollywood was both hated and loved in China. Although generally speaking, American films were well received in China, some of them were resented for a variety of reasons. Owing to differences in cultures, social conventions, and political situations, a significant number of hit movies that did well at the box office in the United States and other parts of the world failed to appeal to the Chinese audience. For instance, *All Quiet on the Western Front* (dir. Lewis Milestone, 1930), which was critically acclaimed in the West, was rejected by Chinese moviegoers because they thought the film's anti-war message would undermine China's will to confront Japanese aggression. Shortly after the film's premiere in Nanjing, the Social Bureau of the Nanjing Municipal Government sent a letter to the National Film Censorship Committee (NFCC), asking the latter to ban the film. The Social Bureau argued that "the film's pacifism would dampen the fighting spirit of the Chinese military as well as of civilians."[75] Even though the censors did not share the view and approved the film for public release, the misgivings about anti-war films and their appropriateness for China struck a resonant chord with the country's political and cultural elite. One of the overseas branches of the Nationalist Party sent the NFCC a letter, calling its attention to films with anti-war messages from abroad.[76] The garrison commander in Shanghai, Gu Zhenglun, wrote to the Nationalist Party central authorities to express his dismay at the showing of films such as *All Quiet on the Western Front* because he, too, viewed these films as detrimental to China's efforts to mobilize the masses for war with Japan.[77] In the end, the Nationalist government in Shanghai issued a ban on all anti-war films. Even in places where such films were released, they were not well attended.[78]

The rejection of *All Quiet on the Western Front* may be largely due to political circumstances, but the criticism of Hollywood by China's leading intellectuals was both constant and consistent. Generally speaking, Chinese critiques focused on five major issues: American films were artistically inferior, politically subversive, economically exploiting, culturally corrosive, and offensive to Chinese dignity. Needless to say, those

issues were inseparable from each other and in the actual articulation of individual critics represented different proportions.

Those who worked in the film industry and understood the business of filmmaking faulted Hollywood primarily on artistic grounds. Gu Jianchen, a leading Chinese film critic, identified four major shortcomings in Hollywood films: their narratives followed a certain formula (always a happy ending); their plots were unrealistic (heroes never die); their characters were farcical and superficial; and finally, their depictions of crimes were liable to provoke copy-cat efforts.[79] With the exception of the last, all the other shortcomings identified here point to a lack of imagination and poor production quality. Fei Mu, one of the most accomplished film directors in the 1930s and 1940s, gave Hollywood credit for its mastery of filmmaking techniques, but insisted that American films were artistically inferior to European productions. Fei attributed the lack of creative freedom of the American filmmakers to the Hollywood movie moguls' preoccupation with mass appeal and profitability, whereas European films were much more steeped in a rich culture.[80]

Other critics rejected American films because they saw Hollywood as the ideological champion of capitalism. Critics with leftist leanings viewed Hollywood's presence in China as an ideological offensive on those who had been colonized, accusing it of cultural imperialism.[81] They argued that American films tend to justify and legitimate the capitalist exploitation of the working class, thereby perpetuating the dominance of the exploiting class over the proletariat.[82] To these leftist critics, the portrayal of material abundance in the United States and American military prowess on the screen was not a realistic reflection of reality, but a form of propaganda for American imperialism.[83] If such leftist criticism was coined in Marxist terms, the Nationalist officials faulted Hollywood on the ground that the individualistic values and hedonism so prominent in American films were incongruous with their own vision of a modern China, which economically had adapted the model of state capitalism. Leaving aside the question of the merits and necessity of this model given the historical circumstances under which China's modernizers made their choice, the model does require a great deal of sacrifice from its citizens and entails the promotion of a frugal lifestyle and limited individual liberty. Seen from this perspective, it is understandable that the Nationalist officials found American films ideologically incongruous with their state building project. Chen Lifu, the chief ideologue of the Nationalist Party and the top official in the party's propaganda apparatus, explicitly explained that the United States differed from China in that it was a highly developed industrial society. As such, 70 percent of a film's function in that country was to entertain the populace and only 30 percent was for educational purposes. The situation in China was precisely the opposite. Its underdevelopment and backwardness dictated that a film's function be 70 percent educational and 30 percent for entertainment.[84]

It is interesting to note that Chinese critics of Hollywood from a diverse political and ideological spectrum found the hedonism and liberal attitudes toward sex in American films most threatening to the moral fabric of Chinese society and a source of "spiritual pollution."[85] In the words of one critic commenting on Hollywood's musicals, there are

two things that stand out about these films: "the forest made of women's legs and the permeation of decadent music."[86] Needless to say, the "decline" of traditional cultural values and moral norms was the result of China's weakness versus the West's strength in modern times. But against that general backdrop, Hollywood presented the most visible challenge to China's indigenous cultural traditions and social mores, and hence, the most convenient scapegoat for all that was wrong with China as well. For that reason, the Chinese cultural elite, left and right, repeatedly appealed to the authorities to take harsh measures to curtail Hollywood's expansion in China.[87]

Although sharing the cultural elite's concern about the moral erosion American films brought to Chinese society, government officials focused on the economic and political damages associated with Hollywood and used censorship as an effective tool. The ban on *Welcome Danger* by Harold Lloyd in 1930 marked the beginning of the censorship of foreign films in China. Soon after the *Welcome Danger* incident, Universal's *East Is West* was also banned. In this case, Chinese diplomats in Chicago alerted the government censors at home to the offensive nature of this film before the film was shipped to China. Subsequently, the censors barred the film from being shown in China and even succeeded in making Universal agree to delete scenes and dialogue that the censors considered offensive. A similar pattern was repeated in *Shanghai Express*, *The Bitter Tea of General Yen*, and *The General Died at Dawn*, the last of which resulted in a ban on all Paramount films in China until the studio caved in to Chinese censors' demands to withdraw the film from circulation.[88]

However, the Nationalist government's desire to maintain a good relationship with the United States and its dependence on American economic and political support precluded it from taking more drastic measures against Hollywood. In a number of cases, the U.S. government intervened to help settle disputes between the Chinese government and Hollywood in favor of American film interests.[89] But the Chinese film industry continued to pressure its government to adopt a protectionist policy against Hollywood in the postwar period.[90]

The Chinese exhibitors had a peculiar relationship with Hollywood. Their dependency on a continuing supply of American films meant that they were vulnerable to Hollywood's exploitation. Hollywood's share in profits usually ranged from 30 percent to 70 percent of the box-office receipts, with the exhibitors responsible for publicity and advertising, even paying the distributors for such things as the trailers and posters.[91] However, despite the periodic conflicts between the two sides, the Chinese exhibitors were Hollywood's closest allies in China because they benefited from the popularity of American films. The Chinese filmmakers, on the other hand, strongly resented Hollywood because it siphoned off audiences, competed for market share, and cut into their profitability. Frequently, the Chinese film industry leaders resorted to nationalist rhetoric in their opposition to Hollywood and formed alliances with the cultural elite and government officials to push for programs that might curtail Hollywood's dominance.

The Communist victory in 1949 and the outbreak of the Korean War in 1950 brought the end of the Hollywood empire in China.[92] As a result, American films would disappear

from Chinese movie theaters for the next thirty years. However, party officials, scholars, and filmmakers were periodically allowed access to American films. Film actress Xiang Mei, who began her film career in the 1950s, recalls *Roman Holiday* (dir. William Wyler, 1953) as one of her favorite American films and that she watched it at least three times.[93] Her story suggests that American films were never entirely erased from public memory and consciousness even during the Mao years.

In recent decades, Hollywood has made a "comeback." Major studios from America have all reopened branch offices in China to distribute and promote their films. The continuous popularity of American films among the Chinese moviegoers, the anti-Hollywood rhetoric voiced by the Chinese nationalists, and the official measures to restrict Hollywood's expansion there are every bit reminiscent of the pre-1949 period. History may not repeat itself, but this sense of déjà vu does make the past all the more relevant to the present.

Piracy and the DVD/VCD Market:
Contradictions and Paradoxes

Shujen Wang

Here's how the Hollywood majors are getting their movies into China: forget
the restrictions on the number of theatrical pics that can be imported; put
them out *cheaply* and *quickly* on DVD....

<div align="right">Ada Shen[1]</div>

The Sisterhood of the Traveling Pants, Warner Bros., and the Chinese Home Video Market

Warner Bros., the Hollywood studio that provided the first revenue-sharing film (*The Fugitive*, see later discussion) to the newly opened Chinese film market in 1994, was again making headlines in 2005. On February 24 Time Warner announced the formation of CAV Warner Home Entertainment Co., a joint venture with China Audio Video (CAV), making Warner Bros. the first U.S. studio to establish its own DVD/VCD distribution and marketing operation in China, releasing 125 titles within a few months (previously, Hollywood majors normally distributed home videos in China through local licensees).[2] In addition to this bold move, which was closely watched and soon followed by competitors[3] and carefully studied by trade organizations and publications, Warner Bros. also made history by day-and-date releasing of DVDs in China at some of the lowest prices in the world. Priced at US$2.65 per copy, Warner Bros. released *The Sisterhood of the Traveling Pants* on DVD in China the same day the film opened theatrically in the United States on June 1, 2005.[4] Since *The Sisterhood of the Traveling Pants* was only released on DVD in the United States on October 11, 2005, Warner created a potential problem of parallel importing. Clearly, these inexpensive *legitimate* discs could potentially be re-exported from China to other territories, including the United States where legitimate DVDs are on average sold for over $20 per copy, disturbing crucial geographical and temporal divisions of the market order. Finally, CAV Warner uses both conventional and "alternative" retail outlets to sell these legitimate DVDs. In interviews, CAV Warner President Fang Donglin revealed CAV Warner's retail strategy to combat piracy by utilizing existing piracy retail outlets. The four types of retail outlets through which CAV Warner sells its legitimate DVDs are: traditional legitimate

DVD outlets such as the state-owned Xinhua Bookstore, online DVD stores, discount markets, convenience stores and news-stands, and your hole-in-the-wall neighborhood corner stores and distributors that normally sell pirated DVDs.[5] Warner Bros. cited two reasons for the new home video distribution, pricing, retail, and releasing strategies in China. On the one hand, the growing and largely untapped Chinese home video market creates enormous consumer demand, making China a *potentially* lucrative market. On the other hand, the staggering optical media (i.e., CD, VCD, DVD, CD-R, VCD-R, DVD-R) piracy rate in China makes it extremely difficult for Hollywood studios to turn a profit. The new pricing, retail, and day-and-date releasing strategies are thus examples of Warner Bros.'s effort to compete with the pirates, by emulating what had been the latter's key advantages of *value* and *speed*. This case is significant because it accentuates some of the most important issues facing the film industry in the "digital millennium": the growing importance of world DVD markets,[6] the increasing appeal of the Chinese film and home video markets to Hollywood majors, and the threat of optical media and online piracy and how it has changed global film distribution in general and undermined the practices of Hollywood studios in particular. Film piracy in China is embedded in complex policy, technology, and global trade contexts. China's position as one of the world's largest DVD markets and its transitional economic and legal environments further provide a fertile ground and porous space in which pirated optical media production, export, and consumption can take root. The increasing significance of intellectual property rights in global trade and the growing importance of the DVD market to the U.S. film industry have also translated into the escalating threat of optical media piracy to the U.S. economy, with the ensuing complications for the Sino-U.S. trade relationship. While the DVD market and optical media piracy do not have a long history because of their tie to the digital technological development, optical media piracy has greatly influenced Sino-U.S. bilateral negotiations and shaped policy making in China in the past two decades. Piracy also has far-reaching implications for the future development of the Chinese film industry, most significantly in the area of film distribution.

Against this backdrop, in the following sections I will examine Chinese film distribution history and structure, piracy and copyright governance in China, the emergence and rise of the VCD, and finally the new battleground of the DVD market and its connections with, and implications for, piracy.

Policy, History, and the Revenue-Sharing System

One of the existing "cultural markets" in China, film has always been viewed as a product of "the political, economic, military, and cultural invasions of the West," carrying with it a "deep colonial branding" from the start.[7] Indigenizing and nationalizing the film industry has thus been the central government and the Communist Party's mission, while the protection of the national film industry remains a priority in China's cultural policies. China began building its own "independent national film system" after the 1949 Communist revolution. Consequently, China banned U.S. films completely in 1950. While the Chinese government began the open door policies in the late 1970s

and embraced market reforms, such reforms did not reach the cultural arena until much later. Founded in 1979, the China Film Corporation became the country's monopoly film enterprise, regulating film distribution and import/export operations.

The adoption of a revenue-sharing system in 1994 was a significant step in China's opening to foreign (and most specifically Hollywood) film imports. It was with this system that the State Administration of Radio, Film, and Television (SARFT) permitted the import of ten revenue-sharing films a year into China. The quota was increased to twenty per year when China gained formal accession to the World Trade Organization (WTO) in December 2001. Revenue sharing refers to the commercial terms and the industry standard to which Motion Picture Association (MPA) member companies subscribe. Under this system, the distributor and exhibitor negotiate the percentage of the box-office receipts each will receive.[8] In China, roughly 13 to 17 percent of box-office revenue goes to the Hollywood majors, which is a very low rate compared to the standard share Hollywood distributors receive elsewhere.[9]

Two separate government agencies oversee the operations of media industries in China, causing significant discrepancies in media policies, with implications for piracy. SARFT regulates the film (theatrical releasing and distribution), radio, and television sector, while the Ministry of Culture monitors the home video (including DVD and VCD) import and distribution business.[10] Beginning in 1997, China opened its market to American home video imports, changing the landscape of film distribution in China. Herein lies the paradox: even though what is recorded on video also exists on film, the former medium is considered new, as opposed to the older and more ideologically loaded medium of "film." The two media are thus treated differently. The procedure and regulations for approving home video titles for domestic distribution are much faster and more lenient than for film. Between 1997 and 2000, for example, the Ministry of Culture approved the import of over eight hundred home video titles, averaging two hundred titles a year, compared to the ten theatrical releases per year during the same period.[11] Moreover, the import of foreign films is subject to strict review and a lengthy censorship process.[12]

These policies have spatial as well as temporal implications for piracy and film entertainment consumption. As I have argued elsewhere, power in this mode of late capitalist expansion is closely connected to one's capacity to overcome constraints of both time and space.[13] By erasing space and rewarding speed, for example, digital technology (and subsequently piracy) has disrupted the existing balance of power. And if mobility equals profitability and if speed in this digital world translates into profit, then the ultra-flexible local, regional, and global piracy networks prove to be among the greatest challenges the film industry has ever had to face. Speed therefore becomes a major goal of, and challenge to, participants in this global informational structure and capitalist expansion. Facing these challenges brought about by the new technology, namely the pirates' increasing command of speed and the global audience's demand for faster and more affordable products and releases, the majors have been compelled to accelerate and expand their global distribution networks. The shortening of the release intervals (and the shrinking of windows) has been one strategy the majors

have employed to combat piracy and meet the global audience demand for speedy delivery.

Thus, while the foreign film import quota in China creates market restrictions and access problems for the Hollywood majors, the timing of such releases also has significant consequences. The increasingly media- and Internet-savvy consumers are well primed for global entertainment information, demanding instant gratification of their desire to see first-run films, preferably right after their respective U.S. release dates. The lengthy review process in China means the local audience normally would not get to see first-run films until several months (if not more than a year) after their U.S. release dates. Piracy provides consumers with true global day-and-date releasing of first-run Hollywood films, offering *immediate* access to the "there" and "now" and to global entertainment happenings.[14]

With its more flexible review process, much higher quotas, and faster release timetable, the home video/home entertainment market in China finally provides Hollywood majors an opportunity to tap into the potentially lucrative market and to compete with pirates.

Optical Media Piracy: Trade, Politics, and Law

China occupies a unique place in the economic and technological development continuum that makes it not only a desirable market for pirated products, but also a production and export base. Technologically, China has reached a level of sophistication that enables it to efficiently produce pirated goods. Economically, much of China has seen an increase in the overall standard of living, generating demands for pirated products, including entertainment, software, and fashion.[15]

This picture, however, is not complete without also taking into consideration the distinctive international trade/political position and the ambiguous legal realities which mark the current Chinese situation. More specifically, the delicate and contentious Sino-American relationship, China's fifteen-year quest to join the World Trade Organization (WTO), and the subsequent compliance with the Agreement on Trade-Related Intellectual Property Rights (TRIPS), form the most important political and legal contexts within which China shapes its unique piracy and copyright governance environments.

Global Trade and IP Regime: WTO and the Sino-American Relationship

> [T]he "sanctity of intellectual property" has replaced earlier issues of international importance to serve in an iconic role in the making of the developed world's foreign policies.... "[P]iracy of intellectual property" will replace nationalization as the main fear of the developed countries for the next fifty years.
>
> James Boyle[16]

In an "economy of signs and space," what is traded and circulated are increasingly signs and are thus postmodern (objects emptied out of meanings), post-industrial

(objects emptied out of material content), and spatial (increased velocities of mobility and flows in the information structure),[17] so that the *control* of intellectual property rights becomes crucial; indeed, what constitutes the global economy of signs is the trading of the rights to those signs. The protection of these rights becomes a priority in national economic development as well as international trade relationships and negotiations.

In the United States, for example, the copyright industries are not only the leading sector in domestic economic growth, they also dominate U.S. foreign sales and exports, surpassing auto, chemical, and aerospace performances. The most recent Siwek Report on copyright industries in the U.S. economy shows that these industries contributed 12 percent to U.S. GDP in 2002, while also serving as the leading foreign sales and export sector.[18] Given that "intellectual property" has replaced tangible products to become the real property, what are traded are increasingly intellectual property *rights*. For the U.S. copyright industries, the importance of copyright protection cannot be overstated, since piracy has become the largest barrier to market access.[19] The International Intellectual Property Alliance (IIPA), for example, estimates that the U.S. copyright industries in 2005 witnessed a $15.8 billion total loss owing to piracy in foreign territories, of which $2.36 billion (15 percent) is estimated to have occurred in China alone.[20] It is not surprising, then, that piracy issues and the perceived weak copyright law and enforcement in China have been the subject of negotiations in annual United States Trade Representative (USTR) Special 301 Reviews.

Fearing that the United States might lose its economic sovereignty to a global trade and legal regime, the U.S. copyright industries did not advocate a multilateral, GATT-based diplomatic effort such as WTO at the outset.[21] Under the leadership of MPAA in 1984 the U.S. copyright industries created the International Intellectual Property Alliance (IIPA) as a separate strategy to strengthen international copyright rights protection. The main IIPA strategy was to support an agenda for the USTR's Section 301 mandate, because the bilateral Section 301 strategy, with the possibility of sanctions, would increase enforcement levels in developing countries.

Under the 1988 Omnibus Act and based on the IIPA recommendations, each year the USTR announces which countries are to be identified as falling under Special 301 conditions.[22] According to the severity of their offences, countries are named TRIPS Copyright Cases, Potential Priority Foreign Countries, Priority Foreign Countries, or put on the Priority Watch List, the Watch List, or accorded Special Mention. These decisions have implications for the type of punitive actions (e.g., unilateral trade sanctions or other such retaliations, and bilateral Section 301 and Special 301 actions undertaken by the USTR) the United States would take against these countries.

Having been designated a Special 301 "Priority Foreign Country" in 1991, 1994, and 1996 by the USTR and put under Section 306 Monitoring from 1997 through 2004, China has often been subject to potential trade sanctions for its failure to contain copyright piracy and to provide market access to the U.S. copyright industries.[23] These unilateral trade sanction threats and bilateral trade negotiations however have proved to be futile, as piracy rates in China remain some of the highest in the world. China has also

always been able to respond to the U.S. threats with its own, leading to eleventh-hour reconciliations. In fact, as Peter Yu has pointed out, this threat–counter-threat process has not only failed, it has also helped China learn how to resist U.S. demands.[24]

Globally, China's ultimately successful fifteen-year quest to join the WTO has had a decisive effect on its copyright governance environment. To gain accession to the WTO, China had to be TRIPS compliant. The establishment of the Agreement on Trade-Related Aspects of Intellectual Property Rights (TRIPS)[25] under WTO auspices means the expansion of global copyright governance into the arena of global trade. Its deep integration and supranational harmonization requirement means that national IP laws (especially those in developing nations) need to be in accordance with those in developed countries.

China now has some of the most comprehensive and modern IP laws in the world.[26] In addition to becoming a World Intellectual Property Organization (WIPO) signatory in 1980, joining the Paris Convention in 1985, the Madrid Convention in 1989, the Berne Convention in 1992, and the Patent Cooperation Treaty in 1994, China also passed the following laws: the Trademark Law in 1982, the Patent Law in 1984, the Copyright Law in 1990, the Software Protection Act in 1991, the Anti-Unfair Competition Law of 1993, and the Rules on the Prohibition of Infringement of Trade Secrets in 1995. Additionally, the amendments to the 1990 copyright law were adopted in October 2001, two months before the formal WTO accession, which brought China into compliance with TRIPS. China also added the Regulations on Computer Software Protection on January 1, 2002 and the Regulations for the Implementation of the Copyright Law that was promulgated on August 2, 2002 and became effective as of September 15, 2002. More recently, China added the Regulations on Collective Management of Copyright in 2005 (effective March 1) and the Regulations on Internet Communication Protection in 2006 (effective July 1).[27] Since there were no IP laws in China before 1982, the legislative development on IP protection has been impressive.

Having the most comprehensive laws in the statute book, however, does not guarantee a nation's compliance, as enforcement is necessarily embedded in a nation's unique cultural, politico-economic, and legal structures. The one-size-fits-all approach of law making does not work in law enforcement. Just as these laws in the statute book may satisfy those substantive standards (Articles 9 through 40) in TRIPS, it is the performance standards (Articles 40 through 61) with a focus on enforcement that provide a space in which both rights holders and the state can negotiate. It is in this gray area that the processes of interpretation and re-territorialization of international IP treaties and agreements prove to be most dynamic. Andrew Mertha, for example, points out in his brilliant study of the politics of piracy in China that the "location" of the exogenous pressure really matters.[28] While top-down pressure can create substantive changes in China's policymaking and legislative and regulatory processes, it is the complex clustering of function- or policy-related bureaucracies (*xitong*) that ultimately determines the outcome of policy implementation and enforcement.[29] So although IP and piracy matters may receive high-level national attention during the policymaking stages, this kind of "elite attention" does not extend to local bureaucracies who have other more pressing and immediate priorities. Meanwhile, although the kind of lateral pressure found between

foreign actors and local enforcement agencies may not have much impact on national policymaking, it proves to be essential in establishing effective enforcement locally.

In China, the protection of intellectual property rights follows a two-track system: the administrative (complaints filed at the local administrative office) and the judicial (complaints filed through the court system) tracks. For administrative enforcement actions, major players include the State Intellectual Property Office (SIPO) that oversees patent matters and the National Copyright Administration (NCA) for copyright-related issues. Confusion can easily arise because the jurisdiction for IP protection is diffused through different government agencies and offices. That said, as far as the settlement of disputes is concerned, the administrative track still offers a quicker and less expensive solution.[30] For the judicial track, rights holders can pursue protection through civil actions in the local People's Courts. Since 1993, China has also maintained IP tribunals in the intermediate People's Courts and Higher People's Courts.[31]

While much progress has been made on the IP legislative front and many pirated products have been confiscated and production lines closed down, the piracy rate in China remains high. One key reason stems from the dynamic and complex relationships among the market, the state, and the law. Deng Xiaoping's Open Door Policy and economic reform brought decentralization in their wake. The Special Economic Zones (SEZs), for example, early on were designated to facilitate China's economic reform, and have grown from the original four designated zones in 1980 to over four hundred today. Even local villages retain economic governing power. This de-centering process produced a profound fissure of the state system and turned the juridical space of sovereignty into relative spaces that were mutually dependent.[32] As Paul Thiers has pointed out, China's unique status as an entrepreneurial socialist state creates a situation in which both the central and provincial/local governments find themselves occupying an ambiguous space in which they operate as both regulators and entrepreneurs, with profound implications for the implementation of IP laws.[33] He argues that this combination of the two conflicting types of functions — the state as both regulatory authority and entrepreneurial competitor — and the resulting "structural conflict of interest" have led to China's incomplete compliance with the WTO and TRIPS provisions and the blocking of effective monitoring and enforcement efforts. For many local officials who are under tremendous pressure to produce significant results in economic development, for example, copyright infringement may provide a far stronger source of revenue than its licit counterpart can, thus creating resistance towards IP law implementation.[34] In short, there are strong economic disincentives against active enforcement.

Optical Media and Internet Piracy: Technology

VCD: Mistaken Identity and the Figure of the Chinese Pirate

> The prospect of an unprotected format created in China harkens back to the advent of the VCD, *a Chinese-invented pirate format*, and raises questions about the Chinese Government's will to deal with the piracy issue.
>
> IIPA[35]

> The VCD is a purely Asian market, and it's driven purely by piracy.
>
> Steven Metalitz, VP, IIPA[36]

To Western copyright industries, the VCD is synonymous with piracy, and Asian (if not Chinese) piracy to be more specific. The story of the VCD, however, has evolved from one of unprecedented technological penetration in China to one of mistaken identity. Is the VCD a "Chinese-invented pirate format" "driven purely by piracy" as the IIPA statements assert? Who invented it and how was it adopted in China? This mistaken identity is indicative of the problematic figure of the Chinese pirate. It also tells the story of the uneven development of technology and the shifting terrain of, and inherent paradoxes in, late capitalism.

Still a little-known entity in the West thirteen years after its inception, the VCD is unique to "emerging markets" and has been the dominant format for recorded home entertainment in China (and other parts of Asia).[37] Only since 2004 has the DVD begun to replace the VCD as a more popular format, both legitimately and illegitimately. China did not invent the VCD as the IIPA mistakenly asserts. Philips and Sony jointly introduced the exciting new digital technology in 1993, only to realize that the future of the new format was doomed upon the pending introduction of the far superior DVD. Their decision to dump the inferior technology to China proves to be one of the most fascinating cases of a reversed flow of technology. It resulted in the redefinition of boundaries and the redrawing of distribution maps, both licit and illicit. It also provides a case study of the re-territorialization of technology in which the state, local manufacturers and consumers collude to change an obsolete global format to meet local needs. Its low cost means profits for manufacturers and affordable quality entertainment for consumers. Its digital capacity means speed and velocity for pirates. The ensuing impressive employment opportunities both pirate and legitimate manufacturers provide means social stability and income for the state and jobs for an otherwise unemployed workforce. The VCD market in China had achieved the fastest and deepest growth of any new technology in history. In order to compete, the Hollywood majors were compelled to produce VCD versions of their films for the Asian markets.[38]

Central to the story of the VCD is the problematic figure of the Chinese pirate, one portrayed by IIPA and the popular press as greedy, excessive, and ubiquitous. Such a portrait, while dramatic, masks the underlying multifaceted realities of piracy in China. A product of a transitional economic and political system and a shadow economy, piracy is very much a part of global capitalist development. The VCD story exposes only the surface of this complex reality. Various networks and actors are involved, each with its own unique set of movements and relationships. It involves networks as small as individuals (e.g., consumers) to ones as large as the state, global corporations, global trade, and legal regimes.

Internet Piracy

Given that the majority of population in China still lives in rural areas[39] in which the personal computer penetration rate is less than 3 percent and a fixed-line infrastructure is lacking, broadband connections in rural China are difficult.[40] Pirated and low-priced legitimate optical discs would likely remain a preferred format of movie consumption in China. In the urban areas, however, Internet piracy has become increasingly prevalent. Stemming Internet piracy in China is now the top priority for many copyright industries.[41] While the overall broadband penetration rate is still relatively low in China, at 15 percent,[42] the projected growth of broadband connections is significant. According to IIPA's 2008 Special 301 Report, China's Internet users grew from 137 million in 2006 to 210 million at the end of 2007, a 53 percent increase.[43] *Screen Digest* also estimated that by 2012, China would see 176.5 million broadband connections and a 37 percent residential broadband penetration.[44] A *Variety* report further showed that by 2012 there would be 500 million Internet users in China, which is more than there are American citizens in total.[45] It is therefore the *potential* of this huge Chinese market that both excites and horrifies the copyright industries. Table 4.1 shows the steady growth of broadband users in China. Table 4.2 illustrates the number and profile of online users in China.

Table 4.1 **Internet and Broadband Users in China (millions)**

	Internet Users	**Broadband Users**
2000	22.5	
2001	33.7	
2002	59.1	6.6
2003	79.5	17.42
2004	94	42.8
2005	111	64.3
June 2006	123	77

Source: *China Telecom*, 2007

Table 4.2 **China Online**

Number of Chinese online	Number of Americans online
253 million	223 million
Number of Chinese citizens expected to be online by 2012	High-end projection of the number of U.S. citizens in 2012
500 million	322 million
Percentage of China's population online	Percentage of U.S. population online
19%	70%

Percentage of China's online population below the age of 30	
69%	
Number of cell phone subscribers in China	
601 million	
Total revenues for China's Internet companies in 2007	
$6 billion	
Projected revenues for Chinese Internet companies by 2010	
$20 billion	

Source: *Variety 2008*

Motion Picture Association of America (MPAA) defines Internet piracy as "the downloading or distribution of unauthorized copies of intellectual property such as movies, television, music, games and software programs via the Internet." The extraordinary speed and power afforded by the Internet, not to mention that it is free of charge to most users, are cited by MPAA as some of the factors that boosted the "global Internet piracy."[46] MPAA's figure has it that of the $6.1 billion its member companies lost to movie piracy worldwide in 2005, $2.3 billion alone came from online piracy (with $1.4 billion from illegal duplication and $2.4 billion from illegal retail).[47] Of the reported 1.5 million websites operating in China, many offer streams, downloads, or links to unauthorized files of copyright materials. There are over a dozen peer to peer (P2P) services and many BitTorrent sites that are based in China and are engaged in illegal file sharing. There are also reportedly 110,000 licensed Internet cafes and around the same number of unlicensed Internet cafes in China that have become centers for illegal downloading.[48]

Given that the Internet is transnational and decentralized, anti-piracy enforcement is challenging. Streaming technology, for example, makes it extremely difficult for Hollywood to stop the users since such technology makes films and television programs instantly available on web browsers and cloaks the user's identity.[49] With all these reports about illegal file sharing, however, it is the source of less than 10 percent of pirated copies of first-release movies,[50] not to mention those who download movies are some of the industry's most loyal customers. Research has shown that downloading does not appear to have affected their movie attendance at theaters.[51]

DVD: The New Frontier

DVD has in the past few years replaced the VHS and Laser Disk to become the format of choice for consumers. In China it has also surpassed the VCD to become the dominant

recording entertainment format. Although the growth of the DVD market in the United States slowed in 2005, it still drives most of the profit for studios and films.[52] The DVD market now grows at a pace three times the size of the theatrical market, with DVD sales projected at $40.4 billion in 2009.[53] DVD has in fact replaced theatrical releasing as the most profitable window for the Hollywood majors, with important implications for the release and circulation of film products (see Table 4.3).

Table 4.3 Media Revenue Breakdown for the Major U.S. Studios 2004

Rank	Media	Revenue
1	Home Video	$21.0 billion
2	Television	$12.6 billion
3	Theatrical	$7.4 billion
4	Pay TV	$4.0 billion

Source: *2005 Annual Report on the Home Entertainment Industry*, Video Software Dealers Association & Motion Picture Association, www.vsda.org

In addition, of all entertainment media, consumer spending on sell-through video (predominantly DVD) also witnessed the highest growth between 1997 and 2004 (more than three-fold, see Table 4.4). Moreover, of the total video revenue in 2003, DVD accounted for close to 75 percent, up from 7 percent in 1999 (see Table 4.5). With the DVD market widely acknowledged as the new frontier for the major Hollywood studios[54] — notably, it is dominated by sales more than rentals and by impulse buying that account for 43 percent of total purchases — it is not surprising that piracy is viewed as especially damaging.[55]

Table 4.4 Consumer Spending on Entertainment Media (1997–2004, in $ million)

Media	1997	2004
Theatrical Box Office	$6,366	$9,284
Video Rental	$7,380	$8,060
Video Sell-Through	**$4,540**	**$13,901**
PPV, NVOD, VOD	$448	$989
Premium TV	$5,959	$8,530
Total Spending	$24,694	$40,764

Source: Warner Home Video (*DVD Statistical Report*, 8th edition, 2005, DVDstats.pdf), www.whvdirect.com

Table 4.5 **Consumer Home Video Spending: DVD Revenue vs. Total Video Revenue in Billions (1999–2003)**

	Total Video Revenue	DVD Revenue
1999	$19	$1.5
2000	$20.2	$4
2001	$20.8	$6.7
2002	$21	$11.9
2003	$23.4	$17.03

Source: *Video Store* Magazine Market Research 2004

Given the maturation of the U.S. domestic DVD market, the global DVD market has become increasingly important in sustaining the high revenue income.[56] With its population of 1.3 billion, a strong economy, and a government that appears to be committed to economic liberalization, China has the potential to become the world's largest video market.[57] The growth of the domestic DVD penetration rate and the rapid decline of the price of DVD players in China (around US$54 in December 2004)[58] further contribute to the remarkable growth of the Chinese DVD market. Between 2000 and 2002, for example, China saw an impressive 867 percent growth of DVD households (by 23.4 million).[59] As Table 4.6 also shows, even though China was not the most lucrative market for DVD revenue in 2003 (it ranked no. ten), it was the fastest growing. From 1998 to 2003, there was a 267 percent growth in revenue, while the United States, the top video market, saw only a 74 percent increase in revenue and the increase in Japan (ranked second in revenue) reached 71 percent.[60]

Table 4.6 **Top 10 Video Markets Worldwide 2003 Ranked by Distributor Revenues from Video Software***

		Revenue 2003 ($bn)	Change 03/98 (%)
1	U.S.A.	13.9	74
2	Japan	3.3	71
3	U.K.	2.5	132
4	France	1.6	103
5	Canada	1.2	84
6	Germany	1.1	109
7	Australia	0.6	156
8	Spain	0.5	106
9	Italy	0.4	48
10	China	0.4	267

* Revenues from DVD, VHS, and VCD units sold for retail sale or rental.
Source: *Screen Digest* 2004

In this context the logic of Warner Bros.'s new DVD pricing and releasing strategy in China is evident. Its emphasis on speed (global day-and-date releasing) and value (at $2.65 per copy) is an attempt at ensuring a slice of the lucrative pie in the Chinese DVD market. It is also an example of how the development of digital technologies has impacted international film markets both temporally and spatially, as represented by the speeding up and stretching out of global DVD distribution.

Conclusion

The Chinese film market at its centennial is marked by paradoxes and contradictions: state monopoly intersects consumer capitalism, post-WTO transnational trade and intellectual property governance cut across nationalist sentiments and local resistance. The boundaries between state and market, commerce and art, and art and politics, are increasingly blurred. Digital technology that erases space while rewarding speed further heightens the tension between the licit and the illicit. China was noted and celebrated, for example, as "the world's fastest growing theatrical market" for Hollywood films with a 50 percent increase in one year alone (in 2004).[61] China, however, is also reported to have the highest film piracy rate (95 percent)[62] in that same year.[63] While the link may be coincidental, piracy markets of Hollywood products have undoubtedly cultivated a new generation of viewers in China for legitimate Hollywood films. Digital technology and piracy have also shifted the power balance and control among different networks and actors, both local/national and global.

These paradoxical developments are symptomatic of the complex underlying forces of globalization, digital technology, policy, and a changing state. With its implications for global capitalism and transnational politics, piracy in particular serves as a lens through which some of these issues are manifested. The complex realities of piracy, however, are not easily reducible to the realms of the legal or the technological. They require critical examination and contextualization. It is against this backdrop that the foregoing analysis examined the dynamic landscape of piracy and the ever more important DVD/VCD market in China. It also explored the effects of technological changes and regulatory expansion and their impacts on the Chinese film market.

Part 2

Film Politics: Genre and Reception

The Triumph of Cinema:
Chinese Film Culture from the 1960s to the 1980s

Paul Clark

In June 1973 an unfamiliar phenomenon was seen in the streets of Beijing: long lines snaking around the sidewalks from cinemas had last occurred in the summer of 1966, when people queued up to watch documentaries of Chairman Mao reviewing Red Guards in Tiananmen Square. Now seven years later the lines were for a wide-screen, full-color melodrama, *Maihua guniang* (*The Flower Seller*), from North Korea. In a matter of weeks it sold six million tickets in Beijing alone.[1] New, Chinese-made feature films (other than films of the model performances) were almost a year away. Beijing filmgoers flocked instead to this song-filled drama, enjoying the exotic costumes and customs, the lush musical score, and the high drama of a young woman forced into a life of misery by an evil landlord. The next comparable hit film in China was probably 1998's screenings of *Titanic*, a quarter-century later.

This chapter will examine film culture (going to the movies and the impact of movies on audiences' attitudes and tastes) from the 1960s to the 1980s. We will trace the strength of films in national cultural consumption from before the Cultural Revolution, through those ten years of so-called "catastrophe" to the working through of the impact of this period in the films of the 1980s. I will argue that film occupied a central position in Chinese cultural life from the mid-1960s until the rise of the Fifth Generation filmmakers in the mid-1980s. Given the centrality of film, the latter group were virtually compelled to use the medium to express themselves in the post–Cultural Revolution era. But the compulsion carried within it the seeds of its own destruction.

Although the North Korean movie hit emerged in the midst of the Cultural Revolution (conventionally dated 1966–1976), the response to *The Flower Seller* was typical for Chinese cinema since films first were watched in China seventy years before the start of the Cultural Revolution. Foreign films have tended to dominate the Chinese box office from those early days. Even at historical moments, like the early 1970s, when the nation was supposedly cut off from much intercourse with the rest of the world, the world's movies have continued to hold considerable attraction.

The response, a year after *The Flower Seller* had been such a success, to a new Chinese-made feature film, *Sparkling Red Star* (*Shanshan de hongxing*, dir. Li Jun and Li Ang, 1974) echoed some of the earlier phenomenon. The new film told the 1930s

story of an heroic peasant boy, Pan Dongzi (Winter Boy), who loses his mother in the
civil war but achieves his dream of joining the Red Army. Long lines of ticket buyers,
delight in hearing the songs from the film on radio, in learning to sing the songs, and
interest in the comic book and other published and broadcast retellings of the story of
the film, all indicated the power of this new film to engage audiences. The impact of
Sparkling Red Star was made possible by the already established film culture of the time.
Filmed versions of the Cultural Revolution "model performances," released starting in
1970, had helped cement the status and importance of film in the collective memory
and consciousness of Chinese audiences.

But this power of film had developed during the preceding two decades. The new
Communist leaders of China after 1949 recognized the potential of film to create a new,
mass culture and present messages in identical form across the nation. In the 1950s film-
going became a regular experience for urban Chinese, often organized by work units
rather than seen as strictly recreational. A nation that in 1949 had perhaps 500 places
that regularly screened films, by the mid-1960s had over 20,000 such venues.[2] By this
time the state-owned film studios were producing close to forty films annually: hardly
a huge number in comparison with other countries and given the size of the Chinese
population. With this relatively low production level, there was space for imported
films: indeed studios in Changchun in the Northeast and in Shanghai supplemented
their earnings with a sideline dubbing foreign films, often using actors who appeared
on screen in local features.[3]

For mass audiences, many of whom had not seen a film before the 1950s, the
conventions of film art had become familiar by the 1960s. The standard treatment of
transitions of time and location (even at the level of the shift from medium shot to
close-up) had to be learned by audiences new to cinema. This helps account for some of
the relative simplicity and obviousness of many of the films from Chinese studios after
1949: audiences had to learn the language of film. A good example is the sequence in
Li Shizhen (1956) in which a servant remarks to the elderly Ming dynasty herbalist that
Li's wife would be better able to thread the needle with which the old man is struggling.
This is followed by the superimposed image of Mrs Li beside a thoughtful Li Shizhen's
head. Here film's freedom with time and space is clearly signalled to audiences new to
the medium. Comic book (*lianhuanhua*) versions of films, posters, and blackboard plot
summaries helped educate audiences on film conventions. The vocabulary of cinema
included the musical scores: these were often Western symphonic music unfamiliar to
the majority of rural or uneducated Chinese. How this music could indicate a character's
or a sequence's mood, how it might suggest mounting tension or triumph, all needed to
be learned by China's film audiences.

The Start of the Cultural Revolution

The success of these lessons and the triumph of film to insinuate itself into the cultural
heart of China were indicated by the major film of the mid-1960s, *Dongfang hong* (*The
East Is Red*, collectively directed, 1965). The film begins with a pan across Tiananmen

Square from the ancient gate where Mao Zedong proclaimed the establishment of the People's Republic and follows a careful selection of workers, peasants, soldiers, intellectuals, and ethnic minorities up the steps of the Great Hall of the People and into the concert hall. This opening positions the film audience into the appropriate place to enjoin with the live audience in receiving the historical and emotional lessons from the musical drama. The narrator, as on the stage, reinforces the audience placement for lesson-learning. The episodes of this musical documentary outlining the humiliation of China under imperialism and the rise and victory of the Chinese Communist Party provided not only some stirring songs that became unavoidable in these years. The film, one of the relatively few made in full color, provided a visual vocabulary for its audiences to express loyalty to Chairman Mao and his new project once the Cultural Revolution got underway in the summer of 1966.

During that summer the loyalty dances (*zhongziwu*) and the agit-prop dramas and tableaux presented in theaters, at work units, and on the streets by professional, semi-professional, and Red Guard troupes drew upon the groupings, individual poses, and the musical reinforcement that had been widely seen in *The East Is Red* and in the series of shorter stage performances that had become the main output of the film studios by 1965–1966.[4] Even the Red Guard plays (*huaju*) performed from the summer of 1966 through to the following year showed the influence of film culture in the presentation of their stories, the use of music, and the mix and range of geographical and temporal settings. Yang Jian, a pioneering researcher on Cultural Revolution culture, has written extensively on these semi-professional street and theater performances in the first years of the Cultural Revolution. He shows how innovative and experimental these agit-prop pieces were. One example is *Zai Liening de guxiang* (*In Lenin's Hometown*, 1968), in which anti-revisionist Soviet workers in 1966 manage to print and distribute the works of Chairman Mao in Moscow.[5] Two of the most widely shown and watched films in the immediate pre–Cultural Revolution period and throughout the following eight years were Soviet films about Lenin: *Lenin in October* and *Lenin in 1918*, directed by Mikhail Romm in 1939 and 1937 respectively. Red Guards presenting stories set in Moscow and combining Russian and Chinese characters becomes a little more comprehensible if we recognize the cultural impact of these and other Soviet films in the 1960s. This suggests how central films had become by the mid-1960s as shapers of Chinese cultural expression and consumption. The 2003 documentary film on the Cultural Revolution, *Morning Sun* (directed by Andrew Gordon and Carma Hinton and scripted by Geremie Barmé) uses the Soviet film adaptation of *The Gadfly* to explore the heroic and romantic self-image of Red Guards at the start of the upheaval.

Meanwhile in the summer of 1966 the most widely watched film star in China was Chairman Mao himself. A series of seven documentaries was made of the eight times in which he inspected Red Guards and other supporters in Tiananmen Square in 1966–1967. These were distributed widely, shown free, or with ticket prices kept low to facilitate attendance. The first of these films, *Mao zhuxi jianyue Hongweibing* (*Chairman Mao Inspects the Red Guards*) was watched for free by over 100 million people on its first release.[6] By the time these films were in release, most cinemas in Beijing had been

taken over to serve as reception centers and makeshift hostels for the thousands of young people pouring into Beijing to "establish revolutionary ties" (*chuanlian*). In the daytime, when the Red Guards were touring the capital or at mass meetings, the cinemas showed the Mao documentaries and other films. Ticket prices were low: ten cents for adults and five cents for children. The seven Mao documentaries were screened in Beijing city 7,218 times to a total audience of 5,313,707 people. Parts of city life may have been in chaos, but the bureaucratic tradition continued, as these precise figures indicate.[7] At night, the young visitors took priority, camping out in the lobbies and auditoriums.

The contexts in which these documentaries of Mao, including others on his meetings with foreign visitors and on other news subjects that television would soon monopolize, point to the strong influence of film culture on other expressive cultural activities in the first years of the Cultural Revolution decade. Advertisements for documentaries in local newspapers indicate that these films were often watched as part of a longer program of film and live performance. The behavior of the Red Guards in the documentaries in showing near-hysterical adulation for the supreme leader was combined with coverage of Red Guard street tableaux, with a disciplined group of uniformed performers reciting Mao quotations in unison while striking frozen poses similar to martyrdom scenes in feature films set in the pre-1949 period. They also resembled the revolutionary statuary familiar from the Soviet Union and, increasingly, in China. Both behaviors (adulation and serried poses) provided models for audiences to emulate. These and the all-knowing, somewhat inflated style of documentary commentary, long a staple of the Central News and Documentary Film Studio and seen in *The East Is Red*, guided viewers in how to respond and learn from watching the documentaries.[8] The so-called "loyalty dances," memorization and group recitation of Maoist quotations, song-singing, and film-viewing thus served as a coherent and powerful means of encouraging and displaying engagement and commitment to Mao's Cultural Revolution project.

Modeling Performance

But new models were also being made available in the form of the "model performances" (*yangbanxi*) which were officially declared the core of the Cultural Revolution canon in May 1967, the twenty-fifth anniversary of Mao's *Talks at the Yan'an Conference on Literature and Art*. The initial tranche of eight model performances included five modern-subject Peking operas, two Chinese-style ballets, and a symphonic work based on one of the model operas. These innovative updatings of a musical theater that was struggling to retain audiences by the mid-twentieth century had emerged over the previous ten years. Their evolution and refinement into model status were a further indication of the centrality of film culture in Chinese life by the 1960s. Feature films from the time provided the plots for several of the new-style Peking and other regional operas that companies around China experimented with in the first half of the 1960s. *Hongdeng ji* (*The Red Lantern*) for example, was based on a published film script *Geming zi you houlai ren* (*The Revolution Has Successors*). The main source for the thirty-eight full-length and short modern-subject Peking operas presented at a national performance

convention in Beijing in the summer of 1964 were films, including such favorites as *Li Shuangshuang*, *Liuhao men* (*Gate No. Six*), *Honghu chiweidui* (*Red Guards of Lake Honghu*, itself a modern musical), and *Qianwan bu yao wangji* (*Never Ever Forget*).[9]

In the course of the refinement of the five new-style operas that became models after 1966, film had a further direct part to play. The opera companies that created *The Red Lantern*, *Shajiabang*, and *Haigang* (*On the Docks*) all invited film studio directors, choreographers, set designers, lighting designers, and musical composers to contribute to the years of experimentation that these works emerged from. The kinds of visual effects achieved through montage, camera angles, and other film devices were attempted in these stage productions. The effort to style the new operas after the kinds of effects seen in a cinema is an indication of how important film culture had become in the lives and tastes of mass audiences in China. The staging of the climactic scene in *The Red Lantern*, for example, in which Granny Li reveals to her granddaughter Li Tiemei that the girl is a blood relative of neither her nor Tiemei's "father," tried to duplicate something of the film effects achieved by cutting and close-ups. The girl starts some distance across the stage from her "grandmother" before slowly moving closer to fall into the older woman's arms. It was a kind of slow zoom effect to a close-up attempted on stage.

One of the most innovative aspects of the model operas was the music, which relied heavily on audience familiarity with film scores. The new-style operas brought Western instruments into the opera orchestra, for the composers felt that only strings and brass instruments could achieve the necessary militant and strong sound required of the martial stories of revolutionary sacrifice. Audiences who had watched a steady diet of Chinese feature films since the 1950s could relatively easily accept the incorporation of tunes like the socialist anthem "The Internationale" and well-loved Maoist song tunes into the updated opera scores. The modifications to the model operas between their proclamation in 1967 and 1970, when new official versions of the scripts began to be published, largely involved this film-inspired refinement of the stage works.

But it was in film form that the model operas and model ballets had their most lasting impact. I would argue that the collective memory of Cultural Revolution culture is heavily reliant on images from the film versions of these works. As films they were fixed in a standardized, close-to-perfect form to meet the ambition of the works to be models for Chinese behavior. Chinese who lived through those years, more recent generations of Chinese, and persons around the world all conjure up film-still images when they think or speak of these model works or even of the Cultural Revolution more generally. It is hardly surprising then that a great deal of time, resources, and artistic and political attention was paid to the creation of the film versions of the "model performances."

The first model opera film was *Zhiqu Weihushan* (*Taking Tiger Mountain by Strategy*, dir. Xie Tieli), which was released on National Day (October 1) in 1970. Work had begun in the fall of 1968, with the opera filmed three times at the Beijing Film Studio before it was deemed acceptable.[10] In similar vein, *On the Docks* was re-filmed when Jiang Qing felt that the shade of the red scarf worn by the female Party secretary, Fang Haizhen, was not quite right.[11] Such attention was necessary, for the films became the definitive versions of the model works. Until their release as films

in the 1970–1972 period, professional and amateur troupes around the nation had presented these works, with all the technical, artistic, and unfamiliar challenges that they presented to both performers and watchers. The Shanghai Ballet Company could only perform their version of *Baimao nü* (*The White-Haired Girl*) to a relatively limited audience. Non-professional performance of ballet had usually less than ideal results. The China Dance Drama Company in Beijing was similarly unable to reach a national audience with its ballet *Hongse niangzijun* (*The Red Detachment of Women*), based on the 1961 film directed by Xie Jin. Filming the ballets, as with the operas, enabled them to be seen in a standard version in all parts of China. Unlike stage performances, films were not subject to "localization," the amusing inserting of local references into dialogue or the renaming of a character to make a joke the locals would appreciate. Most important, careful filming could present perfect versions of the model works, with the film techniques of cutting and close-up taking even tighter command of audience understanding and appreciation of the works. These films provided stills for new, printed versions of the model performances, posters for dormitory rooms, production team offices, or workplace walls. Wu Qinghua, the heroine of *The Red Detachment of Women*, thus leapt across many a wall in the mid-1970s, her red silk jumpsuit clinging to her determined body. Yang Zirong, the hero of *Taking Tiger Mountain by Strategy*, was almost as ubiquitous, with a manly chest heaving under his tiger-skin waistcoat.

Film was so important for the proper dissemination of these model works, and film was an art of such particular skill, that directors who had been the subject of bitter denunciation as bourgeois elements, "capitalist roaders" or worse in 1964–1966 were brought in to direct the celluloid versions of the "model performances." Xie Jin, for example, whose *Wutai jiemei* (*Stage Sisters*, 1964) had been pilloried in 1966, co-directed *On the Docks* and later model operas. Xie Tieli, the director of the much-attacked *Zaochun eryue* (*Early Spring in February*, 1963), made the first model opera film *Taking Tiger Mountain by Strategy* and co-directed *On the Docks*. Their talent as directors apparently outweighed concern about their political reliability when it came to these vital film works.

Old and New Feature Films

General accounts of film during the Cultural Revolution give the impression that all Chinese films made before 1966 were banished from the screens after that year. This is misleading, as many films from the 1950s and early 1960s enjoyed regular and wide distribution in these years, while others were frequently brought out for viewing. The most often watched were the so-called "three old battles" (*lao san zhan*): *Nanzheng beizhan* (*Fighting North and South*, dir. Cheng Yin and Tang Xiaodan, 1952), *Dilei zhan* (*Mine Warfare*, dir. Tang Yingqi, Xu Da, and Wu Jianhai, 1962), and *Didao zhan* (*Tunnel Warfare*, dir. Ren Xudong, 1965). Like most of the model operas, the three films were set during the anti-Japanese or civil wars. They were trundled out at Spring Festival, May First, Army Day (August 1), and National Days throughout the first eight years of the Cultural Revolution period. Viewers soon wearied of repeated screenings of these

war-horse films: many learned the dialogue by heart and were able repeat it, sometimes for ironical effect, in daily life.

Other films from before 1966 were considered forbidden, but, in a long-standing practice, could be brought out of storage in order to be criticized as "negative teaching materials" (*fanmian jiaocai*). Eagerness to see such films was not necessarily an indication of political activism: rather, a rare viewing of a pre-1966 work allowed audiences to indulge in often much-loved features. This was especially true in the first year or so of the period, when films were some of the most obvious objects of Cultural Revolution attack. The reasoning was simple: an article critical of a little-seen historical opera set in the Ming dynasty, or of an obscure academic treatise, would mean little to most newspaper or magazine readers. An attack on a well-known feature film could have much more meaning to all readers, many of whom would have watched the work. The critics also had the advantage that in those days, readers could not view a film for themselves and check the veracity of the criticism in the days before domestic VCR and DVD players. On occasion in these years, other films were shown to commemorate events. *Yingxiong ernü* (*Heroic Sons and Daughters*, dir. Wu Zhaodi, 1964), for example, was one of five features distributed in October 1970 to mark the twentieth anniversary of China's entry into the Korean War. Ironically Ba Jin, the author of the novel on which the film was based, was then under arrest.[12]

In Spring Festival 1974 Chinese audiences were able to watch newly made Chinese feature films (other than the "model performance" adaptations) for the first time in over seven years. Some of these first films were full-color remakes of features from before 1966. The Changchun Film Studio remade *Qingsong ling* (*Green Pine Ridge*, dir. Liu Guoquan and Jiang Shusen, 1973) from 1965, and *Pingyuan youjidui* (*Guerrillas on the Plain*, dir. Wu Zhaodi and Chang Zhenhua, 1974) from the 1955 original, which had inspired the second-tranche model opera *Pingyuan zuozhan* (*Fighting on the Plain*). Even *Fighting North and South* was remade in color (dir. Cheng Ying and Wang Yan, 1974), though, like the other titles, adjustments were made in characters and episodes to suit current political requirements. In many instances in these remakes, some of the key personnel in front of and behind the camera had worked on the original version as well. This is true of the first named directors of each of the above three films.

But of more interest to Chinese audiences, anxious to expand their film viewing opportunities, were the all-new features. One of the most popular was *Sparkling Red Star*, mentioned at the start of this chapter. In 1974, as a student in Beijing, I saw first-hand the appeal of this film, with its cherubic young hero and well-written songs. Both featured prominently in extrapolations of the film in print (comic books, children's stories, and the film script *dianying juben*), on posters, on the radio, on records for broadcasting stations to play, and even on everyday utensils. The kind of modeling seen in the model operas and their recycling in different genres was applied to the new feature films after 1974. For a time that year in Shanghai young people sported a small white towel knotted around their necks, inspired by Zhao Sihai, the steelmaker hero of *Huohong de niandai* (*The Fiery Years*, dir. Fu Chaowu, Sun Yongping, and Yu Zhongying, 1974), who was dressed that way.[13] As feature film production expanded, the power of film to

sway Chinese audiences attracted a lot of attention from the Cultural Revolution cultural leadership associated with Jiang Qing. She led criticism of the oil-field drama *Chuangye* (*The Pioneers*, dir. Yu Yanfu, 1974) and the all-female militia story *Haixia* (dir. Qian Jiang, Chen Huai'ai, and Wang Haowei, 1975). In a celebrated episode welcomed as an indication of a relative thaw in cultural control, Mao Zedong in 1975 reportedly rejected these criticisms of the two films as excessive. But the faction that became the Gang of Four saw the value of film to influence their political audience, ordering the making of features condemned as "conspiracy films" (*yinmou dianying*) after 1976. These included the barefoot-doctor drama *Chunmiao* (dir. Xie Jin, Yan Bili, and Liang Tingduo, 1975) and the unreleased *Fanji* (*Counterattack*, dir. Li Wenhua, 1976). Indeed it was in film that the Gang of Four made their last efforts to thwart the resurgence of more moderate political leaders. After the arrest of Jiang Qing and her cohorts in October 1976, some of the most widely publicized cases of Gang of Four abuse related also to film, arising from the same logic of familiarity to the population as the prominence given to criticism of films at the start of the Cultural Revolution.

But, as the impact of the North Korean melodrama *The Flower Seller* indicated in 1973, foreign films were still major features of Chinese cultural life in these years. Of the seventy full-length features distributed publicly in China between 1966 and 1976, half (thirty-six titles) were foreign films.[14] This meant that these ten years were little different from the decades before or since, in terms of the importance of imported titles in China's film culture. Of the imports, eight came from North Vietnam and eleven from Albania.[15] The 1986 history of the Changchun studio notes, in passing, that among the foreign films dubbed at the facility in 1975 was the first American feature they had handled.[16] Beijing audiences came up with short-hand characterizations of the foreign films, which offered a welcome and relatively rare glimpse into a version of life beyond China's borders: "A Korean film: weep, weep, smile, smile: a Vietnamese film: just rifles and artillery; an Albanian film: all hugs."[17]

The importance of films in providing cultural diversion, educational guidance, and ever-present models of behavior was further indicated by the major effort put into expanding distribution of all films, foreign and domestic. Urban audiences had regular access to cinemas, but the countryside was much less well covered. By 1968 the Shanghai Film Projection Equipment Factory began production of a Super 8 (8.75 mm) projector, which provided portability to mobile projection teams. Similar work was done with 16-mm projectors, copying Bell and Howell machines imported from the United States.[18] One 1975 source claims that the nationwide number of rural projection units, which included mobile teams as well as fixed places for screenings, increased four times over the 1965 level. Guangdong province rural people averaged four film viewings in 1966; eight years later they attended ten annual film shows. In Fujian province rural projection team numbers had doubled by early 1974. In greater Beijing the number of rural projection units also doubled between 1966 and the end of 1975.[19] Nationwide projection units increased 4.2 times in these ten years, audiences by 2.9 times and distribution income went up 59 percent.[20] This growth confirms the prime cultural role of film viewing in the Cultural Revolution.

Post-Cultural Revolution "Wound Films"

Facing up to the experiences of the Cultural Revolution after the death of Mao and the arrest of his widow and her allies also gave film a central place in Chinese cultural life into the 1980s. A series of films emerged from the studios that looked back, not just at the immediate past but at the social damage wrought by political campaigns since the 1950s. Many were based on newly published short stories and novels, but it was as films that these historical assessments reached a wide and fully engaged audience. Indeed audience numbers reached a peak in the late 1970s and early 1980s which they have never achieved since.

Driving this achievement of film to capture the national mood were directors such as the veteran Xie Jin (b. 1923). Xie had never been out of work for very long, despite falling out of favor in 1966 over his film *Stage Sisters*. As we have seen, he directed several of the model works in the last half of the Cultural Revolution decade, including putting *Panshi wan* (*Boulder Bay*, 1976), the most self-parodying of the modernized Peking operas, on screen.[21] I would argue that Xie enjoyed a certain credibility with audiences, in spite of his Cultural Revolution work, for two reasons. He was the originator of the first, non-dance version of the ubiquitous *Red Detachment of Women*, remembered fondly by audiences for its exotic Hainan Island setting and musical score that formed the basis for the ballet adaptation and a Peking opera version. In the years in which they were encouraged and even organized to watch the ballet film, many Chinese each time would have recalled, from the first stirrings of the music, Xie Jin's inventive 1961 original. Xie Jin was also acknowledged as a director who filmed contemporary stories, particularly his 1957 comedy-drama *Nülan wuhao* (*Girl Basketball Player No. 5*) and the farce *Da Li, xiao Li he lao Li* (*Big Li, Little Li and Old Li*, 1962). These sunny stories, often with strong young women in pivotal roles, established Xie Jin's reputation as an entertaining director and presenter of idealized versions of life before the Cultural Revolution upheaval. His career had survived the crackdown on contemporary comedy that had followed the Hundred Flowers liberalization in 1956 and the denunciation of *Stage Sisters* in the late 1960s.[22] When Xie Jin turned to adaptations of so-called "scar literature" (*shanghen wenxue*, also known as "trauma literature"), first with *Tianyunshan chuanqi* (*Legend of Tianyun Mountain*, 1980), audiences flocked in far greater numbers than they had for earlier, post–Cultural Revolution film exposés of the personal damage wrought during the political campaigns of those years.[23] Xie's *Muma ren* (*The Herdsman*, 1981) continued the working out of the Anti-Rightist trauma.

With *Furong zhen* (*Hibiscus Town*, 1986) Xie achieved an extraordinary success, in terms of audience response. Adapted by himself and the former "sent-down" youth writer A Cheng from Gu Hua's novel, this melodramatic epic, with its popular lead actors (Liu Xiaoqing and Jiang Wen), played to huge crowds in the spring and summer of 1986. Xie managed also, with a now keen eye for the changing political climate, to cater to the concerns of the Communist Party leadership to present an homogenized, readily accessible, and standardized version of the campaigns since the late 1950s. Like the Fourth Generation films of this period, *Hibiscus Town* in particular offered to

cinema-goers a shared, collective catharsis. In a fashion similar to the Mao documentaries in the second half of the 1960s and the "model performance" films in the first half of the 1970s, Xie Jin's political melodramas in the first half of the 1980s offered didactic guidance to viewers on how to respond to what they saw and heard on screen. As in the earlier period, film was at its most influential in this context.

The Fifth Generation Emerges

Meanwhile, a new generation of filmmakers was emerging with films that seemed very different from these earlier works. Rather than instruct from the screen, these new films invited audiences to think for themselves. Most recognized internationally was *Huang tudi* (*The Yellow Earth*, dir. Chen Kaige, 1984), a recasting of conventional representations of the Communist Party's historical relationships with China's peasant masses. The solitary Party representative in the story comes to a village collecting folk songs, inspires unachievable hopes in the hearts of two young people, and ultimately fails to deliver on his promises. From a generation which had had their own hopes dashed in the Cultural Revolution years, this new film had allegorical resonance beyond its wartime setting. As with the films by Xie Jin and others a few years earlier, film was the necessary means to work through the trauma of the Cultural Revolution and the new thinking it had engendered in many of this new generation. Similarly, Tian Zhuangzhuang challenged viewers to discover in his ethnic minority films, *Liechang zhasa* (*On the Hunting Ground*, 1985) and *Daoma zei* (*Horse Thief*, 1986), themes relevant to mainstream Chinese life. The plain, unambivalent style with clear lessons delivered, which Chinese audiences had come to expect from films, were absent in many of the Fifth Generation features.

Nonetheless, the attitude to film and its power that this new generation held owed much to the experience of these filmmakers regarding cinema in the 1960s and 1970s. Growing up in the New China, exposed to films which shaped the mass, national culture promulgated by the Party, these young people developed an appreciation of the importance of film. Several, including Chen and Tian, were the offspring of film industry personnel. During the Cultural Revolution period when film was at its most significant in Chinese cultural life, many of these future filmmakers experienced directly the power of the medium. Hu Mei has recounted her excitement at a midnight screening of a film in a mining town, where her army performing troupe was billeted. Wu Ziniu tried to construct for himself the image of heroic strength he had seen in films as a country laborer and then as a local theater actor. Even Peng Xiaolian, deeply immersed in the literary culture of her family, recognized how films could reach a wider audience with more immediate impact.[24] Despite the differences in assumptions about instructing their audiences, I would argue that these new filmmakers were as strongly affected by a conviction of the importance of film in shaping attitudes as the earlier generations who had filmed the "model performances" and the "scar films." Behind a film like Chen's *Haizi wang* (*King of the Children*, 1987), with its autobiographical references from A Cheng's original novella, lay a similar determination to use film to transform its viewers.

The strength of this commitment helps explain Chen Kaige's distress when the film was mocked at Cannes and the general dismissal of the operatic pretensions of his *Bian zou, bian chang* (*Life on a String*, 1990).[25]

The most popular of the Fifth Generation films signaled also the waning of these artists as any sort of coherent group and the end of the triumph of cinema as the core of Chinese cultural life. *Hong gaoliang* (*Red Sorghum*, dir. Zhang Yimou, 1987) was a huge hit in China after it won the top award at the Berlin film festival in February 1988. The newly created "folk songs" in the film helped set off the "Northeast wind" (*xibei feng*) in popular music and added impetus to the cheeky experiments with turning Maoist anthems into rock songs by musicians such as Cui Jian. Young men in particular found the film's presentation of a life lived free from social constraints in manly comradeship intensely appealing. But the phenomena that spun off the film in 1988 — the new music, the greater interest in the "hooligan" fiction of Wang Shuo, even the interest in *qigong* (deep-breathing exercises) and other folk traditions — also suggested how diverse and complicated the cultural scene had become by the late 1980s. Television was just one newly domesticated element shaping cultural consumption. Film could no longer command the kind of attention it had seized and held in the mid-1960s. The long lines at Beijing ticket offices for *Red Sorghum* may have resembled the scenes associated with *The Flower Seller* fifteen years earlier, but by 1988 Chinese audiences had many more choices in terms of cultural consumption. Feng Xiaogang's later success with his New Year movies not withstanding, as the crowds dispersed after watching *Red Sorghum*, the triumph of cinema in China was over.

The Martial Arts Film in Chinese Cinema:
Historicism and the National

Stephen Teo

Martial Chivalry and the Fantastic: From Shanghai to Hong Kong

The martial arts historical film is one of the oldest genres in the Chinese cinema, often used by filmmakers to showcase Chinese history and its warrior myth, embellished with a touch of nationalism — such a trend is best exemplified in recent years by Zhang Yimou's trilogy, *Hero* (2002), *House of Flying Daggers* (2004), and *Curse of the Golden Flower* (2006). As a genre, the martial arts film dates back to the 1920s, the period when the Chinese cinema based in Shanghai really began to develop as an industry with distinct categories of genres that could be described as indigenous. However, in that dawning period, the naming of genres gave the impression of rudimentary development. Most historiographic texts in Chinese film history refer to the *shenguai wuxia pian*, which translates directly as the "gods and demons (*shenguai*) martial chivalry (*wuxia*) film,"[1] as the antecedent genre of what we now know as the martial arts film. The representative example in this early period was the *Burning of the Red Lotus Temple* series released from 1928 to 1931, produced by the Mingxing Studio (Star Motion Picture Studio). Over time, the *shenguai* appellation was dropped so that only *wuxia* remained as the definitive term for the type of martial arts film as we know it today: one that intermixes swordplay and kung fu, and takes place in ancient historical periods. There is also the characteristic of the fantastic, accentuating supernaturalism and the mythical, which is now accepted as part and parcel of the genre, this being a legacy of the *shenguai* label that was attached to the *wuxia* genre back in the 1920s.[2] The attributes of *shenguai*-fantastic elements, such as the ability of swordfighters to leap up onto roofs, to defy gravity and fly, and to project whirlwinds of energy or beams of light rays from the palm of the hand, were already integral to the *Burning of the Red Lotus* series and the plentiful imitations and spin-offs produced by other studios following the huge success of *Burning* (most of the spin-offs included the word "burning" in their titles).

The attributes of the *shenguai*-fantastic were also responsible for bringing about *wuxia*'s downfall in the early 1930s when the KMT government in Nanjing slapped a ban on the genre. The government had taken heed of the many detractors of the genre who warned that the *shenguai wuxia pian* purveyed not only superstition but feudalism,

pornography, and unscientific thinking in the period when China was attempting to refashion itself as a modern nation conforming to the precepts of science and democracy, as advocated by intellectuals of the May Fourth movement. Ironically, the warrior tradition of *wuxia* was at first one of those elements of the genre that intellectuals regarded as a positive counterweight to the image of China as the "sick man of Asia" prevailing at the time.[3] However, for many intellectuals of the left, though *wuxia* was compatible with precepts of revolutionary action, the greatest drawbacks were superstition and feudalism that to them condemned the genre as a whole.[4] Left-wing filmmakers, who took control of the Lianhua studio from 1931 onwards (which was the year when the ban on the genre was put into effect)[5] and went on to create what film historians have generally labeled Chinese cinema's "golden period" of the 1930s, largely rejected the *shenguai wuxia* genre which in their eyes was mired in the past connoting only feudalism and superstition. The martial arts genre, after about four years of earnest development and production, disappeared from the radar screen of Chinese cinema centered in Shanghai.

The genre continued to be produced in the film industry in Hong Kong, a British colony that benefited greatly from the Chinese government's proscription not only of *shenguai wuxia pian* but, later, with the emergence of sound, Cantonese-dialect films produced in Shanghai and in Guangzhou. The ban on these films caused many production companies of that period to go out of business and relocate to Hong Kong, a Cantonese-speaking territory, including the Tianyi company (known in English as Unique), which specialized in *shenguai wuxia pian* and had produced the first Cantonese-dialect film in Shanghai called *Bai Jinlong* (often translated as *White Gold Dragon*). *Wuxia* film continued to be banned on the Chinese mainland until the 1980s, discounting the brief *gudao* (solitary island)[6] period from 1937 to 1941 when the Japanese occupied Shanghai except the International Settlement and the French Concession (which therefore became collectively known as the *gudao*). Following the Japanese occupation of the Chinese zones in the city, the Shanghai film industry collectively removed itself to the *gudao*, and in this artificial oasis of peace and protection, free from the direct interference of the Japanese occupation authorities, production companies started making *wuxia pian* again, a wave initiated by the re-release of the first six episodes of the *Burning of the Red Lotus Temple* series by Zhang Shichuan, its original director. Zhang was also the founder of the Mingxing studio and, having fallen on hard times, was forced to making a living as a *gudao* filmmaker (following the re-release of *Burning*, a new sound version was in fact produced by another company in 1940).

The *gudao* period, long an untouched subject in the historicizing of Chinese cinema largely because of the bitter memories of war and the stain of enemy collaboration on its filmmakers which tainted the whole period with political sensitivity, has been reappraised by historians of late, most notably Poshek Fu.[7] From the standpoint of the *wuxia* genre, the *gudao* period represented a kind of regeneration, if not exactly a rebirth. Filmmakers, often the same people who had worked on the genre in its heyday back in the late 1920s, recycled old formulae that had proven so entertaining to audiences

back then. Entertainment was what audiences in the *gudao* apparently needed most: the kind of popular fare that presented China against the backdrop of its grand and ancient history which could nourish the audience's sense of nationalism in the "extreme period" (*feichang shiqi*) of war and occupation. The *shenguai wuxia pian* provided one such channel of nationalism; another was the *guzhuang* (old costume) movie, a genre that shares intertextual qualities with the *wuxia pian* but is otherwise classified separately as the "historical film," its focus being on ancient history and historical personalities rather than the warrior-chivalric (*wuxia*) tradition and lifestyle. The two genres could occasionally merge,[8] best represented in the *gudao* period by *Mulan Joins the Army* (1939), produced by the enigmatic Zhang Shankun, a leading figure in the *gudao* film industry who was naturally accused of collaborating with the enemy during and after the war.[9] Zhang relocated to Hong Kong, as did most of the *gudao* filmmakers and stars who found themselves tagged as collaborators.

The *gudao* filmmakers brought the old genres of the Shanghai film industry with them to Hong Kong — in fact, virtually transplanting the Shanghai cinema to the British colony. While Hong Kong was developing its own indigenous Cantonese-dialect film industry, the Shanghai migrant filmmakers, on the other hand, began a Mandarin-speaking industry in Hong Kong, which in time operated as a de facto national cinema. This de facto status no doubt was a reflection of the fact that Hong Kong was "never a nation-state" as Chris Berry and Mary Farquhar remind us,[10] but it also fundamentally reflects the state of civil war between the KMT and the CCP (Chinese Communist Party), which put into flux the idea of a single national cinema that could unite all Chinese through a common language. Though the CCP achieved victory over the Mainland and established the People's Republic of China in 1949, the KMT went into exile in Taiwan, claiming to be the sole legitimate government of all China. This continuing political division and the separate developments of film industries in China, Taiwan, as well as Hong Kong in the ensuing Cold War period had the effect of completely muddling the concept of a Chinese national cinema, and continues to do so in the present.[11]

Chris Berry has argued that the "national" in the Chinese national cinema is a fraught concept, proposing a framework where "the national is no longer confined to the form of the territorial nation-state but multiple, proliferating, contested and overlapping."[12] With three competing film industries (China, Taiwan, and Hong Kong) contesting the national, its nature is bound to be multiple, proliferating, contested, and overlapping, but "the national" in this context also seems to me to re-accentuate the form of the territorial nation-state and how much it is contingent on the stability of the nation. This suggests that the "national" is really a psycho-political issue of defining a nation-state in a postcolonial environment[13] and not so much a cultural one since all three competing entities can legitimately be seen as representing the Chinese national cinema in one way or another.[14] In the case of Hong Kong, its de facto status as a national cinema through its production of Mandarin films beginning in the postwar 1940s right up to their demise in the late 1970s is certainly based on a cultural affinity with China, one which is shared by the Chinese diaspora, the major market for Hong Kong films. In other words, it produced an imaginary "cultural China": an abstract, mythical center,

designed to fulfill the cultural needs of the periphery. The *shenguai wuxia* genre was seen as the ideal vessel to channel this vision of imaginary China.

Hong Kong's existence as a British colony proved a congenial environment for the production of such a cultural imaginary.[15] As an offshore base lying on the political periphery of both China and Taiwan, it effectively functioned as another *gudao* for Chinese filmmakers wary of politics, giving them the opportunity to continue their careers and to make films that could entertain the Chinese masses by recycling the same old formulae used in the Shanghai industry. A group of Shanghai filmmakers in Hong Kong worked in the Cantonese cinema where they recycled the old *shenguai wuxia pian* serials, after the Shanghai model. It should be recalled that the genre was still banned in China, and in Taiwan, where the ban was supposedly in force as a legacy of the old KMT censorship regime.[16] Thanks to the Shanghai migrant filmmakers, the *wuxia* serials proliferated in the postwar period in Hong Kong. Anyone familiar with Shanghai in the 1920s and 1930s, walking down a street in postwar Hong Kong would have been struck with a sense of déjà vu. The cinema posters would have acted like a vast screen projecting a memory of Shanghai onto the Hong Kong unconscious. To this extent, Zhang Zhen's description of Shanghai as the "historical 'preconscious' of the Hong Kong cinema" is highly apposite[17] — and it was, significantly, the martial arts genre that served as the most ubiquitous channel of that preconscious screen memory to Hong Kong.

The historical ramifications of this preconscious memory suggest that Hong Kong had inherited the mantle of Shanghai's status as a national film industry producing truly popular genres. The *shenguai wuxia* genre symbolized the legacy of a popular cinema that Hong Kong was to continue throughout the following decades until the present. But the production of the genre in the immediate postwar and post–civil war period attracted the same kind of opprobrium and criticism as had befallen the genre in Shanghai. For example, a critic writing in 1950 attacked *shenguai wuxia pian* produced in the Cantonese cinema, reminding readers that the genre was first banned in the early 1930s because it brought down standards in the Chinese cinema. The critic wrote: "Since ... the banning of the Mingxing Company's *Burning of the Red Lotus Temple*, the products of Chinese cinema, under the supervision of the government, have raised their level of quality and lowered the quantity threshold, thus bringing about the rise of artistic (*wenyi*) and conscionable cinema."[18] The critic was obviously referring to the social conscience films produced by the left in Shanghai in the period following the ban, and he lamented the fact that the Shanghai migrants in Hong Kong had put quantity over quality: having broken through the cordon of film censorship in China by going to Hong Kong, "a libertarian city" where they could be free of restrictions, they had produced nothing of quality.

It was clear that *wuxia pian* were still regarded as lowbrow products of no social significance as well as of inferior quality, technically speaking, and hence to be despised and condemned. The genre was also regarded as an offshoot of the old Shanghai cinema, which seemingly had no grounding in Hong Kong, or at least in the Cantonese cinema. As the Hong Kong film historian Yu Mo-wan has pointed out, the influx of the first

generation of Shanghai filmmakers into Hong Kong helped to foster the *wuxia* genre in the Cantonese cinema, which otherwise lacked the talent and the experience to create its own *wuxia* movies.[19] However, in 1949, the Cantonese cinema produced *The True Story of Wong Fei-hung: Whiplash Snuffs the Candle Flame*, marking the full-fledged emergence of an indigenous Cantonese *wuxia* tradition. It was directed by Wu Pang (Hu Peng), originally from Shanghai, but the central hero Wong Fei-hung was played by Kwan Tak-hing, a Cantonese star hailing from the Cantonese Opera stage. Wong Fei-hung was a historical figure, a real kung fu local hero and son of Guangdong who had made the southern styles of martial arts famous. Kwan Tak-hing reincarnated the hero as a patriarchal figure, always stressing virtues of chivalry (*xia*) and justice. Kwan was to play Wong Fei-hung in a long-running series of films that numbered over seventy, from 1949 until the 1970s.

Perhaps the lasting contribution of the Wong Fei-hung series was that it brought the idea of martial chivalry (*wuxia*) to the fore and disentangled it from the *shenguai*-fantastic that had marked (and marred) the old Shanghai serials. Indeed, director Wu Pang had wanted to make *The True Story of Wong Fei-hung* to counter the pernicious effects of the *shenguai*-fantastic, such as "flying swords clashing with flying knives, whiskers versus gourds, magical ropes catching flying snakes, metal circles colliding with each other, giving off electric sparks."[20] According to Wu, *shenguai* mixed with *wuxia* had produced a crisis for the *wuxia* genre from which he wished to rescue it. The term *shenguai wuxia* became a derogatory term, though in the Cantonese cinema the genre remained a popular-entertainment staple well into the 1960s. The idea in *The True Story of Wong Fei-hung* was to emphasize not the fantastic but realism, and at the same time to stress chivalry (*xia*) or a concern for the underdog, the weak, and the oppressed, as the principal impetus governing the hero's actions. Wong Fei-hung's prowess in the martial arts was designed to show not a supernatural hero but a virtuous man with upright Confucian ideals laced with chivalry.[21]

The action was motivated by chivalry, but in *wuxia* films it is easy to confuse chivalry with violence. Many critics of the genre often attack the tendency of filmmakers to emphasize the martial (*wu*) over chivalry (*xia*), thus sensationalizing violence or the ethos of militarism. Though the question of violence was not an issue at the time of the Wong Fei-hung films (it became an issue later, in the late 1960s and early 1970s),[22] the series began to conceive a depiction of violence as a correlation of chivalry. Violence was in fact an aesthetic component of *wuxia* as it became more and more stylized and choreographed, becoming a key ingredient of the genre over time. Violence is further compounded by the perceived realism of the Wong Fei-hung series. The aesthetic cornerstone of Wong's violence was the ideal of realism as a counter-effect to the fantastic, as I have noted above. In the Wong Fei-hung films, the hero used force sparingly but effectively — and this made the violence and the martial arts seem authentic. In fact, the actor Kwan Tak-hing was hired to play Wong because he was a genuine practitioner of martial arts (and so were his co-stars and character actors who appeared as the villains). Kwan's real-life skills with martial arts or kung fu rounded out his characterization of Wong Fei-hung, and thus began a tradition of martial arts

stars who were themselves genuine martial artists (cf. Bruce Lee, Jackie Chan, Sammo Hung, Jet Li, Michelle Yeoh).

The whole series therefore was crucial to a denomination of another, more realist tradition that somehow stood apart from the fantastic strand of *wuxia*. In fact, the purpose of the Wong Fei-hung films was to initiate a break from the fantastic and thus from *wuxia*. The usage of the term "kung fu film" stemmed from this period and was due mainly to the popularity of the Wong Fei-hung films. As someone who grew up with the Wong Fei-hung films, I can attest to the generic usage of "kung fu" as a term to refer to these films. Later, it was used to refer to the films of Bruce Lee and the wave of kung fu films produced in the 1970s which found distribution in the West. As these films demonstrated, kung fu as a term referred to a specific practice of martial arts (mainly Southern style, accentuating the use of fists and legs over weapons such as swords and lances) which could be distinguished from films of the *wuxia* kind that depicted martial arts in a more fantastic manner and employed swords as the main weapon (the representative type of the latter was the so-called "new school" or *xinpai wuxia* film produced by the Shaw Brothers studio in the mid-1960s — but new school *wuxia* films were already produced in the Cantonese cinema from 1958 onwards).[23]

The fantastic remains integral to *wuxia* (notably the element of flight), and since the Wong Fei-hung series, realism became integral to kung fu films. Roughly speaking, the distinction between *wuxia* and kung fu to this day boils down to the distinction between the fantastic and "realism," although with the advent of computerized digital technology, the distinction of realism in the kung fu genre is highly problematic to say the least (e.g. computer enhancement in the 2006 release *Dragon Tiger Gate*, featuring a young new generation of Hong Kong and mainland Chinese martial arts stars, has practically made the concept of realism and authenticity redundant: no longer is it necessary for stars to be themselves genuine martial artists, though the film does feature Donnie Yen, a true martial artist who also choreographed the film's action sequences).

The *Wuxia* Genre as an Articulation of History and the Nation

The separation of kung fu from *wuxia* may appear purely academic to non-Chinese who tend to see both genres as one generic martial arts class of film.[24] There is, to be sure, considerable overlap between the two, particularly in terms of the chivalry theme (*xia*) if not so much in fighting styles — though even here, there is often a blending of armed and unarmed combat in fight sequences (often a fight sequence would begin with combatants using swords and then resorting to fists after somehow misplacing or losing the swords). However, *wuxia* has a larger claim to being a *historical* genre, and not only because its settings are ancient historical periods stretching from the Qing dynasty back to the Ming, Song, Yuan, Tang, and Qin dynasties, but also because there is a veritable history of *xia* or knights-errant (for which the correct Chinese term is actually *youxia*) as recorded in Sima Qian's *Shi ji* (*Records of the Grand Historian*),[25] and a romantic literature of legendary *xia*: rich sources of inspiration which the cinema could draw upon.[26]

The historical or historicist proclivities of *wuxia* have often been invoked by filmmakers and proponents of the genre as testimony of it being a "national form" (*minzu xingshi*) or something akin to the concept. Du Yunzhi, the veteran film critic and sometime screenwriter of *wuxia* films during the Shaw Brothers studio heyday of "new school" *wuxia* productions, describes *wuxia* in terms of the genre exuding *minzu secai*, or nationalist hues or shades.[27] Du refers to the *guzhuang* (period costume) trappings of the genre, its spirit of chivalric righteousness (*xiayi*), and ethical values as features "not found in Western films."[28] Du of course conveniently forgets that the West has its own period costume genres and spirit of chivalry and ethical values, but the *wuxia* genre was first offered to audiences to show that China possessed its own ancient warrior and chivalric tradition popularized in folklore, legend, opera, and literature, which could then be made use of in the cinema. The early development of *wuxia* film in the Shanghai cinema was an attempt to show Chinese audiences flocking to see Hollywood and European films that Chinese filmmakers could transpose their own culture and genres to the big screen and thus draw them to see Chinese movies. While Zhang Zhen has characterized the rise of the *wuxia* genre, with its precocious images of flying female knights-errant and its use of technology and the body, as a drive towards *modernity*, I would say that the *wuxia* film as a whole was a natural conduit for conveying the concept of a Chinese national cinema.

Since the *wuxia* tradition and culture was a pre-existing form in literature, opera, and the oral narrative tradition with musical accompaniment known as *tanci*, it seemed natural for Chinese filmmakers to simply transfer it to the cinema and present it as an indigenous entertainment form in their attempts to forge a national cinema. This vision of *wuxia* as an indigenous, national form persisted among Chinese filmmakers even though the genre as it developed in Shanghai was partly influenced by Hollywood genres such as the swashbuckler, the western, the epic, and even the detective film. Zhang Zhen informs us that the genre emerged from "a promiscuous body of cultural forms and sensibilities" to occupy a habitus made up of "a composite space of traditional folklore and an emergent urban-based modern folk culture."[29] Possibly, the genre derived its national form from this very composite space, but to my mind, it is the aura of history which renders it a national form though in fact the history is open to question by the very fact of its relationship with film. Pam Cook has written of the contradictory nature of the interrelationship between film and history, stressing that "the tendency of costume and period display to appear as masquerade brings it uncomfortably close to presenting history as fabrication."[30] The *wuxia* genre, being a veritable historical genre (and a period costume genre to boot), is particularly prone to masquerade and Cook's central conceit of "fashioning the nation," as the recent films of Zhang Yimou (*Hero*, *House of Flying Daggers*, and especially *Curse of the Golden Flower*) have shown.

It is perhaps more accurate to say that the *wuxia* genre is historicist rather than historical. I have heard Zhang Yimou's films being dismissed as "orientalist" and "historicist" almost in the same breath, and indeed, one could consider them as being representative of a trend of "orientalist historicism." Orientalism in the genre is, to my mind, an outgrowth of historicism, and is chiefly manifested through the use and design

of period fashion. The perceived orientalism of the genre is beyond the scope of this essay but historicism definitely is not — it is much more relevant to the genre and needs to be understood in greater depth. The historicism of *wuxia* implies, firstly, that the genre is indubitably marked by the history of *wuxia* as recorded in the history books and in popular literature. Here we may say that the martial arts genre is the historiography of *wuxia* intermingling history and fiction, such that "the distinction between truth-telling and fabrication fails to constitute a clear generic demarcation in the Chinese context," as Andrew Plaks, in noting the "quasi-religious preeminence of history within (Chinese) culture," has written.[31] Secondly, history denominates action: the *xia* or knight-errant acts as an agent of history, conscious of his or her role in shaping events and the destiny of the nation, for example, by assassinating a tyrant.

Zhang Yimou's *Hero* is the representative historicist film in that it draws upon the existence of *xia*-assassins (*cike*) who were the subject of a chapter in Sima Qian's *Records of the Grand Historian*, and it deals with the grand subject of history as an exertion of nation (its subject being that the Qin emperor founded China as a nation but being a tyrant, he attracted many assassins; in the film, the assassin played by Jet Li lets the tyrant live so that he could go on to unify the various kingdoms and build a nation). *Hero* came in the wake of two other films about the Qin emperor and the assassins who attempt to kill him — Chen Kaige's *The Emperor and the Assassin* (1998) and Zhou Xiaowen's *The Emperor's Shadow* (1996) — which appear to demonstrate that Mainland filmmakers of the Fifth Generation tend to see the *wuxia* genre as historicist-nationalist and that the highest spirit of *xia* is the intertwining of the chivalric principle with the idea of nation.[32] The historicist momentum in the *wuxia* genre is sourced right back to the very foundation of the nation, with the Qin emperor, and it is no accident that in *Hero* the emperor himself is featured as an expert swordsman, one who naturally embodies the warrior tradition and the principle of chivalry — in short a *xia*.

The intertwining of *xia* with nation in a film such as *Hero* is an overt use of historicism as a method to show how China has reclaimed the *wuxia* genre as a genuine (if perhaps historically problematical) national form, and to make a commentary about China's status as a nation with an ancient past: the past being used to justify China's present form as a nation-state.[33] Such a turnaround is dramatic when we remember that the genre was banned for nearly five decades, but in reclaiming the genre to manifest the nation in the recent works of Fifth Generation directors, are these directors necessarily doing the bidding of the regime? In her book *Public Secrets, Public Spaces*, Stephanie Hemelryk Donald argues that Chinese films contain discourses of civil society in a totalitarian society. In her analysis of a crop of Fifth Generation Chinese films, including *Yellow Earth* (1984), photographed by Zhang Yimou and directed by Chen Kaige, Donald makes the point that Fifth Generation filmmakers employ a strategy of showing a different perspective on the "truth" of history which is particularly effective where "the truth of the past is vital to the legitimacy of a present regime and where the meaning of the nation is mapped onto that version of past events, in order to imbue that legitimacy with an aura of national authenticity."[34] Clearly, by using the past to reflect upon the present, the Fifth Generation directors' perspective on *wuxia* (and so

far, *wuxia* seems to preoccupy only Fifth Generation directors) is a heavily historicist one that could function as an allegory of the totalitarian nation and its excesses. *Hero*, despite the attacks on it as a politically reactionary, even fascist apologia for the present authoritarian regime and its nationalist agenda,[35] is actually an ambivalent allegory of the truth of so-called official history. Its structure of multiple readings reinforces the message that history is ambiguous and truth is relative. Take, for instance, the image of the space left behind by Jet Li's assassin after his execution by arrows: it can actually be read as quite a profound signification of personal space, as well as "public space," in the face of militaristic might; it draws attention to Donald's point that Chinese films engage in a public discourse with the audience where the audience is acutely aware of the hidden textual meanings; in fact "the textual symbolic space is symptomatic of the contemporary political imaginary."[36] (On this score, *Curse of the Golden Flower* is an even more potent indictment of authoritarian excess: the critic Sek Kei opines that only someone who had gone through the Cultural Revolution could have made such a luxuriously perverse and violent film.)[37]

The same kind of allegoristic function implicit in the entanglement of *xia* with nation was also seen in Hong Kong's and Taiwan's new school *wuxia* films in the 1960s and 1970s, principally those directed by King Hu and Zhang Che. Hu's Taiwan-produced *Dragon Inn* (1967) and *A Touch of Zen* (originally released in two parts in 1970 and 1971), and Zhang's *The Assassin* (1968) and *Blood Brothers* (1973), produced in Hong Kong by the Shaw Brothers studio, are critiques of totalitarian government and corruption. In these *wuxia* films, the heart of the national form is an allegory about modern politics, specifically the conflict between the CCP and the KMT. Naturally, by portraying the KMT as the representation of forces of anti-totalitarianism, the allegory is biased towards it — in fact, as Hu's experience in making *Dragon Inn* and *A Touch of Zen* in Taiwan had shown, it was necessary to inscribe such an allegory for the production of these films to be approved — but the historicist function of the genre which stressed a "consistent emphasis on judgment over pure narration in the Chinese tradition"[38] means that Chinese filmmakers seek constantly to adjust their judgments of history as an implicit method of rhetoric. In this sense, Du Yunzhi's view of *wuxia* as a genre exuding "nationalist hues" may be understood as *wuxia* expressing the "national" through the historicist function of commentary and allegory[39] — such a function transcends political division by preserving a national form in the abstract.

A Touch of Zen was a failure at the box office but became an international success in 1975 when it won the Grand Prix for "superior technique" at the Cannes Film Festival. Perhaps it won owing to its allegorical impact, though not strictly within the context of the CCP-KMT conflict. Its final scenes showing a Zen patriarch transfiguring into Buddha while belligerents fight each other were sufficiently transnational to suggest the Cold War conflict between the Soviet Union and the United States, and the need for both parties to transcend their theory of Mutually Assured Destruction (MAD). The more likely reason was its new and refreshing portrayal (at least to Western audiences) of feminist desire embodied within the traditional norms of the *xia nü* (female warrior) — actually the Chinese title of the film, after its original source, a short story in Pu

Songling's *Liaozhai zhiyi* (translated by Herbert Giles as *Strange Stories from a Chinese Studio*).

The *xia nü* figure was an icon of ancient *wuxia* literature practically reinvented by King Hu in his new school *wuxia* films. The figure was first reincarnated by Zheng Peipei in Hu's *Come Drink with Me*, a Shaw Brothers production released in 1966, and thereafter was kept by Hu in his subsequent Taiwan productions, portrayed by different actresses (apart from *Dragon Inn* and *A Touch of Zen*, Hu's other notable *wuxia* movies included *The Fate of Lee Khan* [1973] and *The Valiant Ones* [1975], both made in Hong Kong and featuring a bevy of female knights-errant). As Zhang Zhen has noted, there is a sub-genre of female knight-errant movies in the early Shanghai cinema, often invoking the term *nü xia* (the reverse of *xia nü*, but meaning the same thing) in their titles.[40] This feminine/feminist strand of *wuxia* is much admired in the West through cult appreciation of films such as those featuring Michelle Yeoh, including *Yes Madam* (1985), *The Heroic Trio* (1993), *Wing Chun* (1994), and *Crouching Tiger, Hidden Dragon* (2000) — the first two titles might be described as "modern *wuxia*" films or even "postmodern *wuxia*," which is more appropriate of *The Heroic Trio*, a film set in a vaguely futuristic age that also actively recalls traditional *nü xia*, personified by Anita Mui as a masked Wonder Woman who can practically fly. As Zhang Zhen reminds us, such a figure was not born in a postmodern vacuum. In fact, the postmodern *wuxia* trimmings of *The Heroic Trio* serve to remind viewers that the female heroes in the film descend from a rich pantheon of flying female knights-errant,[41] that is, for viewers who are aware of the rich history of *wuxia*.

Western appreciation of the empowering *nü xia* figure may be skewed towards the gender discourse generally and not so much the awareness of genre conventions and its historical form. The immense success of *Crouching Tiger, Hidden Dragon* in the West is symbolic of this trend generally. Ang Lee's direction is the very antithesis of *wuxia* as a masculine form: all the strong figures in the film are women and the one male knight-errant figure (the Chow Yun-fat character) is inordinately "wimpish."[42] In this way, the film engages the audience in a gender discourse that apparently displays the female in a more advantageous light than the male and critiques the genre as an overtly masculine, militaristic form (director Zhang Che is representative of the masculine trait of *wuxia* though in fact he is not averse to including *nü xia* in his films; his films, I suggest, can be reappraised in the light of the modern gender discourse even from the standpoint of masculinity, particularly in the context of queer theory). While I have in the past been critical of *Crouching Tiger*,[43] I acknowledge that it has many admirers who respect the film for its artful approach and its feminine-gender disposition — two traits that are not always applied to the genre and as such deserve critical recognition. I do not have the space here for a full reappraisal of the film. Suffice it for me to say that *Crouching Tiger*'s success in the West is a significant one for the genre because for the first time, it achieved a genuine transnational crossover.

Conclusion

Crouching Tiger and the *wuxia* films that followed it (including Zhang Yimou's trilogy) have brought the genre full circle to its developmental history. Its beginnings in Shanghai in the second decade of the twentieth century were ostensibly transnational due to the nature of Shanghai and its treaty-port zones occupied by foreign powers. The genre imbibed influences from Hollywood and European genres while at the same time drawing from the fountain of China's history and folkloric past. In doing so, the genre was put forward as a signifier of Chinese national identity and cultural form that could be distinguished from the Westernized or Europeanized form. In the Hong Kong film industry, the genre exalted a vision of cultural China in its most imaginary manifestations. Hong Kong paved the road more systematically for the transnationalization of the genre: its main highway was the Chinese diaspora.

At the start of the twenty-first century, *wuxia* as represented by the success of *Crouching Tiger* has been recognized as a transnational form that throws up questions on the nature of "Chineseness," as Ken-fang Lee argues: the representation of the *wuxia* tradition and culture in the film "calls forth a new cultural identity that de-essentializes home-bound Chineseness," Lee writes.[44] Recent films such as Chen Kaige's *The Promise* (2005), Feng Xiaogang's *The Banquet* (an adaptation of Shakespeare's *Hamlet*), and Zhang Yimou's *Curse of the Golden Flower* (Shakespearean in content, though the plot is derived from Cao Yu's play *Thunderstorm*), are further demonstrations of the increasing transnationalization of *wuxia*. They could even be described as allegories of globalization (Chen's film is perhaps more of a parody). The genre's diachronic line of development in the Chinese cinema therefore appears to indicate that history progresses either purposefully or inadvertently from the nation to trans-nation. However, this might indicate only that the genre is still evolving and that the concept of the nation which forms a part of its corpus is in further need of translation and explication to make it more acceptable to a transnational audience as Chinese cinema faces up to the challenge of globalization. As Chris Berry notes, the form of that challenge appears contradictory: "the transnational continues to grow, but the national persists, often indeed stimulated by the very same transnational forces that we thought might be making it obsolete."[45]

Chinese Animation Film:
From Experimentation to Digitalization

John A. Lent and Ying Xu

Throughout its eighty-year history, China's animation has persisted and excelled under various political, economic, and socio-cultural conditions, including during military invasions, civil war, dictatorships, and both planned and market economies. Despite at times formidable obstacles and unstable states of existence, China in the past produced some of the world's most exquisite animation, and even today promises to be a global behemoth in quantity of production.

As this chapter shows, the government has been a key player in animation development since at least 1949, though its roles have varied widely over time, serving different functions and yielding almost diametrically opposed results. During the planned economy period until the 1980s, when China experienced its two golden eras of animation, a sense of nationalism prevailed. Animators were encouraged to experiment with techniques and content to come up with a uniquely Chinese style of animation, and were given the time, resources, and funding to produce their works. Marketing and distribution were not their concern as the state took care of such matters, concentrating on the huge domestic audience not yet subjected to much imported animation fare. Under such ideal circumstances, China produced a body of animation work both creatively executed and aesthetically pleasing.

The role of the government changed during the recent years of the market economy. In the first stage of the late 1980s–early 1990s, the government weaned the few existing studios from total state support, encouraging them to subcontract for overseas companies and become more commercially oriented, and greatly increased their production quota to satisfy the voracious programming appetites of the increased numbers of television stations. A generally open cultural market permitted the importation of more foreign animation, particularly from the United States and Japan, which affected industry practices and content styles and techniques. After 2000, the government, taking its cue from South Korea, increasingly thought of animation as a potentially profitable cultural product, both domestically and globally, and pumped money into building a bigger infrastructure with thousands of studios, more than 1,230 university animation programs, an annual production quota for domestic television of nearly 102,000 minutes, and scores of extravagant animation and comics festivals whose main purpose is to attract

international buyers. In the process, Chinese-style cartoons have had to take a rear seat to a more quickly made, foreign-influenced, and universally motivated animation.

This chapter details these tendencies as it traces the history of Chinese animation from the earliest works of the Wan brothers and lesser-known pioneers, through the lull of World War II, the golden eras of the Shanghai Animation Film Studio, the reorganization under a market economy, and the present state of astronomical expansion.

The Beginnings and the Wan Brothers

It is difficult to ascertain when animation began in China, because no known copies of most of the pre-1940s work exist. Zeng Guangchang wrote that it might have been in January 1924, when the Shanghai British and American Tobacco Company Film Department produced a funny work, *Happy New Year* (*Guo nian*), drawn by artist Yang Zuotao.[1] Three other shorts reportedly were done in 1924–1925: *Dog Invites Guests* (*Gou qing ke*, by Huang Wennong), *Good Fate* (*Jing hua yuan*), and *Young Boy's Adventure* (*Shao nian qi yu*). The directors and artists of the latter two, both produced by Shanghai South Pacific Film Co., are not known.[2]

More often credited with starting Chinese animation are the Wan brothers (Laiming [1899–1997], Guchan [1899–1995], Chaochen [1906–1992], and Dihuan [b. 1907]; the eldest two were twins) with their 1926 work, *Tumult in the Studio* (*Da nao hua shi*). The four brothers had already made an animated commercial at the end of 1922, *The Typewriter for Chinese by Shu Zhendong* (*Shu Zhendong hua wen da zi ji*), and two more commercials in the two years following. The Wan brothers almost monopolized Chinese animation from 1922 to 1941, making thirty animated works, including entertainment, advertising, and anti-Japanese propaganda films, some silent, others in sound, and ranging from one to eighty minutes. They were responsible for the country's first full animation film (as opposed to combined live action/animation), the first in color, the first full-length feature, and the first using paper-cutting techniques. All of this they accomplished under extremely adverse conditions.

The Wans had a fascination with making pictures move from early childhood, and after seeing Fleischer Brothers cartoons in Shanghai theaters, they set out to discover how animation works. They watched foreign works in theaters countless times, wrote to European and American animators to no avail, and experimented. They went to toy shops on Shanghai's Bund and inspected entertainment instruments from Europe, including a revolving bamboo tube (suggesting the early camera model, the *revolver photographique*).[3]

Working full-time day jobs (one by one, they went to work for Commercial Publishing House [Shang wu yin shu guan]), the Wans spent evenings and Sundays contemplating, plotting, and experimenting.

Methodically, they persisted: their seven-square-meter room became their experimental place, Chinese shadow shows and foreign animation were their references, and their instruments and materials were a still camera with a wooden box they refitted as a projector, some common light bulbs, and pencils. To get the money for these sparse

materials, the Wans had decided not to spend any money on fish or meat for a year and not to make clothes during the New Year.[4] For a dark room, the Wans "moved the stove out of the kitchen and covered the windows completely."

They used the same sense of discovery and rudimentary skills and tools to eventually overcome problems associated with maintaining the continuity of locations and a sense of perspective and distance, until one evening in 1922, they were able to project on the wall in their room animated drawings that appeared lifelike. When news of the Wans' success was made known, the cinema section of the Commercial Publishing House asked them to make *The Typewriter for Chinese by Shu Zhendong*. Their big break came when they were hired as set makers by Changcheng (Great Wall) Film Studio and asked to make an animated film in their spare time. The result was *Tumult in the Studio* (finished in 1926 and released in 1927),[5] usually considered China's first animated film. *Tumult in the Studio* was a combination of real life and cartoon figures, its story very much influenced by the Fleischer brothers' *Out of the Inkwell* series. In the *Tumult in the Studio* cartoons, an artist draws a little man who comes to life, leaves the drawing board, and causes havoc in the studio until the artist captures him and pins him to the drawing board.

After a couple more films, Lianhua Studio, at the time Shanghai's most successful studio with a record of high-quality artistic work, asked the Wans to make animated shorts.

The second stage of the Wans' careers, 1931–1936, yielded mainly propagandistic and educative films, as well as China's first animated sound film *The Dance of the Camel* (*Luo tuo xian wu*). French scholar Marie-Claire Quiquemelle wrote that the brothers produced six "educative" and "patriotic" films for Lianhua before moving to Mingxing Studio in 1933, where they made nine short films and lived "for the first time in comparative comfort and security"[6] until war broke out in 1937. Zhang Huilin identified types of animation produced by the Wans during this period as those with patriotic, anti-Japanese, anti-imperialist, and anti-feudalist propaganda and educational fables.[7]

Among those with strong anti-Japanese or patriotic themes were *Citizens, Wake Up* (*Tong bao su xing*, 1931 or 1932), China's first fully animated film, *Blood Money* (*Xue qian*, 1932), *United Together* (*Jing cheng tuan jie*, 1932), *The Leak* (*Lou dong*, 1934), and *The Year of Chinese Goods* (*Guo huo nian*, no date, ca. 1931–1936). Taking stands against imperialism and feudalism were *Dog Detective* (*Gou zhen tan*, 1931),[8] *National Sorrow* (*Min zu tong shi*, 1933), *New Tide* (*Xin chao*, 1936), and *The Motherland Is Saved by Aviation* (*Hang kong jiu guo*, no date, ca. 1931–1936). The Wan brothers' animation based on fables to educate included *Tortoise and Rabbit Have a Race* (*Gui tu sai pao*, 1932), *Sudden Catastrophe* (*Fei lai huo*, no date, ca. 1931–1936), and *Locusts and Ants* (*Huang chong yu ma yi*, no date, ca. 1931–1936).

By the mid-1930s, the Wan brothers made two decisions that they thought would be propitious for Chinese animation: to survive the fierce competition from European and U.S. films, animated films would have to convert to sound and be more Chinese in orientation. Claiming European and American animators did not want the Chinese to

learn sound techniques, Wan Laiming said he and his brothers fumbled and experimented until they discovered optical sound recording which could be applied.[9] Accepting Mingxing Studio's challenge to produce a sound animation film, the Wans proceeded to make *The Dance of the Camel* (1935), based on Aesop's Fables. The story is about a camel who is invited to a banquet given by a lion. During the festivities, a group of monkeys win applause for their dancing, which the camel also attempts but is booed off the stage.

In many of their early films, the Wans imitated American animators, particularly the Fleischer brothers and Disney. However, in a July 1936 article in a periodical issued by Mingxing, they pointed out that American cartoons were not the only available models, and praised the quality of German and Russian cartoons. Stating that American, German, and Russian cartoons all bore the character of their own cultures, they argued that, "In a Chinese film, one ought to have a story based purely on real Chinese traditions and stories, consistent with our sensibility and sense of humor.... Also, our films must not only bring pleasure, but also be educational."[10]

The third stage in the Wans' careers, 1937–1941, was dominated by anti-Japanese and patriotic shorts and the making of China's first feature-length cartoon. After Japan invaded China in July 1937, and Shanghai was occupied the following month, the Wans left for Wuhan where they worked for the state-run China Film Studio. There they produced two episodes of *Anti-War Slogans Cartoon* (*Kang zhan biao yu ka tong*) and four of *Anti-War Songs Collection* (*Kang zhan ge ji*). In the autumn of 1938, when Japan occupied Wuhan, Wan Chaochen moved alone to Chongqing where he made the puppet animation *Go to the Front* (*Shang qian xian*) and another work, *Wang Laowu Became a Soldier* (*Wang Laowu qu dang bing*). In April 1939, Wan Laiming and Wan Guchan returned to Shanghai.

Free of Japanese invaders until December 7, 1941, Shanghai's foreign concessions became the enclaves where China's film industry survived. Animation was part of the industry, especially after Shanghai investors saw the big stir that the release in China of Disney's *Snow White* made in 1938. Wan Laiming and Wan Guchan saw *Snow White* and thought they too could do a feature-length animated movie and began to make *Princess Iron Fan* (*Tie shan gong zhu*), based on a chapter in the ancient novel, *Journey to the West* (*Xiyou ji*).

Like so many of their previous endeavors, the making of *Princess Iron Fan* was plagued with setbacks. The investors were less than generous; they paid low wages to the staff, set a very close deadline for the work to be completed, and scrimped on materials.[11] The Wans recruited apprentices and taught them the basics, while they worked on the drawings. Lacking color negative film, they used prepared red ink to draw the fiery colors of the Fire-Spewing Mountain onto the celluloid itself. The film could be completed only after the Wans were able to find a new investor. On the heels of the success of *Princess Iron Fan*, the brothers attempted to make two other films, but neither materialized.

For much of the 1940s, the Wans worked at whatever jobs they could find: for a while, Wan Laiming cut out silhouettes which he sold to foreigners on the streets

of Shanghai, and when he and Wan Guchan immigrated to Hong Kong in 1949, they worked as set designers and special effects experts.

After the establishment of the Shanghai Animation Film Studio in 1950, Wan Chaochen was recruited as an animator. Later, Wan Laiming and Wan Guchan also were asked to join the studio which they did by the mid-1950s. Wan Chaochen directed the studio's first color film, the puppet short *The Little Hero* (*Xiao ying xiong*) in 1953. Wan Guchan specialized in a genre he had thought up in 1950, using paper cuttings, which he brought to the screen in 1958 with *Zhu Bajie Eats the Watermelon* (*Zhu Bajie chi xi gua*). In 1961 (and 1964), Wan Laiming was finally able to produce his nearly twenty-year dream, feature-length animation *Uproar in Heaven* (*Da nao tian gong*).

A few others produced animation in the 1930s and 1940s. In 1935, *56 Years History* (*Wu shi liu nian tong shi*) was made by the Nanjing Central University Electronic Education Department, and in 1942, the Manzhou ying hua xie hui (Manchuria Film Association) brought out *Night Pearl* (*Ye ming zhu*). In Hong Kong, in August 1941, nineteen young artists founded the Chinese Cartoon Association and produced *The Hunger of the Old, Stupid Dog* (*Lao ben gou e du ji*, 1941),[12] as well as several cartoons by Qian Jiajun.

A graduate of the Suzhou Art School in 1935, Qian studied animation film principles in his spare time and in November 1940, along with twenty young artists, made *Happy Peasants* (*Nong jia le*), an anti-Japanese short. It was produced by his employer, Chongqing Li Zhi She. Black and white and 780 feet long, *Happy Peasants* tells the story of a girl, who with her father, brother, and dog, defeat the marauding Japanese soldiers who invade their peaceful village. In 1942, Qian joined the Educational Film Association, jointly established by the Education Department of Government Central Film Studio and Li Zhi She. As the head of animation, he created *Generation after Generation Never Stop* (*Sheng sheng bu xi*). He moved to Nanjing in 1946 with Li Zhi She and planned to make *Bee Country* (*Mi feng guo*), which never made it through post-production, and the following year, joined the production team at the Shanghai Chinese Press Editorial Office, which had been commissioned by UNESCO to produce *People and Two Hands* (*Ren yu shuang shou*). Most of the rest of his career was devoted to teaching, including at Shanghai Animation Film Studio.

The Communist Party established the Northeast China Film Studio at Xingshan (now, Changchun), Manchuria, in 1946, where documentaries and two animation films were made. One of the latter was *The Dream of the Emperor* (*Huang di meng*, 1947), a puppet film based on a caricature of Chiang Kaishek drawn by cartoonist Hua Junwu. Veteran writer-actress Chen Bo'er wrote the script and directed *The Dream of the Emperor*, while art design was done by Shi Manxiong and Chi Yong Zhi Ren (Fang Ming). In all likelihood, Chen Bo'er was China's first woman animation director. Thirty minutes long, *The Dream of the Emperor* was put in the fourth section of a newsreel serial, *The Democratic Northeast*. The second of these animated films (both screened in the Communist areas, primarily to soldiers) was *Catch the Turtle in a Jar* (*Weng zhong zhuo bie*, 1948). Artist Zhu Dan did the script while Fang Ming directed the ten-minute caricature cartoon ridiculing Chiang Kaishek's policies.

Te Wei and the Golden Ages of China's Animation

The trials and tribulations of the Wan brothers and other pioneers led to the period that revolutionized the profession, beginning in 1949, when print cartoonist Te Wei and painter Jin Xi were asked by the Ministry of Culture to go to the Northeast and establish an animation group at the Changchun Film Studio. Te Wei was not very enthusiastic about doing animation, because he dreaded "all those monotonous frames," and also because he knew absolutely nothing about animation production.[13] The Changchun Film Studio became the headquarters of these pioneering efforts, because its head, Chen Bo'er, appreciated animation, and wanted to broaden the scope of the studio's films. After only a year (1950), the animation unit moved from Changchun to Shanghai, becoming part of the Shanghai Film Studio, which Te Wei said allowed for "better conditions."[14] In 1957, Shanghai Animation Film Studio was established.

Under Te Wei's tenure as director (until 1984), the Shanghai Animation Film Studio climbed to the peak of the animation world, exhibiting very high levels of aesthetics and experimentation, while also taking on national characteristics, employing Chinese artistic techniques, and adapting stories from China's literature, folklore, and proverbs.

This transformation came about in an off-handed way in the mid-1950s. At the time, Te Wei and his staff were learning animation through "study and exploration," mainly of Soviet concepts and techniques, because, as Te Wei said, "Soviet animation had high level skills and very healthy contents."[15] However, his enthusiasm for the Soviet model abruptly ended when the Shanghai studio's *Why Crows Are Black* (*Wu ya wei shen mo shi hei de*) won an award in Venice in 1955, and the judges mistook the film as a Soviet work. As a result, Te Wei decided Chinese animation had to reflect Chinese customs, tales, and techniques and implored his staff to explore a national path.

Their next film, *The Conceited General* (*Jiao ao de jiang jun*, 1956) was the first such experiment, incorporating Peking opera movements learned from opera teachers invited to the studio. The studio now embarked on a three-decade quest for a Chinese model, which eventually became Te Wei's proudest achievement. As he himself declared:

> I did one important thing; I explored national styles and ways for animation.
> I not only said what had to be done; I not only put a slogan on the wall
> [calling for a national style], but I did something — made outstanding water
> and ink films.[16]

The experimentation with content, techniques, and raw materials accelerated, first with puppets and then paper cuttings, with the already-mentioned *Zhu Bajie Eats the Watermelon*, directed by Wan Guchan and Hu Jinqing. Hu said paper cutting was chosen for animation because it has a "long history and it is traditional. Our thinking was [that] the more national a work was, the more international it would be,"[17] meaning international recognition would result from employing a Chinese style. Many other excellent paper-cutting works followed, including the award-winning *Snipe-Clam Grapple* (*Yu bang xiang zheng*, 1983).

As the 1950s ended, the studio took on a challenge of China's vice premier, Chen Yi, that one day, water and ink (brush) painting mastered by Qi Baishi would be animated. Qi Baishi painted many tadpoles and shrimp and Te Wei and his staff tried many ways to depict them so that they would move. The result was *Where Is Mama?* (*Xiao ke dou zhao mama*, 1960), the story of a school of tadpoles desperately searching for their mother and encountering other creatures in a number of instances of mistaken identity. Though Te Wei solely has been credited with applying water and ink painting to animation, recent research has revealed that A Da probably invented the technique.[18] Three other water and ink films were made by the studio, including the classic, *Feeling from Mountain and Water* (*Shan shui qing*, 1988), on which Tei Wei served as general director.

The ancient Chinese folk craft, paper folding, was applied to animation with Yu Zheguang's *A Clever Duckling* (*Cong ming de ya zi*, 1960), and Wan Laiming used the Peking opera military style of performance in creating *Havoc in Heaven* (*Da nao tian gong*, 1961, 1964). Experimentation in cel animation also proceeded with Qian Jiajun and Dai Tielang, and then, Yan Dingxian and Lin Wenxiao, using the Dunhuang cave paintings as the source for *Spotted Deer* (*Jiu se lu*, 1981), and *The Deer Girl* (*Lu nü*, 1993), respectively. Yan gave details on the conceptualization of the latter's use of the cave paintings:

> The script for *The Deer Girl* was by a painter who had researched the caves. In the caves, there is one painting of several frames concerning a mother deer. It is a Buddhist story with a moral that people should not fight, but should be friends. I thought the story was good for modern times and adopted it to animation. We adopted both the story and art and followed the Dunhuang cave painting form. The deer is a symbol of good fortune. We made three animations about deer — *The Deer Fairy, Jia Zi Rescues the Deer,* and *The Deer Girl.*[19]

Besides indigenous techniques and raw materials, contents of the animation were also Chinese-inspired. As examples, *Havoc in Heaven* was based on the story *Journey to the West; Red Army Bridge* (*Hong jun qiao*, 1964) recounted the conflict between Mao's soldiers and Kuomintang troops; and *Snipe-Clam Grapple* moralized from a Chinese proverb, of a snipe and a clam too busy fighting each other to notice the fisherman who ultimately benefits. *Three Monks* (*San ge he shang*, 1980) also came from a proverb, of monks carrying water: one monk carries the water alone; two monks share the duty; but with three monks, no water is carried.

Stylization was what set Chinese animation apart during those golden years, according to Zhang Huilin.[20] Stylization with the influence of paintings and operas is perfectly represented in Te Wei's *The Conceited General*, Wan Laiming's *Havoc in Heaven*, Yan Dingxian, Wang Shuchen, and A Da's *Ne Zha Conquers the Dragon King* (*Ne Zha nao hai*, 1979), and other works. Zhang explained that structures and facial makeup were done in a conscious effort to represent temperaments and mentalities; backgrounds are stage-like, and physical movements are similar to Peking

opera. Metaphysical beauty, she said, was captured in lines that embody aesthetic values and signify feeling: zigzag, long or short, thick or thin, straight or winding, they bring out subtle emotions. The action also possessed aesthetic value, Zhang said, giving the example of A Da's *Three Monks*, where each monk moves to a different rhythm.[21]

What accounted for the creative experimentation and high degree of aesthetics during those years? Te Wei explained that the studio had ready availability of money, resources, and almost unlimited creative time.[22] Adding to this, animation critic/theorist/scriptwriter Chen Jianyu said, "The government gave money and collected all the outstanding animators together. How long they took to produce, no one cared." Chen added that Te Wei and the other animators were middle-aged, "with much energy," and as recent graduates of film and art academies, some matured at that time. Helpful factors also included a prosperous production system, three generations of animators working simultaneously, and government interest and support.[23]

Of all these factors, the government financial support and hands-off policy were most crucial. Veteran animators suggest that government involvement in animation was generally positive. Famed puppet animator Qian Yunda said of government involvement in animation:

> At that time (1950s–1960s), political factors influenced art very much. The government had demands of us as filmmakers. The government did not give us instructions; instead, they hoped we used animation to show modern class struggle and problems.[24]

Another veteran animator, Zhan Tong, who was on the Shanghai Animation Film Studio staff from 1957 until his death in 1995, gave this description of government-studio relationships:

> We produced films that followed the existing policy of China, that is, to serve the children. In addition, we did some international topics, such as American imperialism and an attack on Eisenhower. Also, some animation films were made in cooperation with the Great Leap Forward political movement, and there were a few adult animation films, but very few.[25]

Te Wei's impression was that the government did not interfere negatively in an effort to help animation develop. He said:

> Seldom was there government control of the animation industry. Some believe there was so little government control so that the industry could develop smoothly. And some senior government leaders have been artists, literary and cultural workers, like Xia Yan, Chen Huangmei, and Premier Zhou Enlai. Even Zhou gave his attention, spiritual support, and suggestions to animation. I saw Zhou many times and he often talked about animation films. On one occasion, when he visited Southeast Asian countries, Zhou took Chinese

animation with him to show his hosts. When he met Japanese delegates, he told them Chinese art films could find paths of their own.[26]

The one major exception, of course, was the so-called Cultural Revolution. During that time, the studio's work was destroyed or shelved, not to be shown in China again until the late 1970s or 1980s, and new production all but dried up from 1965 to 1973. Animators, as all intellectuals and artists, were banished to rural settings, made to work at menial farm jobs and to do self criticism. Some gradually returned to the studio beginning in 1973, but what they produced was mostly propaganda films, of low quality and treated in a realistic manner.

When the Gang of Four perpetrators of the nightmarish Cultural Revolution fell in 1976, Te Wei regained his position as head of Shanghai Animation Film Studio and set into motion a new golden age, even more impressive than the first. Te Wei explained the second period (1976–1980s) was much more intense than the first because all the artists had been oppressed during the Cultural Revolution. With a great deal of pent-up energy, they were eager to display their talent. Thus, the level of work was much higher because no effort was spared to produce their best work. The animation films that marked this immediate post–Cultural Revolution period are still considered among China's strongest achievements in this medium.[27]

After finishing as head of studio in 1984, Te Wei directed his international award-winning *Feeling from Mountain and Water* in 1988. Thereafter, he watched the field of animation move into new directions of digitalization, commercialization, and globalization. Paying tribute to him, critic Chen Jianyu said not only did Te Wei make four of China's masterpieces, but he also founded a Chinese style of animation, led both of China's golden ages of animation, and nurtured a highly talented group that united senior animators with newcomers to the field.[28] In 1989, Te Wei was chosen by the national government as one of the four most outstanding filmmakers from among more than 50,000 people who had worked in the industry.

The Market Economy and Reorganization

When China's planned economy began to be dismantled in recent years, Chinese animation also changed drastically. As studios scrambled to support themselves, they sped up production primarily to satisfy the television market, served as work stations for overseas clients, sought global markets for their own works, and increasingly entered the digital world. In the process, almost all of the types of animation previously made faded into the distance. Chinese animation had become a culture industry.

Until the late 1980s, the Shanghai Animation Film Studio had been subsidized to make 300 to 400 minutes of animation yearly, with the works guaranteed distribution through the China Film Corporation. This secured position broke down as Chinese animation was criticized as lagging behind consumer and market demands, as Japanese and American animation made deeper inroads into Chinese television, and as talented

animators were seduced by higher wages to work for animation subsidiaries of foreign studios that sprouted along China's southern rim in search of cheaper labor.

To cope, the Shanghai studio branched out from educational and artistic animation to a more commercial variety, and in 1991, joined with Yick Hee of Hong Kong to form Shanghai Yilimei Animation Company, Ltd. as its commercial wing. The government continued to pay for 300 to 400 minutes of animation annually, which met payrolls and covered about 70 percent of the studio's operating expenses; the rest had to come from work-for-hire with foreign companies.[29]

In 1994, the Chinese government set into motion a plan to help the studio survive. Shanghai Animation Film Studio was to produce mainly for Shanghai Television Station and to co-produce on a limited basis with foreign companies, the latter meaning that China provided the labor to make foreign-themed animation.[30] Through its Shanghai Television Station, the government pumped 49 million yuan (US$6 million) into television animation from 1996 to 1999.

As these changes occurred, the infrastructure of the Shanghai studio was revamped to meet market demands. A parent organization, Shanghai Animation Film and TV Group Co., was established, which subsumed Shanghai Yilimei Animation Ltd. and Shanghai Animation Film Studio, and at least a half-dozen other entities.

During this drive to self-sufficiency through commercialization, theatrical animation almost became extinct, as did artistic short films. Shanghai Animation Film Studio President Jin Guoping explained:

> Younger animators get used to making TV and foreign company productions and seldom can they sit down, think, and do shorts in an artistic way. They don't have the time to explore new ways. They are not enthusiastic about doing artistic level animation, because they must devote more time and attention to production and get less money in the end.[31]

Zou Qin, who made *Deer and Bull* (*Lu he niu*), a puppet short in which everything is constructed from bamboo, is an example of a young animator torn between artistic and commercial pursuits. Zou said he worked a full year to make *Deer and Bull* and was paid only 800 yuan (US$125 at the time) above his regular salary, but while doing "no intelligence" animation for a while at an overseas animation house in the South, he made 5,000 yuan (US$782) monthly.[32]

The attraction of receiving higher pay from foreign studios based in China has created a gap between senior and younger animators, not only in numbers, but also in philosophies. Qian Yunda pointed to differences he saw in the approaches between senior and junior animators:

> We used to call animation "art films," but the young doubt this designation. They think we seniors pay attention to art, but animation is more visuals and TV effects. They feel animation should be a film, not art. I think the senior generation did combine Chinese art into film and created a Chinese style.

But now, the situation is more demanding in that senior animators, because they must make TV animation for the commercial market, have to put more attention on film skills. Animation in China now faces two problems — how to make animation more like film and how to respond to the market.[33]

The pressure to convert to TV animation very quickly and to produce ever-increasing volumes for that medium has been staggering, and the cause for much discussion concerning the artistic quality of Chinese animation and speculation about the future of art films.

Veteran animator Ma Kexuan, now a professor in digital art and design at Beijing University, felt that overall, the artistic aspects of animation have suffered from the demands of local governments to increase quantity. He noted:

This policy is against creative animation making. The politicians promised the public they could have more productions. It's the concept of catching up, developing our own culture, economy. My personal opinion is that this concept killed animation creativity. I never cared about quantity, only about quality.... When the studio said the amount, not quality, was more important, I left.[34]

Te Wei has placed the blame on foreign impacts, saying,

When I was working, I put more attention on creation. Now retired, I feel some animators pay more attention to working for foreign companies; it's not their work, not Chinese animation. Working for the foreign companies means more pay, but it also means there is not time to do Chinese animation exploration. This is a bad impact.[35]

Still others from the golden ages of animation, such as Yan Dingxian, Zhan Tong, and Chang Guangxi, recognized the need to follow market demands, but with the reservation that Chinese traditions will be followed,[36] or in the faith that the tendency towards commercialization and Westernization will eventually reverse itself.[37]

The Post-2000 Movement to Giantism

Commencing about 2002–2003, Chinese animation entered an era of giantism with new production techniques/emphases, government relationships, and marketing orientations that made the former art form and industry model barely recognizable.

No other country has experienced the rapid acceleration China has had in total production minutes, numbers of studios, and growth of animation training programs and students. For the closing five years of the millennium, the Shanghai Animation Film Studio, which still accounted for the majority of the country's production, had witnessed a staggering increase in yearly produced animation minutes from 500 to 5,000. In 2007,

China accounted for 186 domestically produced animation shows for a total of 101,900 minutes. Whereas previously, production houses included the Shanghai studio, Beijing Science and Educational Film Studio (established 1960),[38] and a very few others, by October 2006, the number of animation and cartoon studios had skyrocketed to 5,473. Nowhere is this growth mania more noticeable than in education and training. By October 2006, China had 447 universities with established animation programs, while a total of 1,230 universities housed schools and departments with animation and cartoon majors. By 2005, the country already had 64,000 animation students; a year later, the number of students in animation programs was estimated to be 466,000.

A number of factors accounted for this transformation, including government involvement, foreign influences and connections, and digitalization advances.

Government Involvement

During the past five or six years, the Chinese government has begun to take notice of animation in a manner similar to that of the South Korean authorities a decade before: by requiring China's television stations to use more domestic cartoons, singling out nine cities as animation industrial bases, supporting many international animation festivals and extravaganzas, and encouraging the development of four national animation teaching and research bases (Beijing Film Academy, Chinese Arts University, Jilin College of the Arts, and Communication University of China). In 2004, the State Administration of Radio, Film, and Television (SARFT) announced it was committing 1,000 hours of animation programming to its 2,000 television outlets. A year later SARFT sponsored the Promotion of Outstanding Domestic Animation Awards, whereby four works are nominated yearly by provincial and municipal broadcasters to be given priority on all channels. Of course, provincial and municipal governments have taken notice of these changes mandated from higher levels.

Speaking at an animation festival in Changzhou in 2005, Director of the Culture Marketing Department, Ministry of Culture Liu Yuzhu, talked about areas where the Chinese government plans to help, including more investment and special funding for animation, incentives for enterprise competiveness and talent scouting and training, appropriating a Western-style marketing model, and improving copyright regulation and cracking down on piracy.[39]

Liu said that Chinese federal and state governments have instituted policy statements because of a number of obstacles to growth that the animation industry faces. Among these, he said, were a public mentality concerned with children's addiction to animation; the loss of the adult market for which animation is not geared; low-level quality and quantity of domestic animation (only one-half of the nation's needs are now met); lack of Chinese stories and a propensity to imitate; an immature industrial base with insufficient markets and loss of part of the local market to cheaper foreign animation; a non-integrated administrative structure of the industry; and a lack of sufficient professionals, especially screenwriters and market personnel with creative ideas.[40]

Foreign Influences

Foreign influences on Chinese animation come through imported programming, subcontracting agreements, co-production arrangements, and international marketing attempts.

Much foreign animation is screened in China; for example, a 2004 survey by China Mainland Marketing Research Co. found that of the top ten cartoon shows Chinese children watch, six are Japanese and two each are American and Chinese. One effect of such a high viewership of Japanese shows is reflected in the style adopted by many Chinese animators, whose artwork, stories, and characters are hardly discernible from anime. Trying to counter this trend, SARFT in 2005–2006 levied rulings that limited the penetration of foreign cartoons on television to 40 percent, barred foreign channels such as Disney, banned TV shows and movies that blend animated elements with live-action performers, and eliminated foreign cartoons from the favored 5 p.m.–8 p.m. prime time slot.

Since becoming an open economy in recent years, China has had a number of relationships with foreign animation companies, allowing them to set up offshore production houses in the 1990s to benefit from China's inexpensive labor pool, and subsequently entering into co-production agreements with a number of them.

Benefits from co-producing that accrue to Chinese studios include moving from strictly work-for-hire (as in subcontracting studios) to a more creative role in animation, enlarging capital investment pools, being involved in larger, more prestigious projects, and gaining wider distribution abroad. Moreover, because sales of animation in China were almost impossible due to widespread piracy, Chinese studios sought co-production deals in which they would share in profits (meager as they are) from North America and Europe.

Besides partnering with companies from Australia, Canada, England, France, Spain, the United States, Hong Kong, and Taiwan, China helped spearhead a Northeast Asia animation consortium with Japan and South Korea in 2003–2004. The three countries with similar cultural, philosophical, and linguistic roots explored a number of possibilities of working together in animation, such as joint production/distribution of at least eight television series, the trading of festival exhibition space, and the extension of meetings for future cooperation. Animators from the three countries are proud of their joint activities thus far, noting that operational decisions and procedures and the division of credits have been executed democratically, allowing each company in these arrangements to reach its full potential.

More broadly, globalization has been an overarching aim of industry decision makers in recent years, hoping to succeed in overseas sales of the country's animation and all the accompanying merchandise. So far, there have not been many rewards, because, first of all, the industry does not have enough experience globally,[41] and second, the animators have not yet solved the difficult puzzle of meeting the expectations of hundreds of millions of Chinese at home while appealing to an international market,[42] termed by one animator as, "fitting into the world and yet, finding the lost Chinese spirit."[43]

Chinese animators seeking export markets face the same difficulties common throughout Asia: 1) animation is produced expensively and sold abroad at low cost; 2) characters and stories do not have universal appeal; and 3) Chinese animation must break into an international market tightly controlled by transnational behemoths who determine who gets in and under what terms.

Digitalization Advances

A third factor that has drastically changed Chinese animation has been the widespread use of computers in studios. For the past five years, Chinese animation has increasingly moved into the digital age with a number of state-of-the-art computerized studios sprouting up, including some with capture motion capacities. The hundreds of animation training programs that have come to the fore also concentrate on digitalization.

Although computer-generated animation has a number of benefits (especially for producers overseeing the budgets), some of its principles and modes of operation are contrary to what existed during China's golden eras. Critics in China and abroad have pointed out that digitalized animation is more formulaic, less spontaneous, and not as open to experimentation as traditional animation. They also bemoan the tendencies of 3D to be too detailed in an art form that traditionally reduced things to their essentials, and the marginalization of the animator who no longer feels as though he/she is creating the character, but instead, is part of a collection of people and programs. An American animator with her own studio in Beijing said recently that among the problems of China's animation are young people who know computer software but lack foundation principles of timing, stretching, etc. that are part of 2D animation.[44]

On the other hand, China has witnessed a surge of independent animation since 2000, urged on by digital technology. Wu Weihua identified three domains of this independent animation: 1) researchers in computer graphics and students of animation, 2) individual animators with backgrounds in professional animation working in non-government studios, and 3) independent Flash animators and self-taught animators.[45]

Opportunities for independent animators are provided in some Chinese art and film institutes, where students are encouraged to produce animation with a blend of digital technology, the visuality of Chinese painting, and classical elite literature, and to distribute their works on the Internet or by DVD. There are Chinese Internet domains, such as the Chinese Animation Association's chinanim.com, that offer stable channels for uploading independent animation.

Conclusion

In the 1970s and 1980s, Chinese animation reached the pinnacle of artistic achievement with a blend of Chinese and foreign materials, techniques, and approaches, along with indigenous art and literature traditions. Some of the work of China's golden ages of animation stands alone in exquisiteness of conceptualization and execution, crafted by artists with almost limitless time and resources.

The picture changed quickly after China abandoned its planned economy system. Time was of the essence as studios scrambled to support themselves, production sped up to feed capitalistic need and greed, and mechanization replaced handcraftsmanship. Government interest and support now was primarily directed at animation as a money-making industry, rather than an art form. In the process, except for the works of a few independents, almost all types of animation previously made faded into the distance. Chinese animation became a culture industry. In the spirit of Horkheimer and Adorno, it was flawed by the transfer of the "profit motive naked onto cultural forms," "eternal sameness," and distribution and mechanical reproduction contrary to the technique of art.[46]

8

Of Institutional Supervision and Individual Subjectivity:
The History and Current State of Chinese Documentary

*Yingjin Zhang**

Throughout the history of Chinese documentary filmmaking, persisting tensions between institutions and individuals have structured patterns of experimentation, proliferation, and diversification. In the presocialist period, the Nationalist and Communist parties both sought to preserve their versions of history by investing in documentary filmmaking and by preserving their achievements (mostly military and political) on celluloid. Nation building was an overriding institutional policy during the socialist period, when the Communist regime expanded the networks of filmmaking and broadened the range of documentary genres beyond newsreels to include education, science, and stage performance. In part owing to the development of television, documentary bloomed in the postsocialist period. New party policies of reform and opening made crucial structural changes possible within film and television industries, and aspiring artists explored a brand new world of independent, unofficial, and semi-official production. Overall, the recent documentary trajectory moved away from an obsession with grand history (war, revolution, modernization) and toward a multitude of recorded images of fast-changing landscapes and mindscapes of contemporary China. Yet, the institutions of the state "system" (*tizhi*) as well as overseas media and arts organizations continue to exert power and invariably shape the formation of individual subjectivities in Chinese new documentary. A proper institutional perspective, therefore, is essential to an understanding of the development of documentary in twentieth-century China.

This chapter is a brief survey of the history and current state of Chinese documentary. The first two sections trace the rise of documentary filmmaking in early twentieth-century China and its development under direct state supervision through the

* The author acknowledges the University of California — San Diego for an academic senate research grant in 2006.

socialist period. The second half of this chapter samples subjects, styles, and special functions of new documentaries and situates this trend of unofficial filmmaking in the institutional context of transnational cultural politics (e.g., domestic marginalization, international film festivals, global media, and foreign investment). Given space limitations, documentary in Hong Kong and Taiwan will not be covered here, although Taiwan has witnessed a rapid growth of documentary in the twenty-first century.[1] Instead, new documentary in mainland China since the late 1980s constitutes the major focus in this chapter.

Early Experimentation: Institutions and Investments, 1905–1949

As in many countries around the world, the production of documentary preceded that of fiction film in China. In 1896, the Lumière Brothers dispatched photographers to capture street scenes in Hong Kong. Two years later, Edison's photographer shot actualities in Hong Kong and Shanghai, while in 1909, the French company Pathé came to shoot scenery in Beijing. Early foreign documentaries displayed orientalist tastes as many of them reportedly focused on Chinese women's bound feet, Chinese men's long queues, as well as opium smoking and other images of a sick China.[2]

Chinese investments in filmmaking started with *Ding Jun Mountain* (*Ding Jun Shan*, 1905), a Peking opera episode shot by a photography studio in Beijing. Apart from its significance in providing a birth year for Chinese cinema, this short film represented an effort to integrate documentary method, theatrical performance, and episodic narrative in a founding moment. The martial outfits of opera star Tan Xinpei (1847–1917) might also work to combat widespread humiliating portrayals of the Chinese in foreign films of the time. This hidden *patriotic* concern was articulated explicitly in a 1919 document the Commercial Press (Shangwu yinshu guan) submitted to the Beijing government to justify its establishment of a motion picture department in 1918: domestically, their films would "aid popular education in resistance to morally detrimental foreign films," while internationally they would "promote Chinese culture, abate foreigners' contempt for China, and stir up patriotism among the overseas Chinese."[3] In the Commercial Press classification of its productions, the first three of five categories (scenery, current affairs, education, ancient drama, and new drama) were related to newsreel and documentary. Of particular importance were newsreels of sports events, for fresh images of athletic and competitive Chinese visually heralded a new China.

Patriotism was even more pronounced in the documentary work of Lai Man-wai (Li Minwei, 1893–1953), a pioneer of Hong Kong and Shanghai cinemas and a firm believer of "national salvation through film" (*dianying jiuguo*). Lai captured rare footage of Sun Yat-sen (Sun Zhongshan), the preeminent Nationalist leader, on several historical occasions from 1921 to 1925, and in 1927 Lai released a nineteen-minute "compilation documentary" (*wenxian jilu pian*) chronicling the campaigns of the Nationalist revolution. By that time, Lai had relocated his film enterprise from Hong Kong to Shanghai, where similar documentaries of current affairs (including anti-imperialist demonstrations in Shanghai) were produced by other private companies.[4]

The Battle of Shanghai in 1932 destroyed several Shanghai studios and convinced many filmmakers to take up the nationalist cause. From then to the end of the resistance war in 1945, anti-Japanese news dominated documentary productions in China. Other types of documentary also developed in the 1930s, such as scenery, sports, theater (*xiqu*, including spoken dramas and regional operas), education, and ethnography. A rediscovered documentary pioneer of this time was Sun Mingjing (1911–1992) of Jinling University in Nanjing, who brought a crew to north China and produced dozens of documentaries for educational purposes.[5] One of them, *Farmers in Springtime* (*Nongren zhi chun*, 1937), won a prize at the Brussels International Exposition in 1937. Ethnographic documentary started in China in 1926, when Swiss explorer Sven Anders Hedin began to lead several Chinese teams through northwest China over an eight-year period; some of their documentaries were shipped to Beijing for screenings at educational institutions.[6] A significant Chinese investment in ethnographic documentary came in 1933 when the Academia Sinica dispatched a team headed by Ling Chunsheng (1902–1987), who held a doctorate in anthropology from the University of Paris, to the Miao and Yao ethnic minority areas in Yunnan and West Hunan.[7]

Compared with experiments by private film companies and academic institutions, the Nationalist government invested much more in documentary filmmaking. In the early 1930s, the government hired such companies as Lianhua to film its anti-Communist military campaigns in south China, but the apparent lack of efficiency prompted the Nationalists to establish their own film enterprises. In 1934, the Central Film Studio (Zhongdian) was founded in Nanjing under the Nationalist Party's central propaganda committee, and within one year, its newsreel production exceeded 200 titles. The emphasis on newsreels of current affairs continued through the war, with only occasional ventures in documentaries such as the ten-reel *Tours of Tibet* (*Xizang xunli*, 1940), whose reduced political message inadvertently increased its ethnographic value.[8] In 1938, the China Motion Picture Studio (Zhongzhi) was instituted in Wuhan under the Nationalist government's military affairs committee, and it was devoted primarily to newsreel production, although some footage was later integrated into documentary works, such as *Long Live the Nation* (*Minzu wansui*, 1949) directed by Zheng Junli (1911–1969). Two other state-funded filmmaking institutions were the China Education Film Studio (Zhongjiao) and the China Agricultural Education Studio (Nongjiao), established in 1942 and 1943 respectively, both in Chongqing, the wartime capital. The Nationalist government developed an elaborate system of mobile projection teams, which toured hard-to-reach places in the hinterland and served millions of troops and civilians. Apart from hinterland screenings, 183 copies of Chinese productions were distributed overseas between 1939 and 1941, and eighteen films were exhibited in ninety-two foreign cities.[9]

During the war, the Communists also experimented with documentary filmmaking. In 1938, Yuan Muzhi (1908–1978), a veteran Shanghai film actor and director, successfully brought filmmaking equipment, including a portable 35mm camera donated by Joris Ivens, a world-famous Dutch documentarist, to the Communist headquarters in Yan'an. Yuan joined the newly established Yan'an Film Corp and immediately embarked on an

ambitious project, *Yan'an and the Eighth Route Army* (*Yan'an yu balujun*). The shooting was elaborately planned and lasted two years. In 1940, Yuan brought the negatives to the Soviet Union for postproduction, but the outbreak of the World War II resulted in the loss of materials.[10] However, the Yan'an Film Corp was able to complete *Joining Production and Fighting* (*Shengchan yu zhandou jiehe qilai*, 1943) and short documentaries under difficult circumstances. Meanwhile, Yuan stayed in the Soviet Union until 1946, when he traveled to Changchun and joined other members of the Yan'an Film Corp in an effort to confiscate film equipment from the Manchurian Motion Picture Corporation (Man'ei), a studio operated by the Japanese since 1938. The Communists relocated some of the Man'ei facilities before Nationalist troops entered Changchun, and with their newly acquired equipment, the Communists were able to establish the Northeast Film Studio and produce numerous documentaries in the ensuing civil war period until 1949.

From 1937 to 1945, the Man'ei invested heavily in over 500 titles of documentary (*qimin dianying* or "education film") and newsreel production — two types classified under "cultural films" (*wenhua dianying*), to be distinguished from feature productions (*yumin dianying* or "entertainment film"), which accounted for around 120 titles. In comparison, the Shanghai film industry under the Japanese occupation invested much less in documentary production. However, when Japanese and pro-Japanese institutions of filmmaking were confiscated by the Nationalist government after the war, pro-Nationalist documentary filmmaking resumed in Shanghai, Beijing, Changchun, and Nanjing, although not as effectively as the Communist operations. From early 1947 to July 1949, the Communist Northeast Studio commanded thirty-two mobile production teams. By the end of 1949, the Communists operated three large film studios (Northeast, Beijing, and Shanghai) and fifty-eight documentary production teams.[11]

Socialist Proliferation: Propaganda and Publicity, 1950–1979

Obviously, prolonged wartime activities in the first half of the twentieth-century gave a particular shape to Chinese documentary filmmaking, and documentary was thus instituted predominantly to serve specific ideological, political, and even military forces. Institutional concerns overwhelmed individual filmmakers, whose room for experiment and creativity was strictly limited and whose role in documentation was largely reduced to a technical or even instrumental function. Political loyalty to a given institution was paramount to a filmmaker's career. In Yuan Muzhi's case, he was transformed directly into a revolutionary in Yan'an. The Communist Party's high opinion of film as a powerful ideological weapon was evidenced in Chairman Mao Zedong's invitation to Yuan to dine with him in private before Yuan departed for the Soviet Union in 1940.[12] Yuan's pioneering work on Communist filmmaking qualified him for ranking positions as head of the Northeast Studio in 1946 and director of the Central Film Bureau in the People's Republic of China in 1949.

If wartime and postwar documentary production was marked by military contingency, in the socialist period documentary was strictly supervised and produced according to pre-assigned studio quotas. Its service to state propaganda was immediate and influential,

and filmmakers were instructed to work on a series of military campaigns (e.g., sea battles, the Korean War) and political events (e.g., land reform, nationalization of industries, abolition of prostitution, ethnic solidarity, diplomatic relations). The demand on documentary production was such that a series of new studios were launched in succession: the August First Film Studio in Beijing in 1952 (initially named the People's Liberation Army Studio), the Central Newsreel and Documentary Studio in Beijing in 1953, the Shanghai Science Education Film Studio in 1953, the China Agricultural Film Studio in Beijing in 1954, and the Beijing Science Education Film Studio in 1960.

Such institutional proliferation prompted a revival of old documentary genres as well as experiments with new categories. Apart from pedagogical titles aimed at mass education in agriculture, science, technology, and health, biographic documentary (e.g., about renowned painter Qi Baishi) brought a fresh look to the screen, and critical documentary (e.g., a work criticizing wasteful or low-quality products) emerged as a rare sub-genre during the short-lived Hundred Flowers Movement in 1957. Scenic documentaries featured picturesque sites such as Guilin, Huangshan, and the Summer Palace in Beijing, and documentaries of arts, performances, and sports were popular. Filming theatrical performances held immense attraction, and with successes such as *Liang Shanbo and Zhu Yingtai* (1954), the first color film in the new China directed by Sang Hu (b. 1916) and Huang Sha, theater documentary (*xiqu jilu pian*) tended to mutate into a distinct genre, that of stage arts (*wutai yishu pian*), sometimes designated separately from features (*gushi pian*) and documentaries (*jilu pian*).[13] Other examples of theater documentaries, such as *The Dream of the Red Chamber* (*Honglou meng*, 1962), directed by Cen Fan (b. 1926) and co-produced by Shanghai's Seagull (*Haiyan*) and Hong Kong's Golden Sound (*Jinsheng*), would each reach 100 million viewers nationwide.

The proliferation of filmmaking institutions and documentary productions was implemented at a dazzling speed during the Great Leap Forward. All provinces and autonomous regions — with the exception of Tibet — launched their own film studios from 1958 to 1960. As for newsreels and documentaries, the combined output of 1,717 reels in 1958–1959 far exceeded the total output of 1,306 reels in the previous nine years, and the 1960 output reached 1,228 reels.[14] A new hybrid genre came into being amid the frenetic proliferation: "artistic documentary" (*yishuxing jilu pian*) or "documentary feature" (*jiluxing yishu pian*), which normally cast real people in restaging "real" events. For example, in *Huang Baomei* (1958), directed by Xie Jin (1923–2009), national model worker Huang Baomei plays herself and, in a controversial ending, leads her six co-workers in a dance in their textile factory, all dressed in fairies' costumes. To fill production quotas, several studios released a total of forty-nine documentary features in 1958, which accounted for 46.6 percent of the year's 105 total feature productions, an annual record not surpassed until 1981.[15] Dozens of similar documentary features were produced in the following two years, and some cast movie stars in place of real people. After 1960, owing to a policy change aimed to correct the Great Leap Forward mentality, this genre disappeared from the Chinese screen entirely.

Although theater and artistic documentaries might have allowed for some imaginative latitude on the part of filmmakers, as a rule documentary production during

the socialist period was strictly regulated and made to function as an indispensable part of the state propaganda machinery. Filmmakers were dispatched all over the country to document achievements in every aspect of socialist construction, advancement in China's diplomatic relations, and increasing solidarity between the Han majority and ethnic minorities. Yet, documentary might serve more than a publicity purpose when it satisfied the audience's appetite for exotic foreign scenery and custom by following the national leaders' visits to friendly countries like Indonesia and North Korea. During the 1950s and 1960s, a systematic "rescue" (*qiangjiuxing*) effort was made to collect visual documents of China's fifty-five ethnic minorities, and the participation of professional filmmakers improved the overall quality of ethnographic documentary.[16]

The institutional role of documentary to serve party interests was most evident during the Cultural Revolution period. Documentaries of Chairman Mao's eight widely publicized receptions of tens of thousands of Red Guards at Tiananmen Square in Beijing were part of the media campaign to mobilize the young and impressionable. To enhance the publicity of her image as a supreme cultural leader, Jiang Qing, Mao's wife for over thirty years by then, personally supervised the documentary filming of some of the eight "model plays" (*yangbanxi*, actually consisting of five Peking operas, two ballets, and a piano-accompanied Peking opera concert performance). Her effort started in 1970, which marked the unprecedented record of zero feature productions since 1967. Some of the model play films cost over a million yuan, and several went through multiple shootings on Jiang's orders. Undeniably, the publicity associated with model play films was enormous, as these films were shown repeatedly across China for years.

The political use of documentary was best exemplified in the production of *Beloved Premier Zhou Enlai Lives Forever* (*Jing ai de Zhou Enlai zongli yongcui buxiu*, 1976). Regarded by most as a moderate leader who had protected artists and intellectuals, Zhou Enlai died on January 8, 1976. Filmmakers from the Central Newsreel and Documentary Studio worked days and nights to complete a documentary by January 28, 1976, much to the displeasure of Jiang Qing and her faction known as the "Gang of Four." However, the documentary went through months of censorship before its release on January 8, 1977, which triggered torrential emotions among audiences across the nation. Yet, even though the "Gang of Four" had been ousted by then, the first version did not show Deng Xiaoping reading the obituary at Zhou's funeral. On January 8, 1978, the deleted footage of Deng's reading was restored for a second round of exhibitions, but his voice was replaced by that of a narrator. On January 8, 1979, the third publicly exhibited version finally restored the original synchronized sound recording of Deng's reading. Although filmmakers claimed that they had preserved historical truth,[17] this case demonstrates that documentary in the socialist period also functioned to inform the public of which leaders were obviously in power and which were likely to be in trouble — a function now taken over by national television newscasts.

Television stations started operations in Beijing, Shanghai, and Harbin in 1958, but limited reception range and the limited ownership of television sets constrained that medium's influence during this period. In 1959, the airtime of Beijing TV (the prototype of China Central Television or CCTV) consisted of 50 percent cinema and 30 percent

theater. Newscasts with onsite reporting were a rarity, and even less common were substantial documentary programs. It was not until 1966 that a thirty-minute documentary about an exhibition of human sculptures with an emphasis on rural class struggle, *The Tax-Collecting Compound (Shouzu yuan)*, generated favorable publicity for Beijing TV. The Ministry of Culture decided to transfer the 16mm documentary onto 35mm format, and the documentary was distributed nationwide and exhibited for eight years.[18]

Postsocialist Diversification: Innovation and Independence, 1980–present

Television broadcasts would eventually take over the news reporting function of documentary films. In the socialist period, newsreels and short documentaries were screened before a feature presentation, and audiences demanded such a bundled package because they would otherwise have no access to moving images of major events before television sets became affordable in the 1980s. Since movie ticket prices were set, newsreels and documentaries before feature presentations appeared as an added bonus, so the bundle exhibition practice worked as an effective promotion of feature films. Occasionally, feature-length documentaries enjoyed separate screenings, and reportedly cities like Beijing, Tianjin, and Shanghai had cinemas exclusively reserved for newsreel and documentary screenings.[19]

The decline of documentary film paralleled the general trend of falling movie attendance. In 1979, movie attendance in China was 29.3 billion or 28 per capita, exceeding the highest record in the United States of 23 per capita. By 1999, the annual attendance had dropped to 1 billion, a merely 3.4 percent of where it had been twenty years before. In comparison, household ownership of television sets skyrocketed from 4.85 million nationwide in 1979 to 274.87 million in 1994.[20] Of course, the decline of the film industry was triggered by many factors other than the rise of television. However, television's growing popularity may actually prove to be a blessing in disguise as far as documentary is concerned, for it is the restructuring of television production that inadvertently has paved the way for the emergence of new documentary, both inside and outside the state system, as we shall see below.

Nonetheless, conventional documentary — distinguished by its unambiguous ideological message and self-confident voiceover narration — still dominated the immediate post-Mao years. Filmmakers cautiously echoed the official line and busied themselves searching for visual evidence in support of new policies — evidence ranging from special economic zones (e.g., Shenzhen), the policy of "one country, two systems" for Hong Kong, to spectacular achievements in sports and scientific expeditions to Antarctica. One new development in the 1980s was the popularity of compilation documentary, particularly biographic documentary, which expediently served to rehabilitate wrongly accused national leaders like former President Liu Shaoqi, but which also subsequently provided a forum for other historical and cultural figures, even movie stars like Zhao Dan (1915–1980). A wider range of subject matter in the postsocialist period encouraged narrative and visual innovation and resulted in a

variety of new styles and new points of view. For instance, a documentary on military dog training is narrated entirely from the viewpoint of a dog, and a documentary of breathtaking natural beauty in Jiuzhaigou and Huanglong is devoid of commentary but accentuated with music, thereby evoking a poetic ambience.

Ethnographic documentary also developed rapidly in this period. In 1979, the Institute of Ethnic Studies in the China Academy of Social Sciences set up a film group, which was subsequently restructured as a research unit in visual anthropology. In 1992, the institute worked with a German institution and restored a number of ethnographic films from the socialist period with added English subtitles. Beginning in the early 1980s, the Central Academy of Ethnic Minorities in Beijing also invested in ethnographic filmmaking. Compared with the previous periods, ethnographic filmmaking has now advanced on all fronts, from the standpoint of academic value and visual quality to its domestic appeal and even in terms of overseas cooperation. Yunnan University established the Institute of East Asian Visual Anthropology in 1994 with the initial support from a media entrepreneur, Xiao Feng, and the institute eventually attracted a multi-year German grant in 1999. Not only has Yunnan TV extended its documentary coverage of ethnic cultures, private film and television companies have entered the scene, producing documentary as well as promoting exhibition by organizing film festivals and preserving visual archives.[21]

Interestingly, ethnic topics attracted a few pioneers of independent documentary, such as Duan Jinchuan (b. 1962) and Jiang Yue (b. 1962). Their unique makeshift mode of production, in conjunction with their path-breaking new styles and their alternative visions of contemporary Chinese society, initiated a growing trend of independent film- and video-making. Nonetheless, the fact that Duan worked at Tibet TV for eight years reveals that issues of ideology, institution, independence, and innovation are not separated but linked together. Before examining new documentary in detail, we must look at institutional and ideological changes that made the major breakthrough possible.

By the early 1990s, official documentary filmmaking had declined precipitously so that the government decided to merge both the Central Newsreel and Documentary Studio and the Beijing Science Education Studio under the sprawling enterprise of CCTV. Similarly, the Shanghai Science Education Studio was integrated into Shanghai Oriental TV. Film studios now produced documentaries for television stations, and compilation documentaries, many of them in multiple episodes, tapped into the studios' rich archives of historical footage and became all the rage in television and film markets. By the mid-1990s, documentary films occasionally became serious contenders at the domestic film box office. *Fierce Battles: True Records of the Korean War* (*Jiaoliang: kang Mei yuan Chao zhanzheng shilu*, 1995), directed by Wang Jinduo, ranked number three in 1996; *Zhou Enlai and Diplomatic Storms* (*Zhou Enlai waijiao fengyun*, 1997), directed by Fu Hongxing (b. 1963), performed even better, raking in 35 million yuan in ticket sales and topping the 1998 box office. Even though mandatory viewings by public schools and complimentary tickets issued by government units might account for the extraordinary box-office figures of such documentaries, which belong to the category of "leitmotif" or "main melody" film (*zhuxuanlü dianying*),[22] their popularity

was unmistakable because *Fierce Battles* was exhibited as late as 1999–2000, and *Zhou Enlai and Diplomatic Storms* was aired a dozen times on CCTV and reached hundreds of millions of viewers. The continuing interest in historical figures and events for Chinese audiences is undeniable.

If these two box-office favorites reconfirm the potential of documentary film in the postsocialist market economy, *The Great Wall* (*Wang changcheng*, 1991), a CCTV documentary series co-produced with Japan, is regarded as a milestone in Chinese television history. A number of successful coproductions with Japan in the 1980s, such as *Speaking of the Yangtze River* (*Huashuo Changjiang*, twenty-five episodes, 1983), had already been credited for bringing new concepts and practices to Chinese television documentary. In *The Great Wall*, extensive use of long takes, follow-up sequences, synchronic sound recording, and the host's interaction with interviewees all seem to cohere into an impressive work that documents local people's daily lives on both sides of the Great Wall.[23]

In retrospect, the shifting of focus to ordinary people evident in *The Great Wall* might have been inspirational to many documentarists eager to explore new territory by resorting to new techniques and styles. Admittedly, this focus itself was not new, for socialist propaganda had been full of model workers and revolutionary heroes. What appeared new, then, was an implicit refusal to elevate ordinary people to "masters of socialism" in accordance with official discourse and an explicit avoidance of self-assuring narration on behalf of the people. In his eight-part documentary *Tiananmen* (started in 1988, completed in 1992), Shi Jian (b. 1963) of CCTV uses long-take tracking shots of Beijing *hutong* (narrow alleys) and residents without establishing their relevance to dominant ideology via voiceover narration. Originally designed for the celebration of the fortieth anniversary of the People's Republic, the series did not pass censorship because its images were judged too "gray" and "passive" for the occasion.[24] Over time, however, the preference of visual exhibition over verbal narration as found in Shi Jian's work would prove to be a distinctive feature of new documentary in China.[25]

Contrary to his fellow aspiring documentarists, Shi Jian chose to stay with CCTV and quickly assumed a leadership position in launching influential television programs: *Eastern Horizons* (*Dongfang shikong*) in May 1993 and *Speaking in Earnest* (*Shihua shishuo*) in March 1996.[26] A sub-program of *Eastern Horizons* was *Living Space* (*Shenghuo kongjian*), and its producer Chen Meng (b. 1961) issued the slogan: "tell ordinary people's stories."[27] It is debatable whether many episodes aired on *Living Space* qualify strictly as documentary, but the program's emphasis on letting subjects tell their stories poses a daunting challenge to conventional television reporting and documentary filmmaking. Ideally, this program would no longer speak for "ordinary people" (*laobaixing*) but rather serve as a conduit to their voices. The television industry's investment in documentary had started with the Shanghai TV program, *Documentary Editorial Office* (*Jilu pian bianji shi*), the first of its kind in the nation. Launched in February 1993 and broadcast at 8 p.m., in prime time, this program retained a high 30 percent viewer rating for two years, with other television stations soon establishing their own documentary programs in the 1990s.[28] For instance, Beijing TV launched *Ordinary*

People's Homes (*Baixing jiayuan*) in March 1997, and Fujian TV began *Shooting Our Own Stories* (*Ziji de gushi ziji pai*) in May 1999. Both programs modified the slogan "tell ordinary people's stories," but they went further than CCTV by training people to shoot their own stories — an unprecedented practice that "subverted" the establishment and "returned documentary to the masses," giving them at least a semblance of long-denied agency and subjectivity.[29]

The expansion of programming gave television producers more freedom in contracting work from people outside the system.[30] Just as Shi Jian could find time away from his CCTV duties to work on his independently produced *Tiananmen*, Jiang Yue, an independent who had quit his assigned job at Beijing Studio, gladly accepted CCTV's invitation to contribute episodes to *Living Space*, while working on his independent documentary, *The Other Bank* (*Bi an*, 1995). Even without working specifically for an official institution, Wu Wenguang (b. 1956) still relied on the camera and other equipment belonging to the state when he shot his early works. In postsocialist China, the borders between official, semi-official, and unofficial were forced open for two-way crossings and creative appropriation. Such open borders were of course never permissible in the rigid socialist system.

New Documentary: Movements and Modalities, 1988–present

A founding moment of new documentary was an informal meeting of Duan Jinchuan, Hao Zhiqiang, Jiang Yue, Li Xiaoshan (b. 1957), Shi Jian, Wen Pulin, Wu Wenguang, and Zhang Yuan (b. 1963) in Zhang's Beijing apartment in the winter of 1991.[31] All concurred with Wu's twofold definition of independent documentary: first, independent thinking, which stresses freedom of expression and non-interference from others; and second, independent production, which requires one's own financial support and not taking money from state funding.[32] Independence thus conceived would encompass several configurations: from complete independence (ideological, financial as well as institutional, like Wu Wenguang and several newcomers), semi-independence (ideological but not entirely institutional or financial, like Duan Jinchuan and Jiang Yue, who did part-time work for state institutions in the early 1990s and pursued contract work for foreign media in the new century), to occasional independence (financial but neither ideological nor institutional, like Shi Jian and Sun Zengtian [b. 1958], who both stayed with CCTV). In the strictest sense, independence refers only to the ideological, for accepting private financial support would still count as taking money from others, and all pioneers of new documentary operated this way in their early years.

Some critics trace the source of independent documentary to the "unofficial" (*minjian*) production of avant-garde arts and obscure poetry (*menglong shi*) from 1979 onwards.[33] In fact, "underground" (*dixia*) has been a frequently used term for such unofficial venues in post-Mao China: underground arts exhibitions and underground publications had attracted public attention in the early 1980s, but underground filmmaking did not emerge until 1988, when several projects were launched separately: Shi Jian's *Tiananmen*, Wu Wenguang's *Bumming in Beijing: The Last Dreamers* (*Liulang Beijing:*

Zuihou de mengxiang zhe, 1990), and Zhang Yuan's docu-drama *Mama* (1991).[34] Also in 1988, Jiang Yue and Wen Pulin started work on *The Great Earthquake (Da dizhen)*, a project abandoned halfway, and Wu Wenguang's consultation for a CCTV series, *Chinese People (Zhongguoren)*, went nowhere after the authorities canceled the project. In fact, "underground" has never been a favorite term for new documentarists, who prefer "independent" *(duli)*, a label allegedly invented by Jiang Yue when he identified himself as such on registration for a Beijing forum on new documentary, which Shi Jian organized in December 1991.[35]

Another term that deserves scrutiny is "movement" *(yundong)*. Lü Xinyu interprets what Shi Jian and his colleagues envisioned in 1991 as a "new documentary movement." However, Duan Jinchuan offers a more moderate view: "actually it did not turn into a movement or a revolution."[36] Duan's reservations may derive from the heavy ideological baggage the term "movement" carries in modern Chinese culture. Politically charged, the term evokes the image of one massive force going all the way to wipe out resistance and conquer territory — something independent documentarists normally attribute to official ideology. Nevertheless, if conceived as motion across physical and conceptual space, "movement" captures the essence of new documentary in China. Indeed, physical movements characterize people on both sides of the camera. Just as Wu Wenguang had moved between Kunming and Xinjiang and had visited Tibet before residing in Beijing in 1988 without any official affiliation, migrant artists in his *Bumming in Beijing* moved to Beijing and tried desperately to make a living. The fluidity of their identities as painter, photographer, theater director, and writer would become even more remarkable in Wu's follow-up documentary, *At Home in the World (Sihai weijia*, 1995), which portrayed these migrant artists to Austria, France, Germany, Italy, and the United States. Wu's fascination with migration continued in his first DV documentary, *Jiang Hu: Life on the Road (Jianghu*, 1999), which documents the difficulties of a private itinerant song-and-dance troupe.[37]

Outside the textual world, Wu traveled to Japan in 1991, where his *Bumming in Beijing* received critical attention at the Yamagata International Documentary Festival. Wu returned to Beijing with copies of representative works by Ogawa Shinsuke and Fredric Wiseman, and for the first time Chinese independents realized what documentary meant and what their foreign counterparts had been doing. Such an unexpected movement of documentary concepts across national borders exerted an immediate influence on China: Ogawa's unwavering concern for disadvantaged villagers has found echoes in Chinese independents' care for the underprivileged and underrepresented,[38] while Wiseman's alternative vision and observational style inspired Duan Jinchuan's *No. 16 South Barkhor Street (Bakuo nanjie 16 hao*, 1997), which earned Duan the nickname "China's Wiseman."[39]

Like Wu Wenguang, Duan Jinchuan was a migrant artist of sorts, whose career trajectory is crisscrossed with movements between the center (Beijing) and the periphery (Tibet); between official (Tibet TV), semi-official (nominal affiliation with CCTV), and non-official (the independent company China Memo he co-founded with Jiang Yue and Kang Jianning [b. 1954] around 2001); as well as between China and overseas (Japan,

France, England). Some critics speculate on the importance of independents' multiple identities: If they did not present themselves as CCTV personnel, would Duan and Jiang be allowed to film sensitive scenes?[40] Now that Duan and Jiang have gone professional and have acquired symbolic capital with their award-winning titles, are they willing to revert to their previously alternative vision and oppositional stance? Moreover, is a compromise the inevitable middle ground between institutional supervision and individual subjectivity?

It is significant to note that China Memo's first documentary series, Duan's *The Secret of My Success* (*Lingqi da shetou*, 2002) and Jiang's *This Happy Life* (*Xingfu shenghuo*, 2002), were produced on presale terms with six European television stations, reportedly at a price eighty times higher than that of CCTV.[41] A third title in the series, *Dancing with Myself* (*He ziji tiaowu*, 2002) was withdrawn by Li Hong (b. 1967), for she did not want the BBC editor to freely re-edit her work, although it was not clear whether the BBC had the right to do so anyway as it had prepaid for the product. Kang Jianning's *Join the Army* (*Dangbing*, 2000) replaced Li Hong's project, and the entire series carries the eye-catching title, "Workers, Farmers, Solders" (*Gong, nong, bing*). The films were screened both overseas and at home, in the latter case both at CCTV and at independent documentary venues. China Memo illustrates that, independent or not, new documentary does not always assume an anti-establishment stance, for "establishment" in the age of globalization refers to "a three-legged system, composed of the party-state apparatus, the marketized economy, and the foreign media and art organizations."[42] Rather than the previously honored outside or marginal position, Duan and Jiang nowadays work inside the market economy and feel both confident and comfortable in their negotiation with the party-state and the foreign media.

To varying degrees, the three-legged system provides a new institutional framework for what can and cannot be produced. If some veteran independents have softened their tones since the late 1990s, newcomers have kept the undaunted spirit of new documentary alive by exploring an even wider range of subject matter. Li Hong articulated the yearnings of young rural girls working as hired nannies in Beijing in *Out of Phoenix Bridge* (*Huidao Fenghuangqiao*, 1997). Du Haibin (b. 1972) shed light on the miserable homeless in *Along the Railroad* (*Tielu yanxian*, 2000). Michelle Chen (Chen Miao) presented a flamboyant Shanghai gay nightclub singer in *The Snake Boy* (*Shanghai nanhai*, 2001). Hu Shu (b. 1967) exposed intimate concerns of female sex workers in brothels and massage parlors in *Leave Me Alone* (*Wo buyao ni guan*, 2001). Ying Weiwei (b. 1970) revealed the bittersweet closet life of a lesbian couple in *The Box* (*Hezi*, 2001). Wang Bing (b. 1967) unraveled an astonishing picture of bankrupt socialist industrial complexes in *West of the Tracks* (*Tiexi qu*, 2001), a three-part, 450-minute epic documentary. Hu Jie (b. 1958) reconstructed the tragic life of a Peking University student in 1957, a rightist persecuted to death in *Searching for Lin Zhao's Soul* (*Xunzhao Lin Zhao de lingyun*, 2004). Earlier, religious themes attracted attention from Duan Jinchuan, Jiang Yue, and Wen Pulin, and environmental issues found an impressive treatment in Hao Zhiqiang's *Big Tree Village* (*Dashu xiang*, 1993).[43]

Subject matter alone, however, does not suffice to distinguish new documentary from state-sponsored productions. Creative treatment with which reality or truth is captured is what makes new documentary a crucial development in contemporary Chinese visual culture. Taiwan scholar Wang Weici delineates four modes of documentary in contemporary China: 1) conventional voiceover (straightforward propaganda), which characterizes the mainstream media; 2) observation, which emphasizes non-interference and derives from Euro-American direct cinema and *cinéma vérité*; 3) interviews, which became popular with CCTV's *Living Space*; and 4) self-reflection, which is still rare in China.[44] In terms of international documentary history, Wang's delineation is incomplete, so here we turn to Bill Nichols, who charts a genealogy of international documentary modes: 1) the "expository" mode (1930s, "directly address the real"); 2) the "observational" (1960s, "eschew commentary, observe things as they happen"); 3) the "interactive" (1960s–1970s, "interview, retrieve history"); 4) the "reflexive" (1980s, "question documentary form, defamiliarize the other modes"); and 5) the "performative" (1980s–1990s, "stress subjective aspects of a classically objective discourse").[45] More recently, Nichols renamed "interactive" as "participatory" and added the "poetic" (1920s, "reassemble fragments of the world poetically") as a new mode.[46]

Nichols's genealogy has been challenged because, historically, documentary modes did not develop in such a neat succession and different modes often exit simultaneously.[47] In postsocialist China, various modes indeed coexist, but Nichols's scheme can still help us understand the important role new documentary modes and styles play in breaking away from the orthodox tradition in China — the voice of the party — which dictates that the viewer be spoon-fed the correct interpretation via voiceover narration, the scenes of poverty and misery be avoided or concealed, and dialogue pre-scripted for subjects, some of whom might even be performed (*banyan*) by others.[48] To distance himself from monolithic official discourse, which denies subjectivity to both documentarists and their subjects, Duan Jinchuan experiments with the observational mode and lets insignificant events unfold right before the viewer, thereby leaving room for multiple interpretations. To restore the subjectivity of his subjects, Wu Wenguang frequently uses on-camera interviews and sometimes even participates directly in a documentary. Nonetheless, due to the reduction of the documentarist's explanatory power, both observational and participatory modes limit the subjectivity of the artist, whose views may be preempted by required non-interference. This deficiency is remedied by the reflexive mode, in which a documentarist — as Ju Anqi (b. 1975) does in his radically experimental work, *There's a Strong Wind in Beijing* (*Beijing de feng henda*, 2000) — accentuates his or her own presence and forces the viewer to confront issues pursued by the documentary. The self-reflexivity thus attained applies not only to the documentarist but also to the camera's mediation role, and the performative mode further questions the fundamentally subjective way any truth can be articulated and captured at all, as in Ying Weiwei's *The Box*, where a lesbian couple act out their embodied truth.[49] Finally, a more artistic option for documenting fleeting images of reality is offered by the poetic mode, which is fruitfully explored by Ou Ning and Cao Fei in *San Yuan Li* (2003), where the global is juxtaposed with the local, the futuristic with the archaic, and the mechanical with the emotional.

Concluding Remarks: De-politicization and Dissemination

Chinese independent documentary since the late 1980s has been credited for a number of significant changes: diversification of styles, de-politicization of narration, restoration of a plebeian (*pinmin*) attitude, individualization (*gerenhua*) of perspectives, establishment of an international outlook, and attention to the ontology of documentary.[50] While its impact on official documentary productions, especially television programming, is unmistakable, one must not forget that new documentary actually started both inside and outside official institutions, and independent works are educational in their own way, even though their creators have denounced official documentary's propagandist function. Owing to its marginalization (*bianyuan*) in contemporary China — a deplorable fact sometimes attributed in part to irresponsible dismissals by self-designated "mainstream" (*zhuliu*) intellectuals — independent documentary has consistently pursued alternative, oppositional, and even subversive functions.[51]

Their opposition and subversion are measured by their frequent claims that their works are more truthful and objective than state-sponsored productions. "My camera doesn't lie," for instance, has been used to show independent filmmakers' defiance against the establishment, but many Chinese independents have to face a dilemma: their versions of truth often encounter two diametrically different receptions — acknowledged as daring and revelatory by the foreign media but dismissed as narcissistic or pretentious by the Chinese media.[52] After all, distribution and exhibition of China's independent documentaries take place more often outside China than inside, and foreign institutions have the power to decide which Chinese work fits their definition of truth and reality in China. An experienced guest at overseas film festivals, Wu Wenguang concedes to the necessity of Chinese independents' vigilance against both mainstream ideology's oppression at home and hegemonic cultural imperialism's interpretation abroad.[53] On a positive note, however, more and more domestic venues are available for exhibiting independent works, especially after the dissemination of digital video (DV) technology in the new millennium.

From the outset, the Chinese media predicted a "DV movement" to sweep across the nation. In 2000, Hong Kong–based Phoenix Satellite TV (Fenghuang weishi) sponsored a documentary program and solicited student works from twenty some universities. Early entries were not satisfactory, as imitations of CCTV's *Living Space* and underground films were judged to demonstrate more attitude than substance. Instead of imitative works, Phoenix TV called for authentic stories for its program *My Parents* (*Wode fuqin muqin*) and encouraged a new kind of DV making characterized by amateurish styles, personal visions, and unofficial perspectives.[54] Interestingly, despite Phoenix TV's disparaging words about underground filmmaking, its characterization of the new DV movement reminds us of independent documentary's alternative visions. New documentary has ostensibly influenced both the DV movement and the media's anticipation of creative results from digital dissemination. Not surprisingly, most independent documentarists now work with the DV camera, regardless of whether they consider themselves part of the new DV movement.

From documenting cultural practices in 1905 to capturing historical events throughout the twentieth-century to articulating personal views in the new millennium, Chinese documentary has gone a long way and accomplished a great deal. The age of institutional monopoly of documentary production is over, although regular means of investment, distribution, and exhibition are still beyond most independents' reach. Still, the DV age has made alternative routes of distribution and exhibition possible (e.g., via DVD, Internet, film clubs), and increasing public attention and semi-official recognition of independent documentary are noticeable in a spate of recent publications of documentary histories as well as interviews, biographies, filmographies, and reviews related to a growing list of independents.[55] The current dissemination of digital technology will only strengthen the diversification of institutional sponsorship, documentary modes, and individual styles. In the long run, the momentum for change will surely come from both inside and outside the state system, from both inside and outside China, and from both veterans and newcomers in China's new documentary.

Part 3

Film Art:
Style and Authorship

9

The Cinematic Transition of the Fifth Generation Auteurs

Ying Zhu and Bruce Robinson[*]

From Art to Commerce: The Transition of the Fifth Generation

Synopsis: A scrappy band of arty intellectual types "sent down" during the Cultural Revolution emerge undaunted from (but also deeply affected by) their hard labor, finds their way into the first class at the newly re-opened Beijing Film Academy in 1978, graduate together in 1982, re-invent Chinese cinema almost in a matter of minutes, astound and amaze critics and art house audiences around the world, and then sell out. "Sell out"? Yes, but in a way that renders the term harmless.

Part of China's massive economic reform effort, between *Yellow Earth* (1984) and *Red Sorghum* (1987), the Chinese film industry was recast from ward of the state to orphan of the marketplace; movies and moviemakers had to start earning their own way. Fifth Generation filmmakers quickly adapted, but as they gave in to commercial imperatives they were also listening earnestly to critics and audiences, responding to creative challenges, exploiting transnational markets and resources, and letting traditional and transcultural creative impulses back into a deliberately sterile film practice that had sought to strip them away. The results were hardly disastrous. In fact, most of the films that astounded and amazed came after this "sell out," making what we now recognize as one of the great "New Waves" in the annals of international film very much a child of mixed creative parentage.

The Fifth Generation's transition is a local story, inscribed in a unique cultural-historical moment, and it is also a generic story of globalization. It is the particular story of Chinese cinema's modernization, and of the creative transition of a distinct group of filmmakers from emphasis on modernizing the film text to emphasis on modernizing the film economy. The Fifth Generation's initial dedication to highbrow formalist experimentation, and their specific aspiration to divorce cinema from drama, gave way in this transition to something more practical, more like popular entertainment, but also more culturally rooted, yet still received as art film internationally. It is a story of globalization because it was international capital, global distribution networks, and

[*] This essay is an update on chapter 4 of Ying Zhu's book, *Chinese Cinema during the Era of Reform: The Ingenuity of the System* (Praeger, 2003), 111–42.

multicultural audiences that allowed Fifth Generation filmmakers to produce their hybrid cinema, their "bastard" child of art and commerce. Zhang Yimou's term for his own early films, "bastard" fits Fifth Generation cinema as a whole, except that in a globalized, post-everything, relativist context there is nothing "illegitimate" between art and commerce anymore.[1] The transition of the Fifth Generation is their Chinese love story, recounted below in three frames.

"Bastard Films": Zhang Yimou's Cinematic Transition

The Fifth Generation filmmakers are in some respects a notably homogeneous group. Most were born in 1950–1956, making them, as Tony Rayns says, "Children of Mao," "born after the Communist victory of 1949 and carefully nurtured in Communist ideology from their first days in kindergarten."[2] Targeted during the Cultural Revolution as "*zhiqing*" (educated young people), they shared the same experiences of disillusionment as its victims. Sent down to the countryside for "re-education," they discovered wretched living conditions and hard labor, confronting levels of poverty and hopelessness strikingly at odds with their former faith in "China's wonderful, perfect future."[3] For many Fifth Generation filmmakers the *zhiqing* experience manifested itself in "a general impatience with the past and a desire to get on with the future."[4] They also shared the Beijing Film Academy, becoming its first new class in 1978.

At the Academy, China's new "open door" policy gave the new film students a look at international cinema and film theory long hidden from view, and they began to break with the past by inventing their own film theory. In 1980, Bai Jingsheng, film critic and professor at the Academy, published an essay entitled "Throwing Away the Walking Stick of Drama," in which he advised filmmakers to recognize the richness of their medium. "When conceiving a film," Bai wrote, "film-makers should deviate from their concept of drama and adopt montage, which combines sound and image."[5] Apparently taking this admonition to heart, soon after they graduated in 1982 this new generation of filmmakers churned out a formalist Chinese "New Wave."

By the late 1980s, the Fifth Generation's willful self-marginalization in its fascination with film form was taken by some critics as an attempt to conceal or compensate for a fundamental inability to construct classical narratives.[6] As much as they endeavored to leave the past behind in their creative practice, their very earnestness about art made a connection with the edifying purposefulness of the socialist cinema of the 1930s and beyond, and they were also still affected by the close relationship between a pragmatic film criticism and an idealistic film practice left over from that didactic tradition. Given this remnant sensitivity, the more the Fifth Generation was charged with narrative impotence, the more compelled its leading player Zhang Yimou felt to demonstrate otherwise. As early as 1988, Zhang expressed concern about the critical consensus that his generation could not mount compelling narratives or direct professional actors.[7] He was eager to make a film that would combine the Fifth Generation's formal experimentation with a classical plot structure. His directorial debut *Red Sorghum* (1987) deliberately employed a conventional narrative with goal-oriented characters actively

exerting their agency to solve a clear-cut problem. The classical narrative was coupled, successfully, with Zhang's penchant for visuality — the flamboyant visual display.

Zhang called *Red Sorghum* a "bastard film,"[8] a term that referred first to the film's story of adultery and second to the wanton assortment of stylistic and narrative devices utilized to construct a compelling drama pleasing to the popular taste. Still recognizably New Wave in its self-reflexive visual style, *Red Sorghum*'s foregrounding of story over style pioneered the Fifth Generation's transition from earnest modernism to more classical filmmaking. *Red Sorghum*'s visuality, an erotic display of richly colored props and ethnographic details, contrasted sharply with the more subdued visual style and Bergmanesque narrational austerity of *Yellow Earth*, for which Zhang had served as cinematographer. The courtship between formal extravaganza, or visuality, and dramatic tension and continuity, resulted in a commercial film that begs for artistic recognition, or an art film with box-office potency. This explains the paradoxical status of Zhang's films as both international art cinema and domestic commercial cinema.[9] In postmodern fashion, Zhang's films are commercialized art films whose style effectively renders the division between art and commerce artificial,[10] and this would become typical of the reformed Fifth Generation in general.

As market imperatives continued to redefine the culture of Chinese cinema in the late 1980s, Zhang turned his attention to popular genre films, making *Codename Cougar* (1988), an action adventure about a failed airplane hijacking involving governments from both Taiwan and mainland China. Attempting to weave together action, political intrigue, and art to please both the critics and the public, *Codename Cougar* was another bastard film, albeit not a great commercial success.[11] Zhang's rendezvous with the male-oriented action genre turned sour. Economically, the Hollywood action adventure formula was too expensive for Zhang to replicate at the time, and politically, China was no place for Oliver Stone–style political intrigue.[12] Nonetheless, the critics generally welcomed Zhang's venture into the popular action genre and his larger project of reconciling art with commerce. Zhang was not alone in this new venture. In their attempt to rescue studios under box-office pressure, other Fifth Generation directors also tried their hand at popular genre films, with limited success.[13]

Zhang's next feature, *Judou* (1990), was a rural melodrama set in feudal China. In *Judou*, Zhang maintained a delicate balance between his impulse for visual extravagance and the box-office requirement of a classical narrative foundation. *Judou*'s success won more overseas investment for Zhang, further liberating him from the constraints of the domestic industry. *Judou* also signaled that his ability to narrate a popular drama was no longer in doubt.

Freed from domestic commercial concerns, Zhang's next project, *Raise the Red Lantern* (1991), displayed his formal obsession at its extreme. The film was a global sensation, garnering a nomination for the best foreign film Oscar in 1992. The film was also voted best picture by Chinese audiences in 1993. The overseas critical success and domestic popular success of *Raise the Red Lantern* raised eyebrows among Chinese critics. Though the film's physical splendor arguably underlines the sad fable of woman as ornament, its dour theme and visual extravagance were deemed at best reactionary

and at worst ingratiating to foreign audiences by some Chinese critics. Doubts were also expressed again about Zhang's versatility as a filmmaker.

As if to demonstrate his versatility again, Zhang took a drastic turn for his next project, *The Story of Qiuju* (1992). A cinéma vérité–style film set in contemporary China, *Qiuju* recounts the semi-comic story of a village woman's tenacious quest for justice. The film shocked Zhang watchers for its uncharacteristic naturalism, which also recalled Italian neorealism.[14] To Chinese critics, the film was a welcome sign of the prodigal son's return to the humanistic tradition of an earlier Chinese cinema. Coincidentally, a debate was raging in the early 1990s among Chinese intellectuals concerning the loss of a "humanist spirit" in China's cultural landscape.[15] *Qiuju* suggested Zhang's embrace of the humanist spirit embodied in the films of Third and Fourth Generation filmmakers like Xie Jin, Wu Yigong, and Wu Tianming.

Zhang's next project, *To Live* (1994), pursued this humanistic tradition a little further, presenting a tender rendition of one family's struggle through decades of turbulent political movements. Zhang sent the film to the Cannes Festival without obtaining prior permission from the Chinese authorities, provoking a ban on the film in China's domestic market. Shying away from political complications, Zhang returned to a safer historical remove for his next feature, *Shanghai Triad* (1995), a gangster movie set in 1930s Shanghai. Seven years after the failure of *Codename Cougar*, Zhang was ready for another actioner. *Shanghai* starts off as a gangster film about the decline of a Mafia family, but Zhang's penchant for love triangles soon turns it into a female *Godfather*, weaving a tangled web of emotions between a young woman, her old master, and her young lover. The foregrounding of female desire and sexuality was a bit of a stretch for a male genre traditionally privileging gangsters rather than their mistresses. *Shanghai Triad*'s focal point is Bijou, a seductive nightclub singer and mistress of a triad boss (played by Gong Li). Zhang's camera constantly shifts its point of view, undermining the narrational coherence otherwise maintained by restricting access to the story and characters to a boy's voyeuristic yet distant gaze. By switching the film's point of view between the peeping boy and the classical omnipresent point of view, Zhang makes arbitrary intrusions into the private life of Bijou, further altering the stylistic and thematic motifs of a classic gangster film. The Chinese film circle's critical and professional assessment of the film was lukewarm.[16] Still, *Shanghai Triad* became a popular hit, aided by the public's tabloid obsession with the real-life love affair between Zhang Yimou and his leading lady.

The commercial success of *Shanghai Triad* underscored Zhang's willingness to appeal to popular tastes, and he was open about his contempt for the "elitist" approach still practiced by some of his contemporaries.[17] In a 1997 interview, Zhang brushed off criticism that pressed films into "isms" and "waves,"[18] saying that "filmmaking is an individual activity and therefore should not be confined by 'isms' and 'waves,'" and that "a filmmaker's ultimate vindication is box-office success rather than critical acclaim."[19]

Since *Shanghai Triad* Zhang has become an international juggernaut, directing live opera in China (*Turandot*) and the United States (*The First Emperor*), the promotional

short film for China's successful bid for the 2008 Summer Olympics, the live closing ceremony of the 2006 Winter Olympics, and both the opening and closing ceremonies of the 2008 Summer Olympics in Beijing. He also served as president of the 2007 Venice Film Festival jury. From politically suspect young Turk whose early films were sometimes banned at home, Zhang has become China's semi-official cultural ambassador to the world. He also continues to make films. Recently he completed an epic triad of big-budget, martial arts films (*Hero*, 2002; *House of Flying Daggers*, 2004; *Curse of the Golden Flower*, 2006), bringing his trademark visual style to Chinese cinema's trademark action genre, updating both with injections of Kurosawa's East-meets-West themes and sensibilities, and trying out some tricks of the Hollywood blockbuster trade along the way.

In his quest for box-office success and international appeal, Zhang has invented a winning formula that surely contains some lessons for other filmmakers who would seek to combine broad-based popular appeal in their non-English-speaking domestic markets with critical acclaim and secondary market success on the global art house circuit. Zhang's formula is comprised of three elements: thematic universality and multiplicity; theatricality; and compositional stylization and symbolism. These are detailed below.

Thematic Universality and Multiplicity

Termed a "leveraging" strategy by Hjort in her discussion of the transnational appeal of Danish cinema, thematic multiplicity combines the "opaque," the "translatable," and the "international" elements of a particular culture to connect with both domestic and international audiences.[20] Opaque elements are those firmly rooted within a particular cultural imagination that might not be understood by the cultural outsider; translatable elements are still particular but share enough markers to make them comprehensible to many outsiders; and international elements are shared transculturally.

Thematic universality relies mostly on international elements. Zhang's first feature, *Red Sorghum*, celebrated a carnivalesque spirit and the triumph of primitive passion. The theme was at once provocative to Chinese newly liberated from Mao's rigid oversight of even their most intimate affairs, and equally appealing to the international art film circle, which easily recognized a compelling variation on the clash between nature and culture. Zhang's subsequent films *Judou*, *Raise the Red Lantern*, and *Shanghai Triad* dealt with female sexual transgression and the brutality of a repressive patriarchy, themes consistently appealing to liberal-minded Western intellectuals and at the same time daring and sensational to the Chinese public. *The Story of Qiuju*, though specific to the time and space of the contemporary Chinese legal system, ultimately dealt with human relationships and the irony of inhumanity performed in the service of blindly enforcing regulations designed to preserve our humanity, another universal subplot. *To Live*'s comic depiction of ordinary folks' optimistic resilience in the face of unthinkable suffering across decades of disastrous political movements likewise appealed universally. In sum, Zhang's "national allegories" were both culturally specific and cross-culturally recognizable.

Subplots in Zhang's films were not only transcultural but also ambiguous and multilayered, encouraging multiple interpretations according to different political and cultural orientations. In the case of *Red Sorghum*, to Western eyes the symbolism of the color red and the fields of red sorghum, associated in the film with an illicit sexual consummation, might suggest something culturally exotic — a characteristic oriental or folk superstition — and/or a political commentary on a state and an ideology associated with the color red. To the Chinese popular audience, it is simply the colorful backdrop of a forbidden sexual relationship heretofore unpresentable on screen thanks to the censors, hence repelling and exciting at the same time. To the Chinese critic it signifies a filmmaker's profound reflection on traditional Chinese culture. The same principle applies to the red lanterns in *Raise the Red Lantern*, the red- and yellow-splashed dye mill in *Judou*, the colorful puppet show in *To Live*, and so on.

Theatricality

All of Zhang's popular films are literary adaptations. Literary adaptations have been a staple for the rest of the Fifth Generation directors as well, again since getting past the formalist obsession of their initial period, when they looked to poetry for inspiration. Poetry brought narrative ambiguity and reflexivity to their formal experimentation, whereas novels tend to induce narrational intensity, clarity, and continuity. The reformed Fifth Generation's reliance on popular novels suggests a predilection for classical narratives and a notable return to tradition; early Chinese films were also distinguished by their connection with indigenous popular literature.

Zhang in particular has expressed his admiration for Steven Spielberg's "story-telling ability," a knack for constructing dramatic tales with cross-cultural appeal.[21] In preferring the classical master Spielberg over the modernist masters Bergman and Fellini, Zhang's filmmaking philosophy contrasts sharply with the Fifth Generation's early anti-theatrical aspirations. However, while admiring Hollywood masters for their ability to manipulate audience emotions, Zhang's narrative is tailored to a particular geo-linguistic region. In order to accommodate the Chinese audience's melodramatic taste, "contaminated" by decades of a socialist realist cinema insisting on a clear-cut central conflict and unambiguous characterization, Zhang makes significant cuts to the narrative complexity and thematic density of the novels that serve as his sources. He confesses to liking "the kind of work ... that tells a very simple, not complex, story. It is tiresome to watch a film whose meaning is unclear."[22]

With occasional exceptions, Zhang's simplified popular narratives generally center on a love-hate triangle, with an unambiguous central conflict and final resolution. All of Zhang's films feature goal-oriented characters. If the central conflict in *Red Sorghum* was somewhat unfocused, the conflicts are much clearer in Zhang's later features. The fate of the illicit relationship between Judou and Tianjing in *Judou*, the fate of the wealthy merchant's concubines in *Raise the Red Lantern*, the fate of a woman's quest for justice in *The Story of Qiuju*, all work within a tightly woven three-act structure progressing from an efficient exposition through a prolonged complication to a timely climax followed by a brief resolution.

Closely related to classical narrative is Zhang's theatricality. Zhang's films tend to feature few changes of location and a relatively immobile camera. Cinematic motion is achieved more by actors' blocking and performance than by camera movement. For the most part characters enter and exit scenes laterally, like characters in a stage drama. Corresponding to the limited location changes is the infrequent camera movement within a single shot, leaving the burden of cinematic motion to editing and character movement. Zhang is not hostile to cinematic motion; rather his movements rely heavily on the event in front of the camera and on the movement and rhythm established by shot sequences. As such, Zhang's formal experimentation selectively combines mise-en-scene's stylized settings and expressive lighting with Soviet montage, which takes symbolic editing to its core. The combination is selective because it is conditioned by Chinese cinema's shadow-play tradition, which tends to de-emphasize motion invoked by camera movements, emphasizing instead the narrative "transparency" achieved by discreet editing and subtle camera movement.

Symbolic Stylization

The straightforward plot progression and one-dimensional characterization in Zhang's narratives are offset by his nearly overwhelming color motifs. Zhang is particularly attentive to the use of color for setting emotional tones and suggesting thematic associations. He has a penchant for the primary colors of red, blue, and yellow. His particular obsession with the color red, by now well known, is played out as red sorghum in *Red Sorghum*, red dye in *Judou*, red lanterns in *Raise the Red Lantern*, and red chili peppers in *The Story of Qiuju*. Emblematic of passion and vitality, the color red also matches the earth tone in Zhang's native province of Shaanxi, where red is widely used for various festivities by the native inhabitants.[23] In *The Story of Qiuju*, red is used to embellish the film's overall yellow tone evocative of human life. In *Shanghai Triad*, Zhang uses deep, rich colors to create moods: blue for ominous night scenes, gold and red for the romanticized rural setting. Zhang's color schemes are matched by his equally mannered composition. He often delights in the symmetrical framing of gorgeous objects, be they human subjects or still life. The cascading sheets of fresh-dyed silk in *Judou* cut vertical lines that divide the screen into symmetrically balanced parts. *Raise the Red Lantern* is a maze of obsessively symmetric doorways framing doorways and courtyards leading inward to other courtyards, of patterned tiles on the roof and patterned indoor decorations, a repertoire repeated recently in *Curse of the Golden Flower*, set in the Forbidden City.

Courting validation from both critics and audiences, at home and abroad, Zhang transformed the early Fifth Generation's New Wave elitism into a stylish new populism, combining art cinema's stylistic abstraction with classical cinema's narrative continuity, and adding in elements of Chinese cinematic tradition, and elements of his own distinctive obsessions. This combination has helped his films to achieve their paradoxical stature as international art cinema and domestic popular cinema. In international film circles, Zhang's auteur status has also resulted partly from being cleverly positioned by his distributors as a politically marginalized artiste, an image that may have reached

the end of its life cycle given Zhang's recent work on the Olympic project and in other state-sponsored arenas. Zhang himself has long claimed to be apolitical, and he has been perceived so by Chinese patrons fed up with the browbeating political films of the Mao era. Zhang's films have generally been well received by Chinese audiences. *Red Sorghum* was a box-office hit. *Judou* and *Raise the Red Lantern* were released in China after he made *The Story of Qiuju* and were also warmly received.[24] His first urban comedy, *Keep Cool* (1997), ranked no. 4 in domestic box-office returns,[25] and his recent martial arts epics have ranked right at the top.

In the late 1990s, freed from both critical and financial pressure, Zhang shifted his focus from popular entertainment films to serious social drama. His *Not One Less* (1999) and *The Road Home* (1999) tackled contemporary social issues. *Not One Less* defends the right of poor Chinese kids from the countryside to a basic education. *The Road Home*, mega star Zhang Ziyi's acting debut, is a paean to the purity of love between a man and a woman from a different era, and a direct comment on China's commercialization. At the turn of the twenty-first century, Zhang made *Happy Times* (2000), a bittersweet comedy about a May-December romance between a fifty-year-old bachelor and a blind girl thrust together under circumstances neither anticipates. *Happy Times* was Zhang's second foray into the contemporary urban comedy genre that had become, by the late 1990s, the staple of the popular Chinese New Year films.[26] After this came the three blockbuster-style martial arts epics, with one more social drama squeezed between them: 2005's *Riding Alone for Thousands of Miles* is a kind of Sino-Japanese reconciliation prayer articulated at the level of small lives reaching across vast spaces of emotional isolation for moments of connection, as well as a personal tribute to its Japanese star, Ken Takakura, a childhood idol of Zhang's.

Now long past the collective Fifth Generation commercial "sell out" referred to in the opening paragraphs of this chapter, Zhang's emergence as an international cultural kingpin and frequent avatar of the state's ambition to cultivate and project China's "soft power"[27] abroad, combined with a seeming thematic trend in his recent films, have let him in for individual criticism as an *ideological* sell out as well. Two of Zhang's recent epics, *Hero* (2002) and *Curse of the Golden Flower* (2006), have won him ratings as a purveyor of "fascist thematic and aesthetic orientations."[28] *Hero*, in particular, is frequently read as a celebration of autocratic rule and Chinese territorial and cultural unity as a transcendent ideal. Coincidentally, Chinese unity/nationalism and the necessity of strong central leadership are two pillars — with broad public and intellectual support — of the Party's postsocialist, reform-era claim to political legitimacy. Of course, *Hero* does not have to be read as a fascist apologia,[29] but its apparent fit with China's prevailing political, intellectual, and popular climate helped it to set a box-office record for domestic films.

In addition to this recent controversy over his trio of blockbuster-fashioned epics, Zhang has long featured as the subject of critical musing over whether his films are submissively dressed for the West in "Orientalist"-pleasing exotic attire, or more introspectively "self-Orientializing" with box-office benefits.[30] Given his enormous stature and his resources, Zhang is in a position now to do whatever he wants, though

still within limits set by the state's censors. Worth considering, however, is the possibility that he is also a kind of Gulliver figure at this point, a cultural giant captive in some degree to the expectations of various fans and factions who would tie him to one ideal or another. Expectations of Zhang are now very high and very many, and he may feel pulled in several directions at once.

From Docudrama to Melodrama: Tian Zhuangzhuang's Cinematic Transition

Among Fifth Generation conversions to conventional cinema, Tian Zhuangzhuang's was the most dramatic because of his very public early career claim to be "making films for the audiences of the next century."[31] As it turns out, the audiences of "the next century" — this century, that is — have moved ever farther away from anything remotely New Wave. Tian modified his claim in the mid-1990s, suggesting that his early films' anti-theatrical approach was actually motivated by his desire for success in the international art film circle and therefore had nothing to do with either an elitist or a populist cinematic ideal.[32] When his two New Wave features failed utterly at the box office, Tian was obliged to turn out a number of contract films. Soon after, he turned his attention to popular genre films. His popular musical *Rock 'n' Roll Youth* (1988) rode the rising tide of rock music among urban youth. Another popular feature, *The Imperial Eunuch* (1990), catered to mainstream audiences' interest in royal gossip. Tian's populist approach reached an apex in his internationally acclaimed yet domestically banned feature, *The Blue Kite* (1993). A year after *The Blue Kite*'s international debut, Tian was banned by the Ministry of Radio, Film & Television from film production. The ban was lifted in early 1996, and Tian was elevated to a position of authority at the Beijing Film Studio. He then devoted his energy to film packaging, matching specialty directors with niche markets and staying away from directing until 2002, when he directed *Springtime in a Small Town*, a remake of a 1948 film, followed by a documentary reprising his early interest in China's ethnic minorities (*Tea-Horse Road Series: Delamu*, 2004), and another narrative feature, *The Go Master*, in 2006.

In his non-directorial career, acting as a semi-official, semi-independent agent, Tian has helped to push the films of the Sixth Generation onto China's screens. For his own part, he has vowed to avoid Chinese cinema's current big budget mentality, focusing instead on small productions for niche markets, and so far he seems to be keeping to this vow.[33]

The Blue Kite

Tian's signature film, *The Blue Kite*, tells the story of an ordinary family's tragic experience through the plague years of the Mao era. The original script was returned by the censors for a rewrite. Tian hired a writer to write a different script and had it approved, but then used his original as the shooting script. Tian shot the film over a three-month period in the winter of 1991–1992 as a co-production between Beijing Film Studio and Hong Kong's Longwick Film Production Ltd. After the shooting,

he showed a rough cut to Beijing Film Studio, the Film Bureau, and the Ministry of Radio, Film & Television. A joint decision was made that since the film did not follow the approved script it should proceed no further.[34] Tian was barred from shipping the working print to Japan for post-production as originally planned. Since no film lab in China dared touch the film, the raw prints were put on a shelf for a year. Eventually, a company in the Netherlands, Fortissimo Film Sales, picked up overseas distribution rights and completed post-production according to Tian's remote instructions. When the film debuted at Cannes in 1993, critics trumpeted it as vastly superior to Chen Kaige's more visible, co–Palme D'Or winner, *Farewell My Concubine*.

Depicting an extended family caught up in the political turmoil of 1950–1960s China, *The Blue Kite* maintains the epic length and extensive cast of characters typical of the classical double-track narrative of little people living through big events. Yet the big events in *The Blue Kite* serve to dramatize the little people, not the national history. The film opens in 1953, with the marriage of lovely Chen Shujuan, a school teacher, and gentle Lin Shaolong, a librarian. The two celebrate not only their love but also the dawn of a true People's Republic. The couple soon has a son, Tietou, and the remainder of the story is told from the viewpoint of the mischievous boy who, as the film progresses, grows from an energetic, impish toddler into a pubescent brat. The plot follows Tietou's childhood during the years 1953–1967 when China was caught up in a succession of worsening mass movements: the Rectification Movement and Anti-Rightist Campaign, the Great Leap Forward, and finally the Cultural Revolution.

Throughout, Tian's narrative is a carefully plotted one, lightened most of the way by small but regular moments of comic relief and irony. The rigorous plot structure highlights, chronologically, the three marriages of Tietou's mother. After Tietou's birth comes the Rectification Movement of 1957 urging citizens to "let a hundred schools of thought contend." A colleague of Tietou's father innocently implicates him in criticism of their work conditions. When official policy reverts again to thought control, the father is banished to a labor camp, where he is later killed by a falling tree. The informer helps the widow and becomes rather sympathetic, eventually winning Shujuan's love and marrying her. The second husband dies from a liver ailment aggravated by the rampant malnutrition and overwork of the Great Leap Forward as it continues into the early 1960s. Tietou's mother is courted next by a high-ranking bureaucrat who marries her and transports her to a bourgeois villa. During the frenzy of the Cultural Revolution, Shujuan's third husband is humiliated and beaten by righteous Red Guards. Though the mutual dependency and love between mother and son form the emotional spine of the film (the relationship is not idealized — Tietou is an exasperating boy), there are also a number of sharply etched minor characters filling out the background of *The Blue Kite*'s broad canvas. Tietou's uncle is going blind, and the uncle's girlfriend, star of an army theater troupe, is sent to jail because she refuses an order to have sex with political leaders; meanwhile, Tietou's aunt is also implicated in the never-ending political movements, and Tietou's grandmother is heartbroken. This complex narrative stands in direct contrast to Tian's plotless, documentary-style New Wave films, *Horse Thief* and *On the Hunting Ground*. The

detached, "emotionally lacking" quality of these early films gives way in *The Blue Kite* to a sensitive depiction of human suffering.[35]

Tian's appropriation of a classical cinematic paradigm for *The Blue Kite* is evinced in the film's rigid and elaborate formal parameters. The setting in *The Blue Kite* is shifted from the uncontrolled, naturalistic space of Tian's New Wave films to a confined indoor mise-en-scene. Most of the action happens in and around a courtyard in Beijing. The confined cinematic space keeps the overarching narrative focused. Several moments in the film call for elaborate crane shots and a complex montage. The death of Tietou's "uncle," for example, uses a crane shot accompanied by a blue light raking across the set. Yet *The Blue Kite* also displays much restraint, foregrounding dramatic conflict over cinematic style. The framing, camera movements, and cuts in the film serve to give us the information we need without drawing attention to themselves. The long shots and shots included purely for their formal beauty in Tian's New Wave films are replaced by (mostly) medium and close-up shots that advance the story.[36]

For all its depth of feeling, *The Blue Kite* is not melodramatic. Its quiet, understated mood aligns it with humanist realism more than with melodrama. The film warmly observes the rhythms of Tietou's extended family — the meals and arguments, the worries about money, and the sweet moments when a put-upon mom finds joy in playing with her bright child. Meditative, subtle, and psychologically complex, *The Blue Kite* diverges from both Chen Kaige's epic-prone filmmaking (discussed below) and Zhang Yimou's visually splashy styles. It is commonly acknowledged in Chinese film circles that Tian has always been something of a renegade, hard to classify. In *The Blue Kite* Tian looks like the most classical filmmaker of his generation, and this would be ironic, except that he practices his classicism on such a high plane that he manages to stand apart yet again.

From *Horse Thief* to *The Blue Kite*, Tian's ethnographic, semi-documentary approach with its mysterious, haunting, rigorous manner and avant-garde aesthetics is replaced by a classical approach with a well-defined plot structure and an understated formal style. *The Blue Kite* is a serious attempt to reconcile with the classical narrative form Tian so despised earlier. After a long hiatus, two new narrative films, a re-make of a Chinese classic (*Springtime*) and a Chinese/Japanese biopic (*The Go Master*), and one new documentary suggest that Tian intends to keep pursuing his own creative verity. At the same time, like the rest of the Fifth Generation's leading filmmakers he has left avant-garde formalism behind, incorporating practices from Hollywood, proceeding generations of Chinese filmmakers, and the Chinese shadow-play tradition into his own style.

Concubine Film: Chen Kaige's Cinematic Transition

It took half a decade after the release of Tian Zhuangzhuang's *Rock 'n' Roll Youth* and Zhang Yimou's *Red Sorghum* for Chen Kaige to come to terms with a populist cinematic practice. Chen's transition came with the critical and popular success of *Farewell My Concubine* in 1993. That year's co–Palme d'Or winner at Cannes (Jane Campion's *The*

Piano was the other winner), and a best foreign film nominee at the Academy Awards, *Farewell My Concubine* was also the year's biggest international art house box-office success.[37] Banned in China for its treatment of homosexuality and the brutality of the Cultural Revolution, once it was unbanned and reached its domestic audience, the popular reception was positive.[38]

In *Farewell My Concubine*, Chen abandons the New Wave's modernist bent and turns to the melodramatic conventions of classical Chinese cinema and Hollywood. Between *Yellow Earth* and *Farewell My Concubine* the normative conceptions of how a film should look and sound clearly changed for Chen. Like the other Fifth Generation filmmakers, the change in Chen's practice is only partly attributable to the changed mode of production from state-supported institution to commercial industry. Being products of the particular cultural-historical experience of mid-twentieth-century China makes Chen and the others, for instance, more susceptible than filmmakers from other cinematic traditions might be to expert and popular criticism, and to the melodramatic and dramaturgical traditions of Chinese cinema and shadow plays. But in addition to these general susceptibilities, the three formidable figures discussed here also exhibit powerfully individual cinematic conceptions and practices shaped by their personal experiences, especially their experiences with particular film projects. A look at the production history of *Farewell My Concubine* can help to untangle the complex creative dynamics behind Chen's particular practice.

The Production of Farewell My Concubine

Farewell My Concubine was a co-production between Hong Kong–based Tomson Films and Beijing Film Studio. When Hsu Feng, the head of Tomson Films, first approached Chen with a homoerotic story of the linked destinies of two Beijing Opera stars, the idea of adapting a popular Hong Kong novel did not quite click for Chen.[39] Historically, Hong Kong was regarded by Chinese intellectuals as a cultural wasteland — the British colony could not possibly produce any authentic cultural products. Still longing for the perfect union between an avant-garde cinema and an enlightened audience, Chen was shopping around for a weightier project than the adaptation seemed to promise.[40]

Still, Chen could hardly afford to spurn the overtures of a powerful Hong Kong producer. His filmmaking had suffered a setback since *Yellow Earth*, turning out two flops in succession. With their intellectually and philosophically inclined themes and minimal storylines, both *King of the Children* (1987) and *Life on a String* (1990) were critical and commercial disasters. The austerity of Chen's philosophical probing became so unbearable that the critics at Cannes went so far as to give *King of the Children* the "Golden Alarm Clock" award for most boring picture of the year. At the same time, Chen was treated to the spectacle of his former cinematographer, Zhang Yimou, becoming a rising star at international film festivals. Worse, talk began to circulate that what made *Yellow Earth* a breakthrough for Chinese cinema was really its captivating imagery, credited more to Zhang's imagination than to Chen's vision. The critical and commercial success of *Red Sorghum* added more fuel to the fire but also suggested the tantalizing

possibility of a Chinese film that could bridge the gap between art and commerce even as it also generated cross-cultural appeal.

Chen seemed to have few choices but to accept Hsu's offer. What finally connected Chen with Hsu was the latter's self-proclaimed aspiration to make a global commercial hit that would also be culturally valuable.[41] Chen later told a reporter from the *World Press Review* that *Farewell My Concubine* was a commercial project with an intellectual soul.[42] He accepted Hsu's offer with three story changes. He added a section about the Cultural Revolution to make the epic weightier, with a broader scale. He beefed up the weak female character, a saucy prostitute who stirred up trouble and teased out the sexual ambiguities between the two leading men. As it turned out, some of the film's most effective moments were those depicting the bitter jealousies between these three characters. Finally, Chen had one of the male characters commit suicide instead of leaving for Hong Kong with his buddy after the Cultural Revolution.[43] The suicidal ending, along with the new political edge and the presence of a stronger female character who further complicated the gay theme, made the story more melodramatic than the original novel.

Budgeted at $4 million, *Farewell My Concubine* was considered lavish next to the $100,000 budget for the average Chinese film.[44] With a pre-sold commodity already on hand (the popular novel), Chen brought in established stars. While the internationally acclaimed leading lady, Gong Li, would boost the film's appeal to the West, the leading man, Leslie Cheung, a Hong Kong pop singer and movie icon in the Far East, would secure audiences in Hong Kong, Taiwan, the Mainland, Singapore, and Japan. Shot on location in Beijing, the film went over budget and behind schedule. The final price tag was roughly $5 million.[45] Worth the price, of course, when the film came out a critical and commercial hit.

Farewell My Concubine and a Classical Style

Farewell My Concubine differs decisively from Chen's early films. Thematically, it moves away from the early New Wave's preoccupation with Chinese culture at large towards individuals' repressed emotions and sexual passion. Chen had persistently pursued Chinese culture themes in all the films he made up to this one: *Yellow Earth* served as a profoundly ambiguous and multilayered contemplation on China's revolution and Chinese civilization; *Big Parade* examined relations between the minimal individual and the massive collective so blurred in Chinese consciousness; *King of the Children* raised philosophical questions about how children become part of a culture and what education could do for them and for China; *Life on a String* contemplated Chinese culture at its most fundamental level.

Farewell My Concubine was Chen's first film to focus on the fate of individuals rather than the nation. Spanning a half century of Chinese history from the era of the warlords in the 1920s to the end of the Cultural Revolution, *Farewell My Concubine* charts the tale of a love triangle that begins in the harsh confines of an all-male Beijing Opera school where young Dieyi is being trained to take on female roles while his pal Xiaolou trains for the male lead parts. Dieyi's boyish devotion to Xiaolou soon turns

into a homosexual crush that prevails even after Xiaolou marries a prostitute from the House of Blossoms bordello. Chinese homosexuality, the exquisite Beijing Opera, and the violent Cultural Revolution, all the film's key elements, are at once culturally specific and cross-culturally translatable. Chen attributes these new thematic concerns partly to his own attempt to come to terms with popular tastes, and partly to the interests of his Hong Kong investor and his American distributor in the picture's box-office potential.[46]

Stylistically, *Concubine* moves away from Chen's early cinematic austerity that insisted on minimal dialogue and plot structure, non-star casting, long shots instead of close-ups, location shooting, a mostly static camera, and simple mise-en-scene. The static long shots of the distant ravines and slopes of the Loess Plateau, the silent, expressionless soldier, and the muted peasants in *Yellow Earth* are replaced in *Farewell My Concubine* with elaborate takes and close-ups of expressive faces for dramatic tension, the crucial component of a classical, communicative narrative.[47] The sexual tension in particular is delivered mainly via close-ups, revealing meaningful gazes exchanged among the three main characters. Emotions are also highlighted in elaborating actions. Anguish is expressed in violence and love in love-making. At the beginning of the movie, Dieyi's mother, a prostitute unable to raise the child herself, deposits him at the Beijing Opera School. Informed that the school cannot take in a boy who has six fingers on one hand, she quickly chops off the extra finger. As opposed to the long takes in *Yellow Earth*, the images here are brief: swinging knife, crying child, bloody hand, new pupil at the school.

Meanwhile, the setting in the film shifts from the harsh landscape and remote villages of Chen's early films to the refined stage of an urban metropolis. A dense in-studio mise-en-scene supersedes sparse natural settings. Large crowds of extras on massive sets are meticulously blocked to re-create the mood and ambiance of Beijing and Beijing Opera from a different era. Meanwhile, the Opera school setting gives Chen ample opportunities for a flamboyant visual exhibition, rich panoply of color and pageantry. The colorful mise-en-scene resembles Zhang Yimou's style much more than Chen's early New Wave style.

Farewell My Concubine returns to a Chinese cinema tradition that historically combined two seemingly antagonistic production practices, one driven by profit, in the tradition of Hollywood melodrama, one driven by moral mission, in the tradition of Chinese shadow play. Despite the apparent contradiction in purposes, however, the sentimentality and moralization of the shadow-play tradition actually coincide nicely with Hollywood melodrama. Both shadow-play and classical Hollywood championed continuity editing for narrative coherence. They both fashioned a goal-oriented protagonist, although what counted as heroic differed according to different ideological underpinnings. Finally, they both sublimated style to narrative.

Chen's willful commercialization became more evident in his subsequent films, *Temptress Moon* (1996) and *The Emperor and the Assassin* (1999). *Temptress Moon*, a sexual intrigue about love and betrayal set in 1920s Shanghai, narrates a callous gigolo's sexual dance with the female head of an opium-dazed family he is supposed to seduce. As convention has it, the woman he sets out to seduce, played by Gong Li, is his childhood love interest. The assignment opens a Pandora's Box of unresolved childhood conflicts for the smooth urban hustler played by Leslie Cheung. With an investment of

50 million yuan, *Temptress Moon* has all the ingredients of a Hollywood melodrama. The most expensive Asian film ever produced at the time, *The Emperor and the Assassin* is a historical epic revolving around Ying Zheng, the ruthless third-century B.C. ruler who became China's first emperor after conquering and forcibly unifying the country's seven kingdoms. The conquest was achieved through a staggering loss of life, and in the end, Ying Zheng's united China lasted only fifteen years. The film's production scale and its blood-soaked narrative of back-stabbing imperial politics, murderous betrayals, and mass slaughter closely resemble one of Cecil B. DeMille's grandiose melodramatic epics. As Stephen Holden puts it, "in its blend of pomp, suds, swashbuckling action and moralizing (about the price of power and imperial ambition), the movie conveys the sweep of history with a capital H."[48] Both *Temptress Moon* and *The Emperor and the Assassin* followed the same international co-production and distribution strategy, featured globally recognizable stars, and narrated visually and thematically provocative stories set in China's past.

Most recently, Chen has made a new film in the Fifth Generation humanist mode, *Together* (2002); an English-language Hollywood sexploitation film, *Killing Me Softly* (2002); and a beat-Zhang-Yimou-at-his-own-game-and-shoot-for-the-Oscar blockbuster mode martial arts epic, *The Promise* (2005). *Together* is a melodramatic look at the tension between old and new lifestyles and impulses in contemporary Beijing, depicted in a father-and-son relationship. Generally well reviewed, it also received an audience award for best picture at the Tribeca Film Festival in 2003. *Killing Me Softly* is a career outlier, Chen's first and only English-language film, and one that makes an odd choice for any filmmaker with artistic ambitions, looking like little more than an excuse to get female lead Heather Graham naked. It elicited poor reviews and poor box office, and was hardly noticeable. *The Promise*, as many reviewers noted (often in headlines), did not live up to its promise. Most recently, Chen made a follow-up to *Farewell My Concubine*, a biopic about the famous Chinese Opera performer Mei Lanfang, who is supposed to have been the inspiration for one of the two opera performers in the film. With *Together* and *Mei Lanfang*, Chen appears to be returning to the classical melodramatic mode.

From being one of the pioneers of Chinese modernist cinema, Chen has become one of the masters of Chinese classical cinema. What is at stake in Chen's cinematic transition is the cross-cultural appeal of the commercialized Fifth Generation. The declining domestic film market forced Fifth Generation filmmakers to branch out and test the global market. The extent of U.S. dominance in audiovisual markets on a global scale, meanwhile, has further compelled them to draft Hollywood strategies into the service of their cross-cultural campaign. So far Zhang Yimou has worked this better than Chen Kaige — blockbusters and Heather Graham may not be Chen's forte.

Competitive Strategies and the Cross-Cultural Appeal of the Fifth Generation

As Michael Porter suggests, to achieve and sustain a competitive edge in an increasingly globalized cultural market, national/regional cultural industries typically

employ production strategies including cost leadership, marketing focus, and product differentiation.[49] China's Fifth Generation filmmakers achieve a cost leadership position through co-productions financed by overseas investors that exploit low cost Chinese resources. Their marketing focus aims for two niche markets, the international art house market and the domestic mainstream market. Product differentiation is achieved (ideally) through producing films that are distinctly Chinese but also narratively and thematically accessible across cultures.

Fifth Generation filmmakers also employ textual strategies associated with the Hollywood standard of "quality," particularly Hollywood's core values of narrative clarity and coherence. Of course, Hollywood's hegemonic notion of quality does not stop at coherence and economy of narrative — these are complemented by star actors and directors and technical aspects of acting, cinematography, mise-en-scene, editing, and so on, also commonly understood as superior. A point worth highlighting here is that the relative worth of cultural products is determined only partially by comparative assessments of intrinsic features such as aesthetic qualities.[50] Hollywood's dominance must be attributed in large measure to its economic, demographic, and geopolitical power as a major component of *the* major culture. Thus, the globalization of China's Fifth Generation cinema is in essence a process of the economically, demographically, and geopolitically less powerful Fifth Generation's assimilation into the globally prevalent narrational mode.

While recognizing the power dynamic involved in Hollywood's dominance, one must also acknowledge that cultural survival and "resistance" depend more on historically formulated audience identities than on regulatory intervention. Chinese audiences' tastes were shaped, historically, by Hollywood-influenced melodramas with clear moral implications set up by a well-defined central conflict and delivered via contrived twists and turns. The box-office success of the post–New Wave Fifth Generation can be attributed partly to their discovery of a cinematic strategy that reprises to a significant extent a notion of cinematic and narrative "quality" well established in the popular Chinese psyche. Conversely, the box-office demise of the Fifth Generation's early New Wave cinema can be explained partly by Chinese spectators' indifference to alternative cinematic representations such as European art cinema, or, for that matter, the historical materialist/socialist realist cinema.

In an ironic twist, the Fifth Generation's reprise of a classical narrative tradition actually connects them with Chinese cinema's theatrical roots. The classical Hollywood narrative is not necessarily unique to the American film industry, since various cultures share a similar progression of narrative traditions. The shadow-play tradition genetically linked to traditional Chinese stage drama very much resembles classical/new Hollywood. However, the Fifth Generation's adaptation is not a complete throwback to the shadow-play tradition that privileged cinema's dramaturgy. Rather, the Fifth Generation's post–New Wave revels in film's visual potency while seeking to synthesize it with drama's theatricality. Thus, the antagonistic relation between film's audiovisual parameter (cinema) and theatricality (drama) in the hands of the early New Wave is transformed in the post–New Wave into something closer to a balanced unity. The ultimate goal,

moreover, is to fully extend the feature film's pictorial and dramatic potential in order to compete not only with Hollywood but with television and home video as well.

As Chinese cinema's economic reform gradually opened up the domestic film market and attracted multiple domestic and international financiers, and as China's cultural, economic, and political atmosphere became more stable and relaxed (at least in the entertainment sector) by the late 1990s, the post–New Wave Fifth Generation changed their cinematic strategy, turning to making films with more nuanced blends of popular and artistic, traditional and innovative, domestic and cross-culturally appealing elements. They also became less swayed by critical discontent and more concerned about cultivating a friendly relationship with the state and the public for their films' domestic market. Their effort in cozying up to the state would pay off when they took yet another turn into the domestic blockbuster films of the early 2000s.[51]

With varying degrees of state support and domestic and international recognition, by now not only the practice but also the position of Fifth Generation filmmakers has shifted. Succeeded by a less homogeneous "Sixth Generation," they are no longer China's cinematic avant garde. In fact, by now, figures like Chen Kaige, Tian Zhuangzhuang, and Zhang Yimou constitute something like a film "establishment" in China.

10

Transmedia Strategies of Appropriation and Visualization: The Case of Zhang Yimou's Adaptation of Novels in His Early Films

Liyan Qin

Zhang Yimou's film *Ju Dou* (1990) won the Luis Buñuel Award at Cannes and was nominated for an Academy Award for the best foreign language film. The film is based on Liu Heng's novel *Fuxi, Fuxi*. Yet, when we examine the novel, we discover that everyone meets a different fate than is the case in the film. The old man Yang Jinshan dies one day peacefully, instead of being drowned. Tianqing, despairing of his hopeless relationship with Ju Dou, drowns himself in a quite honorable and even graceful way, instead of being killed by his son. Ju Dou may be alive even now, instead of being consumed in flames. Tianbai, the demonic child in the film, leads a perfectly normal life in the novel. How should we account for the radical differences between the novel and the film?

Zhang had always preferred adaptations to original scripts. Four of his early films, *Red Sorghum* (*Hong gaoliang*, 1987), *Ju Dou* (1990), *Raise the Red Lantern* (*Da hongdenglong gaogao gua*, 1991), and *To Live* (*Huo zhe*, 1994), are all based on important novels by, respectively, Mo Yan, Liu Heng, Su Tong, and Yu Hua, three of whom are also listed among the screenwriters in the filmic adaptations of their own novels. However, the listing of screenwriters is less important than the evolution of the screenplays. In fact, Zhang's input was crucial in shaping each of these scripts. In each film, Zhang himself was one of the screenwriters, although he was not listed in the credits.

What interests me in this chapter is how Zhang remodeled these novels into films marked with his own signature. I will read his above-mentioned four films as a group, both against their literary sources and against one another. These films all deal with twentieth-century Chinese history and all focus on Chinese culture. What are the patterns underlying the changes Zhang made to the novels? Why were these changes made? What image of China emerges from these films? How has this image itself changed with time? These are some of the questions to be addressed in this chapter. However,

before examining the case of Zhang Yimou, I will first give a brief overview of the past century of Chinese filmic adaptations.

Adaptation of literature has been an important genre in Chinese films from the 1920s, when Chinese filmmakers began their work in earnest, until now, when they routinely win international acclaim. Their literary sources range from Chinese literary classics to works by contemporary Chinese writers, from the plays of Shakespeare to the novels of Tolstoy. Different types of literature were preferred, and the same type of literature was dealt with in different ways, during various periods, in response to and in negotiation with changing cultural, political, and commercial needs.

From the very beginning, Chinese cinema appropriated popular opera, drama, and Chinese and foreign literature. In 1927–1928, there was a trend of filmmaking based on traditional Chinese literature, called by historians the "traditional film movement" (*guzhuangpian yundong*). From 1928 to 1932, Shanghai studios experienced another surge, this time of making films about martial arts, monsters, and immortals, which was closely related to the popularity of martial arts novels during the 1920s. Writers, especially those of the so-called "Butterfly" group, were also actively involved in filmmaking.[1] With the onset of the leftist movement in the early 1930s, the link between literature and film continued, though not generally in the form of adaptations, since the leftists carried out their political agenda by entering studios as original screenwriters.[2] During the war years (1937–1945), Xinhua, the biggest studio in the foreign settlements in Shanghai, reverted to traditional Chinese themes. Then, between 1945 and 1949, many foreign literary works, especially by Russian authors, appeared on the screen, although they were often sinicized beyond recognition.[3]

After the establishment of the People's Republic of China (PRC) in 1949, adaptation of literature continued to make up a major portion of Chinese films. For example, fully one half of the productions released by the Beijing Film Studio from 1949 to 1999 were literary adaptations.[4] Yet, at the same time, from 1949 to the Cultural Revolution in 1966, filmmakers were also seeking political acceptance. Films based on foreign literature totally disappeared, and adaptations of classical Chinese literature virtually disappeared as well. Most films at this time dealt with the immediate past, focusing on the successes of the Communist Party, and filmic adaptations of literature in this vein were often made in the late 1950s and early 1960s.

Leftist literature was another major type permitted on the screen. Xia Yan, the leading leftist screenwriter in the 1930s, now played a major role in the adaptation of such literature. However, in dealing with leftist literature, filmmakers were walking a much finer line. Leftist literature, by definition, means progressive literature that leans toward the communist vision, but has not yet attained the heights of communism. The stories often take place before the advent of or in the absence of the Communist Party. Without the Party, the heroes must prove limited. If not handled well, adaptation of leftist literature can be entrapping. Therefore, filmmakers chose only works by established writers, such as Lu Xun, Mao Dun, Ba Jin, and Rou Shi.

To make the leftist literature acceptable on screen, filmmakers made changes and tried to inject "correct" messages into the films.[5] Thus, most of these films often run

towards a teleological end, preparing for the advent of communism. Another way to make the message unmistakable is to give it verbal forms, so filmmakers often added speeches, subtitles, or voiceovers, usually at the beginning or at the end. In spite of these changes, the films still presented themselves as filmic copies or translations of the original. The changes were done in a subdued way and were believed to be compatible with the spirit of the original. The gesture of paying homage to the source and acknowledging its primacy can be seen when many such adaptations begin with an image of a book. This constant referring back to the book shows the high authority of the canonical writers and the relative status of films vis-à-vis literature. The filmmakers, by making use of these writers, were co-opting an important political resource.

The output of both film and literature in the Cultural Revolution years (1966–1976) was meager. The major films of this period were the eight "model operas" (*yangban xi*), and Hao Ran was the most frequently adapted writer. Interestingly, the eight model opera-movies were all extremely faithful adaptations, including six Peking operas, and two dance operas. The operas in turn were adaptations of local operas, novels, earlier films, or drama plays. In addition, a few popular black-and-white films made after 1949 were remade in color. Thus, the Cultural Revolution film scenario was one of recycling and repackaging.

In 1979, films and filmic adaptations witnessed a new departure. This "new era" (*xin shiqi*) of films began, as in literature, by exposing wounds left by the Cultural Revolution and reflecting on past national policies. Adaptations were often based on contemporary novels and suggested a parallel development in film and literature. Then, in the early 1980s, leftist literature reappeared on screen but with the emphasis changed to apparently nonpolitical works. Meanwhile, filmmakers also looked at modern Chinese writers beyond the leftist scope, with such writers as Shen Congwen (1902–1988) and Xu Dishan (1893–1941) rediscovered. The communist history was still sometimes revisited, but now the focus was changed to personal emotions and experiences.[6] Meanwhile, both filmmakers and theorists were feeling a new surge of confidence in the status of film as an art independent from drama or literature. Filmmakers, especially when dealing with contemporary literary materials, did not hesitate to make radical changes.

The Fifth Generation of Chinese filmmakers made their appearance by making use of marginalized revolutionary literature. The two films that launched the Fifth Generation, *The One and the Eight* (*Yige he bage*, 1983) and *Yellow Earth* (*Huang tudi*, 1984), were both adaptations, the former based on a poem by Guo Xiaochuan written in 1959 but never published except for circulation for internal criticism (*neibu pipan*), and the latter based on a lyrical essay. As rightly pointed out by film scholar Ying Zhu, such choices contributed to the new filmmakers' "anti-narrative tendency" against the shadow-play tradition of filmmaking in China.[7] Both sources included elements of reflection and darkness. By availing themselves of these marginalized or even condemned literary works before the Cultural Revolution, the new filmmakers made sure that their voice was different. By choosing a poem and an essay as the basis of their first important films, they made it impossible to be faithful. What they sought from literature was often a clue upon which to build their films and they had no qualms in making changes. They

resort to a stylized use of visual images, which are totally absent in the original literary works.

In the following pages, I will examine Zhang Yimou's early adaptation films from three intertwined angles: the "culture" images he adds, the patriarchs and young lovers he represents, and the communist history he tries or tries not to engage.

Constructing a "Chinese Culture": Rituals, Arts, and Space

Unlike the original novels, Zhang Yimou's early films are heavily flavored with cultural details. Take the famous sedan dance in *Red Sorghum*, for example. Mo Yan writes in his novel that, on the way of the bride Jiu'er's journey to her leper husband's house, "the lazy drummers and horn-players stopped playing not far away from the village,"[8] although the sedan-bearers did jostle the bride. Yet this detail is enlarged into a scene taking up about one-ninth of the whole length of the film. The sedan-bearers stop their progress, perform a well-rehearsed dance, and sing a complete song. Similar long self-contained episodes of dance and song, of combinations of the visual and the audio, are frequently found in Zhang's films. These ritual-like episodes can entertain, as if Zhang were putting his camera in front of a real stage, recording some performance — shadow play, Peking opera, or sedan dance. Moreover, these cultural elements, which often recur, are also used structurally to help sustain narrative unity.

We can examine the shadow play in *To Live* more closely to see how the rituals and other cultural elements work both thematically and formally. The shadow play is a crucial addition to the original novel, in which there is not one word about shadow plays, and the protagonist Fu Gui is by profession a peasant. This addition conveniently serves multiple functions. First, the shadow play is again a combination of songs and dances, and easily appeals both to the Western audience's appetite for the exotic oriental, and to the Chinese audience's zeal for the local and the traditional. With its combination of the visual, the auditory, and the ritual, it is a perfect choice to present an ethnographic China.[9]

The shadow play is also a symbol of the pre-Communist Chinese culture, which is always threatened by communism. That the puppets are flat human beings carries the implication that their fate somehow parallels the fate that overtakes real people. The box of puppets also serves as a thread that strings the political campaigns together. It first survives the Nationalist troops who seem much more lenient than the charging Communists. The helpless puppet on the tip of the bayonet of a Communist soldier foreshadows the terror the Communist regime is going to inflict on Chinese culture. After 1949, the puppets go through one ordeal after another, and are finally burned at the beginning of the Cultural Revolution. However, the box miraculously survives as an undying reminder of the old culture. At the end of the film, Fu Gui drags the box out from under the bed, and it now is used as the container for a group of chickens representing hope.

Moreover, for Zhang, whole spaces can be saturated with "culture." It is not by accident that in three of the four films, the protagonists are respectively, wine-makers,

dyers, and shadow-play performers, while the latter two groups are mere peasants in the original novels. By making them artisans or artists, Zhang links them with culture and tradition. He can also more conveniently put them into a well-defined space. In these films, one of the most significant carriers of "culture" is the space Zhang constructs in which isolated cultural elements combine to create a mood.

It is interesting to see how this space and the spirit of the culture therein change with time. Both the winery in *Red Sorghum* and the dying mill in *Ju Dou* are places of manual labor with primitive-looking equipment. Yet these spaces are made to contain different moods. Through changes made to the original novel, Zhang practically reconstructs the winery in *Red Sorghum* into a utopia, a self-sufficient place far from the world and free from political authorities and social surveillance. Zhang also deliberately erases the social distinctions in the winery. In the novel, Jiu'er exercises a tight control over the workers who stand in awe of her. Yet in the film, Jiu'er happily stands on the same level as the workers, and insists that "we are equal in this winery." The winery becomes a big fraternity. This equality stands in sharp contrast to the rigid hierarchy in *Raise the Red Lantern*, where each mistress has a fixed position in the family and a fixed courtyard, and each is enclosed in her own space.

The proportion of the indoor and outdoor scenes also changes in Zhang's films from the 1980s to the 1990s. In *Red Sorghum*, we seldom have an indoor scene. Scenes in the winery do not seem to happen indoors. The indoor and the outdoor form one big unity. However, in *Ju Dou* and *Raise the Red Lantern*, the settings are changed "to the claustrophobic inner space."[10] The vision becomes severely restricted in *Ju Dou*. In the original novel by Liu Heng, the relationship between Tianqing and Ju Dou takes place in the fields where they work together. By contrast, in Zhang's film, most actions occur indoors. This indoor space of the mill is under two layers of surveillance. First, it is the territory of the patriarch Yang Jinshan, the mill owner. Then, embedded in the village, the mill is also subjected to social pressures from the village community. Yet Ju Dou and Tianqing can still sometimes steal off to the outdoors to enjoy themselves. The bright cloths hung in the courtyard can still sometimes break through the enclosed space.

By contrast, the mansion in *Raise the Red Lantern* becomes totally closed. Unlike the open space of *Red Sorghum* in which spontaneity is celebrated, Zhang makes the house in *Raise the Red Lantern* a prison. In the original novel, there is still a garden, which is cut by Zhang to make the enclosure complete. Everything is artificial, without a tree to be found. In whatever direction you look, you see either a courtyard, a wall, a screen, or a cavernous room. This is a world governed by its own iron laws. The original novel never pays much attention to the architecture of the house, yet Zhang makes the house an important character in the film. It repeats itself horizontally and vertically, with unknown recesses where fearful secrets are hidden. The symmetrical and overwhelming architecture often fills the whole screen, in which move tiny human beings who seem unable to bear its pressure and are even swallowed by it. Thus, there is a perceptible tendency from *Red Sorghum*, through *Ju Dou*, to *Raise the Red Lantern*, to become more and more oppressive. Also contributing to this tendency is Zhang's characterization of the old patriarchs and the young lovers.

The Patriarchs and the Young Lovers: Demonization and Agency

Wendy Larson aptly summarizes Zhang Yimou's early films in this way: "The female character played by Gong Li is positioned between two men, one an older man who is diseased, perverted, or cruel … and the other a younger man."[11] This pattern applies to *Red Sorghum*, *Ju Dou*, and *Raise the Red Lantern*. At the beginning of each film, we find a soon-to-be married or newly married woman on her way to be initiated into a horrible knowledge of her marriage. Each marriage is against her will. However, within this persistent narrative pattern, the films are different in their representation of the patriarchs and the young lovers.

The main patriarchal figure in these films is the woman's old husband. Compared with the original novels, this patriarch is dehumanized and even demonized. One strategy of Zhang is to make him "invisible." In *Red Sorghum*, on Jiu'er's wedding night, her leper husband is not represented on screen. We only see Jiu'er retreat inch by inch from this figure off-screen. Zhang's treatment of Master Chen in *Raise the Red Lantern* is similar. In the original novel, Master Chen, depicted as cold and cruel, is also shown to have many weaknesses. Yet in the film, we never see his face clearly. Either he is shown in long shots, almost always in black clothes, or his presence off-screen is suggested by fragments of his clothes. We only hear his voice, cold and flat. By making the patriarch invisible, Zhang is not making him absent, but omnipresent as a pure watching and commanding "gaze."

In *Ju Dou*, the old patriarch Yang Jinshan does appear in some humanized details. He can be ridiculously miserly and is very much attached to his mule. It is in Tianbai, Yang Tianqing's biological son and Yang Jinshan's acknowledged son, that demonization culminates. In the original novel, Tianbai, as a teenager, is strong and smart. After the death of Tianqing, he is inconsolable. He kills no one. Yet in the film, he kills both of his fathers. He never utters words except those that nail the other characters to their social roles: *die* (father), *niang* (mother), and *ge* (elder brother). He becomes a pure symbol of the patriarch: a mere grim and cold presence with watching eyes and killing hands.

Moreover, with time, there is a tendency for the patriarch to become more and more powerful. In *Red Sorghum*, Li Datou the leper appears "invisibly" only once, and then mysteriously dies, presumably murdered. Then every trace of him is destroyed. The matter-of-fact occasion of his death in the novel is turned in the film into an exuberant and extravagant festival. Jiu'er and the workers celebrate his death, and Jiu'er suggests that "they sluice" the whole place "with sorghum wine thrice." All are ecstatic. The fire and the wine make sure that the old world is completely eradicated, and a brand-new world is created for everyone.

With *Ju Dou*, the old patriarch Yang Jinshan becomes much more powerful. Crippled for life, he can still rob Tianqing of his son and transmit his message effectively to Tianbai, who is Yang Jinshan resurrected with a vengeance. The unfortunate Ju Dou and Tianqing can defy the old patriarch, but they cannot defy Tianbai the child-patriarch whose presence alone is enough to persecute them. Even at the end of the film, when Ju Dou sets fire to the dying mill, we are not told what may become of

Tianbai. If the fire in *Red Sorghum* is happy and celebratory, then the fire in *Ju Dou* is destructive and suicidal. Similarly, in *Raise the Red Lantern*, Master Chen is absolute in his authority.

The patriarchs also gain more and more support from tradition and society. The leper in the 1980s *Red Sorghum* works alone, while the patriarchs in the later films can invoke the collective authority of tradition. The emphasis on this vicious patriarchal tradition is almost entirely added by Zhang. Thus, in *Ju Dou*, we see Yang Jinshan bow to the altar of his ancestors, and the family patriarchs convene for important decisions. In *Raise the Red Lantern*, Songlian's first stop in her tour of the mansion is the room where portraits of family ancestors are hung. This room, nonexistent in the original novel, is also where the family dines under the gaze of the ancestors. In this film, Zhang makes the phrase "old rules" (*lao guiju*) a recurring theme. Everything is conducted according to the old rules. This makes the events in the story timeless. Master Chen is only one of a series of patriarchs, and Songlian is only one of many victims. Near the end of the film, after Songlian goes mad, another mistress is married into the mansion, innocent and ignorant, just as Songlian used to be. The reign of the patriarch is thus perpetuated.

With the tendency of the patriarchs to become stronger is a parallel tendency for the male lover to become weaker. From *Red Sorghum* through *Ju Dou* to *Raise the Red Lantern*, the male lover degenerates from a hero to a coward to less than a coward. The alterations Zhang makes to the character of Tianqing, the male lover in *Ju Dou*, are particularly telling. In the original novel, Tianqing is only sixteen when he meets Ju Dou. He is "innocent and healthy, happy and exuberant," and his story is that of a "love hero."[12] His characterization is not without a touch of the sublime or heroic. Yet in the film, Tianqing is already in his early forties. Thin, almost withered, and docile, he is only a diminutive version of the same character in the novel. The film also has Tianqing killed by his son, sealing his total defeat. The male lover in *Raise the Red Lantern*, the patriarch's son, is if anything even more pathetic. The romantic sentiments between him and Songlian never even materialize. Significantly, the male lover is also bound to the patriarch by stronger and stronger ties, from a stranger to a nephew to a son, and the moral demands on him become more stringent.

The increasingly powerful patriarchy and increasingly weak rebellion are often cited as evidence of Zhang's conformism to the current regime. It seems that we should distinguish between what the film represents and what the film makes the audiences identify with. Take Tianqing in *Ju Dou* for example. Zhang deliberately makes him much weaker than in the novel. Yet the perspective of the director himself is obvious. To Zhang, Tianqing "is a typical Chinese … He has a very heavy burden, and his mind is repressed and distorted," and he "represents the repressed part of we Chinese."[13] Here, Zhang seems to be carrying on the self-assumed task of Chinese intellectuals since the May Fourth Movement: to expose and critique the ugly side of the so-called Chinese "national character."

Engaging the History of Chinese Communism Obliquely

In rewriting twentieth-century Chinese history, Zhang Yimou has to deal with the rise of communism. He was born in 1950, and grew up under the Maoist regime. From the changes he makes to the original novels, we can see how his strategies evolve in tackling this issue, how he sometimes tries to avoid it, and sometimes confronts it in a circuitous way.

The novel *Red Sorghum* clearly offers some negative images of the Communist troops, which are deleted by Zhang in his film. He turns Luo Han, a senior worker in the winery, into a Communist. Old and obedient, Luo Han is quite unusual for a Communist, and in the end he is flayed. His violent death, though tragic, is unsightly, and classic Communists in films do not die in this way. Moreover, he is by far outshone by the muscular, energetic, and rambunctious "grandpa." Luo Han obviously harbors some romantic sentiments for Jiu'er, yet Jiu'er falls for "my grandpa." Zhang deliberately makes the rascal-like "grandpa," the real hero of the film, different in every way from the hero in classic Communist films. In the novel, one of grandpa's methods to woo Jiu'er is to implement a new technology in the winery. This introduction of modern science is deleted in the film, and the grandpa remains reckless.

The final fight with the Japanese in the film can well illustrate how Zhang tries to make "grandpa" a spontaneous hero not guided by any fixed ideology. "Grandpa" is called "Commander Yu" in the novel, because he has a semi-regular troop, no less than forty in number, armed with all kinds of rifles and other weapons. He plans the ambush to be a concerted action between his troops and the Nationalists, although the latter fail to show up. Yet in Zhang's film, grandpa, grandma, and the winery workers become pure "commoners" (*lao baixing*), without allegiance to any political authority. Their ambush is done on the spur of the moment with homemade weapons. It is an action purely of the common folk and by the common folk. Thus the film, despite the presence of a Communist, gives the glory to a spontaneous and reckless hero and the folks he represents.

Moving to *Ju Dou*, Zhang tries to avoid addressing the post-1949 period by deleting all traces of a Communist presence in the original novel. *Fuxi, Fuxi*, on which the film is based, is quite similar in structure to Yu Hua's *To Live*. In the novel, the story begins in 1944, after which the village experiences one Communist campaign after another right up to the Cultural Revolution. Yet in the film *Ju Dou*, to make the story totally pre-revolutionary, the action begins in the 1920s. Thus, even with a considerable lapse of time, the story can still end before the advent of communism. However, this seeming lack of interest in post-1949 political history is only temporarily repressed. It returns with a vengeance in *To Live*.

If *Red Sorghum*, *Ju Dou*, and *Raise the Red Lantern* are snapshots of the Republican period, then *To Live* is ambitious enough to be a national epic. According to Yu Hua, author of the original novel, the book is first of all a story of one man's life, and lastly a story of a nation. Zhang's film elevates this last theme over and above other themes, presenting the story of a nation through one family's fate. To do so, he

adds more "culture" into the film, plays up the significance of national politics and at the same time manages to avoid political critiques that are too overtly direct.

In the novel, politics serves only as a vague backdrop against which the family life unfolds. The novel does not even mark in any way the establishment of the PRC. Yet the film's representation of China is completely structured around national politics. To make the protagonist Fu Gui and his family more representative of China and more exposed to politics, the film transplants his family from a village in the novel to a town. The town helps to magnify repercussions of national politics, which in the village can only be remotely felt. On-screen captions specify the time and the current national events. Emblems of the age are profusely used. Most tellingly, the Cultural Revolution, represented only peripherally in the novel, is extravagantly shown in the film: the ubiquitous faces of Mao; the ever-present shrill voice of the loudspeaker; streets full of crowds and big character posters. A prominent example of the foregrounding of politics in the film is the marriage of Fu Gui's daughter Feng Xia. The film practically repackages the rustic marriage in the novel into a typical Cultural Revolution ritual, in which every detail is emblematic of the age. Thus, the political background moves front and center and becomes the focus of the film.

Despite his political caution, in comparison for example to Tian Zhuangzhuang's *The Blue Kite*, which represents some of the same historical period far more bleakly, Zhang's political critique in *To Live* is nonetheless conveyed through the film's highlighting of politics, as seen by the seeming "coincidence" of Fu Gui's family catastrophes with political campaigns. Politics is the obvious murderer of Feng Xia. If her marriage is a packaging of the happy or harmlessly funny elements of the Cultural Revolution, her death captures the dark side of that campaign. In the novel, Feng Xia dies of bleeding in a hospital staffed with normal doctors. Her death, which may well happen at any period, is narrated by Yu Hua in starkly simple words. This death is fleshed out into the most tragic scene of the film. The Red Guards seizing the hospital, the escorting to the hospital of a condemned and abused old doctor, the irrevocable process of Feng Xia dying — these are all added by Zhang. With these new elements, the scene is transformed into an indirect yet no less strong critique of the radical politics at the time.

This may bring us to a feature of the political critiques couched in the film. These critiques are often oblique or ambiguous. Verbal homage is sometimes paid to the authorities, yet visual images often negate the verbal messages. One telling example is the scene of the defeat of the Nationalist army. Lao Quan, a Nationalist soldier, says confidently that the Communists are kind to captives so long as you raise your arms high. Yet he himself receives a Communist bullet. The following scene of Fu Gui and his friend Chun Sheng being overtaken by the Communist soldiers is a striking representation of the menacing and ominous advent of the Communists. First we have an overview shot of Fu Gui and Chun Sheng, two tiny black spots floundering in the snow. Then we see the avalanche of Communist soldiers approaching and engulfing them. Yet, this unusually unflattering representation of the Communists, due to its visual nature (no words are uttered), lends itself to multiple interpretations and thus may hope to circumvent censorship.

One paradox of the political critiques in the film is that, on the one hand, the film adds much more political content; on the other hand, the political edge of the original novel, if found too sharp, will be downplayed or displaced in the film. The famine in the late 1950s and the early 1960s, described in detail in the novel, is absent in the film. Zhang also changes the timing of the ending. The novel narrates Fu Gui's life right up to the present and ends on an unmistakably pessimistic note. The de-collectivization in the early 1980s makes his life even worse. The violent death of his grandson, after the reforms begin, represents a continuation of the cycle of catastrophes for the family. Fu Gui, bereft of all family members, now has only an old cow to keep him company. The film, by contrast, is ended immediately after the Cultural Revolution and purposely stops short of venturing into the present. All political critiques are aimed at the past, which is already safely dead and buried. Also, the film is blessed with a subdued happy ending. Not only do four family members survive, but they represent three generations. They dine, talk, and laugh even as the credit lists appear on the screen, conveying a sense of everlasting peace and security.

At the same time, perhaps we should also guard against the temptation to read too many critiques into Zhang's films. Rather than a simple desire to critique negatively, his attitude toward communist history is ambivalent. The scenes of commune dining, steel making, and Feng Xia's marriage are not without a dimension of the carnival, although the happy mood in each case soon turns sour. Zhang believes that, at that time, "people willingly threw themselves into these two great movements [the Great Leap Forward and the Cultural Revolution]."[14] In fact, like Feng Xia's husband, Zhang himself used to be good at drawing portraits of Mao. When Rey Chow demands the characters in *To Live* "to speak out against injustice and to propose political alternatives,"[15] she might be expecting too much or having too fixed a view of agency or resistance. Not only are the characters not allowed to speak out, but they sometimes internalize the official ideology so much that they do not want to speak out, or have nothing to speak out about in the first place.

Conclusion: Visuality, a Double-Edged Sword and Its Ascendance

Zhang Yimou's success is without parallel among Chinese filmmakers, both nationally and internationally, artistically and commercially. His emphasis on visuality is certainly one of the secrets of his success. His films are beautifully made, with an impressive and rich color design, no matter what the subject is. These visual elements are often what can sell well to both Western and Chinese audiences. To Western audiences, what is presented in these films in dazzling detail is Chinese culture, or the "Other" as opposed to Western culture. From this transnational perspective, Zhang's success can be read as a symptom of global capitalism and the postcolonial situation. This aspect of his films has been amply studied by important critics both in and outside China. To Chinese audiences, these films are equally or even more engrossing, because they show them a China they are not familiar with, yet one to which they can relate. This is a China of the remote areas (unfamiliar in space) and of the past (unfamiliar in time),

with its strange customs and costumes, architecture, and artifacts. Zhang employs the ambiguous nature of images to his full advantage, so that each set of audiences can see in his images something they want to see, although these interpretations may be contradictory with one another.

However, Zhang's excessive reliance on an exaggerated aestheticization of film images, especially saturated color and rich, sensual lighting and composition, can cover up other "problem" areas. When Mayfair Yang interviewed Zhang and commented that "You make your tragedies very beautiful in *Red Lantern*," Zhang answered, "When tragedy is 'made aesthetic' (*meihua*), then it is all the more overpowering."[16] However, seen another way, the tragedy is also diluted, and practices which are supposed to be condemned may appear to be attractive. Take for example the practice of having the favorite mistress's feet massaged in *Raise the Red Lantern*. The massage, like the lanterns, is supposed to be a manifestation of the power relationships under patriarchy. Yet, by depicting a mesmerized Gong Li enjoying the massage, the film presents it as a form of desirable sensual pleasure. That which is "made aesthetic" often loses at least some of its subversive edge.

The emphasis of Fifth Generation filmmakers on visuality was indeed revolutionary when their early films offered a stark contrast to the Chinese film-making tradition, in which story and dialogue are the main means of expression. Over time, when this emphasis on visuality turned routinized and even automatic, it became less and less subversive and more and more hollow. Zhang's two recent films, *Hero* (*Yingxiong*, 2002) and *House of Flying Daggers* (*Shimian maifu*, 2004), and *The Promise* (*Wuji*, 2005) by Chen Kaige, another leading director of the same generation, have all gone to an extreme in their excessive foregrounding of visuality at the expense of other filmic elements. Visuality here exists for its own sake. These films' beautiful costumes and scenery, dazzling martial arts special effects, strung together with meager story lines and ridiculously shallow conversations, become mere spectacles for consumption. The enticing visuality may thus turn out to be a double-edged sword which can ironically reduce the power of film as a multifaceted platform of arts.

Zhang's career can also reveal the attitude of filmmakers toward their source material and the manner in which that attitude may change over time. Speaking about the two writers on whose works he based his *Not One Less* (*Yige dou buneng shao*, 1998) and *The Road Home* (*Wode fuqin muqin*, 1999), Zhang has this to say:

> Their novels can only give me a point to start with.... Sometimes the changes to the original novel amount to 90% ... because the present condition of Chinese literature is not like ten years ago. It is very difficult to see a complete and impressive novel.... It is impossible to see such novels as *Red Sorghum* (*Hong gaoliang*) or *Wives and Concubines* (*Qiqie chengqun*), which are so complete in content and meaning that we only needed to change 40%.[17]

It is difficult to say whether literature is really suffering a decline as Zhang believes, or whether it is because he is becoming more and more confident or even arrogant in his attitude towards literature. In 2006, Zhang made another blockbuster "adaptation"

film, *Curse of the Golden Flower* (*Mancheng jindai huangjinjia*), this time not based on contemporary Chinese literature, but on a classical play by canonical modern Chinese playwright Cao Yu (1910–1996). Far from being inhibited by the classic nature of the original source, Zhang freely made drastic changes, and even transplants the story to ancient China.

Zhang's comments also point out the change in the relationship between the screenwriter and the director in China's evolving film industry. Directors used to receive a script already completed in the studio, and his or her task was to make the script into a film. With the advent of the Fifth Generation, directors became far more important and independent. As the pivots of the filmmaking process, they now have much more leverage in their dealings with writers. Writers are eager to have their works adapted for both the monetary benefits and the fame. They are willing to change their own works, or have them changed, in ways that can please the director. Zhang estimates that in his meetings to discuss the scripts with writers, the presentation of his views would occupy 70–80 percent of the time.[18]

Zhang's fellow and rival director Chen Kaige's *The Promise* can more enlighteningly illustrate a new dependency of literature on film. In that instance, the film became the starting point, and literature a byproduct. Chen sold the novelization rights of the film, and an "American Idol–style" online campaign was launched for audiences to vote for the adapter (writer), which fully testified to the increasing commercialization of literature and the ascendance of visuality in the Internet age. The book was finally published by the prestigious People's Literature Press (Renmin wenxue). From a new art that fought for its legitimacy by claiming that it was literature, to an art that fought for its independence by trying to break away from literature, film has now become a dominant art form over literature, hiring all-too-willing writers either to write scripts dictated by a director, or write a novel based on a film.

Boundary Shifting:
New Generation Filmmaking and
Jia Zhangke's Films

*Shuqin Cui**

A significant component of contemporary Chinese cinema is the work of the new generation film directors. By "new generation," I mean filmmakers born in the late 1960s and the early 1970s, whose maverick works are distinct from those of the Fifth Generation and counter to the mainstream film industry. Their coming-of-age experience reflects a historical moment when China changed from an egalitarian, socialist nation-state to a market-driven, postsocialist entity. Their filmmaking practice is persistent in the pursuit of subjective auteurship and alternative aesthetics. The early works are characterized by urban space as setting, rock music as expressive sound, and alienated youth as central characters. Working outside the official system, the young filmmakers engaged in independent filmmaking and encountered trouble with funding, distribution, and access to audiences. The desire to remain independent and the difficulty in doing so have caused these filmmakers to move between the margins and the mainstream and to make films both inside and outside the system. Elsewhere, I have argued that labeling new generation filmmaking as "independent" or "underground" is fraught with contradictions: to make a film in China, directors must negotiate between personal and mainstream production, domestic reception and international recognition, capital resources and market distribution.[1] Faced with socio-political and commercial pressures, few independent directors are able to remain true to their identities and intentions.

The alliance between the new generation and the mainstream can be attributed to various factors. The state no longer has sole authority over film production and distribution. Hollywood blockbusters are imported, and many entities — such as joint or private film corporations, independent producers, and movie theater networks — compete to maximize market share and seek revenue for distribution. The official State

* I am very grateful for permission from Kirk A. Denton and *Modern Chinese Literature and Culture* to reprint this article. Special thanks also go to Stanley Rosen and Ying Zhu for selecting this paper to be included in this volume. With this revision, I have had the opportunity to add a discussion of Jia Zhangke's recent Venice Golden Lion Award film, *Still Life* (2007).

Administration of Radio, Film, and Television (SARFT) and the state-controlled studio system remain in force, but they too have to take the market and audience seriously. Under these conditions, filmmakers in contemporary China seek all possible means to survive and to succeed. Young directors whose works have been cut off for so long from audiences and neglected by the mainstream finally recognize the necessity of making films both inside and outside the system. Examples that demonstrate the return to the mainstream are a group of new films made within the official system and dealing with the theme of a past lost in memory and neglected in representation. The year 2005 alone saw the release of Gu Changwei's *Peacock (Kongque)*,[2] Wang Xiaoshuai's *Shanghai Dreams (Qing Hong)*, and Zhang Yang's *Sunflower (Xiangrikui)*,[3] three films that tell coming-of-age stories. The cinematic representation of the coming-of-age experience allows these directors to situate their generation in the historical moment of the 1970s, when they themselves, like the protagonists of their films, cope with a difficult socio-political transition.

From among the new generation film directors emerged an "exemplary figure," Jia Zhangke. Unknown in film circles with his local origin in Shanxi, Jia began to make films with a digital camera, and his works reached audiences only through pirated copies. Today an internationally acknowledged director who attracts funding, Jia shifts across the boundaries between state-market, local-global, and marginal-mainstream. As with his peers, the generation born in the 1960s or 1970s and its youthful subculture are Jia's central concerns. Unlike his peers, however, Jia uses a personal and subjective lens to show a persistent concern for local experience and marginal groups. The director locates his young protagonist against a place-space caught between the local and the global, between a political past and a pop culture present. The creation of this spatial imagination and temporal transformation illustrates how local Chinese struggle as well as adapt to the transition, and how the film director crosses the line between independent and mainstream norms.

In this chapter, I argue that new generation filmmaking, personal and rebellious in its origin, has never ceased to negotiate a space between the periphery and the center, the local and the global. With the local-global as a spatial framework, and taking Jia's five films — *Xiaowu* (1997), *Platform (Zhantai*, 2000), *Unknown Pleasure (Ren xiaoyao*, 2002), *The World (Shijie*, 2004), and *Still Life (Sanxia haoren*, 2006) — as textual evidence, this chapter explores first the anxiety and uncertainty inscribed in the film narratives and visual articulations. I argue that China at the turn of the millennium strives for and is driven to a new world system defined as transnational globalization. While affiliation with the global accelerates a market-driven economy, the encounter between the local and the global is fraught with contradictions as capitalist practices collide with socialist ideologies. Such an encounter becomes more intriguing as the director and his films shift across the boundaries between local settings and the global market.

The chapter further examines how, as the director interprets local space to reveal the abrupt dislocations in China's socio-economic landscape, he furthers his investigation by focusing on forms of popular culture. Trends from Mao's mass culture to contemporary pop genres provide temporal illustrations of the shifting social scene. Pop forms such

as music, songs, KTV, media, fashion, and hairstyle all function as indices of socio-cultural change. A single performance brings the audience back to Mao's era, and a multi-soundtrack installation suggests the confluence and divergence of the local and the global. As the long take rejects the audience's engagement, the soundtrack becomes the primary mode for comprehension. It is through this pop and multi-installed soundtrack that the audience experiences deeply the feeling of anxiety and uncertainty about a society running headlong towards an ambiguous destination.

The chapter closes with an open question: "beyond the local but out of the margins?" The release of *The World* finally locates the film director in the mainstream film production system. This position, however, does not guarantee wide distribution and ample profits. *Still Life* brought international recognition. The awards led to global funding resources but did not stimulate domestic audiences. This paradox suggests that negotiations between margin-center and local-global remain a constant struggle. To survive and succeed in a filmmaking field dominated by multifaceted forces, filmmakers like Jia Zhangke must continue to negotiate the boundaries of the official mainstream and the commercial market.

Between Local and Global

Jia Zhangke's films inspire us to think about cultural studies and theories beyond the framework of the nation-state. Contemporary cultural theory, as Janet Wolff suggests, "has started to move away from its earlier, rather ethnocentric approach, to investigate the global dimensions of cultural production and consumption."[4] This global dimension — characterized by the circulation of images, information, technologies, people, capital, and ideologies — brings the world into realignment. The cartographies of the remapping enable Jia's films to bring a local place face to face with the global space. In so doing, margins come into representation; indeed, "marginality has become a powerful space."[5]

As its economy booms, China becomes increasingly enmeshed in the networks of transnational capitalism. The global/local interaction can best be viewed from a dialectical perspective: global capitalism both integrates with and contradicts postsocialist localities. China's affiliation with the world system accelerates its market-driven economy, but the central government retains its monopoly on power. Information technology and commodity circulation may offer connections to the global village, but the technological revolution distances Chinese people from their local origins and cultural traditions. As globalization weaves a web of relations among nations, it exacerbates social differences and economic inequalities within the locality. The gulf between rich and poor, center and periphery, elite and ordinary widens as rapidly as globalization itself spreads. The significance of Jia's films lies in the deep concern for those marginalized by the forces of globalization: economic outsiders, youth subcultures, and "floating" migrants, for example, are left behind by the increasingly affluent mainstream.

Jia's cinematic representation of the local in the age of globalization begins in Fenyang, Jia's hometown, moves to Datong, and ends in Beijing. Such a move

indicates Jia's constant search for meaning in local experience and may also represent his transition, as a director, from the periphery to the center. Fenyang, a rural town in the northern province of Shanxi, is the primary setting for the films *Xiaowu* and *Platform*. Although out of the way and seemingly insignificant, Fenyang becomes the site where the local and the global converge. To further explore the local/global encounter, Jia takes his camera from Fenyang to Datong, a crumbling industrial city also in Shanxi, to make *Unknown Pleasure*. The young protagonists in the film are unemployed, but they are well connected to global images and media. In a further transformation, Jia's *The World* links the Shanxi natives with the metropolitan and the global. The site of the global — a theme park in Beijing — can define the world, ironically, only with replicas of international landmarks. This artificial articulation of the greater world adds to the film characters' confusion about their personal and local identities. While his characters drift in different directions, Jia, too, travels across multifaceted boundaries: from independent to official, domestic to international, and avant garde to commercial.

Fenyang, where Jia spent his childhood, is a departure point for his cinematic exploration. In the opening sequence of *Xiao Wu*, an extreme close-up shot magnifies a pair of hands lighting matches. The Chinese characters for "Shanxi" are clearly visible on the matchbox. Not all viewers will notice the place name because it is in Chinese, but it serves the purpose of establishing the setting and foregrounding the local space as the central subject of the film. The sequence that follows reveals a locale in the throes of socio-cultural and economic transition: on the one hand, the landscape is marked with an ancient gate, yellow earth tones, and signs of poverty; on the other hand, it is commercialized with KTV bars, restaurants, hair salons, and gaming tables. The spatial display reveals a postsocialist geography where a commercial culture emerges side by side with the vestiges of local tradition.

In this setting, where the local and the global interact, the film follows a drifter who wanders on the socio-economic margins. The title character, a pickpocket in an oversized Western suit and oversized glasses, searches for a place and an identity in this ever-changing society. As a professional thief acting against mainstream ethical norms, Xiao Wu negotiates between the center and the periphery. In the postsocialist milieu, whereas get-rich-quick entrepreneurs represent China's passion for individual success, the drifting pickpocket seeks self-identity in a KTV salon, where consumer culture redefines gender/sexual relations. Although he does not know how to sing, Xiao Wu still pays the 50 yuan hourly fee to rent the KTV room and have a female companion. The pickpocket and the singing girl are both peripheral to the socio-economic order, yet inside the KTV bar anyone who has the cash assumes the power to take another as a commodity. With money gained through his skill at stealing, Xiao Wu can temporarily transform himself from a member of the underclass into a consumer. Nonetheless, his inability to sing along with the girl bruises his pride and sense of masculinity.

The film does not condemn the protagonist's lower-class origins; it portrays him as something of a social outcast, but one with dignity. Later, alone in an empty public

bathhouse, the protagonist is finally able to sing (though out of tune) the theme song, "Rainy Heart," to express his emotions toward the girl. The long take extends the personal moment, and the mood lingers as the camera tilts up from Xiao Wu to the ceiling of the bathhouse. Naked and alone, Xiao Wu has a private moment during which he experiences a sense of being himself. The moment also allows the audience a glimpse into Xiao Wu's inner world. The pickpocket and the singing girl sense themselves falling in love, but they fail to realize that their relationship is grounded in a commercial transaction. The girl eventually leaves Xiao Wu and the small town for a better business opportunity. Xiao Wu keeps expecting his beeper to ring with a call from her, but it rings only just as Xiao Wu is about to commit a theft, resulting in his arrest. We learn in the next scene that the message left on his beeper is not from his girlfriend but is merely a weather broadcast. Although technology brings new possibilities to the floating population — the girl is free of spatial boundaries — it does not foster promising human relationships.

Peripheral individuals such as Xiao Wu at once subvert and are subordinated to the police network, an arm of the state apparatus. On the bus from village to town, Xiao Wu refuses to buy a ticket, identifying himself as a policeman. Xiao Wu's daily activities include stealing residents' identity cards, which he then drops into the public mailboxes to taunt the security authorities. He does not realize until the end of the film that the state continues to exercise its powers over him. Caught by the police, Xiao Wu is chained to a street-side utility pole and left for public display (Fig. 11.1). Framing him as the center of attention, a point-of-view shot from Xiao Wu's perspective shows us how the onlookers in the film visually seize the character with an interrogating look. Humiliated, with no way to escape, Xiao Wu experiences violation by public spectatorship in a public setting. The camera then turns 180 degrees to assume the onlookers' viewpoint, and the shot invites the audience to identify with the force of their gaze. The shifting camera angles, as Kevin Lee indicates, turn both the character and the cinematic production into "public spectacles."[6]

After his first feature *Xiao Wu*, Jia made *Platform* and *Unknown Pleasure*, also set in the Shanxi region; neither was distributed publicly in China. Entering the mainstream

Figure 11.1: Xiaowu, chained to a utility pole

became a possibility, however, when *The World* received official approval. As the director expected, changing the setting of a film from the regional place to the metropolis opens up the market and brings greater recognition. But perhaps a transition from local to urban might lead only to another form of marginality. Seeing himself as well as his characters as migrants adrift in the metropolitan center, Jia sets his film in a Beijing theme park, where a miniaturized "world," with replicas of the Eiffel Tower, the Great Pyramids, London Bridge, and the Twin Towers in Manhattan, is transplanted onto China's landscape (Fig. 11.2). This constructed space and its splendid commodities, which lure visitors to "see the world without ever leaving Beijing," again raise the question of the encounter between the local and the global, between periphery and center.

Figure 11.2: The World Park in Beijing

The world in *The World* is divided into underground and aboveground spaces and between onstage and backstage spaces. On the theme park's performance stage, singers and dancers play various roles as world citizens. "Backstage" — in basement dressing rooms, on construction sites, and in nearby garment factories — tangled life stories unfold. Most of the actors are local fellows from Shanxi province who had roles in Jia's previous films. They leave their local identities — pickpocket from Fenyang, unemployed youth from Datong — behind to join the "floating population" of migrants from rural areas who search for work in urban centers. Beepers are replaced with cell phones, and Shanxi dialects are mixed with Mandarin Chinese. This geographical and socio-cultural shift lands them in the urban margins, where they survive as singing/dancing girls, security guards, and construction workers. The migrants immediately find themselves caught between their local origins and global landscapes.

The engagement between global interests and local migrants unfolds through spatial forms. In the sequence before the credits appear, a tracking shot leads the audience through the dressing rooms in the basement of the performance center. In make-up and in costume, the performers are ready to go onstage in global roles with their own

identities concealed behind masks. After the stage performance, an establishing shot of the theme park, with its fabulous visual spectacles, occupies the screen. To contrast with the overarching landscape of the theme park, Jia inserts an image of a homeless person entering screen left, turning to face the camera, and then exiting screen right. In the background, behind the moving figure, is the theme park. With this startling contrast, the film title, "*The World* — a Jia Zhangke Film," scrolls in.

The sight of the homeless person wandering before the splendid world puts the local-global encounter into focus. The setting of a theme park in China with the world as subject poses immediately the question of translocation or dislocation: the Eiffel Tower and the Great Pyramids are out of place in Beijing. Yet the "displacement or dislocation itself becomes a defining factor" in the articulation of local-global discourse.[7] Translocation of the Western Other through miniaturization opens up a "glocal" site that indicates China's desire to integrate itself into the global community. This global village, with its fragmented architectural sites/sights artificially displayed, bears no connection to any geographical or national boundaries. In a couple of hours a visitor to the theme park can view the entire world without any border restrictions, but their "travel," of course, is not real, showing how artificial the global condition can be. Once culturally distinctive world sites/sights are rendered into representations and commodities, the miniaturized globe remains only a visual display for consumption by the local tourists.

Visitors to the theme park connect to and comprehend the world by having their photographs taken in the famous architectural replicas. The photographed image, a superimposition of the local self on the world replicas, seems to promise one a global identification. This global identification, like the replicated objects, becomes an artifact that can be made or re-made through mechanical reproduction. In other words, identity and image become increasingly interchangeable via the mimetic visual form of photography. One's social and global identity, as Daniel Jewesbury indicates, resembles "a promiscuous image-commodity endlessly replicated and disseminated in the tourist imaginary."[8] Apart and different from the tourists, the park's service workers (the migrants) are also turned into commodities because they expend their labor in exchange for its economic value. Whether an actor or a security guard, the employee has a legitimate association with the place/space only through performance and service. Away from their stage and service roles, s/he does not inhabit but only "dwells in relation to" the place/space.[9]

Although he links the local and the global through his glocal mise-en-scène, Jia fails to realize that the local finds little space to establish its own identity and experience. "In a sense," as Manohla Dargis comments in her review of *The World*, "this miniaturized world creates a prison for the filmmaker. Mr. Jia isn't just enamored with his metaphor; he's mesmerized by it. As he wanders around the amusement park, repeatedly cutting away to the phony Eiffel Tower jutting into the China sky, the pyramids and the Manhattan skyline, he increasingly comes across less like a filmmaker who knows what he is after and more like a besotted tourist."[10] Dargis's comments suggest a dilemma facing the film director: the move from periphery to center does not necessarily prompt a new sense of identity.

Beyond the glittering theme park lie the underground spaces where "the floating population" dwells. Air-raid shelters turned into motel rooms, garment-making workshops, and construction sites — here the film uncovers fragments of life stories: sexual relationships, emotional frustrations, and struggles against an alien environment. A powerful scene about a migrant takes place in a hospital emergency room. A young man known as "Little Sister" (Er guniang) comes to Beijing to look for a better life.[11] His Shanxi friends proudly show him the theme park. Unfortunately, a construction accident leaves him hospitalized in serious condition, and in his final moments of life, he writes his friends a note. With the soundtrack silent, an extreme long take pans through the characters waiting outside the emergency room. The lingering shot tests the patience of the audience, anxious to know what the note is about. An emerging long list of names and debts finally explains why Little Sister has moved to Beijing. Migration and the construction industry give Little Sister the opportunity to be a contract laborer but not a consumer in the global market. The construction site is a place where one can survive as a migrant, but it is also where death comes all too easily. The dying migrant and the scrolling list of creditors silently yet powerfully indicate how China's rapid development exacts a high human cost.

In *The World*, Jia is still deeply concerned about people on the margins. But in contrast to his previous films, he now has the budget and the state approval necessary to make a movie that will attract a wider audience. Innovations include CGI (computer-generated images), song-and-dance numbers, and special effects. The computer images and animation sequences open fresh possibilities for narrative constructions and visual effects. For instance, the security guard receives a cell-phone message, which the audience reads when it is transformed into an animated text on the screen. From the message we learn that the owner of a garment-making shop from Wenzhou has invited the security guard to stop by. The film director again applies a colorful animation sequence to show the man on a horse rushing to see his new lover and falling into a sexual romance (Fig. 11.3).

In the juxtaposition between cinematic representation and computer animation, desires, frustrations, and sexual relations entrapped in cinematic space find freedom in

Figure 11.3: Computer-generated flash art

the world of animation. Computer technology is used as an on-screen narrative device, with animation as the visual attraction. In "The Cyberfilm: Hollywood and Computer Technology,"[12] Eric Faden points out that "on one hand, digital technology comes wrapped in a utopian veil of endless visual possibilities. On the other hand, it shadows deepest cultural fears: the loss of personal identity and memories." In Jia's film, the paradox lies in the integration between local experience and cyberspace.[13] When the local is plugged electronically into the global, local identity and experience give way to an image-making system controlled by computer technology. Technical manipulation can remove the image from the character's socio-cultural framework and visually distort the truth. The insertion of animation into local experience, seemingly for the sake of visual spectacle, suggests an effort by the film director to get closer to the mainstream commercial culture.

From Mao to Pop

In addition to articulating local-global tensions in spatial, social, and visual constructions, Jia uses pop culture to reflect further on socio-economic changes. Popular cultural trends — music, song, films, media, fashions, hairstyles — function as "the index of social change" and essential modes of cinematic constitution.[14] In China, where a thriving market economy develops under the aegis of an authoritarian political system, official discourse and popular culture have merged in the cultural industry.[15] State-dominated or state-sponsored cultural production feeds a mainstream that advances official ideologies. Market-operated and mass-consumed pop culture legitimates alternative channels where cultural producers and consumers can adopt different voices. A neat dividing line between the mainstream and the subculture can hardly be drawn, though, because both undergo a continual process of commercialization and consumption. Attracting audiences and seizing market share have been the primary concern for survival and success in all realms of cultural production, state and private sectors alike. As contemporary China rapidly engages with global trends, popular culture becomes "the best place to test the assertion that capitalist globalization is now an accepted reality, as the world space of cultural production and representation is inhabited by images and goods pertaining to the everyday life of the world population, circulated in a global market."[16]

In Jia's films, pop culture functions not only as a signifier of but also as a participant in socio-historical transformations. In the title sequence of *Platform*, for instance, popular music marks the transition from revolutionary mass culture to commercial pop trends and from socialist collectivization to postsocialist privatization. The film begins with a restaged Cultural Revolution performance of "Train Going to Shaoshan" (*Huoche xiangzhe shaoshan pao*). The familiar political content and absurd performing style take the audience immediately back to the heyday of the Cultural Revolution. Although the performance brings back a collective memory of socio-political history, its restaging presents an example of mass cultural production and popular consumption.

A soundtrack with prominent popular music and songs is a signature of Jia's films. His soundtracks work in conjunction with the visual realm to create a multifaceted aura

that exemplifies not only a socio-historical moment but also the trajectory of popular culture itself. As Hilary Lapedis indicates, "Pop music has had an existence and mass audience prior to its associations with the visual; it stands as an image in its own right."[17] Consider, for example, a sound montage in *Platform* that accompanies a scene set at a local film theater. First, the theme music of a popular Chinese film, *Little Flower* (*Xiaohua*), emanates from a loudspeaker as we see the space in front of the theater.[18] The music fades away and is replaced by music from Raj Kapoor's 1951 Bollywood classic *Awaara* as the film cuts from outside to inside the movie theater.[19] Suddenly, the loudspeaker disrupts the music with a loud announcement that someone is looking for someone. This sound montage creates an aura through the intertwining of musical, cinematic, and cultural codes. The soundtrack takes the audience back to the late 1970s and early 1980s, when Bollywood films and romantic domestic productions gradually replaced the revolutionary model dramas on the Chinese cultural scene. However, the violence of the loudspeaker, recalling the socialist era, suppresses other sounds and the everyday life of the people. Along with the fad for bell-bottom pants, the soundtrack returns us to the past through the familiar language of popular music. For the youth of Jia's generation, such popular sounds and images accompanied their adolescent adventures; for the youth of the film, they act as articulating motifs in the coming-of-age narratives.

In addition to the pop soundtrack, Jia conceptualizes his narrative themes in relation to popular songs. Each of Jia's films has a title song with components essential to the film's thematic constructions. *Platform* takes its title from a popular song, heard throughout the film; each time, under different conditions and in different forms, the song suggests different connotations. Originally from the disco album "87 Crazy," the song allows the protagonist to express a sense of longing and loss. One line of the lyrics reads: "Waiting alone at the platform without knowing the destination." As the film narrative continues, the words remain the same but the rhythm changes. The male lead, Cui Mingliang, now a musician with a punk hairstyle, plays a rock-and-roll version of "Platform" with his rock band. The stage is in a tent set in the middle of nowhere before a handful of rowdy locals, who respond to the performance by throwing trash at the band. In another sequence, rock music is fashioned even further into an "all-star-rock-break-dance" show. When no one attends, however, the troupe tries to lure an audience with announcements from the loudspeaker that its performers are "stars from the United States and Singapore." After failing to negotiate a venue and a possible sponsorship with the local authority, the performing troupe ends up staging the show on the back of a truck in the open air along a highway; the only viewers are passing trucks and other vehicles "applauding" the singers with their horns.

These examples show the film director using pop music or performance as an audiovisual mode to reveal the disillusionment of youth caught between the local and the global. The scenes illustrate that the concept of profit-driven cultural production is at odds with local perception. As the local meets the global in pop forms — rock music, punk hairstyles, designer fashion — the encounter is a collision rather than a fluid integration. The problems lie first in a spatial contradiction where the local is

driven toward the global but is not ready to be part of it. The inability to secure a stage and public space in the local area for performing the new music suggests the distance between the local and the global. The film casts doubt over whether the local Chinese can become integrated with the global as everyday consumers of such cultural forms as rock-and-roll music. It also invites the audience to examine issues of disjunction and contradiction between the local setting/audience and global trends.

The title song of *Unknown Pleasure* calls for freedom from any constraints, as a line from its lyrics indicates: "I follow the wind and roam carefree, a hero unashamed of his humble origins, because of ambitions and pride in my heart." In this film, one of the protagonists, Binbin, is arrested for attempted bank robbery. In a local police station, the officer orders him to sing (Fig. 11.4). With Binbin locked in handcuffs and confined in the police office, the film ends with the image of a captured criminal and the sounds of "Unknown Pleasure," suggesting with a self-reflexive audiovisual metaphor that the body may be restrained, yet the music allows the "hero" a final expression of resistance and free will. Restricted from the social space of public theaters and barred from the mainstream, Jia's films never cease to search for alternate possibilities. The insertion of different voices into the soundtrack presents the most forceful mode of enunciation. "Music is tamed noise," as Jacques Attali states, "a structural code that defines and maps positions of power and difference that are located in the aural landscape of sound. Noise or sound that falls outside a dominant musical code transgresses the dominant ordering of difference."[20] Taking Attali's assumption as a primary thesis, the editors of *Mapping the Beat*, a collection of essays that view sound as a spatial topography as well as a cultural phenomenon, see relations of power located in the shifting boundary between noise and music.[21] Jia's creative use of the soundtrack extends the distinction between noise and music. His multi-track sound, apart from the pop music, makes use

Figure 11.4: Binbin, forced to sing

of oppositions between audio and visual as well as between different forms of sounds. The "counterpoint-as-contradiction or audiovisual dissonance" opens up possibilities of recognizing sound as a territory of power negotiation and socio-economic change.[22] In Jia's films, loudspeakers, the characteristic mass media form of the socialist past, are used to broadcast both political messages and commercial advertisements. The film soundtrack oscillates between the political and the commercial, suggesting the contradictions that exist when the remaining political tradition meets emerging commercial or global trends.

In one sequence in *Platform*, the loudspeaker first airs a political message — "construction of a cultural and civilized village" — and then a personal advertisement — "please come to my household, if anyone needs pork meat." An official voice of authority speaking in standard Mandarin shares the loudspeaker with the voice of a peasant speaking in local dialect; the official political discourse and the commercial pleading of the peasant represent a power negotiation in the soundtrack. Such audio representations not only subordinate a hegemonic authority but also remap socio-economic territories so that the local now has a place. With the soundtrack's counter voices comes an audiovisual dissonance in which image contradicts sound. In another sequence in *Unknown Pleasure*, while a lottery ad plays through stereo speakers, two plainclothes security guards seize a "criminal." The collision between image and sound shows a tension between commercial and political power. The lottery advertisement wishes consumers good luck, but the police authorities demonstrate their power to restrict. The counterpoint indicates the friction between emerging commercial culture and the remaining political structure. In playing sound against image, the sequence suggests that whereas the state apparatus restrains one's deeds, commercial forces penetrate one's mind and arouse desires.

The media, particularly television news coverage, deliver the world into the living rooms of local Chinese. Yet access to world news does not create engagement with the world: the gap between international news and the local audience in terms of image and sound indicates the disconnection between the global and the local. Such moments occur in a series of sequences in *Unknown Pleasure*. In one scene, the audience hears the sound of television news coverage about a Falun Gong member committing suicide in Tian'anmen Square. What we see on screen is the image of Xiaoji's father looking to win a dollar bill from a wine bottle cap. The characters ignore the television coverage to debate the question of how much one American dollar is worth. In another incident at Binbin's home, the television broadcasts news on the "Hainan Incident,"[23] where an American intelligence aircraft collided with a Chinese military jet near Hainan. Binbin pays no attention to the news as he asks his mother to lend him some money. As the sound of an explosion is heard, Binbin responds, "Is the United States invading again?" The film then cuts to Xiaoji's place where the television highlights news about the explosion. Xiaoji, however, is searching for the dollar bill missing from his father's wallet.

The television and its news coverage offer the local audience a window to current events and the network of global communication. Indeed, the flow of information and

media technology begins to dissolve the boundaries of nation-states. People seem to "live not in a local or even national society but as nodes in a network society."[24] But in the sequence discussed here, characters show little interest in, and are in fact quite ignorant about world news. What everyone is keenly engaged with are symbols and behaviors seen as American: the dollar bill, the film *Pulp Fiction*, and the idea of becoming a hero through bank robbery. In fact, one scene in *Unknown Pleasure* is a reworking of the pre-title sequence of Tarantino's *Pulp Fiction*. The two protagonists, Qiaoqiao, with Honey Bunny's hairdo, and Xiaoji, in the role of Pumpkin, are talking about *Pulp Fiction* and the thrill of bank robbery. The film, in accelerated cuts, keeps the "antiheroes" in different frames. As Xiaoji mimics Pumpkin's line, yelling "This is a robbery," a cut takes the audience to an underground disco scene.

The parody and the impersonation might lead us naturally to Walter Benjamin's concept of the work of art in the age of mechanical reproduction. Jia's films, however, are concerned less with the artwork in mass production than with the global circulation of images for cultural consumption and social identity. As the young heroes adopt images and thereby play at a globalized identity, the director films the local in terms of a global imagination. The two protagonists do put their imitated gestures into practice during the bank robbery. In a confined mise-en-scene, the film cuts between the two teenagers as they disguise themselves as bank robbers. With one as the other's alter ego or mirror image, they comment on each other's credibility as a criminal. For Xiaoji, the bomb looks real but not the person; for Binbin, neither the bomb nor the person looks real. With the dummy bomb and the inspiration of *Pulp Fiction*, they restage the drama in a real bank. It ends with Binbin caught by the police and Xiaoji fleeing the scene. As the characters mimic the actors in *Pulp Fiction* and Jia incorporates Tarantino's images in his own film, the local and the global integrate in the making and circulation of images. "The power of mimesis, of creating representations of others and other places," as Michael Taussig indicates, "allows one to be lifted into other worlds. Mimesis (the art of imitation) and alterity (the relation of self and other and the production of identity through difference) are inextricably bound together."[25] For the film director, the escapade at the bank allows his tragic-comic hero to bring change to a frozen existence. Violence is the last romantic expression for the youth.

Beyond the Local but out of the Margins?

With *The World*, Jia Zhangke and his films move beyond their local origins. But the question lingers as to whether this spatial transition generates mobility from the margins to the center. As I finished writing this essay, news came that Jia's 2006 feature, *Still Life*, had won the Golden Lion award at the Venice International Film Festival and the Grand Prize at the Toronto International Film Festival. Art house recognition and film festival accolades abroad do not ensure widespread domestic reception, however, as film production and distribution must respond to administrative regulations and commercial competition.

The transformation of the film industry from an ideological apparatus under a socialist planned economy to a commercial enterprise in a competitive market has opened up possibilities as well as problems. On the one hand, the profit-driven market turns filmmaking and distribution into primarily financial concerns. State capital or private finance fund blockbuster projects packaged with super-stars and special visual effects but which do not explore subjects in-depth. Film theaters, concerned foremost with box-office receipts, give priority to such titles for prime-time screenings. Audiences who can afford the expensive ticket pay to view the film on larger screens. On the other hand, small budget productions, art films, and alternative experiments are shunned by theater networks simply because they do not generate enough revenue. Interested viewers will find a pirated copy for appreciation at home. To make matters worse, administrative interference reinforces unfair competition in terms of resource allocation, theatrical distribution, and media publicity. For instance, Jia's *Still Life* was scheduled for screening in Chinese theaters the same day as Zhang Yimou's *Curse of the Golden Flower*. Up against Zhang's big budget production, *Still Life* lost potential audience and profits. The result does not imply that Zhang's *Curse* is superior to Jia's *Still Life* in quality and aesthetics; it illustrates the power of production capital, theater release, and media publicity in determining commercial success.

Working under the prevailing socio-economic conditions, film directors, especially those outside the official system, thus face a predicament: lean towards the mainstream, remain independent/alternative, or work the boundaries between them. Jia's *Still Life* reflects such a dilemma in its shifting modes between documentary and feature, between art film and commercial considerations. Shot in Fengjie, a town over two thousand years old at the mouth of Qutang Gorge, Yangtze River, this film takes Jia beyond his local places in Shanxi and metropolitan Beijing. The camera intends to capture life in Fengjie before it vanishes due to the Three Gorges Dam project.[26] The unfamiliar locale and the unknown people challenge the film director to consider potential perspective and visual construction. Jia inserts two Shanxi natives, Zhao Tao and Sanming, as the protagonists who travel to Fengjie to look for their estranged spouses. Through this outsider's point of view, the film follows them to inspect the new space and fresh images. The credit sequence begins with a three-minute-long pan shot, introducing common people on a ferry on the Yangtze River. The camera is eager to know the passengers, as it pans across them closely, one after another. The lingering pans move across the screen like a Chinese scroll painting, unfolding horizontally from right to left. Unlike a scroll painting, however, the director foregrounds human figures rather than subordinate them to the landscape. Shot against the light, the play of shadow and light illuminates human figures with a sculptural texture. Behind the camera is the concerned gaze of the film director. Through this engaged point of view, the film leads the audience to a place on the edge of disappearance as migrants cope with socio-cultural and environmental catastrophe.

Still Life is a sister piece to Jia's *Dong*, a documentary about how the painter Liu Xiaodong creates an oil scroll on the subject of migrant workers at the Three Gorges.[27] Jia follows the artist with a camera to document the process of making art. Inspired, Jia infused narrative plots into the documentary structure to bring about the

fictional version, *Still Life*. Intertexual references between painting and filming, between documentary and fiction, occur in multifaceted juxtapositions. Among the interactions are the *multiple viewpoints* through which the migrant images unfold in both the painting and the film, the landscape of the Yangtze River serving as background. A group of migrant workers is centered against this spatial backdrop. The artist situates himself very close to his real-life models and uses his brush to depict eleven semi-nude workers on his canvas. Behind the artist and models stand the film director and his cameraman, filming the painting process. Beyond the artist's and director's gaze comes the vision of the audience. One realizes that the Three Gorges landscape and the migrant workers are the foremost concerns of both artist and director. The multiple viewpoints invite us to confront a social group often ignored and marginalized in China's contemporary scenes.

In his review of *Still Life*, Shelly Kraicer comments that "Jia's camera has two key preoccupations: physical bodies and landscapes."[28] The Three Gorges Dam project, the predominant backdrop of the film, holds vast importance in its social, political, economic, and environmental impact. But *Still Life* keeps the dam as the backdrop and foregrounds ruined structures as the central mise-en-scene. The ruins of demolished houses occupy the entire frame, with bricks and rubble in the foreground and fragmented walls and building parts in back. Human laborers on site are dwarfed by the scale of destruction as they hammer objects piece by piece. The soundtrack of rhythmic hammering and images of partially naked workers' bodies draw one's vision to an environmental catastrophe and socio-political devastation.

A tradition in Western art and aesthetics sees human-made and nature-made ruins as monuments signifying time, transformation, and thereby history; the ruin images in contemporary Chinese art, however, point to destruction and disappearance. The notion of ruin, as Robin Visser explains in her study of urban planning, "is one of the most prevalent expressions of the 1990s urban aesthetic, where past and present disappear in each other."[29] The ruin mise-en-scene in *Still Life* reminds us of Rong Rong's experimental photographs and Zhang Dali's graffiti art where radical and massive demolition is the iconographic sign of China's transformation through modernization and commercialization. The ruin images, as Wu Hung in his *Transience* explains, "shook their audience because they register, record, restage, or simulate destruction — destruction as violence and atrocity that left a person, a city, or a nation with a wounded body and psyche."[30] In *Still Life*, the contrast between the ruins and the dam monumentalizes first destruction then construction. The construction of the dam turns Mao's ideals into reality and glorifies governmental hegemony. The ruins, by contrast, are a sign of spatial-cultural disappearance. The dam project has caused millions to lose their homes and has flooded hundreds of locations. By foregrounding the ruins, the director expresses his concerns about the dam's impact on ordinary people and protests their exploitation by government agencies. The dismantled buildings and mounds of rubble are the parting images of a people and place about to disappear.

Figures central to the painting and the film are the ordinary migrant workers. Their graphic and visual configuration focuses on the physical body, specifically the laboring

body (Fig. 11.5). These body images are the primary artistic and discursive modes for the construction of the migrant social identity. Half-naked, dark-skinned, sweat-soaked, dirty male bodies have been a central mise-en-scene in urban China. The bodies are everywhere, but identities remain invisible. The primary workforce for China's economic development, inferior in socio-political status, this collective entity remains subject to economic exploitation and socio-cultural neglect. For the artist, the partially nude bodies inspire him with a sense of the original beauty and energy that he has been trying to capture in his artistic creations. The artist chooses a painting position close to the models, only one meter away. Having the group of migrant workers positioned below the horizon line, the artist has to bend and kneel in the process of painting. In doing so, he expresses that "his body becomes part of the group and the painting, laboring process." In addition, the artist intentionally situates and enlarges the socially marginalized working bodies against the magnificent background of river and mountains. The composition and the amplification offer the migrants a deserved dignity.

Figure 11.5: Multiple viewpoints

For the director, the laboring bodies offer not only visual inspiration but also discursive possibilities. In the final sequence, for instance, the film frames the protagonist Sanming with the demolition workers before he leaves for home. The camera quietly pans through the bare-chested group. They toast Sanming's departure and talk about finding jobs as coal miners in Shanxi. Sanming informs them that it is a risky job and dozens of miners die each year. The camera patiently pans each one of the men and stops at the last one, in the corner, who is smoking in silence. Again, the body image and the topic of relocating jobs exemplify the social status and floating lives of the

migrant workers. The worker possesses only the body through which they make a living. In the following shot, we see the group walk through the ruins following Sanming as they move to a destination unknown to them. A melancholy melody arises, and in the far background a person walks along a tightrope spanning two ruined buildings (Fig. 11.6). The spectacle is breathtaking, and the message is metaphorical: life is hard but one has to go through it.

Figure 11.6: A point-of-view shot of person walking along a tightrope

Mass migration has been a challenging phenomenon in contemporary China. As the subject generates heated discussions in the media in urban milieus, the migrants themselves, a social group on the margins, remain literarily silent. In both Jia's documentary and feature, the artist and the director demonstrate high respect and serious concern for the workers. Nonetheless, the migrant remains a body image rather than a subjective entity. The transformation of body image onto canvas and film screen allows the artists a discursive register and mode of representation. For instance, during the process of Liu Xiaodong's painting, one of the workers lost his life when trapped under falling debris. While his figure inscribed on canvas leaves a graphic memory, Jia casts the death into a mode of drama. In the feature film version, the director changes the identity of the victim from the migrant into his "Chow Yunfat [Zhou Runfa]" hero, killed by thugs. It is difficult to accept the fact that the dead migrant can be so easily displaced to fill the film's narrative need.[31] The nameless body and the image subject to articulation keep the migrant in the position of Other.

Moreover, the relation between artist and migrant remains the norm of looking and being looked at. The gaze, although engaged and concerned, faces the challenge of seeing the migrant not simply as Other. Situating the migrants against the Three Gorges Dam, while foregrounding the subaltern as the socio-cultural center of interest, provides potentials for the artists themselves. For Liu Xiaodong, the Three Gorges Series allows his art to move beyond the mundane subjects of daily life, and for Jia, to break from his Shanxi locality. The vulnerability and silence of the migrants invite the artists to shoulder moral responsibility and give voice to their subjects. In addition, the establishment of a personal point of view and the application of new realism as a form appropriate to migrant representation mark a departure from official discourses.[32]

With the iconic body images and landscape of ruins, the film narrative follows two Shanxi characters and unfolds through a parallel structure. Sanming comes from Shanxi to Fengjie to look for his wife, separated from him for sixteen years. Shen Hong also comes from Shanxi, in her case to search for her estranged husband, who has not been home in two years. Sanming wants to reunite with his wife while Shen Hong decides to divorce her husband. The characters' journey from Shanxi to Fengjie takes them from northwest to southwest China; it also indicates the director's spatial and cinematic relocation after his latest film *The World*. With two Shanxi natives as protagonists, *Still Life* brings a desiring gaze to a new place and culture.

The socio-economic reality in Fengjie is striking to both the characters and the audience. After a motorcycle carrier takes Sanming to his destination, a point-of-view shot reveals nothing but the river. The address "Blue Stone Street No. 6" has already vanished beneath the water. The question of the fate of the former residents drives the narrative and fosters a feeling of anxiety. Moreover, the disappearance of long-standing habitations exemplifies the uncontrollable transformation of China. In an age of globalization and modernization, China's landscape is constantly re-made by the construction of national projects, commercial districts, and urban skyscrapers. Left behind are remnants of the old world: massive ruins and the "missing subject."

The parallel narratives are punctuated with four material symbols: cigarettes, wine, tea, and candy. Each is used to help enact a film narrative. Sanming, as an outsider, offers cigarettes to the locals to gain their acceptance. In his effort to locate his wife, he comes across his wife's brother, a sailor. In their confrontation, the mise-en-scene keeps Sanming off the frame, reflecting his status as an outsider, but puts the brother at the center. Three young men enter the frame one after another, holding their noodle bowls and ignoring the off-screen Sanming. Shunned and humiliated, Sanming insists on seeing his wife and daughter. A conflict seems unavoidable. For a cultural courtesy and cinematic transition, the sequence shows that Sanming offers his "relatives" two bottles of wine. The film thereby is able to mediate the tension and dissolve to another scene.

In parallel, Shen Hong fails to locate her husband but finds a tea bag from the locker that he left behind. Tea does not lessen Shen Hong's anxiety, as the film shows her constantly drinking from her water bottle. In the course of looking for her husband, she learns that he has become acquainted with another woman. The moment of finding each

other, the film shows, becomes the moment of separation. With the dam construction site as background and pop music spilling from loudspeakers, husband and wife finally meet and swing with the melody. But the romantic moment turns into permanent separation. Shen Hong asks for a divorce and leaves the man behind. The Three Gorges Dam, as a gargantuan political-economic project and landscape upheaval, has caused and witnessed countless human dramas: migration, dislocation, separation, and loss. The film then returns to Sanming's narrative via the metaphor of toffee. The film frames Sanming and his wife inside a semi-demolished building. Our vision is drawn to the contrasting mise-en-scene: the ugly urban architecture in the far background and the ruined buildings in front. Sanming's wife offers him a white rabbit toffee; he takes half and returns the other half to the woman. The toffee exchange suggests hope and potential reunion. Ironically, Sanming has to return to his coal mining job and make money to buy his wife back.

Conclusion

In his filmmaking career, Jia Zhangke has struggled to negotiate between the margins and the center. From *Xiao Wu* to *The World* and from *Platform* to *Still Life*, the trajectory exemplifies how filmmakers like Jia try to survive and succeed despite a film industry run by market competition and official manipulation. The significance of Jia and his films lies in his persistent negotiation between center and periphery, between local and global. His concern for people on the socio-economic margins, his experiments with visual articulation, and his refusal to bow to the mainstream have enabled him to continue as an independent filmmaker in contemporary China. Nonetheless, filmmaking and market distribution have yet to allow enough space for independent or alternative films to flourish. After *Still Life* earned international recognition, Jia may no longer need to worry about funding for future films, and his audience may not need pirated copies to see them. But a green light from official authorities and recognition from international critics do not ensure commercial success. The film industry regulators and movie theaters in China are not eager to screen Jia's new film because it will not generate the kind of revenue returned by Hollywood imports and mainstream commercial productions. Thus, as Jia's long takes switch from local Fenyang to metropolitan Beijing and then to Fengjie, answers to questions about how far one can go after leaving one's place of origin and whether the director has already moved out of the margins remain uncertain.

New Year Film as Chinese Blockbuster: From Feng Xiaogang's Contemporary Urban Comedy to Zhang Yimou's Period Drama

Ying Zhu[*]

Chinese New Year Film as Domestic Blockbuster

For almost a decade now, Chinese cinema has cultivated a unique brand of film that caters to the Lunar New Year market. Originated in Hong Kong, New Year films quickly caught on in the People's Republic of China, owing to the imperatives of China's new market economy. Markets, obviously, like films that turn a profit, and the bigger the better. New Year films cash in on the Chinese winter "holiday economy," an annual period of lavish consumption when the available audience is so massive that any major film release is a potential blockbuster. Leading the charge in cultivating the New Year film is the television soap opera director-turned-filmmaker Feng Xiaogang. The lucrative New Year market has inspired regular crops of New Year films by other filmmakers, but most have been box-office flops. Feng owned the New Year film market until 2002, when Zhang Yimou's martial arts debut *Hero* (*Yingxiong*) became the number one box-office film, cashing in on Feng's absence from the New Year market that year. Two years later, Zhang's martial arts epic, *House of Flying Daggers* (*Shimian maifu*, 2004) overtook Feng's *A World Without Thieves* (*Tianxia wuzei*) as the number one box-office film.[1] The box-office success of Zhang's third period drama, *Curse of the Golden Flower* (*Mancheng jindai huangjinjia*, 2006) sealed his status as the domestic box-office king, deposing Feng, who had held the title since his New Year film debut, *Party A, Party B* (*Jiafang yifang*) in 1997.

None of Feng's New Year comedies were big budget films, and while they performed like blockbusters at the box office, marketing was primarily via word of mouth. Zhang's big budget, epic-scale period dramas and their Hollywood-style marketing campaigns transformed the Chinese New Year film and added a new season to the blockbuster

[*] A different version of the chapter that centers more on Feng Xiaogang, "Feng Xiaogang and Chinese New Year Films" appeared on *Asian Cinema*, 18:1 (Spring/Summer 2007): 43–64.

cycle. *House of Flying Daggers* was released in July and August of 2004, targeting the Chinese summer season previously associated with animated films for children. Thanks to Zhang, the popular domestic films once dominated by Feng's urban comedies and linked to the New Year season now imitate the Hollywood blockbuster in terms of style, budget, marketing, and even release seasons.

In Hollywood, most box-office blockbusters are so-called "high concept" films.[2] The origin of the term is often associated with Barry Diller, a programming executive at ABC in the early 1970s. Diller introduced the made-for-television movie format, which thrived on stories that could be easily summarized in a sentence or two.[3] The summary sentence would then appear in the *TV Guide* synopses. Thus, "high concept" designates a narrative that is relatively straightforward, easily communicated, and readily comprehended. Common elements of high-concept films include seasonal subjects, star actors and/or directors, a condensed three-act structure, and an arresting visual style. This chapter traces the evolution of the mainland Chinese New Year film from its origins in Feng's modest urban comedies to Zhang's Hollywood-style high concept blockbuster films, then back again to Feng, who now seems to be taking the high concept road himself. It explores the success of Feng's New Year films with Chinese audiences and then compares Feng's textual strategies with Hollywood's "high concept" formula and Zhang's period dramas, revealing an inconclusive but suggestive narrative of industrial and, in Feng's case, personal transformation.

Chinese New Year Films and Hollywood Blockbusters

China's winter holiday season, running from early Christmas to the end of the Chinese Lunar New Year, has been a golden period for domestic film releases for the past decade.[4] Such was not the case before 1995. Theaters used to close down for the Lunar New Year week under the assumption that people would prefer traditional Spring Festival activities such as window shopping, family reunions, and nature outings. This assumption was instantly shattered by Jackie Chan's *Rumble in the Bronx*, released at the end of 1995. Billed as a New Year celebration film, *Rumble* made a big splash in Mainland movie theaters, setting a new box-office record of RMB 80 million. Four more Jackie Chan New Year films conquered the Mainland market in succession: *First Strike* (1996), *Mr. Nice Guy* (1997), *Who Am I?* (*Wo shi shei*, 1998), and *Gorgeous* (*Boli zun*, 1999). Chan's success alerted the Chinese film industry to the box-office potential of the New Year season. In 1997, Feng Xiaogang made China's first domestic New Year film, the satirical comedy *Party A, Party B*.

To avoid direct competition with Jackie Chan's New Year film and to cash in on Western holidays newly fashionable among urban youth and yuppies, *Party A, Party B* debuted ahead of the Lunar New Year on Christmas Eve. The film earned at least RMB 36 million in box-office revenues nationwide, a comparatively huge return in the fledgling Chinese commercial film market. Feng's subsequent New Year films *Be There or Be Square* (*Bujian busan*, 1998), *Sorry Baby* (*Meiwan meiliao*, 1999), *A Sigh* (*Yisheng tanxi*, 2000), *Big Shot's Funeral* (*Dawan*, 2001), *Cell Phone* (*Shouji*,

2003), and *A World Without Thieves* (*Tianxia wuzei*, 2004) all led the domestic box office.

Sorry Baby, for instance, grossed RMB 20 million at the box office nationwide after its release on Christmas Eve in 1999. In Beijing alone, the film raked in RMB 8.5 million to overtake the Hollywood blockbuster *Enemy of the State* (Tony Scott), which grossed RMB 4.3 million. It is worth noting that *Sorry Baby* was financed by a pioneering private production firm, Huayi Brothers. The film earned Huayi Brothers around RMB 10 million in total advertising income, a financial breakthrough for the fledgling private company. Riding the success of Feng's New Year films, Huayi Brothers soon established itself as a leading private enterprise in the Chinese film industry, and later co-produced Feng's *Big Shot's Funeral* with Columbia Pictures Asia. The film topped the domestic box office for domestic films in 2001 and was distributed in the United States in selected theaters. Because of the success of this co-production, Huayi Brothers and Columbia Pictures Asia co-produced a number of additional films including *Warriors of Heaven and Earth* (*He Ping*, 2003), *Kekexili* (*Lu Chuan*, 2004), *Kung Fu Hustle* (Stephen Chow, 2004), and Feng's *Cell Phone*, all of which ranked at the top in box-office receipts. *Cell Phone* alone earned Huayi RMB 20 million in ad revenue before it was distributed to theaters. The ascendance and solidification of private film financing and distribution in China owe much to the New Year film practice.

It is worth noting that Feng's *Party A, Party B* came at a time when the Mainland film industry was in a prolonged funk owing to the loss of state support, the arrival of blockbuster Hollywood pictures, and thriving alternative entertainment options. The depressed market for domestic pictures called for drastic measures and the New Year film became the perfect vehicle for the Chinese film industry to tap an emergent middle class brimming with disposable income and ready to be entertained during the holiday season. *Party A, Party B* announced its "New Year" status by attaching, at the beginning of the film, a brief image of an animated tiger that wished all an auspicious "Year of the Tiger."[5] Feng's subsequent New Year films, and later Zhang Yimou's, have likewise flaunted their status as event films built for the holidays.

Release timing has long been a key calculation in Hollywood. Hollywood event films are crafted for two golden release periods, summer and Christmas. Since the phenomenally successful release of *Jaws* (Steven Spielberg) in the summer of 1975, summer has been increasingly seen as the most favorable release time. Currently 40 percent of Hollywood box-office revenues are derived from the summer season. This pattern has developed in conjunction with the targeting of youthful audiences as youth have increasingly come to dominate the theater-going public. Now in second place in the U.S. market, the Christmas vacation period has remained a very important release season. Traditionally the Christmas season brings prestigious, Oscar-hopeful movies, but blockbusters may also appear around Christmas. Both release seasons have been expanding so that summer now begins before Memorial Day in May and Christmas slightly before Thanksgiving in November.[6]

In China, the introduction of Hollywood-style distribution has contributed to the formation of a golden release season running from Christmas through the Lunar New

Year holiday, and since *House of Flying Daggers*'s summer release in 2004, the summer season previously dominated by Hollywood action movies is now witnessing more competition from domestic action pictures and A-class dramas. A third lucrative release season for the Chinese filmmakers is the short Valentine's Day weekend when studios release romantic date films catering to young urban professionals.

Feng Xiaogang's New Year Films as "Talk of the Nation"

Movies do not get to be box-office blockbusters without some immediate cultural relevance to their audience. Helped no doubt by his television experience, Feng's solo success in the early years of the New Year film market stemmed in large part from his ability to check the pulse of Chinese culture. Feng's films all deal with sensitive and seasonal issues including private entrepreneurship (*Party A, Party B*), life in the Chinese diaspora (*Be There or Be Square*), extra-marital affairs and the collapse of the traditional domestic sphere (*A Sigh* and *Cell Phone*), commercialization's excesses (*Big Shot's Funeral*), and the widening social and economic gaps between the rich and the poor (*Sorry Baby* and *A World Without Thieves*).

Party A, Party B (1997) tells the story of a service company called "For One Day Dreams Come True" that strives to help its clients realize their bizarre fantasies by offering staged realities. The film came at a time when private entrepreneurship was in vogue and successful, and adventurous entrepreneurs were fabled heroes. The film derives considerable humor from the idiosyncratic requests of clients and the innovative solutions that the service company comes up with, which parody classic moments in Chinese revolutionary films as well as canonic Hollywood films. One theme that emerges from the flamboyant operation of the service company is aiding strangers in need, and this is echoed years later in *A World Without Thieves*. In one of the service company's deals, the leading man, Yao Yuan, loans his apartment out to a couple in a long distance marriage who wish to share their last moments together before the gravely ill wife succumbs.

Be There or Be Square (1998) is a comedy about an on-and-off relationship between two Chinese living in Los Angeles. The protagonists have adapted to American cultural and economic life. The exotic diasporic experience holds endless fascination for the majority of Chinese who have yet to set their feet outside China. The daily routines of living in the United States, such as loading groceries in a supermarket parking lot, pumping gas and washing windows at a self-service gas station, and even encounters with petty crime, are revelations that play to popular Chinese fantasies about living abroad in the world's most powerful (albeit corrupted) nation. The living space occupied by the two protagonists when they are still struggling new immigrants is plagued by random crime and their own feelings of cultural alienation. As they climb the economic ladder, success comes with a vengeance, with the Los Angeles Police Department apparently at their service. The film's sketch of America is distorted, colored by the same strong sense of Chinese chauvinism that runs through Feng's popular television serial, *A Native of Beijing in New York*. This sense of Chinese cultural superiority mixed with a romantic

version of America as a land of opportunity and social mobility appealed powerfully to Chinese audiences in the late 1990s.[7]

Feng's third New Year film *Sorry Baby* (1999) is another topical film. It tells the story of a private chauffeur who tries to get ten thousand yuan in back pay from his employer, the wealthy manager of a travel agency. Desperately needing the money to help his hospitalized sister, the driver kidnaps the rich man's girlfriend. The man refuses to pay, betting that the driver is only bluffing. Predictably, the driver falls in love with his captive and the two conspire to punish the rich man. The film captures two of the most disturbing aspects of contemporary China, the division between the poor and the rich and the collapse of social morality, a topic that would be revisited in *A World Without Thieves*.

Feng's fourth New Year film, *A Sigh* (*Yisheng tanxi*, 2000) is a melodrama that deals with one of China's most touchy topics, the extramarital affair.[8] With marriage breaking down partly as the result of philandering husbands, the extramarital affair has entered public discourse in contemporary China. *A Sigh* taps into this popular interest. Married for ten years, middle-aged television soap opera scriptwriter Liang loves his wife and their six-year-old daughter and is perfectly happy with his life until he falls for a young woman with whom he had a one-night stand. The film opens as a light romantic comedy but the mood soon becomes dark. Torn between his family and his lover, Liang tries desperately to please both. The torturous triangle between Liang, his lover, and his wife captivated millions of Chinese viewers and Feng's non-judgmental approach encouraged public discussion of the topic. The film is at once tragic and comic, a tension keenly felt by Feng in his effort to balance the genre's demand for happy endings and his desire to explore the dark side of the human experience and psyche. *A Sigh* was Feng's first attempt to seriously engage in the moral and ethical debates surrounding love and marriage, themes that would be revisited in his sixth New Year film, *Cell Phone*.

After taking a detour for an ambitious transnational project, Feng returns to the domestic sphere in *Cell Phone* (2003), once again probing into intricate spousal and romantic relationships. The film tells the story of a successful television anchorperson whose extramarital affairs are exposed when his wife accidentally comes across some of the amorous mobile phone messages he has sent to his mistress. Eventually, the multiple deceptions facilitated by his mobile phone lead to the breakup of his marriage and the loss of his job. Around him other people's lives are also adversely affected by their cell phones. *Cell Phone* was a smash hit in China, tapping into the country's obsession with mobile phones as well as its concern about philandering husbands.[9] The film became the talk of the nation, creating a public stir. It was reported that desperate wives started to check on their husband's cell phones and that the phone companies had to reassure their customers about privacy concerns. *Cell Phone* created a sensation, arguably unmatched by any film or television production since *Yearnings*, the first Chinese telenovela from a decade and a half ago.

Before *Cell Phone*, Feng made *Big Shot's Funeral* (*Dawan*, 2001), an acute commentary on Chinese society's rampant commercialism and a metacinema exercise that dissects not only the artifice of filmmaking but also the film's own status as a

cultural commodity.[10] When Hollywood director Don Tyler, played by Donald Sutherland, collapses in the middle of shooting a remake of *The Last Emperor*, his dying wish is to have a comedy funeral so that his death and reincarnation will be a joyous rather than sad occasion. The cameraman hired to document the process of shooting Tyler's new masterpiece, Yoyo, is entrusted with the task of arranging a fitting tribute to the great master. Yoyo decides to turn Tyler's funeral into an international TV event. To raise money for the proceedings, he manages to sell advertising spots to various sponsors. As in *A Sigh*, what opens as a hilarious comic situation soon disintegrates into a series of semi-coherent dark sequences. Released only days after China formally gained its WTO admittance on December 11, the film was Feng's first international venture, backed by Hollywood money and stars.[11] The film did extremely well, particularly in Shanghai, which is unusual as Feng's films are strongly inflected by Beijing Mandarin speech and affectations and can be off-putting to the more cosmopolitan audience in Shanghai.

The success of *Big Shot's Funeral* in the south solidified Feng's status as a blockbuster filmmaker at a national level. Yet the film performed poorly in Hong Kong, grossing a mere $93,266 in its first seven weeks.[12] Aside from the film's strong Beijing accent, it is possible that the overtones of Chinese chauvinism in Feng's pompous parody of Hollywood popular culture and his satirical take on commercialism did not sit well with Hong Kong audiences who enjoy their popular and consumer culture. Internationally, the film remains obscure, far short of bringing to the award-starved director the same critical recognition that Zhang Yimou, Chen Kaige, and Jia Zhangke have enjoyed. The film's overseas distributor, Columbia Pictures, did not make much of an effort to promote the film. Indeed, as Stanley Rosen notes elsewhere in this volume, *Big Shot's Funeral* only played in two theaters for six days in the United States, accumulating a box office total of $820! McGrath (2006) speculates that Westerners might be far less inclined to consume images of a China that look too much like their own societies, particularly when such images are packaged in a farcical comedy associated with contemporary Hollywood rather than in the somber art or exotic martial arts films associated with "the (Chinese) other."

Feng's seventh New Year film, *A World Without Thieves* (2004), touched yet another national nerve, this time concerning the widening social and economic gap between the rich and the poor, an issue very much on the minds of the Chinese public. Recent research by the Chinese Academy of Social Sciences (CASS) shows that the disposable income of the richest families, who account for 10 percent of the population, averages eight times that of the poorest. This growing disparity has given rise to strong feelings of resentment toward the rich in Chinese society, well captured in the fictional universe of *A World Without Thieves*.

The film is a tale of two thieves in a romantic relationship who try to shake off their disgraceful profession by protecting a potential victim from other thieves. The con-artist couple, Wang Bo and Wang Li, head to the mountainous west after relieving an urban businessman of his BMW. A chance encounter with a naive young carpenter pits their professional instincts against their moral compass. The young man, Shagen, a country boy from Hebei province who has spent the past five years repairing Buddhist

monasteries in Gansu province, is about to return home with his life savings, 60,000 yuan, in cash. After selling the BMW, Wang Bo and Wang Li board the same train as Shagen. As it happens, a group of organized thieves led by the legendary Uncle Li also boards the train. Touched by the young man's kindness and his unwavering belief that there are no thieves in the world, the two pickpockets fend off the other pickpockets in an attempt to keep the imaginary ideal world together for the young man. The pair succeeds, at the expense of the life of the male thief, Wang Bo, played by Hong Kong pop star Andy Lau.

The film proclaims loudly and clearly that the real thieves are the urban upstarts who amass their outwardly legitimate fortunes illegally and brutally. The first segment of the film witnesses the con-artist pair acquiring the BMW by scamming it out of a rich man. As Wang Bo drives the car out of the man's heavily guarded upscale villa, he shouts at the guard who salutes him, "Are you blind? Why don't you stop me, because I drive a BMW? Does driving a BMW make me a good person?" Wang Bo's ironic comment and the caricature of the rich man position the filmmaker squarely with the socially disenfranchised yet morally superior thieves. The film's heroes are these idealized thieves who make it outside the corrupt system and redeem themselves by protecting the innocent.

Some Chinese critics suggest that *Thieves* speaks to the moral and existential anxiety of China's emerging upper middle class. As the film opens, the female con-artist is tutoring a rich CEO in English, which immediately puts her in a culturally superior position since speaking English signals sophistication and status. The couple's knowledge of English suggests that they are well equipped to participate in China's new economic transformation. They are, as their antagonist Uncle Li puts it, talented people who should be cherished by China in its march towards modernization. Li openly laments the crudity of his own understudy and attempts to recruit the couple by staging a thievery competition. The battle over Shagen's life savings thus has more to do with Li's desire to win over Wang Bo than with Shagen's money. Indeed, the English-speaking con-artists are would-be members of an exclusive class of knowledge-based professionals that includes stock brokers, IT-savvy entrepreneurs, and MBAs employed by transnational firms. To a certain extent, the battle between the two groups of thieves on the train and one group's chivalrous conduct represents the fantasy of enlightened professionals who imagine a better society protective of small people. In speaking to this class of skilled, newly rich people, the harsh reality of the country boy Shagen and his contemporary rural dwellers is cast aside in Feng's romantic version of a world without thieves. Indeed, Feng's characters are always in the lifestyle vanguard, and generally reckless in the pursuit of alternative and risky pleasures.

A World Without Thieves: Feng's High Concept Turn

Robert McKee calls the classical three-act story structure the "archplot," as opposed to the "miniplot" of modernist films and the "antiplot" of postmodernist cinema.[13] As McKee puts it, in an archplot the story builds around an active protagonist who

struggles against primarily external forces, through continuous time, within a consistent and causally connected fictional reality, to a closed ending of absolute, irreversible change. Often seen in European art films, the "miniplot" prefers open endings, internal conflicts, and multiple and/or passive protagonists. The "antiplot" drifts even further, into coincidences, non-linear time, and inconsistent realities. An archplot or classical narrative structure is at the core of a high concept film. High concept's emphasis on simple and definable storylines derives from the belief that films with confusing narratives do not usually fare well at the box office.

Feng Xiaogang's filmmaking practice has witnessed an intuitive move toward the high concept approach: cultivating seasonal subjects, gradually turning away from broken episodic narratives, utilizing transnational stars, and developing a sleek visual style.[14] With the exception of *Sorry Baby* (1999), Feng's New Year films prior to *A World Without Thieves* swung between miniplot and antiplot. *Party A, Party B* follows the four co-founders of the company as they provide dream realization services to their clients. The narrative is thus loosely constructed around a series of episodes playing out the customers' individual fantasies: from becoming the American General Patton to being a victim of domestic abuse; from a rich man burdened with fancy banquets and keen to experience meager food in the poor countryside, to a long-separated couple enjoying a newly decorated apartment in their last months together. The film employs an episodic narrative structure that moves the story ahead via a series of miniplots randomly pieced together by satirical threads. The sprawling narrative and ensemble casting allow for a deliberate display of various aspects of contemporary Chinese society.[15] They also make *Party A, Party B* more akin to European art film than to Hollywood's high concept film.

In *Be There or Be Square*, a series of contrived (co)incidences link the two romantic leads together in a chain of events that set off their fickle relationship. As the attraction between the two grows, so does the apprehension. She is furiously independent and he is not ready to settle down. The narrative again progresses episodically, with the two protagonists' passive courtship punctuated by three incidental separations and subsequent chance encounters. They eventually move in together and set up a lucrative Chinese school. Financial success fails to solve their cultural alienation. As another new year approaches, they must decide whether to build a permanent nest together in Los Angeles or to return to China. The film's open ending, passive protagonists, reliance on random collisions of characters, and fragmented narrative put its narrative structure somewhere between miniplot and antiplot.

Sorry Baby was the first Feng Xiaogang film with a straightforward if not so tightly woven plot, clearly defined protagonist and antagonist, and narrative closure. As Feng himself has suggested, this was his first attempt to move away from the European films so influential with Chinese filmmakers in the 1980s and toward the Hollywood-style story structure so popular with Chinese audiences in the late 1990s.[16] His Hollywood turn hit a speed bump in his next project, *A Sigh*, a dense melodrama dealing with extramarital affairs and the breakdown of a family. The dark tone and pensive approach that follows, simultaneously, the disintegration of a family, the breakup of an affair, and

the painful journey of a man who desperately wants to hold on to both, make the film yet another low concept drama, more European than Hollywood in its deliberate pacing and its non-judgmental perspective that offers no psychological closure.

Big Shot's Funeral took a decidedly messy narrative turn. The interplay between metacinematic parody of transcultural exchange and farcical depiction of commercialism sprawling out of control leaves little room for a classical narrative to settle in. In a typical antiplot fashion, the story of *Big Shot's Funeral* jumps inconsistently from one "reality" to another in an effort to create a sense of absurdity. As many critics have noted, the film is indecisive, abrupt, and incoherent.

Feng's next project, *Cell Phone*, was more precise in its thematic probing and more focused in its narrative structure. Depicting spousal cheating and the role of modern cell phone technology in facilitating the old habit, the film follows its protagonist through several short-lived affairs and the dissolution of his marriage. The cell phone deployed as cheater's companion and potential bomb of revelation adds many funny twists to the domestic drama, making it a much lighter version of *A Sigh*. The complexity of the human relationships involved does not fit easily into a classical narrative, however, and the film returns at times to episodic sequencing to map out the evolution of multiple affairs.

The Chinese narrative tradition has tended to place equal emphasis on overlapping events as well as the interstitial spaces between events, in effect placing non-events alongside events in conceiving of the human experience in time. Chinese authors and readers have been interested in how a large number of individual characters are depicted in detail rather than in the continuous flow of a story line. In short, episodic structure and elaborate depiction of discrete characters and events are characteristics of traditional Chinese narrative, seen as a contributing factor to Chinese cinema's perceived slow pace. Feng's New Year films have to a varying degree carried this legacy.

A World Without Thieves was the first Feng Xiaogang film to make a clean break with this narrative mode. The film's fast-paced and straightforward narrative structure is a clear departure from Feng's earlier episodic approach. The plot of *A World Without Thieves* builds around Wang Bo, the master con artist who actively engages in a battle against rival thieves to protect Shagen's life savings. The Uncle Li character is not in the original novel, yet the addition of Li, portrayed by Ge You, contributes significantly to the film's narrative intensity. In turning the funny-faced Ge You into a cool and composed criminal mastermind, Feng located the antagonistic force and action arc essential to an archplotted, high concept movie. The plot fills the film with fast-paced fist fights as thieves clash on the train, picking pockets and trying to outwit each other. Each battle raises the stakes as the train moves closer to its destination and the thieves move closer to a final confrontation. Wang Bo ultimately sacrifices his life in his determination to outsmart Uncle Li and save Shagen's money. Wang Bo's death, albeit played out in a low-key fashion, seems to defy the classical call for the hero to walk out triumphantly. Yet triumph via death as ultimate redemption is hardly new in popular crime genres in Hollywood and Hong Kong. What matters in an archplot is not so much a happy ending as a closed ending.

The straightforward narrative in *A World Without Thieves* is enriched by a romantic subplot between the two protagonists. Subplots in classical narratives function to move the plot, carry the theme, and dimensionalize an otherwise linear and action-oriented story. Frequently, classical subplots revolve around heterosexual romance that helps to reveal extra dimensions of the characters. The subplot in *A World Without Thieves* revolves around the romantic relationship between the lead characters Wang Bo and Wang Li. Their partnership is at a crossroads early on in the film as she discovers that she is pregnant with his child. She is determined to quit the life of thievery so their child can start afresh. Her decision becomes the inciting incident that sets the story in motion. Unaware of her pregnancy, Wang Bo is unwilling to call it quits. The tension mounts as she involves him in the fight for Shagen's life savings. Her persistence together with the innocence of Shagen eventually turns him around and the two reconcile.

The subplot fleshes out the psychological trajectory of Wang Bo's redemption, which complements the main narrative arc involving the deadly competition between Wang and his antagonist. With its chain-linked causalities laid bare in linear time (as linear as travel by train!), its plot driven by external conflict, its active protagonist and forceful antagonist, and its closed ending, *A World Without Thieves* is a consummate specimen of an archplot in the service of a high concept film. The tightly woven plot and subplot are further enriched by funny sequences including an uneven battle of wits between the sophisticated Wang Bo and Uncle Li's goons that momentarily reduces the goons to laughing-stocks before their fellow travelers on the train. The funny sequences and witty dialogue are the only elements carried over from Feng's earlier New Year films. Otherwise, *A World Without Thieves* is a decisive break — a high concept, action-driven gangster film.

A World Without Thieves is also the only Feng Xiaogang film so far to move out of the cityscape and into the wilds of beautiful northwest China. Most of the movie takes place aboard the train, which traverses starkly beautiful terrain as the thieves circle their prey. This gives the film a spectacular visual aspect unseen in Feng's previous films. And again, for the first time Feng uses special effects to enhance the visual illusion. While Zhang Yimou's penchant for lavish visual stylization is commonly acknowledged (Zhang got his start as a cinematographer), Feng's sleek look is less commonly noted yet equally compelling, particularly in *A World Without Thieves*.

Textual strategies aside, the near-Hollywood-style marketing campaign and saturation release strategy employed by the movie's distributor warrant special consideration. A saturation release requires wide public awareness and interest in the film ahead of its opening weekend. This is normally achieved via a comprehensive marketing approach including print, trailers, television commercials, merchandising, and music tie-ins. While the marketing machinery of the Chinese entertainment industry is not up to speed yet on merchandising and music tie-ins, *A World Without Thieves*'s marketing effort was otherwise a creditable imitation of the Hollywood high concept marketing campaign.[17] The film's total advertising budget for TV, newspaper, Internet, and other media exceeded 15 million yuan (US$1.8 million). To prevent box-office ticket sales from being affected by VCD/DVD copies, especially pirated ones, video copies of

the film were not released until fifteen days after the theatrical premiere.[18] For cinema chains in southern China, Cantonese copies were released.[19] With a trendy topic, stars with trans-regional appeal, a condensed classical narrative, a sleek visual presentation, and a Hollywood-style marketing campaign, *A World Without Thieves* is a decisive high concept turn for Feng.

From Feng Xiaogang to Zhang Yimou

Zhang Yimou's blockbuster turn had its roots in the action films he made since the late 1980s. Zhang is convinced that the action-oriented blockbuster (*dapian*) is the only genre that can raise Chinese cinema out of its prolonged recession.[20] Along the way to establishing his international reputation as an art film director, Zhang twice tried his hand at male-oriented action films, first with *Codename Cougar* (*Daihao meizhoubao*, 1988), and then again with *Shanghai Triad* (*Yao a yao, yaodao waipo qiao*, 1995). Both films received mixed reviews, and neither was conceived in the blockbuster mold.[21] It was only with *Hero* that Zhang began to put his action blockbuster theory into action, with an ambitious turn into the historical martial arts form — the most popular and the most convention-bound Chinese action genre of all. Since *Hero* appeared shortly after Ang Lee's *Crouching Tiger, Hidden Dragon* had transformed martial arts from international cult genre to international sensation, it was widely assumed that Zhang was simply following the leader; but he insists that this was simply a coincidence, that both films were in production at about the same time, and that he had long cherished the idea of making a marital arts film.[22] Moreover, *Hero*'s financiers had stipulated a martial arts film from the beginning.[23]

 To keep the door open to a potential best foreign language film award at the Oscars, which has repeatedly evaded him, Zhang focused his martial arts debut on the spirit of chivalry and humanism and reined in the excessive violence and unmotivated fight sequences traditionally associated with the genre.[24] But the watered-down, "arted-up" fight scenes provoked anger and irreverent laughter among Zhang's domestic audience. Criticized at home for this genre disloyalty and abroad for its perceived endorsement of collective goals (achieved by brutal means) at the expense of individuality, *Hero* raked in critical ire and box-office success: everybody saw it, and almost everybody complained about it. A few Chinese critics did at least endorse Zhang's resort to the blockbuster format. Leilei Jia, for one, proclaimed *Hero* a historic first instance of fighting fire with fire — putting a massive Hollywood-style marketing campaign in the service of the Chinese film industry's struggle *against* Hollywood for supremacy in the Chinese domestic market and a more competitive position internationally.[25] As Jia put it, *Hero* pitched a regimental, systematic, and international challenge to imported blockbusters, and better yet, it did this on the back of a multi-million dollar foreign investment.[26] The film's massive marketing campaign coupled with China's best known director, an all-star cast, and the promise of a major new martial arts spectacle did bring audiences into theaters, making *Hero* the number one domestic box-office performer in 2002, the year that Feng Xiaogang went on his cinematic hiatus.

The first Zhang Yimou film to rival a Feng Xiaogang film (*A World Without Thieves*) head-to-head at the domestic box office was *House of Flying Daggers* (2004). This second martial arts effort combined Zhang's trademark dazzling imagery with transnational stars, a more linear narrative, and more conventional characters, making *House of Flying Daggers*, like Feng's *A World Without Thieves*, a fair facsimile of a Hollywood high concept film. Meanwhile, with a budget of $45 million, Zhang's third martial arts film, *Curse of the Golden Flower*, is another high concept film, and reportedly the most expensive Chinese film to date.

The fundamental difference between Zhang and Feng until very recently has been the former's international bent and the latter's domestic bent.[27] Zhang's films targeted overseas art house markets from the beginning, while Feng's are just now attempting to branch out. While Feng's films have performed well domestically, most of Zhang's films have received a lukewarm response from their native audience. The box-office success of *House of Flying Daggers* may owe more to its "front-loaded" marketing and saturation release strategy than to its actual audience appeal. Indeed, it faced a flood of criticism from both press and public in China for its thin storyline and overt, genre-offending stylization. A random sampling of audience reactions finds that Zhang's martial arts films have largely failed to win the hearts of Chinese viewers.[28]

Zhang's penchant for (especially visual) stylization has consistently met with skepticism in China. High concept films typically include slick and arresting images designed to capture viewers' attention, yet the excessive stylization of *House*, coupled with its thinly established plot, failed to engage audiences emotionally. The thin plot may have been a response to domestic criticism of the overtly convoluted plot structure of Zhang's previous martial arts epic *Hero*.[29] At the same time, Zhang's desire to maintain a global presence also makes him susceptible to the expectations of global art house audiences. Zhang's ability to balance culturally opaque, translatable, and fully universal cinematic elements served him well in the 1990s, making him an art house sensation internationally and a box-office force domestically. Yet as he has made a more conscious effort to combine art and commerce, the gap between the two has seemed to widen beyond his grasp. The era of "killing two birds with one stone" might be over, and Zhang might have to invent a cinematic language that will speak to his own countrymen if he is serious about keeping his hand in the domestic market.[30]

Feng's contemporary urban films, on the other hand, have regularly succeeded with ordinary Chinese, and except for *A World Without Thieves* these have all been films that do not conform to Hollywood principles — they are not high concept, and they do not set out to be blockbusters, much less the action-oriented blockbusters that Zhang prescribes. The combination of irony, sentimentality, and reflexivity in Feng's often personal films has proved entertaining enough to achieve blockbuster status at the domestic box office without resorting to an imported formula. The entertainment value of Feng's New Year films rests primarily upon their cultural proximity to a Chinese society caught in chaotic transformation.[31] Feng has created a formidable oeuvre of texts that document the transformation of Chinese society during the post-Mao, post-Deng era. This "current affairs" quality of Feng's films is what sets him apart from Zhang Yimou, whose martial

arts epics have retreated to China's dynastic history. Feng's seasonal treatments specific to contemporary Chinese society and the strong regional flavor of his films make them more relevant to Chinese moviegoers but difficult to travel globally.

Instead of being content with his domestic success, it seems that Feng too is "cursed" with the desire to go global. Feng's 2006 feature, *The Banquet*, a Chinese version of Shakespeare's *Hamlet*, is an epic swordsman picture.[32] Leaving his familiar urban terrain, Feng may be falling into the trap of the Zhang Yimou–style epic drama, characterized by lavish production values and highly stylized kung fu sequences. *The Banquet*'s melodramatic narrative, sparse dialogue, and the whisper-quiet delivery contrast sharply with Feng's accustomed witty urban satire. The film came out in September 2006 to a lukewarm reception.

The turn to martial arts period dramas by Zhang Yimou, Chen Kaige, and even Feng Xiaogang on the heels of Ang Lee's success seems to have relegated Chinese cinema to the global "ghetto" of martial arts flicks. Even Hollywood feels uneasy about the fact that most Chinese films competing at the Academy Awards these days are of a single type.[33]

While Feng's early New Year films defied the textual conventions of Hollywood blockbuster films, he is gradually moving toward the high concept, blockbuster formula, or at least toward Zhang's Chinese variation on that formula. This transformation from New Year urban comedy to action-packed period drama released during the summer season eventually cut the critical and popular tie between Feng and his ardent followers that depends so much on contemporary cultural relevance. Feng did return to the domestic market by making *Assembly* (2007), a heart-warming drama about a PLA captain's quest for honor and justice for his falling solders. The film was endorsed by the both the public and the state, making Feng the real turn-around hero. Feng's most recent New Year's film, *If You Are the One* (*Feicheng wurao*), set a new box-office record in 2008.

Notes

INTRODUCTION

1. This is a variation of the opening paragraph in Ying Zhu's article, "The Past and Present of Shanghai and Chinese Cinema," *New York Times* China Studies Website (April, 2006): http://www.nytimes.com/ref/college/coll-china-media-001.html (accessed December 22, 2008).

2. This would include Sheldon Lu and Emilie Yeh, eds., *Chinese Language Film: Historiography, Poetics, Politics* (University of Hawaii Press, 2005), which charts the cinematic traditions of mainland China, Taiwan, Hong Kong, and the Chinese diaspora from the beginning of Chinese film history to the present; Yingjin Zhang, *Chinese National Cinema* (Routledge, 2004) which provides, in broad strokes, a chronological history of Chinese film that encompasses the cinemas of Hong Kong, mainland China, and Taiwan; and Darrell William Davis and Emilie Yueh-yu Yeh, *East Asian Screen Industries* (British Film Institute, 2008), which offers in-depth case studies of the screen industries of Japan, South Korea, Taiwan, Hong Kong, and mainland China in the context of their response to global trends, in particular the move to de-regulation.

3. For example, Chris Berry's edited volume, *Chinese Films in Focus: 25 New Takes* (BFI, 2004, 2008), now in a second edition, is a less ambitious yet equally daunting exercise in traversing Chinese-language films from the three production centers of Chinese cinema, focusing on key individual films from each location; Chris Berry and Mary Farquhar's *China on Screen: Cinema and Nation* (Columbia University Press, 2006), which argues for the abandonment of "national cinema" as an analytic tool for the contested and constructed nature of "Chineseness" but at the same time groups together for academic treatment, under the rubric of "China," celebrated film practitioners of Chinese heritage from mainland China, Hong Kong, Taiwan, and the Chinese diaspora; and Rey Chow's *Sentimental Fabulations: Contemporary Chinese Films* (Columbia University Press, 2007), which considers the persistence of the "sentimental mode" in a variety of Chinese-language films that appeal to the West.

4. See, among others, Nick Browne, Paul G. Pickowicz, Vivian Sobchack, and Esther Yau, eds., *New Chinese Cinemas: Forms, Identities, Politics* (Cambridge University Press, 1994); Chris Berry, ed., *Perspectives on Chinese Cinema* (British Film Institute, 1991); and Sheldon Lu, ed., *Transnational Chinese Cinemas: Identity, Nationhood, Gender* (University of Hawaii Press, 1997).

5. For additional studies that encompass Greater China, but which depart from the cultural-linguistic framework, see Michael Berry's *Speaking in Images: Interviews with Contemporary Chinese Filmmakers* (Columbia University Press, 2005); Wang Shujen's *Framing Piracy: Globalization and Film Distribution in Greater China* (Rowman and Littlefield, 2003); and Gary X. Xu's *Sinascape: Contemporary Chinese Cinema* (Rowman and Littlefield, 2007). However, in these cases the broad focus on Greater China is accompanied by the narrow focus on film directors (Berry), piracy and distribution (Wang), or case studies of individual films that illustrate the complex nature of transnational film production and consumption (Xu), leaving large areas of Chinese film and film history untouched.

6. On Taiwan, see Emilie Yueh-yu Yeh and Darrell William Davis, eds., *Taiwan Film Directors: A Treasure Island* (Columbia University Press, 2005) and Feii Lu and Chris Berry, eds., *Island on the Edge: Taiwan New Cinema and After* (Hong Kong University Press, 2005). For Hong Kong, see David Bordwell, *Planet Hong Kong: Popular Cinema and the Art of Entertainment* (Harvard University Press, 2000); Stephen Teo, *Hong Kong Cinema: The Extra Dimensions* (University of California Press, 1998); and Poshek Fu and David Desser, eds., *The Cinema of Hong Kong: History, Art, Identity* (Cambridge University Press, 2002). Although it links Hong Kong with Asian and international film markets, Gina Marchetti and Tan See Kam's anthology *Hong Kong Film, Hollywood and the New Global Cinema* (Routledge, 2007) nonetheless features Hong Kong as a distinctive film production center.

7. Paul Clark, *Chinese Cinema: Culture and Politics since 1949* (Cambridge University Press, 1988).

8. Paul Clark, *Reinventing China: A Generation and Its Films* (Chinese University of Hong Kong Press, 2005).

9. Ying Zhu, *Chinese Cinema during the Era of Reform: The Ingenuity of the System* (Praeger, 2003); Jason McGrath, *Postsocialist Modernity: Chinese Cinema, Literature, and Criticism in the Market Age* (Stanford University Press, 2008).

10 Paul G. Pickowicz and Yingjin Zhang, eds., *From Underground to Independent: Alternative Film Culture in Contemporary China* (Rowman and Littlefield, 2006); and Zhen Zhang, ed., *The Urban Generation: Chinese Cinema and Society at the Turn of the Twenty-First Century* (Duke University Press, 2007). For a valuable discussion of the reasoning behind the "Sixth Generation" label, as well as its "increasingly shaky" accuracy, see Shaoyi Sun and Li Xun, *Lights! Camera! Kai Shi! In Depth Interviews with China's New Generation of Movie Directors* (Eastbridge, 2008), ix–xiii.

11. Shuqin Cui, *Women through the Lens: Gender and Nation in a Century of Chinese Cinema* (University of Hawaii Press, 2003); Jerome Silbergeld, *China into Film: Frames of Reference in Contemporary Chinese Cinema* (Reaktion Books, 2000) and Silbergeld's *Body in Question: Image and Illusion in Two Chinese Films by Director Jiang Wen* (Tang Center for East Asian Art, Princeton University, 2008); Yingjin Zhang, *Screening China: Critical Interventions, Cinematic Reconfigurations, and the Transnational Imaginary in Contemporary Chinese Cinema* (Center for Chinese Studies Publications, 2002); Rey Chow, *Primitive Passions* (Columbia University Press, 1995).

12. One effort at comprehensiveness, growing out of a week-long Chinese film festival in October 2000, is Haili Kong and John A. Lent, eds., *100 Years of Chinese Cinema: A Generational Dialogue* (Eastbridge Press, 2006); however, as suggested in the title, the focus is on the generational differences that distinguish individual Chinese filmmakers rather than the system as a whole.

13. In their book, *China on Screen*, Chris Berry and Mary Farquhar argue for the abandonment of "national cinema" as an analytic tool and propose "cinema and the national" as a more productive framework as they showcase how movies from Greater China construct and contest different ideas of the Chinese nation. Sheldon Lu and Emile Yeh's *Chinese Language Film* chooses to make do without deploying the notion of "nation" or "national" and to employ instead "Chinese-language cinema" in justifying their grouping of films from Greater China. Expressing the same frustration with the perceived inadequacy of the (Chinese) national cinema paradigm, Yingjin Zhang's *Chinese National Cinema* chooses to employ discrete chapters on film industries in the Mainland, Hong Kong, and Taiwan. Regardless of the nuances in their respective approaches, all three books have chosen to be inclusive in their canvas of Chinese cinema, covering a broad range of film practices within the confines of Greater China based on a cultural-linguistic model.

14. For a report on the seven-year ban on Jiang Wen, see ScreenDaily.com, July 13, 2000. Lou Ye's case, in which he was reportedly banned for five years, has been extensively discussed in the Western media, with reports in *Variety*, September 18 and October 23, 2006; *The Los Angeles Times*, May 19, 2006, E9; ScreenDaily.com, April 24, 2006; and *The New York Times*, September 5, 2006, B2. In a sign of changing times, Lou told interviewers at the Pusan Film Festival in 2006 that he planned to continue working despite the ban (*Variety*, October 23–29, 2006, 12).

15. Shaoyi Sun and Li Xun, *Lights! Camera! Kai Shi!*, xiii–xv.

16. See the chapter on Fifth Generation filmmakers by Ying Zhu, which addresses this film in the context of Tian's body of work.

17. Perry Link, "Introduction," in Kang Zhengguo, *Confessions: An Innocent Life in Communist China* (W. W. Norton, 2007), xxi.

18. This is taken directly from Stanley Rosen, "Foreword," in Ying Zhu, *Television in Post-Reform China: Serial Dramas, Confucian Leadership and the Global Television Market* (Routledge, 2008), xvii–xviii.

19. The original script was called *Life and Death in Beijing*, which would have been still more problematic. See *Variety*, February 7, 2007, 14 and February 19–26, 2007, 45; *Financial Times*, March 5, 2007, 15; *Newsweek* (International Edition), February 19, 2007; and The Hollywood Reporter.com, February 11 and 20, 2007.

20. Joey Liu, "Film Banned after Footage of Uncut Version Put on Net," *South China Morning Post*, January 5, 2008, 5.

21. Rowan Callick, "China's Censorship Syndrome," *The Australian*, May 14, 2008, 29.

22. On the *Lust, Caution* case see Stanley Rosen, "Priorities in the Development of the Chinese Film Industry: The Interplay and Contradictions among Art, Politics and Commerce," paper presented at the Conference on "Locality, Translocality, and De-Locality: Cultural, Aesthetic, and Political Dynamics of Chinese-Language Cinema," Shanghai University, July 12–13, 2008. For a discussion of the increasing political pluralization that marks the policy process more generally, see Andrew C. Mertha, *China's Water Warriors: Citizen Action and Policy Change* (Cornell University Press, 2008).

23. See the detailed cover story "Xianggang dianying chunhui dalu" (The return of spring for Hong Kong films in the Mainland), *Yazhou zhoukan* (Asiaweek), March 26, 2006, 20–27.

24. Zhou Tiedong, "Overview of the 2007 Chinese Film Industry," talk presented at the conference "Chinese Film at 100: Art, Politics and Commerce," University of Southern California, April 24–26, 2008.

25. *The New York Times*, June 17, 2007, Arts and Leisure section, 22.

26. David Barboza, "A Leap Forward or a Great Sellout?" *The New York Times*, July 1, 2007, Arts and Leisure section, 7.

27. Clifford Coonan, "China Outgrows Mom & Pop Era," *Variety*, March 12–18, 2007, A2.

28. Sen-lun Yu, "*Zhang Side* Dominates Top Chinese Awards," *Variety*, October 29, 2006 (online).

29. It is worth noting that scholars have pointed out the extent to which the content and form of Chinese cinema have come to reflect the perceived value of international film festivals and transnational capitals. Paul Pickowicz's essay, "Social and Political Dynamics of Underground Filmmaking in China" (in Pickowicz and Zhang's edited volume, *From Underground to Independent*) deployed the framework of "new Occidentalism" to describe the need for Chinese filmmakers of global inspiration to make movies about China that they imagine foreign viewers would like to see. The Chinese filmmakers must now navigate between the imperatives of both the domestic censors and the overseas distributors.

30. High concept films are generally associated with formulaic mainstream films in which the story can be summarized in no more than one or two sentences, and the term is therefore used primarily in relation to Hollywood blockbusters. The term has also been associated with films that integrate production with marketing. See Justin Wyatt, *High Concept: Movies and Marketing in Hollywood* (University of Texas Press, 1994) and Charles Fleming, *High Concept: Don Simpson and the Hollywood Culture of Excess* (Doubleday, 1998).

31. It should be noted that Feng has not gone quietly into the night in the competition with Zhang Yimou. His most recent New Year's film, *If You Are the One* (*Feicheng wurao*), set a new box-office record in 2009.

32. Ying Zhu, "Commercialism and Nationalism: Chinese Cinema's First Wave of Entertainment Films," *CineAction*, 47 (1998): 56–66.

33. Ying Zhu, *Chinese Cinema during the Era of Reform: The Ingenuity of the System* (Praeger, 2003), 198.

34. Sheldon Lu, "Tear Down the City: Reconstruct Urban Space in Contemporary Chinese Popular Cinema and Avant-Garde Art," in Zhang Zhen, ed., *Chinese Cinema and Society at the Turn of the Twenty-first Century* (Duke University Press, 2007), 141.

35. For a detailed account of the roles and functions of contemporary Chinese television dramas see Ying Zhu, *Television in Post-Reform China: Serial Dramas, Confucian Leadership and the Global Television Market* (Routledge, 2008).

36. The "Xie Jin model," which Xie himself was never comfortable acknowledging, included an emphasis on Confucian values, the choice of popular subject matter, and the use of conventional melodramatic narratives. See Yingjin Zhang and Zhiwei Xiao, *Encyclopedia of Chinese Film* (Routledge, 1998), 376–77, and Rosen video interview with Xie in Los Angeles, April 8, 2002 (unreleased). After Xie's death, controversial blogger Song Zude, a wealthy mainland Chinese TV and film producer known for his vicious critiques of Chinese celebrities and called "The King of Media Hype," launched an attack on Xie, which brought down official and public abuse on Song himself.

37. "Vernacular Modernity, National Identity, and Cultural Politics of Melodrama: A Tribute to Director Xie Jin," Shanghai University, June 13–15, 2009.

CHAPTER 1

1. Zhang Xiaotao, "Mainland Films 2005" (Dalu dianying 2005), *Arts Criticism* (*Yishu pinglun*), 1 (2006): 63–66.

2. Yao Zhiwen, "Some Suggestions on the Development of the Chinese Film Industry" (Dui Zhongguo dianying chanye fazhan de jidian jianyi), *Journal of Zhejiang Institute of Media & Communications* (*Zhejiang chuanmei xueyuan xuebao*), 6 (2006): 14–16.

3. Rao Shuguang, "Three Questions about Chinese Cinema" (Guanyu Zhongguo dianying de san ge wenti), *Contemporary Cinema* (*Dangdai dianying*), 2 (2006): 57–58.

4. Yin Hong and Zhan Qingsheng, "Notes on the Chinese Film Industry, 2005" (2005 Zhongguo dianying chanye beiwang), *Film Art* (*Dianying yishu*), 2 (2006): 14, Table 2.

5. Xinhua Economic News Service, January 9, 2007.

6. The number quoted comes from the *2008 Research Report on Chinese Film Industry* (Beijing, China Film Press, 2008), 22.

7. See the website Reference.com, http://www.reference.com/browse/wiki/Curse_of_the_ Golden_Flower (accessed January 15, 2008).

8. Bruce Robinson, "Chinese Mainland New Era Cinema and Tiananmen," *Asian Culture Quarterly*, 2 (1992): 38

9. The first Chinese film was made in Beijing in 1905 by a photo shop owner, Ren Qingtai. The film he made was a recorded version of a Beijing opera performed by a popular opera singer. Ren screened his film at a tea-house style exhibition site. See Ying Zhu, *Chinese Cinema during the Era of Reform: The Ingenuity of the System* (Westport, CT: Praeger, 2003), 177.

10. Zhu, *Chinese Cinema during the Era of Reform*, 177.

11. Film distribution and exhibition in today's China very much resembles the earlier period, driven by the demand for Hollywood features.

12. Film stocks were later imported to China from the United States. World War I made it possible for Hollywood to replace Europe as the dominant force in the Chinese film market.

13. The emergence of long narrative is considered by Chinese film historians as Chinese cinema's real dawn.

14. Ouyang Yuqian, *Since I Started My Acting Career* (*Wode yanyi shengya*) (Beijing: China Drama Press, 1959).

15. David Desser, "Session: Trends and Concepts in Chinese Cinema," *Quarterly Review of Film Studies*, 10 (April 1989): 358

16. See Zhiwei Xiao's chapter in this volume for a detailed discussion on the presence of Hollywood films in China prior to the establishment of the People's Republic of China.

17. See "The Opening Statement of United Film Exchange" (Lianhua xuanyan) published in the special edition of *The Evening of Shanghai* (*Shenzhou gongshi Shanghai zhiye*), 4 (1926): 39.

18. The first sound film was introduced to China from the United States in 1929.

19. For a detailed history of the period described in this paragraph, see Zhiwei Xiao, "Chinese Cinema," in Yingjin Zhang and Zhiwei Xiao, eds., *Encyclopedia of Chinese Cinema* (London: Routledge, 1998), 18–21; Yingjin Zhang, *Chinese National Cinema* (New York: Routledge, 2004), 83–95; Yingjin Zhang, "A Centennial Review of Chinese Cinema," http://chinesecinema.ucsd.edu/essay_ccwlc.html (accessed May 12, 2008).

20. Because of space limitations, this section mainly focuses on the industrial-institutional aspect of Chinese cinema during the period. For thorough analyses of actual films being made during this period, see Paul Clark's chapter in this volume. For a comprehensive history of cultural production including film during the Cultural Revolution, see Paul Clark, *The Chinese Cultural Revolution: A History* (Cambridge University Press, 2008). For an exhaustive examination of feature films made between 1976 and 1981, that is after the Cultural Revolution but before the deepening of the policy of Reform and Opening, and their cinematic construction of postsocialist Chinese culture, see Chris Berry, *Postsocialist Cinema in Post-Mao China: The Cultural Revolution after the Cultural Revolution* (New York: Routledge, 2004).

21. "Changchun Film Studio" (Changchun dianying zhipianchang), in Zhongguo Dabaike Quanshu Zongbianji Weiyuanhui "Dianying" Bianji Weiyuanhui, ed., *China Encyclopedia: Film (Zhongguo dabaike quanshu: dianying)* (Beijing: China Encyclopedia Press, 1998), 46.

22. "Beijing Film Studio" (Beijing dianying zhipianchang), in *China Encyclopedia: Film*, 30–31.

23. "Shanghai Film Studio" (Shanghai dianying zhipianchang), in *China Encyclopedia: Film*, 46.

24. Rao Shuguang, "A Sketch of One Hundred Years of Chinese Market" (Bainian Zhongguo shichang saomiao), in Zhongguo Dianying Bianjibu, ed., *China Film Yearbook Centennial Special Volume (Zhongguo dianying nianjian Zhongguo dianying bainian tekan)* (Beijing: China Yearbook Press, 2006), 500.

25. For a more detailed account on the specialties of various studios see George Semsel's "China," in John A. Lent, ed., *The Asian Film Industry* (London: Christopher Helm, 1990), 11–33.

26. Semsel, "China," 11–33.

27. Paul Clark, *Chinese Cinema: Culture and Politics since 1949* (Cambridge: Cambridge University Press, 1987), 35.

28. See *Literature and Art Gazette (Wenyi bao)*, February 1952, 37. Paul Clark also mentions the incident. See Paul Clark, *Chinese Cinema: Culture and Politics since 1949* (Cambridge: Cambridge University Press, 1987), 36.

29. For a detailed discussion on film production and screening during this period, see Paul Clark's chapter in this volume.

30. See Dorothy J. Solinger, *From Lathes to Looms: China's Industrial Policy in Comparative Perspective, 1979–1982* (Stanford: Stanford University Press, 1991).

31. According to Ni Zhen during our interview in Beijing in the summer of 1997, within the first three years of the reform, the distribution-exhibition sector accumulated almost 1 billion yuan and invested roughly 500 million in expanding and strengthening the distribution/exhibition operations.

32. China Film Distribution and Exhibition Company (China Film, Zhongguo dianying faxing fangying gongsi) was established in 1951. A direct unit under the Ministry of Radio, Film & Television (MRFT), the company was in charge of film distribution nation-wide. For a detailed account of the evolution of China Film see Emilie Yueh-yu Yeh and Darrell William Davis's article, "Re-nationalizing China's Film Industry: Case Study on the China Film Group and Film Marketization," *Journal of Chinese Cinemas*, 2.1 (May 2008): 37–52.

33. Zhen Ni, ed., *Reform and Chinese Cinema (Gaige yu Zhongguo dianying)* (Beijing: China Film Press, 1994), 45–46.

34. Ma Qiang, "The Chinese Film in the 1980s: Art and Industry," in Wimal Dissanayake, ed., *Cinema and Cultural Identity: Reflections on Films from Japan, India, and China* (Lanham: University Press of America, 1988), 168.

35. Ni, ed., *Reform and Chinese Cinema*, 51.

36. This chapter mainly focuses on the impact of globalization on the domestic industrial structure. For the issue of globalization of Chinese film in terms of film exports abroad, see Stanley Rosen's chapter in this volume.

37. "A Chart of Ten Domestic Blockbusters," *Film Art (Dianying yishu)*, 3 (1996): 4.

38. Pan Lujian, "Aside from *Red Cherry*'s Commercial Operation" (*Hong Yingtao* zai shangye yunzuo zhi wai), *Film Art (Dianying yishu)*, 3 (1996): 6.

39. Lao Mei, "Domestic Films: Dawn and Shadow" (Guochan dianying: shuguang he yinyang), *Film Art (Dianying yishu)*, 2 (1996): 44.

40. Fan Ping, "Domestic Pictures in 1997 Dare Not Entertain Bill-Sharing," *Chinese Film Market*, 8 (1997): 7.

41. The term "big picture consciousness" is taken from Zhang Tongdao, "A Retrospective of Chinese Cinema in 1995" (Kuayue xuanhua: 1995 nian Zhongguo dianying huigu), *Film Art (Dianying yishu)*, 3 (1996): 23.

42. A detailed comparative analysis of the process of "de-Westernization" of blockbusters in China and South Korea is available in Chris Berry, "What's Big about the Big Film?: 'De-Westernizing' the blockbuster in Korea and China," in Julian Stringer, ed., *Movie Blockbusters* (London: Routledge, 2003), 214–29.

43. Zhang Tongdao, "A Retrospective of Chinese Cinema in 1995," 23–27.

44. Fan Jianghua, Mao Yu, and Yang Yuan's report on film market in 1996, *Chinese Film Market*, 1 (1997): 4–7.

45. This view was also expressed by a Chinese film historian, Shao Mujun, in his essay "Chinese Film amidst the Tide of Reform," in Wimal Dissanayake, ed., *Cinema and Cultural Identity*, 199–208.

46. Willie Brent, "China to Raze the Red Tape, Centralize Studios," *Variety*, May 13–19, 1996, 44.

47. Brent, "China," 44.

48. *Chinese Film Market*, August 1997, 10–11.

49. *Chinese Film Market*, August 1997, 10–11. The total number of theaters in China in 1997 is not available.

50. *Chinese Film Market*, August 1997, 38.

51. See "1997 Film Market Report," *Chinese Film Market*, May 1997, 4–5.

52. Chinese Entertainment Network News, March 1999.

53. Formed in 1999, CFG combined China Film Corporation, Beijing Film Studio, China Children's Film Studio, China Film Co-production Corporation, China Film Equipment Corporation, China Movie Channel (Television), Beijing Film Developing and Printing & Video Laboratory, and Huayun Film & TV Compact Discs Company.

54. Zhang Xudong, *Postsocialism and Cultural Politics: China in the Last Decade of the Twentieth Century* (Durham, NC: Duke University Press, 2008), 17

CHAPTER 2

1. Sean Smith, "Invasion of the Hot Movie Stars: Chinese Cinema Has Brought New Fun, Glamour, Humor and Sex Appeal to Hollywood," *Newsweek*, May 9, 2005, 37.

2. For details on the box-office results of all Zhang Ziyi films which have had an American

release, see http://www.boxofficemojo.com/people/chart/?view=Actor&id=zhangziyi.
htm.

3. Bruce Wallace, "The Geisha, in Translation: In Rob Marshall's *Memoirs of a Geisha*, with Chinese Stars and a Pan-Asian Cast, Will Some Essence Go Missing?" *Los Angeles Times*, March 6, 2005, E1, 10–11; "Miami Vice Bags Chinese Star," *Screen International*, April 1, 2005, 3; Michael Fleming, "H'Wood on Li Spree," *Daily Variety*, March 30, 2005, 1.

4. See the comments of Politburo Standing Committee member Li Changchun, reported by the Xinhua News Agency (BBC Monitoring Asia Pacific — Political, August 27, 2007).

5. Some years ago when I asked Zhao Shi, widely seen as the "godmother" of Chinese film and now the deputy director-general of the State Administration of Radio, Film, and Television, what she wanted from the United States, her immediate response was "reciprocity" in terms of releasing Chinese films in the United States, a message she has also conveyed to various American film studios. More recently, Zhou Tiedong, the former director of the American office of the China Film Import and Export Corporation, has been put in charge of a new office of Chinese film export promotion, with a similar mandate.

6. Melinda Liu, "Crouching Tiger, Shooting Star: Zhang Ziyi Can Kick, Swing a Sword and Throw Jackie Chan; No Wonder Hollywood Loves Her," *Newsweek*, February 26, 2001, 48; William Foreman, "*Crouching Tiger* Is an Example of Greater China's Hidden Power," Associated Press, March 26, 2001; Yeow Kai Chai, "*Tiger*'s Triumph Opens Doors," *The Straits Times* (Singapore), April 1, 2001.

7. Up through 2005 at least, Chinese films have perhaps tended to be more successful in the West than in East Asia, although there has been particular interest in the performance of Chinese films in Korea and Japan. See the work of Zhao Muyuan, a Ph.D. candidate from Singapore currently at Qinghua University, including "Xinshiji Zhongguo dianying zai dongya piaofang shichang de geju (Report on the box office of Chinese films in the East Asian market), in Cui Baoguo, ed., *2007 nian: Zhongguo chuanmei chanye fazhan baogao* (Report on development of China's media industry 2007) (Beijing: Shehui kexue wenxian chubanshe, 2007), 290–308, and related articles in *Dangdai dianying* (Contemporary Cinema), 1 (2007): 129–34 (on Japan) and 2 (2007): 134–39 (on Korea). In 2005, only 6 of the 375 films imported into Japan were from mainland China, with 15 more from Hong Kong. By contrast, 153 (40.8 percent) were from Hollywood. In the same year, Chinese films garnered only 1.4 percent of the Korean box office, while Hollywood had 38.8 percent; Korean films took in 55 percent.

8. IT Facts, www. itfacts.biz/index.php?id=P3159.

9. Screendaily.com, May 2, 2008.

10. MPA companies include Buena Vista (Disney), Paramount, Sony, Fox, Universal, and Warner Bros. Jeremy Kay, "Int'l Grosses Overtook US in 2004, Says Glickman," Screendaily.com, March 15, 2005. Indicative of its international focus, the Motion Picture Association of America now refers to itself as the Motion Picture Association (MPA).

11. For some details see, Stanley Rosen, "Quanqiuhua shidai de huayu dianying: canzhao Meiguo kan Zhongguo dianying de guoji shichang qianjing" (Chinese cinema in the era of globalization: prospects for Chinese films on the international market, with special reference to the United States), *Dangdai dianying* (Contemporary Cinema), 1 (2006): 16–29, at 19, and the detailed statistical data available at www.boxofficemojo.com.

12. For typical examples of this literature, see Peter Biskind, *Down and Dirty Pictures: Miramax, Sundance, and the Rise of Independent Film* (New York: Simon & Schuster, 2004); Emanuel Levy, *Cinema of Outsiders: The Rise of American Independent Film* (New York: New York University Press, 2001); Greg Merritt, *Celluloid Mavericks: A History of American Independent Film* (New York: Thunder's Mouth Press, 2000).

13. Lorenza Munoz, "Art House Films Go In-House," *Los Angeles Times*, April 6, 2005, C1, 5. On the difficulties of defining the terms "independent film" and the "studio system" in the new Hollywood, see A. O. Scott, "The Invasion of the Midsize Movie," *The New York Times*, January 21, 2005, B1, 22.

14. Rana Foroohar, "Hurray for Globowood," *Newsweek*, May 27, 2002, 51.

15. Jeremy Kay, "2007 Review: Hollywood Looks for Local Heroes," Screendaily.com, December 21, 2007.

16. Associated Press, April 17, 2007. After Andrew Lau Wai-keung, the director of the Hong Kong hit *Infernal Affairs*, made his Hollywood directing debut he noted that "Going to Hollywood is every filmmaker's ambition, including myself," but he promised not to "forget about Chinese and Hong Kong movies." *South China Morning Post*, November 29, 2007, 10.

17. Gabriel Snyder, "Box Office Winners and Sinners," *Premiere*, February 2005, 62–64, 123.

18. *Los Angeles Times*, December 19, 2006, A1, 22; www.boxofficemojo.com.

19. *Los Angeles Times*, May 29, 2007, C1–2.

20. "2006 U.S. Theatrical Market Statistics," MPA website, 9. Reported negative costs represent the amount each studio invests in a film but do not include investments from non-MPA sources and therefore do not reflect the full costs of production for the average MPA film, which actually would be higher if the rising stream of outside investment money were factored in. See *The Hollywood Reporter*, March 7, 2007 (online).

21. *Los Angeles Times*, May 7, 2007, A1, 14; *Los Angeles Times*, December 12, 2006, A1, 22.

22. *The New York Times*, March 6, 2008, B2.

23. Screendaily.com, January 30, 2009.

24. http:www.imdb.com/boxoffice/alltimegross?region=non-us (accessed June 16, 2008).

25. On the "brand" (*pinpai*) effect in Chinese films, see Huang Shixian, "Yu Haolaiwu 'boyi': Zhongguo dianying chanye jiegou zhongzu de xin geju — jianlun 2004 nian xin zhuliu dianying 'sanqiang' de pinpai xiaoying" (Playing chess with Hollywood: the new pattern in the structure of the Chinese film industry — the "three strengths" of the brand effect of Chinese mainstream films), *Dangdai dianying* (Contemporary Cinema), 2 (2005): 11–17.

26. For a detailed breakdown of box-office results and other data relating to Jackie Chan's films and other Asian films that have been released in the United States, go to http://www.boxofficemojo.com.

27. Terrence Rafferty, "Screams in Asia Echo in Hollywood," *The New York Times*, January 27, 2008, AR 13.

28. Box-office data for the films described in this section derive from www.boxofficemojo.com, with additional information from the Internet Movie Database (www.imdb.com).

29. The American version of *The Grudge* also suggests some of the difficulties of taking an Asian film and remaking it, even with the same director, Shimuzu Takashi, in charge. First, to guarantee access to the target audience the film needed a PG-13 rating. Second, there are certain cultural concessions necessary in making the translation to Western

markets. As Manohla Dargis noted in her review, the result is "an unsatisfying hybrid of two very different film cultures ... [and a film] cursed by one of the greatest evils known to studio filmmakers: the teenage demographic." See "A House Even Ghostbusters Can't Help," *The New York Times*, October 22, 2004, B20.

30. www.boxofficemojo.com. The second most successful remake of a Chinese-language film was *Tortilla Soup* in 2001, a remake of Ang Lee's *Eat Drink Man Woman*, which made $4.5 million in the United States and is no. 14 on the list of Asian remakes. Eleven of the top fourteen on the list are remakes of Japanese films.

31. Associated Press, February 26, 2007. For the difficulties Lau had in bringing his vision to the screen, see *South China Morning Post*, November 29, 2007, 10.

32. Robert Mitchell, "Out of Hiding: Foreign Films Flying in UK," *Screen International*, March 11, 2005, 25; Adam Minns, "Foreign Language Films Take on Popcorn Crowd," *Screen International*, October 15, 2004, 9. The market for Indian, or Bollywood, films is excluded in this table since these films play to an exclusive market in limited areas of the country.

33. Jack O'Dwyer, "Crouching Tiger Gets PR Buzz," *Jack O'Dwyer's Newsletter*, January 17, 2001.

34. On the marketing of *Kung Fu Hustle* see Jeremy Kay, "Kung Fu Hustles North American Audiences," *Screen International*, April 22, 2005, 24 and Andrew C. C. Huang, "Marshaling the Comic Arts," *Los Angeles Times*, April 10, 2005, E6. On *Kung Fu Hustle* as an example of the "Hollywoodization" of Chinese cinema, see Christina Klein, "Is *Kung Fu Hustle* Un-American?" *Los Angeles Times*, February 27, 2005, M2.

35. Forthcoming blockbusters include John Woo's $80 million *Battle of Red Cliff*, Chen Kaige's *Mei Lanfang*, and Stephen Chow's *A Hope*.

36. On the importance of the opening weekend, see Dade Hayes and Jonathan Bing, *Open Wide: How Hollywood Box Office Became a National Obsession* (New York: Miramax Books, 2004). For extensive information on all aspects of financing, marketing, distribution and so forth see Jason Squire, ed., *The Movie Business Book*, 3rd edition (New York: Fireside, 2004).

37. Chinadaily.com, December 16, 2005. Despite a strong box office in China, Chen and the film have faced a good deal of ridicule in the Chinese press and on the Internet, highlighted by Hu Ge's twenty-minute spoof entitled "*The Blood Case That Started from a Steamed Bun*." See "Dang Kaige zaoyu Hu Ge" (When Kaige encountered Hu Ge), cover story in *Zhongguo xinwen zhoukan* (China Newsweek), 8 (March 6, 2006): 20–32. Chen in turn threatened to sue Hu for defamation, which turned the ridicule on the Internet into widespread anger at his arrogance.

38. *The Hollywood Reporter*, January 4, 2006; *Variety*, December 29, 2005; *Entertainment Weekly*, May 3, 2006; *The Washington Post* (n.d.); *Chicago Sun Times*, May 5, 2006 (all online).

39. New Zealand Press Association, September 16, 2006 (online).

40. www.chinaview.cn, September 5, 2006.

41. Senh Duong, Rotten Tomatoes website, September 13, 2006.

42. www.lovehkfilm.com/panasia/banquet.htm.

43. *The Hollywood Reporter*, September 8, 2006 (online).

44. Scarlet Cheng, "Director with a Midas Touch," *Los Angeles Times*, January 2, 2007, E1, 2.

45. *The Hollywood Reporter*, November 13, 2006; *Variety*, November 12, 2006 (both online).

46. Owen Gleiberman, E.W.com, January 3, 2007. A separate paper could be written on the reception of Zhang Yimou's films within China. For example, both *Hero* and *House of Flying Daggers* received mixed reviews. On *House of Flying Daggers* see "Zhang Stabbed by His 'Dagger'," *China Daily*, August 28, 2004 (online). On Zhang more generally see the many articles in the popular magazine *Sanlian shenghuo zhoukan* (Sanlian Life Weekly), 30 (July 26, 2004): 20–52. The cover, with a big picture of Zhang, offers the title "Zhang Yimou de yishu baquan" (Zhang Yimou: Hegemon of the arts).

47. Xinhua News Agency, February 8, 2007.

48. Xinhua News Agency, February 27, 2007; *Variety*, January 15–21, 2007, 13. For a detailed discussion see David Barboza, "A Leap Forward, or a Great Sellout?" *The New York Times*, July 1, 2007, AR7.

49. A. O. Scott, "Fanciful Flights of Blood and Passion," *The New York Times*, December 3, 2004, B21. Scott distinguishes between Zhang's first phase of the early 1990s, and the films of "stirring, visually glorious tales of historical turmoil and forbidden love," the second phase and its stories of "peasant indomitability like *Not One Less* and *The Road Home*" and the current third phase where Zhang has "reinvented himself" as an action filmmaker.

50. For box-office details on these and Ang Lee's American films, see http:///www.boxofficemojo.com/people/chart/?view=Director&id=anglee.htm. For a comparison of the box-office results in the United States of leading Chinese directors and stars, see Tang Weiqi, "Zhongguo dianying haiwai piaofang bu wanquan tongji" (Incomplete statistics on the box office overseas of Chinese films), *Dianying shijie* (Movie World), 9/10 (2007): 25–29.

51. Miramax and its boss Harvey Weinstein have come in for a substantial amount of abuse over their treatment of Asian films, with critics pointing to the delayed releases of *Shaolin Soccer* and *Hero* as examples of missed opportunities. For details on these critiques, see Robert Wilonsky, "Kung Fu'd: Or, What Does Miramax Have against Asian Films?" *Dallas Observer* (Texas), January 29, 2004 (online); Janice Page, "Heroic Journey," *The Boston Globe*, August 22, 2004, N9; Christina Klein, "Why Does Hollywood Dominate US Cinemas?" *Yale Global Online*, August 17, 2004; G. Allen Johnson, "Worldwide, Asian Films Are Grossing Millions. Here, They're Either Remade, Held Hostage or Released with Little Fanfare," *San Francisco Chronicle*, February 3, 2005 (online); Peter Biskind, *Down and Dirty Pictures*. For Harvey Weinstein's explanation for his company's lack of success with *Shaolin Soccer* and his defense of the treatment of *Hero*, see Harvey Weinstein, "Climbing the Chinese Wall," *Daily Variety*, September 1, 2004, 15.

52. G. Allen Johnson, "Worldwide, Asian Films ...," *San Francisco Chronicle*; *Variety*, February 10, 2007 (online); cinemasie.com.

53. This list can be found at http://moviemarshal.com/boxworld.html.

54. *Screen International*, November 5, 2004, 27.

55. *Pearl Harbor* came in at no. 79 and, even though it is mostly about the effects of the Japanese attack on the United States, it was even more successful abroad than in the United States.

56. Zhou Tiedong, "Overview of the 2007 Chinese Film Industry," presented at the University of Southern California's conference *Chinese Film at 100: Art, Politics and Commerce*, April 24–26, 2008; *Variety*, January 11, 2007 (online).

57. *Screen International*, January 9, 2009, 24.

58. *Variety*, January 11, 2007 (online).

59. A. O. Scott, "Fanciful Flights," *The New York Times*, December 3, 2004, B21.

60. John Pomfret, "A 'Tiger' of a Different Stripe; America's Favorite Chinese Film Is a Flop in Beijing," *Washington Post*, March 22, 2001, C1.

61. Karen Mazurkewich, "Killing Two Markets with One Movie — Columbia Shoots for Cross-Border Success," *The Asian Wall Street Journal*, January 25, 2002, W1. There is even debate on whether *Crouching Tiger* performed well in Asian markets. See Derek Elley, "Asia to *Tiger*: Kung-fooy," *Variety*, February 5–11, 2001, 1 and the response from screenwriter James Schamus, "Guest Column," *Variety*, February 12–18, 2001, 7. Also see Henry Chu, "Crouching Tiger Can't Hide from Bad Reviews in China," *Los Angeles Times*, January 29, 2001, A1, 10. My co-editor Ying Zhu has noted the lack of authenticity of these films.

62. Mark Holcomb, "Once Upon a Time in the East: A Chinese B Western," *Village Voice*, September 7, 2004, 58.

63. Susan Walker, "Westerns Is Eastern, Horses Are Camels, 6-Guns Are Swords," *The Toronto Star*, October 1, 2004, D4.

64. For a detailed discussion on the film see Ying Zhu's chapter in this volume, "New Year Film as Chinese Blockbuster: From Feng Xiaogang's Contemporary Urban Comedy to Zhang Yimou's Period Drama."

65. "*Big Shot* on Commercialism," *China Daily*, December 20, 2001 (online).

66. Wendy Kan, "*Big Shot* Doesn't Win Over Locals," *Variety*, May 27–June 2, 2002, 8.

67. See http:// www.boxofficemojo.com/movies/?id=bigshotsfuneral.htm.

68. Anna Smith, "*Big Shot's Funeral*," *Time Out*, November 13, 2002. Erik Eckholm, "Leading Chinese Filmmaker Tries for a Great Leap to the West; Will a Zany Satire Be a Breakthrough for a Popular Director?" *The New York Times*, June 21, 2001, E1.

69. Wendy Kan, "Comedy Hit Banks on Crossover," *Variety*, March 25–March 31, 2002, 26.

70. Derek Elley, "*Big Shot's Funeral*," *Variety*, March 25–March 31, 2002, 41.

71. Dave Kehr, "*Postmen in the Mountains*," *The New York Times*, October 22, 2004, B12.

72. "Banned Chinese Film Takes Top TriBeCa Prize," *The New York Times*, May 2, 2005, B2. A separate paper could be written just on the banned or truncated Chinese films that have been featured at Western film festivals, such as Lou Ye's *Summer Palace*, Li Yang's *Blind Shaft*, and the original versions of Jia Zhangke's *The World* and Li Yu's *Lost in Beijing*.

73. Dana Harris, "Zhang Pulls 2 Cannes Films, Blames West," *The Hollywood Reporter*, April 21, 1999 (online).

74. Todd McCarthy and Derek Elley, "Zhang's Political Exit Apolitical After All," *Variety*, April 22, 1999, 30.

75. www.lovehkfilm.com/panasia/banquet.htm.

76. Elizabeth Guider, "H'Wood's Global Warming," *Variety*, January 3–9, 2005, 1.

77. Patrick Goldstein, "Brand Blvd.," *Los Angeles Times*, January 11, 2005, E1, 4 and 6.

CHAPTER 3

1. Ruth Vasey, "Foreign Parts: Hollywood's Global Distribution and the Representation of Ethnicity," *American Quarterly*, Vol. 44, No. 4, Special issue: "Hollywood, Censorship, and American Culture" (December 1992): 617–42 and *The World According to Hollywood, 1918–1939* (Madison: University of Wisconsin Press, 1997). See also

Stanley Rosen's chapter in this volume and Luo Sidian (Stanley Rosen), "Quanqiuhua shidai de huayu dianying: canzhao Meiguo kan Zhongguo dianying de guoji shichang" (Chinese-language film in the age of globalization: an American perspective on the international distribution of Chinese films), *Dangdai dianying* (Contemporary Cinema), 1 (2006): 16–29.

2. Ryan Dunch, "Beyond Cultural Imperialism: Cultural Theory, Christian Missions, and Global Modernity," *History and Theory*, 41 (October 2002): 301–25.

3. For representative work see Kristin Thompson, *Exporting Entertainment: America in the World Film Market, 1907–34* (London: British Film Institute, 1985); David W. Ellwood and Rob Kroes, eds., *Hollywood in Europe: Experiences of a Cultural Hegemony* (Amsterdam: Vu University Press, 1994); Victoria de Grazia, "Mass Culture and Sovereignty: The American Challenge to European Cinemas, 1920–1960," *Journal of Modern History*, 61 (March 1989): 53–87, and Ian Jarvie, *Hollywood's Overseas Campaign: The North Atlantic Movie Trade, 1920–1950* (Cambridge: Cambridge University Press, 1992).

4. See Richard Patterson Jr., "The Cinema in China," *China Weekly Review*, March 12, 1927, 48, and see "Er shi si niandu waiguo yingpian jinkou zonge" (The total number of imported films for 1935), *Dian sheng* (Movietone, hereafter *DS*), 5.17 (May 1936): 407.

5. See the document dated November 1944 from Wang Jingwei government's propaganda department to Shanghai municipal authorities, asking the latter to ban the display of photo pictures of American movie stars. Shanghai Municipal Archive (hereafter SMA), R001-18-01769.

6. *Shanghai dianying zhi* (A gazette of Shanghai cinema) (Shanghai, 1999) and Gu Zhonli, "Jiajin guochan dinying de shengchan, tigao yingpian de zhi he liang" (Speed up the production of domestic films and improve their quantity and quality), in *Dazhong dianying* (Popular Cinema, hereafter *DZHDY*), 1.7 (September 16, 1950): 12–13.

7. "Dianyingyuan zhan hu yule jie shouxi" (Movie houses led other entertainment establishments), *Yule zhoubao* (Entertainment Weekly), 1.21 (1935): 526.

8. Shen Ziyi, "Dianying zai Beiping" (Film in Beijing), *Dianying yuebao* (Film Monthly), 6 (1928), reprinted in *Zhongguo wusheng dianying* (Chinese Silent Cinema, hereafter *ZHWD*) (Beijing: Zhongguo dianying chubanshe, 1996), 182–86.

9. Wei Taifeng, "Da guangming dibuguo Nanjing, Migaomei xinpian shouyingquan yizhu" (Grand was defeated by Nanjing, MGM's premiere right changed hand), *Yinghua* (Movies), 11 (1934): 268–69.

10. "The Girl Guides," *China Weekly Review*, November 7, 1936, 343.

11. "Chuangkan zhi hua" (Inauguration remarks), *Haolaiwu zhoukan* (Hollywood Weekly), 1 (1938).

12. "Meizhou tanhua" (Weekly talk), *Haolaiwu zhoukan* (Hollywood Weekly), 4 (1938).

13. Zheng Yimei, *Yingtan jiuwen — Dan Duyu he Yin Mingzhu* (Memories of the film world — Dan Duyu and Yin Mingzhu) (Shanghai: Shanghai wenyi chubanshe, 1982), 20.

14. See *Beiyang huabao* (Northern Pictorial), 19 (1933): 939.

15. Gong Jianong, *Gong Jianong congying huiyilu* (Gong's film career: a memoir) (Taibei: Zhuanji wenxue chubanshe, 1980), 30.

16. "Shanghai dianying guanzhong de yiban taidu" (The general attitude of Shanghai's movie goers), *Dianying zhoukan* (Movie Weekly), 27 (March 1939): 904.

17. "Shanghai zhipianye zhi qiongtu moyun" (The desperate film industry in Shanghai), *Dianying zhoukan* (Movie Weekly), 76 (April 1940): 5.

18. Gao Bohai, "Tianjin Jigushe ji Jigushe zidi ban" (The Jigu society in Tianjin), *Tianjin wenshi ziliao xuanji* (Selected Historical Documents), no. 17, Tianjin, 178–89.

19. Ulf Hedetoft, "Contemporary Cinema: Between Cultural Globalization and National Interpretation," in Mette Hjort and Scott MacKenzie, eds., *Cinema and Nation* (London and New York: Routledge, 2000), 278–97.

20. Cited in Larry May, *Screening out Past: The Birth of Mass Culture and the Motion Picture Industry* (Chicago and London: The University of Chicago Press, 1983), 171.

21. "Film Exhibitions and Market — China," *Commerce Reports*, February 1917, 713.

22. "The Hong Kong Motion Picture Trade," *Commerce Reports*, October 29, 1923, 293.

23. "Bianzhe nahan" (Editor's cries), *Xin yinxing* (Silverland), 3 (1928): 49.

24. "Zheng da youjiang" (Soliciting correct answers with reward), *Yule xinwen* (Entertainment News), 1 (June 1949).

25. See for examples, "Xuanju mei de waiguo dianying nannü mingxing" (Voting for the most beautiful foreign film stars), *Yinmu zhoubao* (Screen Weekly), 16 (1931): 6.

26. "Censorship against Paramount," *Motion Picture Herald*, January 2, 1937, 29.

27. Huang Zongzhan (James Wong), "Suo wang yu Zhongguo dianying jie" (What I hope the Chinese filmmakers would do), *Silverland*, 11 (1929): 14–16.

28. For examples, see Ian Jarvie's *Hollywood's Overseas Campaign: The North Atlantic Movie Trade, 1920–1950* and Ruth Vasey's *The World According to Hollywood, 1918–1939*.

29. See the secret report on *Major Google* and the Nationalist government's internal discussion about the film in SMA, Q1-7-479, dated 1948.

30. See the preface to Su, ed., *Yingtan bai xing ji* (Who is who in Hollywood) (Tianjin: Da gong bao she, 1935).

31. *Zhongyang dianying shencha weiyuanhui gongbao* (The Central Film Censorship Committee: news bulletin, hereafter *ZDSHWGB*), 1 (1934): 10.

32. "He Tingran jun zhi dianying tan" (T. J. Holt comments on film), *Shenbao*, August 8, 1926, reprinted in *ZHWD*, 99–100.

33. Bing Hong, "He duzhe tanhua" (Heart to heart with readers), *Xin yinxing* (Silverland), 4 (December 1928).

34. Xin Ping, *Cong Shanghai faxian lishi, 1927–1937* (Discovering history in Shanghai) (Shanghai: Shanghai renmin chubanshe, 1996), 38–44. Xin estimates that Shanghai's population increased from 1,289, 000 in 1910 to 2,641,000 in 1927. These statistics approximate the editor's 3 million estimate.

35. Guo Youshou, "Wo guo dianying jiaoyu yundong zhi niaokan" (An overview of educational film in China), *Jiao yu xue yuekan* (Teaching and Learning Monthly), 1.8 (1936): 2.

36. "Ying guangda shimin zhengyi yaoqiu, Hu dianyingyuan ju ying meipian, ge bao tongshi ting zai meipian guanggao" (Yielding to the demand of the citizens, Shanghai's cinemas stopped showing American films and newspapers advertisements), *Wenhui bao*, November 16, 1950.

37. *Hubei shengzhi* (Hubei Provincial Gazette) (Wuhan: Hubei renmin chubanshe, 1993), 137.

38. See *Mingxing banyue kan* (Star Bi-Weekly), 1.2 (June 1933): 3.

39. Xin Leng, "Rendao xiandu guangan lu" (Preview comments on Humanity), *Da gong bao*, May 14, 1932.

40. "Yingshi suibi" (Casual remarks), *Dianying huabao* (Movies), 22 (1935): 14.

41. Fei Mu, "Guopian guanzhong" (Domestic film audience), *Dianying huabao* (Movies), 36 (1936): 3.

42. "Shui duo le guopian shichang" (Who takes the audience away from domestic films), *Yule zhoubao*, 1.3 (1935): 76.

43. Ruth Vasey, *The World According to Hollywood, 1918–1939* (Madison: University of Wisconsin Press, 1997).

44. Zhiwei Xiao, "Nationalism, Orientalism and an Unequal Treatise of Ethnography: The Making of *The Good Earth*," in Susie Lan Cassel, ed., *From Gold Mountain to the New World: Chinese American Studies in the New Millennium* (Alta Mira Publishing Co. 2002), 274–90.

45. Feng Zixi, "Wo zai Pingan dianyingyuan ershi nian de jingli" (My twenty years at Pingan theater), *Tianjin wenshi ziliao*, 32 (1985): 213–22.

46. Chen Dabei, "Beijing dianying guanzhong de paibie" (The classification of Beijing's movie goers), *Zhongguo dianying zazhi* (China Screen), 8 (1927), reprinted in *ZHWD*, 607.

47. It was reported in *DS*, 9: 1 (1940) that Grand Theater installed the first earphone system.

48. Fei Shi, "Li Zhuozhuo dui Zhang Yi buman" (Li is unhappy with Zhang), *Ying wu xinwen* (Movie and Dance News), 1.2 (1935): 5.

49. T. S. Young, "The Girl Guides," *China Weekly Review* (November 7, 1936): 343.

50. Ouwai Ou, "Zhonghua ernü mei zhi gebie shenpan" (Assessing the beauty of Chinese women), 17 (1934): 12–16.

51. Liu Xu, "Xiandai nuxing xinmu zhong de yinmu duixiang" (Modern women's most desired men — a response to screen images), *Furen huabao* (Women's Pictorial), 31 (1935) and Da Bai, "Biaozhun nanzi de zhuanbian" (The change in the notion of ideal man), *BYHB*, 24 (1934): 1160.

52. Wang Baisou, "Yeshi jiaoyu" (It is also educational), *Minguo ribao*, March 7, 1931.

53. Zhu Zisheng, "Nannü qinghua zhinan" (A guide for courtship), *BYHB*, 25 (February 1935): 1210.

54. Luo Man, "Kiss manhua" (Casual remarks about kissing), *Dianying* (Movies) (1932): 14.

55. "Caozong shijie de dianying" (The movie made world), *Xin yinxing* (September 1929): 14.

56. "The Movies and China," *China Weekly Review*, November 8, 1930, 360.

57. Cheng Bugao, 39.

58. Zhou Shixun, "Yingxi tongyu" (Scathing comments about film), *Dianying zazhi* (Movie Magazine), 1: 3 (1932).

59. "Our Films Disillusioning the East," *Library Digest*, 90:26 (August 1926); *China Weekly Review*, March 12, 1927; Sherman Cochran, *Inventing Nanjing Road: Commercial Culture in Shanghai, 1900–1945* (Ithaca: Cornell University Press, 1999), 39.

60. William Marston Seabury, *Motion Picture Problems: The Cinema and the League of Nations* (New York: Avondale Press, 1929) 28.

61. Charles Merz, "When the Movies Go Abroad," *Harper's Monthly Magazine*, 152: 163 (January 1926).

62. See *Dianying yishu* (Film Art), 1.1 (1932): 8.

63. Leo Ou-fan Lee, "Urban Milieu of Shanghai Cinema," in Yingjin Zhang, ed., *Cinema and Urban Culture in Shanghai, 1922–1943* (Stanford: Stanford University Press, 1999), 89.

64. "Zhong Mei dianying guanxi" (The reel relationship between China and the U.S.),

Dianying zhoukan (Movie Weekly), 83 (May 1940).

65. Wang Ruifeng, "Zhongguo dianying zuijin zhi xin de qingxiang" (New trend in recent Chinese films), *Yingmi zhoubao* (Movie Fan Weekly), 1.8 (1934): 130.

66. Zheng Junli, *Xiandai Zhongguo dianying shilue* (An outline of modern Chinese cinema), reprinted in *ZHWD*, 1410.

67. Wu Yonggang, *Wo de tansuo yu zhuiqiu* (My exploration and pursuit) (Beijing: Zhongguo dianying chubanshe, 1986), 176.

68. Gui Fengbo, "Dui jinhou zhipianye de jianyi" (My advice to film producers), *Da gong bao*, June 12, 1935.

69. Hu Yunshan, "Yin xiang zagan" (Casual comments on the film industry), *Lianhua huabao*, 5: 8 (April 1935).

70. Wu Yu, "Yinse de feng" (Silver wind), *Dianying zhoukan* (Movie Weekly), 26 (1939).

71. *DS*, 3.9 (1934): 176.

72. "Xingqi zaochang dianying shi ertong men de" (Sunday morning show belongs to children), *Qingqing dianying* (Chingching Cinema), 5.17 (1940): 3.

73. "Meiguo yingjie zhi jinghua yundong" (The sanitization movement in American film industry), *DS*, 3.11 (1934): 208. See also *Dianying shijie* (Movie World), 2 (1934).

74. Xiao Guo, *Zhongguo zaoqi yingxing* (Movie stars from early Chinese cinema) (Guangzhou: Guangdong renmin chubanshe, 1987), 49.

75. *Dianying jiancha weiyuanhui gongzuo baogao* (The work report of the national film censorship committee) (Nanjing, 1934), 66.

76. *BYHB*, 21 (December 1933): 1026.

77. Nanjing, No. 2 Historical Archives, 2(2)-268, dated July 1934.

78. See "Jinying feizhan yingpian" (The ban on anti-war films), *Dianying huabao* (The Movies), 7 (1934): 11 and Xian Cheng, "Shoudu de dianying guanzhong" (Film audience in the capital), *Chen bao*, October 6, 1932.

79. Gu Jianchen, "Zhongguo dianying fadashi," in *Zhongguo dianying nianjian* (Chinese film year book, 1934) (Nanjing, 1934).

80. Cited in Ding Yaping, *Yingxiang Zhongguo: Zhongguo dianying yishu, 1945–1949* (China on screen: cinema art between 1945 and 1949) (Beijing: Wenhua yishu chubanshe, 1998), 221.

81. Feng Wu, "Lun Zhongguo dianying wenhua yundong" (On Chinese film culture movement), *Mingxing yuebao* (Star Monthly), 1: 1 (May 1933), reprinted in *Zhongguo zuoyi dianying yundong* (The leftist cinema movement in China, hereafter *ZHZDY*) (Beijing: Zhongguo dianying chubanshe, 1993), 64.

82. Yi Lang, "Mei ziben jingong Zhongguo dianying jie hou zenyang tupo muqian de weiji" (How to make breakthrough after the invasion of Chinese film industry by American capital), *Dianying yishu* (Film Art), 3 (1932), reprinted in *ZHZDY*, 92–93.

83. Pang Zichun, "Meiguo yingpian de midu" (The poisonous American films), *Chenbao*, October 4, 1932, 8.

84. Chen Lifu, "Wo guo suo xu waiguo yingpian zhi biaozhun" (Criterion for selecting foreign films), *Quanguo dianying gongsi fuzeren tanhuahui jiniance* (Proceedings of the symposium of Chinese film industry leaders) (Nanjing, 1934), 77.

85. Paul Pickowicz, "The Theme of Spiritual Pollution in Chinese Films of 1930s," *Modern China*, 17.1 (1991): 38–75.

86. "Guochan dianying de jinbu" (The progress of domestic productions), *Shanghai yingtan* (Shanghai Cinema Forum), 1: 3 (1943).

87. See Nanjing No. 2 Historical Archives, 12 (2) 2258, dated 1936 and SMA, S6-13-

612, Shanghai's city council members appealed to the government to implement quota system, dated 1947.

88. For more details of this case, see the telegraph to NFCC, SMA, 235-2-1622, 62; PCA file, the folder under the title of the film, Herrick Marraret Library, Beverly Hill, CA; and *JNGB*, 1.1 (1932): 40.

89. SMA, S319-1-23.

90. "Zhipian ye yaoqing fangying ye taolun duifu waipian banfa" (Film producers invited exhibitors to discuss ways to deal with foreign films), SMA, S319-1-20, dated May 1948.

91. See the letter from John Hung-kwang Chow, the secretary of the Shanghai Cinema Exhibitors Guild, to A. Ohlmert, the secretary of the Film Board of Trade (China), dated March 28, 1946, Shanghai Municipal Archives, S319-01-00023.

92. Zhiwei Xiao, "The Expulsion of Hollywood from China, 1949–1951," *Twentieth Century China*, vol. 30, no. 1 (November 2004): 64–81.

93. Zhang Ling, "Buneng wangji de meili Xiang Mei" (The unforgettable beauty, Xiang Mei), *Meizhou wenhui zhoukan* (Wenhui Weekly, North American edition) (January 10, 2004): 63.

CHAPTER 4

1. Ada Shen, "Slipping under the Wall: Warners Hopes to Crack China with Low-Cost DVDs," *Variety* 298, no. 2 (2005): 5(1), emphasis added.

2. See Time Warner, "Warner Home Video Announces Historic Joint Venture with China Audio Video to Become First U.S. Studio to Establish In-Country DVD/VCD Operation in China," February 24, 2005, www.timewarner.com/corp/newsroom/pr/0,20812,1030960,00.html (accessed January 1, 2006); Alestron, Inc., "Warner Bros. Fights against Pirated Film DVD in China," news provided by Comtex.China, February 28, 2005 (SinoCast via Comtex); and Ada Shen, *Slipping under the Wall*.

3. Fox and Zoke Culture Group of China joined forces in November 2006 to form their own DVD distribution operation in China. In November 2007, Paramount and Dreamworks joined CAV Warner Home Entertainment, releasing *Transformers* and *Shrek the Third* in China.

4. See Bao Ong and Sarah Schafer, "DVD's: 'Traveling' to China," *Newsweek*, June 20, 2005), 6. *Screen Digest*, "International Box Office Surges: China Is the World's Fastest Growing Theatrical Market," Vol. 36, February 2005 (TableBase™ Accession # 131960249). See also movies.aol.com/movie/main.adp?mid=19138 - 50k - Dec 30, 2005 (accessed January 1, 2006).

5. See Li Yaxin, "Zhonglu Huana yiyahuanya daoban dian mai zheng ban, zheng ban DVD mai 10 yuan" (CAV Warner play the piracy game by selling legitimate DVDs in piracy stores, legitimate copies are sold for ten renminbi), *Diyi caijing ribao* (First Financial Daily), December 13, 2006, tech.tom.com/2006-12-13/04B5/8605965/.htm/ (accessed May 14, 2008).

6. This is true especially in emerging economies.

7. See Yu-zhu Liu, ed., *Wenhua sh chang shiwu quanshu* (Overview of cultural market practice) (Beijing: Xinhwa, 1999), 217. Other cultural markets include cultural entertainment, audiovisual, performance, print, artifacts, cultural tourism, artworks, stamps, and new culture.

8. See MPAA website.

9. Shujen Wang, *Framing Piracy: Globalization and Film Distribution in Greater China* (Lanham, MD: Rowman & Littlefield, 2003).

10. See Liu, ed., *Wenhua shichang*, and the PRC Radio and Television Association (1996) for detailed discussions of regulations and policies.

11. Wang, *Framing Piracy*.

12. In 1998–1999, for example, because of the critical stance Disney's *Kuntun* and Columbia's *Seven Years in Tibet* took of China's Tibet policies, both companies were temporarily banned from importing films to China; this gave the other majors an upper hand in getting the allotted ten revenue-sharing film slots.

13. Wang, *Framing Piracy*.

14. As Larkin has pointed out in his study on video piracy in Nigeria, this kind of access to other places has led to new types of leisure and social association while provoking infrastructural innovations. Brian Larkin, "Technology and the Domain of Piracy," paper presented at "Contested Commons/Trespassing Publics: A Conference on Inequalities, Conflicts and Intellectual Property," New Delhi, India, January 6–8, 2005.

15. As most emerging/transitional economies, however, the rise of the economic standard has not reached the point where most people can afford authentic legitimate luxury goods.

16. James Boyle, *Shamans, Software, and Spleens: Law and the Construction of the Information Society* (Cambridge, Mass.: Harvard University Press, 1996), 3–4.

17. Scott Lash and John Urry, *Economies of Signs and Space* (London: Sage, 1994), 4.

18. Stephen Siwek, "Copyright Industries in the U.S. Economy: The 2004 Report," International Intellectual Property Alliance, 2004, www.iipa.com/2004_SIWEK_FULL.pdf (accessed May 25, 2005).

19. IIPA, "Intellectual Property Protection as Economic Policy: Will China Ever Enforce Its IP Laws?" IIPA 2005, www.iipa.com/2005_May16_China_CECC_Testimony (accessed May 25, 2005).

20. IIPA, "Copyright Industries Release Report on Piracy in 68 Countries/Territories and Press Their Global Trade Priorities for 2006," IIPA press release February 13, 2006, www.iipa.com (accessed February 23, 2006).

21. Michael P. Ryan, *Knowledge Diplomacy: Global Competition and the Politics of Intellectual Property* (Washington, D.C.: Brookings Institution Press, 1998). Mark D. Alleyne, *International Power and International Communication* (New York: St. Martin's Press, 1995).

22. Initially, the Trade and Tariff Act of 1974 enabled the United States to take retaliatory action against any country that denied it rights granted by a trade agreement or unfairly restricted U.S. commerce. The cooperation among the copyright industries and the resulting lobbying leverage IIPA possessed had led to the expansion and the change of language of the 1974 Trade Act. The Trade and Tariffs Act of 1984 extended the definition of unfair trade practices to include intellectual property rights violations. The 1984 Trade Act also empowered the USTR to undertake annual review of problem countries, which could result in a USTR investigation and subsequent trade sanctions. After its annual review, USTR would name TRIPS Copyright Cases, Potential Priority Foreign Countries, Priority Foreign Countries, Priority Watch List, Watch List, and Special Mention according to the severity of their offenses. See Wang, *Framing Piracy*, 33 and 39.

23. China was put on the Priority Watch List in 2006, 2007, and 2008.

24. Peter K. Yu, "From Pirates to Partners: Protecting Intellectual Property in China in the Twenty-First Century," *The American University Law Review*, 50 (2000): 131–99.

25. The TRIPS Agreement is Annex 1C of the Marrakesh Agreement Establishing the World Trade Organization, signed in Marrakesh, Morocco on April 15, 1994.

26. Peter K. Yu, "From Pirates to Partners."

27. See National Copyright Administration of the People's Republic of China website, www.ncac.gov.cn.

28. Andrew C. Mertha, *The Politics of Piracy: Intellectual Property in Contemporary China* (Ithaca and London: Cornell University Press, 2005), 230.

29. Mertha, *The Politics of Piracy*, 227.

30. APEC, "An Introduction to China's Intellectual Property Protection," APEC Competition & Law Database, Sponsored by Fair Trade Commission, Chinese, Taipei, 2007, www.apeccp.org.tw/doc/China/ Comlaw/cniss01.html (accessed January 19, 2007).

31. U.S. Department of Commerce, "Protecting Your Intellectual Property Rights in China: A Practical Guide for U.S. Companies," China Gateway 2003, www.mac.doc.gov/China/Docs/BusinessGuides/IntellectualPropertyRights.htm (accessed January 19, 2007).

32. See, for example, Ronen Palan, "Trying to Have Your Cake and Eating It: How and Why the State System Has Created Offshore," *International Studies Quarterly*, 42: 4 (December 1998): 625–44.

33. See Paul Thiers, "Challenges for WTO Implementation: Lessons from China's Deep Integration into an International Trade Regime," *Journal of Contemporary China*, 11.32 (2002): 413–31.

34. Margaret M. Pearson, "China's Integration into the International Trade and Investment Regime," in Elizabeth Economy and Michael Oksenberg, eds., *China Joins the World: Progress and Prospects* (New York: Council on Foreign Relations Press, 1999), 161–205.

35. IIPA, "2006 Special 301 Report: People's Republic of China (PRC)," February 13, 2006, www.iipa.com/countryreports.html (2006SPEC301PRC.pdf, February 23, 2006), 115, emphasis added.

36. Andrew Tanzer, "Tech-Savvy Pirates," *Forbes*, 162, no. 5 (September 7, 1998): 162–65.

37. In 2004 there were 107 million VCD households, a steady increase since the launch of the player in 1994. See *Screen Digest*, "World DVD Growth Slows to Crawl: DVD Shipments Rise but Returns Are Slowed by Falling Prices." 333, November 2005 (TableBase™ Accession #140196159).

38. See Shujen Wang, *Framing Piracy*, for a detailed account of the development of the VCD.

39. China's rural population is historically about 80 percent of the total population, now estimated at over 60 percent, see U.S. Department of Agriculture (2005). U.S. Department of Agriculture, "Commercialization of Food Consumption in Rural China," *Economic Research Service*, July 2005, www.ers.usda.gov/Publications/err8/err8 reportsummary.htm (accessed October 19, 2008).

40. *Screen Digest*, "Chinese Broadband Market Booms: China Claims World's Second Highest Broadband Subscriber Total," May 2008, TableBase™ Accession #180228785 (accessed October 8, 2008).

41. IIPA, "2008 Special 301 Report: People's Republic of China, 2008, http://www.iipa.com/countryreports.html (accessed October 21, 2008).

42. *China Daily*, "Net Piracy Still Poses a Challenge," January 18, 2008, www.chinadaily.com.cn (accessed October 8, 2008).

43. See also Table 4.1. *China Telecom*, "China Number of Internet Users for 2000 to 2005, and Number of Broadband Users for 2002 to 2005, and Both through June 2006," February 2007, 14(2): 1, TableBase™ Accession #161119240.

44. *Screen Digest*, 2008.

45. *Variety*, "The Internet Re-oriented," 411.11 (August 4, 2008): 3.

46. MPAA, "Internet Piracy," 2005, www.mpaa.org/piracy_internet.asp (October 19, 2008).

47. While MPAA complains about its member companies' loss in China due to the high piracy rate, it is the Chinese filmmakers who are bigger sufferers. In China, the piracy rate of MPAA member companies was 24 percent in 2005, it was 55 percent for Chinese filmmakers (or a loss of $2.6 billion). *China Daily*, "Movie Industry Counts Cost of Online Piracy," April 12, 2007, www.chinadaily.com.cn (accessed October 8, 2008).

48. IIPA, 2008.

49. *Bloomberg News*, "Anonymous Web Piracy a $7.1-Billion Threat to Hollywood Filmmakers," Financial Post (p.FP7), April 19, 2008, *National Post's Financial Post & FP Investing* (Canada).

50. See Ponte, citing an MPAA report. Lucille M. Ponte, "Coming Attractions: Opportunities and Challenges in Thwarting Global Movie Piracy," *American Business Law Journal*, Summer, 2008.

51. Ponte, "Coming Attractions."

52. The maturing of the DVD market was due partially to the falling of the DVD price with average price of a retail DVD of $26.80 in 1997 to $16.59 in 2004. World retail DVD prices have fallen around 40 percent between 1997 when the format launched and 2004. The world's lowest average retail DVD price is no doubt in China, with a retail DVD priced at $2.17 in 2004. *Screen Digest*, "World DVD Growth Slows to Crawl." *Video Store*, "Exclusive Research," January 18, 2004, 26(3) (TableBase™ Accession # 122623925): 1. *USA Today*, "Video Slips as DVD Market Matures," January 3, 2006, yahoo.usatoday.com/tech/news/2006-01-03-dvd-ces_x.htm?esp=1 (January 13, 2006).

53. *USA Today*, "Video Slips"; *Video Business*, "Growing Disc Dominance," August 22, 2005, 25(34) (TableBase™ Accession #135903944): 1. Entertainment Merchants Association (EMA), *2006 Annual Report on the Home Entertainment Industry*, www. entmerch.org (July 7, 2007).

54. Even though the focus is still on the VCD and the DVD markets, pirates have moved towards the much more portable and cheaper burner labs. See MPA, "MPA Anti-piracy Enforcement Operations Show Shift in Tactics by Movie Pirates: Downloads, Difficult-to-Detect Burner Labs Supplant Factory Production," MPA Press release, February 7, 2006, www.mpa.org (accessed February 7, 2006). Inextricably connected to technological developments, piracy is linked to technology. It also has spatial implications. Burner labs are much more local. From large scale optical media production that are more expensive to burner labs that are low cost, local, and easy to set up and move.

55. See the *DVD Statistical Report*, 8th edition, 2005: 3 (DVDstats.pdf).

56. *Video Business*, "Growing Disc Dominance."

57. Its huge population will enable the country to generate increases in media penetration that surpass the total market size of most other regions. China's spending growth is also projected to average 25.2 percent in 2005–2009, the highest in the world. PricewaterhouseCoopers, "Global Entertainment and Media Outlook: 2005–2009," (NY: PricewaterhouseCoopers LLP, 2005), www.pwc.com/e&m (pwc_outlook2009. pdf, April 30, 2006), 7.

58. *Screen Digest*, "China Yet to Realise Video Potential: Piracy Undermines Growth as New Formats Emerge," Vol. 37, February 2005 (TableBase™ Accession # 132539205).

59. IIPA, "USTR 2005 'Special 301' Decisions on Intellectual Property Based on IIPA's 2004 Estimated Trade Losses Due to Copyright Piracy (in millions of U.S. dollars) and Piracy Levels In-Country," 2005, www.iipa.com.2005_Apr29_USTR_301_DECISIONS.pdf (accessed May 25, 2005).

60. The impressive growth of DVD has compensated for the decline in VHS and VCD spending. Worldwide spending on DVD in 2004, for example, was $48 billion and at more than five times spending on VHS and an increase of 31 percent (*Screen Digest*, "China Yet to Realise Video Potential"). Another indicator of the strength of DVD is the compound annual growth rate (CAGR). Between 1997 and 2004, DVD spending grew at CAGR of 154 percent, while the VHS spending witnessed a decline of 16 percent, and VCD spending just over 10 percent (ibid.). Retail DVD has also far surpassed the rental DVD market. DVD household on the other hand has grown at CAGR of close to 140 percent since 1997 when the format launched. *Screen Digest*, "World DVD Growth Slows to Crawl."

61. *Screen Digest*, "International Box Office Surges: China Is the World's Fastest Growing Theatrical Market," Volume 36, February 2005 (TableBase™ Accession # 131960249).

62. According to "IIPA 2007 Special 301 Reports, Appendix B: Methodology," piracy level estimates are based on the percentage of potential market lost to piracy. It involves the calculations of revenue losses, legitimate market sizes, and potential legitimate markets without piracy to arrive at the final estimates. See 2007spec301methodology.pdf at www.iipa.com/2007_SPEC301_TOC.htm (accessed May 27, 2008).

63. IIPA, "Intellectual Property Protection as Economic Policy: Will China Ever Enforce Its IP Laws?" IIPA 2005, www.iipa.com/2005_May16_China_CECC_Testimony (accessed May 25, 2005).

CHAPTER 5

1. The figures are from Tian Jingqing, *Beijing dianyingye shiji, 1949–1990* (Historical events in the Beijing film industry) (Beijing: Zhongguo dianying chubanshe, 1999), 184–85. The film had first been released in China the previous September as part of a North Korean film festival.

2. Zhongguo dianyingjia xiehui dianyingshi yanjiubu, ed., *Zhonghua renmin gongheguo dianying shiye sanshiwu nian, 1949–1984* (Thirty-five years of the PRC film industry) (Beijing: Zhongguo dianying chubanshe, 1985), 339.

3. For an outline of the film industry in the 1949–1966 period, see Paul Clark, *Chinese Cinema: Culture and Politics since 1949* (Cambridge: Cambridge University Press, 1987), especially chapters 2, 3, and 4. The appendix (185–86) presents annual production levels.

4. See the listings in Zhongguo dianying ziliaoguan and Zhongguo yishu yanjiuyuan dianying yanjiusuo, eds., *Zhongguo yishu yingpian bianmu, 1949–1979* (Catalogue of Chinese art films) (Beijing: Wenhua yishu chubanshe, 1981), 871–72, 880–83, 901, 917–18, 929, 944–45.

5. See Yang Jian, "Wenhua dageming de Hongweibing xiju" (Great Cultural Revolution Red Guard plays), *Xiju* (Drama), 3 (September 1999): 51–64 (esp. 60–61).

6. The titles and further viewing figures are given in Yu Li, ed., *Zhongguo dianying zhuanye shi yanjiu: dianying zhipian, faxing, fangying juan* (Research on Chinese film

specialist history: film production, distribution and screening) (Beijing: Zhongguo dianying chubanshe, 2006), 110–11. See also Shan Wanli, *Zhongguo jilu dianying shi* (History of Chinese documentary film) (Beijing: Zhongguo dianying chubanshe, 2005), 234–35.

7. The figures are from Tian Jingqing, *Beijing dianyingye shiji*, 157–58. Later in the Cultural Revolution perhaps the most widely watched Chinese film star to rival Mao was Cambodia's Prince Norodom Sihanouk, whose meetings and travels were covered in full-length documentaries and newsreels.

8. See, for example, the advertisements in *Yunnan ribao* (Yunnan Daily), May 20, 1967, 4, where the documentary on Mao's fifth and sixth inspection of Red Guards is listed, along with other performance displays of Maoist loyalty.

9. See the collected programmes from the 1964 convention, held in the rare book collection of the National Library, Wenhua bu Beijing bianzhe kan, ed., *Jingju xiandaixi guanmo yanchu dahui jiemudan (heding ben)* (Programmes of the modern-subject Peking opera performance convention) (Beijing, 1964), n.p. Many of the originary films had, of course, started as spoken dramas (*huaju*).

10. A lively account of the making of the *yangbanxi* films can be found in Zhai Jiannong, *Hongse wangshi: 1966–1976 nian de Zhongguo dianying* (A red past: 1966–1976 Chinese film) (Beijing: Taihai chubanshe, 2001), 64–184.

11. In an interview in Beijing, July 3, 2002, the cinematographer Li Wenhua suggested to me that Jiang Qing had rejected the first version of the film because the Pearl River Film Studio projector lens and booth glass were dirty, giving a murky quality to the print Jiang Qing watched there.

12. *Zhongguo dianying nianjin 1981* (China film yearbook) (Beijing: Zhongguo dianying chubanshe, 1982), 713–14.

13. See the interview with Yu Yang, *Dianying yishu* (Film Art), 4 (August 1993): 82 and 84.

14. Zhongguo dianyingjia xiehui dianyingshi yanjiubu, ed., *Zhonghua renmin gongheguo dianying*, 340.

15. Tian Jingqing, *Beijing dianyingye shiji*, 184.

16. Hu Chang, *Xin Zhongguo dianying de yaolan* (The cradle of New China's films) (Changchun: Jilin wenshi chubanshe, 1986), 336–37. Hu does not give a title for the American film.

17. Tian Jingqing, *Beijing dianyingye shiji*, 184–85.

18. See examples in Yang Haizhou, ed., *Zhongguo dianying wuzi chanye xitong lishi biannianji (1928–1994)* (Chronology of the film materials industry system) (Beijing: Zhongguo dianying chubanshe, 1998), 248–49, 253, 267.

19. Zhong Ying, "Jinyibu fazhan nongcun dianying fangying wang" (Further develop the rural film projection network), *Hongqi* (Red Flag), 6 (June 1975): 50–53. The Fujian figures are from *Guangming ribao* (Guangming Daily), January 31, 1974, 2. The Beijing figures are from Tian Jingqing, *Beijing dianyingye shiji*, 190.

20. Yu Li, ed., *Zhongguo dianying zhuanye shi yanjiu*, 116.

21. *Boulder Bay* on stage includes a kind of fantasy sequence in which the heroes battle underwater. It also was unusual in including a married central character. For further discussion, see Paul Clark, *The Chinese Cultural Revolution: A History* (Cambridge University Press, 2008), 50–54.

22. On the fate of satire and other comedies in 1957, see Paul Clark, *Chinese Cinema*, 70–79.

23. Yomi Braester offers an insightful discussion of these late 1970s films in his *Witness against History: Literature, Film, and Public Discourse in Twentieth-Century China* (Stanford: Stanford University Press, 2003), chapter 5, 131–45. For a fuller examination, see Chris Berry, *Postsocialist Cinema in Post-Mao China: The Cultural Revolution after the Cultural Revolution* (New York: Routledge, 2004).

24. For a group biography of these and five other Fifth Generation filmmakers, see Paul Clark, *Reinventing China: A Generation and Its Films* (Hong Kong: The Chinese University Press, 2005), part 1, 10–53.

25. See Clark, *Reinventing China*, 155, 156–58.

CHAPTER 6

1. Translations of *shenguai wuxia pian* (in some accounts, the order is reversed, thus *wuxia shenguai pian*, without necessarily changing the meaning of the term) vary with different authors: Zhang Zhen translates it as "martial arts-magic spirit film" (see *An Amorous History of the Silver Screen: Shanghai Cinema, 1896–1937* [Chicago: University of Chicago Press, 2005], 199; see also her essay "Bodies in the Air: The Magic of Science and the Fate of the Early 'Martial Arts' Film in China," in Sheldon Lu and Emilie Yeh, eds., *Chinese-Language Film: Historiography, Poetics, Politics* [Honolulu: University of Hawaii Press, 2005], 52–75, 53). Yingjin Zhang translates *shenguai pian* as "films of immortals and demons" and refers generically to "martial arts films" without reference to *wuxia pian* (see *Chinese National Cinema* [New York and London: Routledge, 2004], 40). My translation of *shenguai* is closer to Yingjin Zhang's, while in translating *wuxia* as "martial chivalry," I wish to denote the element of chivalry as being essential to the genre.

2. Film historians Hu Jubin and Li Suyuan tell us that *shenguai* and *wuxia* were two separate and distinct genres. According to Hu and Li, the *shenguai* connection brought the element of the supernatural to *wuxia*, which essentially expresses the warrior tradition and lifestyle. As a supernatural genre, *shenguai* possessed its own characteristics. See Li Suyuan and Hu Jubin, *Zhongguo wusheng dianying shi* (A history of the silent Chinese cinema) (Beijing: China Film Press, 1996), 222.

3. The film magazine *Yinxing* (Silver Star), published in the 1920s, edited by Lu Mengshu, advocated a movement known as "New Heroism" (*xin yingxiong zhuyi*), loosely based on the ideas of Romain Rolland. The movement emphasized heroism with a strongly humanist element which could be useful in fostering a military tradition (*shangwu*) that had long disappeared in China. No doubt, the emphasis on militarism was a response to the perceived weakness of the scholar tradition which had let the nation down and contributed to the decline of China "from being the Middle Kingdom for centuries to the 'Sickman of Asia' in just two generations' time," as Tu Wei-ming has put it. See Tu, "Cultural China: The Periphery as the Center," *Daedalus*, Vol. 120, No. 2 (Spring 1991): 1–32, 23.

4. One representative view was expressed by the leftist May Fourth writer Mao Dun (pseudonym of Shen Yanbing) in an essay, "Fengjian de xiao shimin wenyi" (Literature and arts of the feudalistic petty urban bourgeoisie), published in the magazine *Dongfang zazhi* (Eastern Miscellany), 30:3 (January 1, 1933). Mao Dun criticized the *Burning of the Red Lotus Temple* series for drawing its material from feudal thought, and considered that its chief aim was to propagate feudalism. The heroism expressed in these films, according to Mao Dun, was of an unhealthy kind because it transformed revolutionary class struggle into private feuds.

5. Among the reforms and prohibitions which came into effect in 1931, the KMT government had also banned celebration of the Lunar New Year, and abolished the internal transit tax known as likin (*lijin*), levied by the provinces.

6. I am borrowing here Poshek Fu's translation of the term, from his work on the *gudao* period. See Fu, *Between Shanghai and Hong Kong: The Politics of Chinese Cinemas* (Stanford: Stanford University Press, 2003); and *Passivity, Resistance, and Collaboration: Intellectual Choices in Occupied Shanghai, 1937–1945* (Stanford University Press, 1993). Jay Leyda translates *gudao* as "Orphan Island." See Leyda, *Dianying — Electric Shadows: An Account of Film and the Film Audience in China* (Cambridge, MA: MIT Press, 1972).

7. See Fu, works cited in note above. See Li Daoxin, *Zhongguo dianying shi 1937–1945* (Chinese film history 1937–1945) (Beijing: Shifan University Press, 2000), for an assessment of the whole war period, including films produced in Shanghai after it was fully occupied by Japan following Pearl Harbor.

8. The *guzhuang* genre was already popular in the 1920s well before the craze of *shenguai wuxia pian*. In fact, the *shenguai* genre was early on connected with the *guzhuang* film, as demonstrated by the 1927 production of *Pansi dong* (Cave of the silken coil) based on an episode from the classic *Xiyou ji* (Journey to the west), and through this connection, one could say that the action elements in the story eventually evolved into a full-fledged *wuxia* form. Dai Jinhua associates the early martial arts films with *guzhuang baishi pian* (classical-costumed tales of anecdotal history), which took their ancient stories from popular tradition. In fact, she tends to see *wuxia* films as a sub-type within the larger, generic form of *guzhuang baishi pian* (such a tendency not to recognize *wuxia* as a genre category on the part of a Mainland critic such as Dai reflects perhaps the long history in which the genre was banned in China, resulting in critical neglect until quite recently). See Dai Jinhua, "Order/Anti-Order: Representation of Identity in Hong Kong Action Movies," in Meaghan Morris, Siu-Leung Li, and Stephen Chan, eds., *Hong Kong Connections: Transnational Imagination in Action Cinema* (Hong Kong: Hong Kong University Press, 2005), 81–94.

9. Nothing epitomized the charged political atmosphere of the times more than the incident which occurred in Chongqing on the day of the premiere in January 1940 of *Mulan Joins the Army*. A mob invaded the projection room, grabbed the print, and burnt it outside the street. For a description of the event, see Fu, *Between Shanghai and Hong Kong*, 43–48.

10. Chris Berry and Mary Farquhar, *China on Screen: Cinema and Nation* (New York: Columbia University Press, 2006), 38.

11. For an astute discussion of the complexities of the Chinese national cinema, see Yingjin Zhang's "Introduction: National cinema and China," in *Chinese National Cinema*, 1–12.

12. See Chris Berry, "From National Cinema to Cinema and the National," in Paul Willeman and Valentina Vitali, eds., *Theorising National Cinema* (London: British Film Institute, 2006), 148–57, 149.

13. Tu Wei-ming's claim that China's semi-colonial experience had "severely damaged her spiritual life and her ability to tap indigenous symbolic resources" may strike a relevant chord here. See Tu, "Cultural China," 2.

14. The idea of culture where the structure of "the national" has eroded becomes more important. As Ernest Gellner has suggested, culture becomes essential to a person's identity if he or she is not held in place by a structure of stable relationships implicit in

the concept of the nation. See Gellner, "Nationalism," in *Thought and Change* (London: Weidenfeld and Nicolson, 1964), 147–78, 157–58.

15. The British colony also served in other ways to preserve Chinese customary practices and cultural forms, such as Lunar New Year festivities and Cantonese opera, discouraged or banned by the KMT government. See Barbara Ward, "Regional Operas and Their Audiences: Evidence from Hong Kong," in David Johnson, Andrew J. Nathan, and Evelyn S. Rawski, eds., *Popular Culture in Late Imperial China* (Taipei: SMC Publishing, 1987). In 1931, a Singapore *Straits Times* correspondent reported that, following the edict to ban Chinese New Year festivities, there was a "big influx to Hong Kong of people from Canton, bent on celebrating the festival with all the age-old ritual of China." See "Hong Kong Letter," *The Straits Times*, February 21, 1931, 6.

16. After the Japanese surrender, Taiwan experienced a brief period of practically no censorship during which *shenguai wuxia* serials produced in 1920s Shanghai such as the eighteen-episode *Burning of the Red Lotus Temple* were released in the island, to great business. See Ye Longyan, *Taiwan dianying shi* (A history of cinema in Taiwan) (Taipei: Chinese Taipei Film Archive, 1994), 92.

17. See Zhang Zhen, "Bodies in the Air," in Lu and Yeh, eds., *Chinese-Language Film*, 52.

18. Maige erfeng (a pseudonym meaning Microphone), "Yueyu pian de guoqu weilai" (Cantonese cinema: its past and future), *Dianying shijie* (Movie World), no. 2 (Hong Kong: August 5, 1950).

19. See Yu Mo-wan, "Swords, Chivalry and Palm Power: A Brief Survey of the Cantonese Martial Arts Cinema 1938–1970," in *A Study of the Hong Kong Swordplay Film* (1945–1980) (5th Hong Kong International Film Festival catalogue, 1981), 99–106.

20. Wu Pang, *Wo yu Huang Feihong* (Wong Fei-hung and I) (Hong Kong: published by Wu Pang, 1995), 5.

21. For a discussion of the realism issue and Wong Fei-hung's Confucianist ideals, see the excellent article by Hector Rodriguez, "Hong Kong Popular Culture as an Interpretive Arena: The Huang Feihong Film Series," *Screen*, 38.1 (Spring 1997): 1–24.

22. For example, in 1972 following the boom in kung fu films, the government in Singapore, a key market for Hong Kong films, announced a ban on violence in film, specifically targeting Hong Kong martial arts films. See *The Sunday Times* (Singapore), May 21, 1972.

23. The term "new school" (*xinpai*) was appropriated from literature, used to refer to the novels of Jin Yong and Liang Yusheng which came into popularity in the 1950s through their serialization in newspapers.

24. Leon Hunt's *Kung Fu Cult Masters, From Bruce Lee to Crouching Tiger* (London and New York: Wallflower Press, 2003) is representative of this view, though Hunt shows that he is aware of the distinction between kung fu and *wuxia* (6–9). In the main, the book deals with kung fu cinema and hardly touches on the *wuxia* film, save for examples such as *Crouching Tiger* and *Hero*.

25. For an English translation of *Shi ji*, see Burton Watson's *Records of the Grand Historian of China* (New York and London: Columbia University Press, 1961), in two volumes. *Records* contains two chapters dealing with *xia*, namely *Youxia liezhuan* (Biographies of knights-errant), and *Cike liezhuan* (Biographies of assassins).

26. See James Liu's *The Chinese Knight-Errant* (Chicago: University of Chicago, 1967) for a standard account, in English, of the history and literature of *xia*.

27. See Du Yunzhi, "Wuxia pian yu xiayi jingshen" (Wuxia film and the spirit of chivalric righteousness), *Xianggang yinghua* (Hong Kong Movie News), February 1968, 62–63, 62.

28. Ibid.

29. Zhang Zhen, "Bodies in the Air," 64.

30. Pam Cook, *Fashioning the Nation: Costuming and Identity in British Cinema* (London: British Film Institute, 1996), 68.

31. Andrew H. Plaks, "Towards a Critical Theory of Chinese Narrative," in Plaks, ed., *Chinese Narrative: Critical and Theoretical Essays* (Princeton, New Jersey: Princeton University Press, 1977), 309–52, 316 and 312.

32. The Hong Kong critic Sek Kei points out that Zhou Xiaowen's *The Emperor's Shadow* was not yet, in 1996, "*wuxia*-ized" (*wuxia hua*), meaning that it remains essentially a historical genre film (the type identified by Dai Jinhua as *guzhuang baishi pian*), and that it was only with Zhang Yimou's *Hero* that the grand spectacle of history became entangled with the *wuxia* blockbuster. See Sek Kei, "Huangjin jia you zhengzhi yingshe?" ("Is there political allegory in *Curse of the Golden Flower*?"), *Mingpao*, December 29, 2006. For a highly critical analysis of all three Qin emperor and assassin films, see the chapter "Nanren de gushi" (A male story), in Dai Jinhua's *Xingbie Zhongguo* (Gendering China) (Taipei: Rye Field, 2006), 159–98.

33. It must also be stated that the same nationalist spirit is present in the kung fu genre, as evidenced in Ronny Yu's *Fearless* (2006), starring Jet Li as the nationalist kung fu fighter, Huo Yuanjia.

34. See Stephanie Hemelryk Donald, *Public Secrets, Public Spaces: Cinema and Civility in China* (Lanham, Boulder, New York and Oxford: Rowman and Littlefield, 2000), 23.

35. See Evans Chan's "Zhang Yimou's *Hero*: The Temptation of Fascism," originally published online in *Film International*, 2:8 (March 2004). See also J. Hoberman's review of *Hero* in *Village Voice*, August 23, 2004, http://www.villagevoice.com/film/0434,hoberman2,56140,20.html.

36. Ibid., 143. Dai Jinhua's critique of *Hero*, on the other hand, asserts the primacy of perspective (invariably male and patriarchal) over space, and that such a perspective reveals the filmmakers choosing to stand unabashedly on the side of "power, conquest, might." See Dai Jinhua, *Xingbie Zhongguo*, 181.

37. Sek Kei, "Mancheng jindai huangjin jia guguai" (The bizarre *Curse of the Golden Flower*), *Mingpao*, December 27, 2006.

38. Plaks, "Towards a Critical Theory," 326.

39. King Hu's films in particular were exemplary: Yingjin Zhang states that they "exhibit powerful Chinese *national* characteristics," and being set in remote historical times, "invited an *allegorical* reading" (emphases his). See Zhang, *Chinese National Cinema*, 141.

40. See Zhang Zhen, "Bodies in the Air," 65, and her chapter "The Anarchic Body Language of the Martial Arts Film," in *An Amorous History of the Silver Screen*, 227 ("Bodies in the Air" is a reworking of this chapter in Zhang's book).

41. Zhang Zhen, "Bodies in the Air," 53.

42. I am grateful to Professor Chua Beng Huat of the National University of Singapore for this observation.

43. See my essay "Wuxia Redux: Crouching Tiger, Hidden Dragon as a Model of Late Transnational Production," in Morris et al., *Hong Kong Connections*, 191–204.

44. Ken-fang Lee, "Far Away, So Close: Cultural Translation in Ang Lee's *Crouching Tiger, Hidden Dragon*," *Inter-Asia Cultural Studies*, 4.2 (2003): 281–95, 281.

45. Berry, "From National Cinema to Cinema and the National," 149.

CHAPTER 7

1. Zeng Guangchang, "Chinese Early Animation," *Jiangsu Film*, December 1992.
2. Zhang Huilin, *Ershi shiji Zhongguo donghua yishushi* (Twentieth-century Chinese animation art history) (Shangxi: Peoples' Art Press, 2002), 26. Besides Zhang, other surveys of the history of Chinese animation are: David Ehrlich and Jin Tianyi, "Animation in China," in John A. Lent, ed., *Animation in Asia and the Pacific* (Sydney: John Libbey, 2001), 7–29; John A. Lent and Xu Ying, "Animation in China Yesterday and Today — The Pioneers Speak Out," *Asian Cinema*, 12.2 (Fall/Winter 2001): 34–49; John A. Lent and Xu Ying, "China's Animation Beginnings: The Roles of the Wan Brothers and Others," *Asian Cinema*, 14.1 (Spring/Summer 2003): 56–69.
3. Bao Jigui, "China's First Animated Sound Film, *The Dance of the Camel*," *Hong Kong Film Archive Newsletter*, 13 (2000): 11–12.
4. Bao Jigui, "China's First Animated Short, *Tumult in the Studio*," *Hong Kong Film Archive Newsletter*, 12 (May 2000): 6–7.
5. Confusion surrounds the production and release of *Tumult in the Studio*. Some sources list 1926, others, 1927. Probably the film was finished in late 1926 and released in 1927. Other sources claim 1920, probably an error in translating "1920s." Ethan Gilsdorf, "Chinese Animation's Past, Present, and Future: The Monkey King of Shanghai," *Animato* (Winter 1988): 20–23; *Shanghai Animation Film Studio 1957–1987* (Shanghai: Shanghai Animation Film Studio, 1987), n. p. Similar problems exist concerning titles, translations varying so widely that a title sometimes counted as two separate films.
6. Marie-Claire Quiquemelle, "The Wan Brothers and Sixty Years of Animated Films in China," in Chris Berry, ed., *Perspectives on Chinese Cinema* (London: British Film Institute, 1991), 177.
7. Zhang, *Ershi Shiji*, 37.
8. Zhang, *Ershi Shiji*, gave 1933 as the date of *Dog Detective*.
9. Quoted in Zhang, *Ershi Shiji*, 40.
10. Wan Laiming, Wan Guchan, and Wan Chaochen, "Talking about Cartoons," *Mingxing Huabao*, 1936; quoted in Quiquemelle, "The Wan Brothers," 178.
11. Bao, "China's First Animated Sound Film," 11.
12. Cheng Jihua, ed., *Chinese Film Developing History* (Beijing: China Film Press, 1981), 428.
13. Te Wei, interview with authors, Shanghai, June 16, 2001.
14. Te, interview.
15. Te, interview.
16. Te, interview.
17. Hu Jinqing, interview with authors, Shanghai, June 17, 2001.
18. Ma Kexuan, interview with John A. Lent, Changzhou, September 29, 2005.
19. Yan Dingxian, interview with authors, Shanghai, June 17, 2001.
20. Zhang Huilin, "Some Characteristics of Chinese Animation," *Asian Cinema*, 14.1 (Spring/Summer 2003): 70–79.
21. Zhang, "Some Characteristics," 71.
22. Te, interview.
23. Chen Jianyu, interview with authors, Shanghai, June 16, 2001.
24. Qian Yunda, interview with authors, Shanghai, June 17, 2001.
25. Zhan Tong, interview with John A. Lent, Shanghai, August 15, 1993.
26. Te, interview.

27. Te, interview.
28. Chen, interview.
29. Jin Guoping, interview with John A. Lent, Shanghai, August 13, 1993.
30. Jin Guoping, interview with authors, Shanghai, June 17, 2001.
31. Jin, interview, 2001.
32. Zuo Qin, interview with John A. Lent, Shanghai, August 13, 1993.
33. Qian, interview.
34. Ma, interview.
35. Te, interview.
36. Yan, interview; Chang Guangxi, interview with authors, Shanghai, June 17, 2001.
37. Zhan, interview.
38. See Xu Ying, "Animation Film Production in Beijing," *Asian Cinema*, 11.2 (Fall/Winter 2000): 60–66.
39. Liu Yuzhu, untitled keynote speech presented at China International Cartoon and Digital Arts Festival, Changzhou, September 28, 2005.
40. Liu, untitled keynote speech.
41. James Wang, interview with authors, Taipei, Taiwan, July 27, 2005.
42. Yan Dingxian, "The Cultivation of Animation Talents through Practice," paper presented at 2006 International Animation Artists Salon, Wuhan, November 2, 2006.
43. Wang, interview.
44. Becky Bristow, untitled talk, 2006 International Animation Artists Salon, Wuhan, November 3, 2006.
45. Wu Weihua, "Independent Animation in Contemporary China," *Cartoons*, 1.2 (Winter 2005): 21–25.
46. Theodor W. Adorno, "Culture Industry Reconsidered," in *The Culture Industry: Selected Essays on Mass Culture* (London: Routledge, 1991 [1975]).

CHAPTER 8

1. For documentary film in Hong Kong and Taiwan, see relevant sections in Fang Fang, *Zhongguo jilupian fazhan shi* (History of the development of Chinese documentary cinema) (Beijing: Zhongguo xiju chubanshe, 2003), and Shan Wanli, *Zhongguo jilu dianying shi* (History of Chinese documentary film) (Beijing: Zhongguo dianying chubanshe, 2005); see also Robert Chi, "The New Taiwanese Documentary," *Modern Chinese Literature and Culture*, 15, no. 1 (Spring 2003): 146–96.
2. Shan Wanli, *Zhongguo jilu dianying shi*, 8–9; Cheng Jihua, Li Shaobai, and Xing Zuwen, eds., *Zhongguo dianying fazhan shi* (History of the development of Chinese film), 2nd edition (Beijing: Zhongguo dianying chubanshe, 1981), 1: 16.
3. Fang Fang, *Zhongguo jilupian fazhan shi*, 12–29; Yingjin Zhang, *Chinese National Cinema* (London, Routledge, 2004), 21.
4. Fang Fang, *Zhongguo jilupian fazhan shi*, 44–47.
5. See Sun Jianqiu, "Sound and Color in Sun Mingjing's Silent B/W Films: The Paradox of a Documentary/Educational Filmmaker," *Asian Cinema*, 17, no. 1 (Spring/Summer 2006): 221–29; Ying Zhu and Tongdao Zhang, "Sun Mingjing and John Grierson, a Comparative Study of Early Chinese and British Documentary Film Movements," *Asian Cinema*, 17, no. 1 (Spring/Summer 2006): 230–45.
6. Wang Weici, *Jilu yu tansuo: 1990–2000 dalu jilupian de fazhan yu koushu jilu* (Document and explore: The growth of documentary in mainland China and its

related oral histories, 1990–2000) (Taipei: Guojian dianying ziliao guan, 2001), 20–22.

7. Zhang Jianghua et al., *Yingshi renleixue* (Visual anthropology) (Beijing: Shehui kexue wenxian chubanshe, 2000), 193–94.

8. Fang Fang, *Zhongguo jilupian fazhan shi*, 85.

9. Zheng Yongzhi, "Sannian lai de Zhongguo dianying zhipian chan" (China motion picture studio in the past three years), *Zhongguo dianying* (Chongqing) 1: 1 (January 1941).

10. Li Daoxin, *Zhongguo dianying shi, 1937–1945* (Chinese film history, 1937–1945) (Beijing: Shoudu shifan daxue chubanshe, 2000), 138–57.

11. Shan Wanli, *Zhongguo jilu dianying shi*, 97, 113.

12. Shan Wanli, *Zhongguo jilu dianying shi*, 85–86.

13. China Film Archive, ed., *Zhongguo dianying dadian: gushi pian, xiqu pian, 1977–1994* (Encyclopedia of Chinese films: Feature films, theater films, 1977–1994) (Beijing: Zhongguo dianying chubanshe, 1995). Most often, though, theater films are treated under feature films; see Chen Huangmei, ed., *Dangdai Zhongguo dianying* (Contemporary Chinese cinema) (Beijing: Zhongguo shehui kexue chubanshe, 1989), 2: 424–57.

14. Shan Wanli, *Zhongguo jilu dianying shi*, 178–79.

15. Yingjin Zhang, *Chinese National Cinema*, 196.

16. Fang Fang, *Zhongguo jilupian fazhan shi*, 255–65; Wang Weici, *Jilu yu tansuo*, 23–45.

17. Shan Wanli, *Zhongguo jilu dianying shi*, 291–96, 308.

18. Fang Fang, *Zhongguo jilupian fazhan shi*, 247–55; Guo Zhenzhi, *Zhongguo dianshi shi* (History of Chinese television) (Beijing: Wenhua yishu chubanshe, 1997).

19. Gao Weijin, *Zhongguo xinwen jilu dianying shi* (History of newsreels and documentaries in China) (Beijing: Zhongyang wenxian chubanshe, 2003), 337–38.

20. Shan Wanli, *Zhongguo jilu dianying shi*, 390–92.

21. Fang Fang, *Zhongguo jilupian fazhan shi*, 301–5, 448–55, 478–80; Wang Weici, *Jilu yu tansuo*, 46–61. For an English overview of the documentary treatment of ethnic minorities in China, see Yingchi Chu, *Chinese Documentaries: From Dogma to Polyphony* (London: Routledge, 2007), 148–82.

22. For a discussion of leitmotif film, see Yingjin Zhang, *Screening China: Critical Interventions, Cinematic Reconfigurations, and the Transnational Imaginary in Contemporary Chinese Cinema* (Ann Arbor: Center for Chinese Studies Publications, University of Michigan, 2002), 191–202.

23. Shan Wanli, *Zhongguo jilu dianying shi*, 394–95.

24. Lü Xinyu, *Jilu Zhongguo: dangdai Zhongguo xin jilu yundong* (Documenting China: The New Documentary movement in contemporary China) (Beijing: Sanlian shudian, 2003), 151.

25. For new documentary's departure from the logocentric tradition in modern Chinese visual culture, see Paola Voci, "From the Center to the Periphery: Chinese Documentary's Visual Conjectures," *Modern Chinese Literature and Culture*, 16, no. 1 (Spring 2004): 65–113.

26. For CCTV programs, see Liang Jianzeng and Sun Kewen, eds., *Dongfang shikong de rizi* (Days with the Eastern horizons) (Beijing: Gaodeng jiaoyu chubanshe, 2003); Liang Jianzeng Sun Kewen, and Chen Meng, eds., *Shihua shishuo* (Speaking in earnest) (Beijing: Gaodeng jiaoyu chubanshe, 2003).

27. Lü Xinyu, *Jilu Zhongguo*, 229.

28. Shan Wanli, *Zhongguo jilu dianying shi*, 405–6.
29. Fang Fang, *Zhongguo jilupian fazhan shi*, 345; Wang Weici, *Jilu yu tansuo*, 542–73.
30. For an example of the transformation of official television programming in CETV (China Education Television) during this period, see Yingchi Chu, *Chinese Documentaries*, 95–116.
31. Yingjin Zhang, "Styles, Subjects, and Special Points of View: A Study of Contemporary Chinese Independent Documentary," *New Cinemas* (UK) 2, no. 2 (2004): 120–21.
32. Lü Xinyu, *Jilu Zhongguo*, 204.
33. Cui Weiping, "*Zhongguo dalu duli zhizuo jilupian de shengzhang kongjian*" (Space for the growth of the independent documentary in mainland China), *Ershiyi shiji* (Hong Kong), 77 (June 2003): 84–94.
34. For an insightful analysis, see Jing Wang and Tani Barlow, eds., *Cinema and Desire: Feminist Marxism and Cultural Politics in the Work of Dai Jinhua* (London: Verso, 2002), 71–98. Mixing documentary footage in a dramatic feature did not start with the Sixth Generation directors like Zhang Yuan, as Tony Rayns claims; see Cheng Qingsong and Huang Ou, *Wode sheyingji bu sahuang: xianfeng dianying ren dang'an — shengyu 1961–1970* (My camera doesn't lie: documents on avant-garde filmmakers born between 1961 and 1970) (Beijing: Zhongguo youyi chuban gongsi, 2002), vi. Rather, in the early 1930s, leftist filmmakers had already experimented with this method in films like *Wild Torrents* (*Kuangliu*, 1933), directed by Cheng Bugao (1896–1966) and scripted by Xia Yan (1900–1995); see Fang Fang, *Zhongguo jilupian fazhan shi*, 55–58.
35. Zheng Wei, "Jilu yu biaoshu: Zhongguo dalu 1990 niandai yilai de duli jilupian" (Documenting and expression: mainland Chinese independent documentary since 1990), *Dushu* (Beijing), 10 (2003): 76–86.
36. Lü Xinyu, *Jilu Zhongguo*, 141, 97. Shi Jian was a co-founder of the youth film experimental group "SWYC" — an acronym for "Structure, Wave, Young, Cinema"; the first letter in each term refers to a letter from each member's name: Shi Jian, Wang Zijun (Beijing TV), Kuang Yang (China Academy of Social Sciences), and Chen Jue (TV Drama Production Center) — which independently produced *I Graduated* (*Wo biye le*, 1992) to articulate college graduates' personal views; see Fang Fang, *Zhongguo jilupian fazhan shi*, 363–64. Contrary to Lü, Zhang Tongdao only recognizes a television documentary "movement" inside the official system; see Shan Wanli, ed., *Jilu dianying wenxian* (Compendium of documentary studies) (Beijing: Zhongguo guangbo dianshi chubanshe, 2001), 826.
37. The images of movement are found in the title of an article by Bérénice Reynaud, "Dancing with Myself, Drifting with My Camera: The Emotional Vagabonds of China's New Documentary," *Senses of Cinema* (Australia, 28 [September–October 2003], http://www.senseofcinema.com/contents/03/28/chinas_new_documentary.html [accessed July 23, 2005]). See also Matthew David Johnson, "'A Scene beyond Our Line of Sight': Wu Wenguang and New Documentary Cinema's Politics of Independence" and Valerie Jaffee, "'Everyman a Star': The Ambivalent Cult of Amateur Art in New Chinese Documentary," both in Paul G. Pickowicz and Yingjin Zhang, eds., *From Underground to Independent: Alternative Film Culture in Contemporary China* (Lanham, MD: Rowman & Littlefield, 2006), 46–108.
38. As Ishizaka Kenji observes, "Of all the Asian filmmakers, the Chinese have by far been the most profoundly influenced by Ogawa Shinsuke ... even though they have never seen the films!" See Abé Mark Nornes, *Forest of Pressure: Ogawa Shinsuke and*

Postwar Japanese Documentary (Minneapolis: University of Minnesota Press, 2007), 227. As Nornes recalls, Wu Wenguang admitted in Japan that he never made it through any of Ogawa's documentaries.

39. Shan Wanli, *Zhongguo jilu dianying shi*, 385.
40. When confronted by security guards outside government buildings, Duan and Jiang did not disclose that they were not state employees. See Mei Bing and Zhu Jingjiang, *Zhongguo duli jilu dang'an* (Records of China's independent documentary cinema) (Xi'an: Shaanxi shifan daxue chubanshe, 2004), 6.
41. Shan Wanli, *Zhongguo jilu dianying shi*, 422. Duan received from CCTV 160,000–170,000 yuan (US$20,000–21,000) for each feature-length documentary; see Fang Fang, *Zhongguo jilupian fazhan shi*, 393.
42. Chris Berry, "Independently Chinese: Duan Jinchuan, Jiang Yue, and Chinese Documentary," in Pickowicz and Zhang, eds., *From Underground to Independent*, 109, 117–19.
43. For discussions of some of these works, see Lü Xinyu "Ruins of the Future: Class and History in Wang Bing's *Tiexi District*," *New Left Review*, 31 (2005): 125–36; Ban Wang, "Documentary as Haunting of the Real: The Logic of Capital in *Blind Shaft*," *Asian Cinema*, 16, no. 1 (Spring/Summer 2005): 4–15; and Yiman Wang, "The Amateur's Lightning Rod: DV Documentary in Postsocialist China," *Film Quarterly*, 58, no. 4 (Summer 2005): 16–26.
44. Wang Weici, *Jilu yu tansuo*, 597–616.
45. Bill Nichols, *Blurred Boundaries: Questions of Meaning in Contemporary Culture* (Bloomington: Indiana University Press, 1994), 95.
46. Bill Nichols, *Introduction to Documentary* (Bloomington: Indiana University Press, 2001), 99–138.
47. See Stella Bruzzi, *New Documentary: A Critical Introduction* (London: Routledge, 2000).
48. Mei Bing and Zhu Jingjiang, *Zhongguo duli jilu dang'an*, 18. While working on *The Silk Road (Sichou zhi lu*, 1980), a television series co-produced with Japan, the Chinese crew insisted on hiring pretty actresses to pose in the melon field whereas the Japanese zoomed in on real farmers in ragged clothing; see Fang Fang, *Zhongguo jilupian fazhan shi*, 312.
49. For a study of *The Box*, see Yingjin Zhang, "Thinking outside the Box: Mediation of Imaging and Information in Contemporary Chinese Independent Documentary," *Screen*, 48, no. 2 (Summer 2007): 179–92.
50. Fang Fang, *Zhongguo jilupian fazhan shi*, 374–77.
51. Zhu Rikun and Wan Xiaogang, eds., *Duli jilu: duihua Zhongguo xinrui daoyan* (Independent records: interviews with Chinese cutting-edge directors) (Beijing: Zhongguo minzu sheying yishu chubanshe, 2005), 1. To distinguish it from three other types of documentary in the 1990s, namely "mainstream," "elite" (*jingying*), and "populist" (*dazhong*), Zhang Tongdao defines "marginal documentary" as an underground production focused on marginalized people and expressive of non-mainstream — albeit not anti-mainstream — ideology; see Shan Wanli, ed., *Jilu dianying wenxian*, 842–43.
52. For further elaboration, see Yingjin Zhang, "My Camera Doesn't Lie? Questions of Truth, Subjectivity, and Audience in Chinese Independent Film and Video," in Pickowicz and Zhang, eds., *From Underground to Independent*, 23–45.
53. Fang Fang, *Zhongguo jilupian fazhan shi*, 276.

54. Fenghuang weishi (Phoenix Satellite TV), ed., *DV xin shidai 1* (DV New Generation 1) (Beijing: Zhongguo qingnian chubanshe, 2003), i–iii, 1–8.

55. Apart from publications mentioned above, see relevant sections in Cheng Qingsong, *Kandejian de yingxiang* (Films permitted for watching) (Shanghai: Sanlian shudian, 2004), and Zhang Xianmin and Zhang Yaxuan, *Yigeren de yingxiang: DV wanquan shouce* (All about DV: works, creation, comments) (Beijing: Zhongguo qingnian chubanshe, 2003).

CHAPTER 9

1. We will explain Zhang Yimou's usage of the term later in the chapter.

2. Tony Rayns, "Screening China," *Sight and Sound*, July 1991, 26–28.

3. Tony Rayns, *King of the Children and the New Chinese Cinema* (Boston: Faber and Faber, 1989).

4. Rayns, *King of the Children and the New Chinese Cinema*.

5. Bai Jingsheng, "Throwing away the Walking Stick of Drama," in George Semsel et al., eds., *Chinese Film Theory* (New York: Praeger, 1990), 5–9, quote from 8.

6. See, for instance, Chen Muo's discussion in his book, *On Zhang Yimou* (Beijing: China Film Press, 1995).

7. Zhang Yimou, "Sing a Song of Life," *Dangdai Dianying*, 13.2 (1988): 81–88.

8. Zhang rejects the categorization of cinema into mainstream and New Wave and considers *Red Sorghum* a bastard film. See Zhang Yimou, "Sing a Song of Life," *Dangdai Dianying*, 13.2 (1988): 81–88. See also Luo Xueying, *Red Sorghum: The Real Zhang Yimou* (Beijing: China Film Press, 1988), 49.

9. *Red Sorghum* was a major box-office success in China. Tickets in Beijing were twice as expensive as the average urban price and there was a brisk trade in black market tickets. See Chris Berry's article "Market Forces: China's 'Fifth Generation' Faces the Bottom Line," in Chris Berry, ed., *Perspectives on Chinese Cinema* (London: BFI, 1991), 114–24.

10. The Chinese film critic Chen Muo, in his somewhat broad categorization of Chinese cinema, suggests that commercial cinema naturally comprises government-sponsored picture, art picture, and entertainment picture. See Chen Muo, *Anthology of Chen Muo's Film Criticism* (Nanchang: Baihuazhou Art and Literature Press, 1997).

11. See Luo Xueying's interview with Zhang Yimou in her book, *Red Sorghum: The Real Zhang Yimou* (Beijing: China Film Press, 1988), 62–63. The failure of *Codename Cougar* would unfortunately delay such an aspiration for another ten years — Zhang did not make another contemporary urban film until 1997 with his comedy debut *Keep Cool*.

12. When Zhang started making the film, the relationship between the Mainland and Taiwan was decent enough to provide some official Mainland encouragement and support for his efforts. While he was making the film the cross-straits relationship soured so he went through the motions to complete what he knew would not be a successful film. This anecdote was relayed to me by Stanley Rosen who asked about the film when he interviewed Zhang Yimou years ago.

13. Berry, "Market Forces," 114–24.

14. See Zhang's own words in Robert Sklar's article, "Becoming a Part of Life: An Interview with Zhang Yimou," *Cineaste*, 2.1 (1993): 28.

15. Xu Lin and Zhang Hong, "The Crisis of Literature and the Humanist Spirit," *Shanghai Wenxue*, 6 (1993): 65–66.

16. See Ying Xiong, "*On Shanghai Triad*," *Dianying yishu*, 248.3 (1996): 8–10.

17. See Tony Rayns, "To Live," *Sight and Sound*, October 1994. Zhang's disadvantaged family background might partially explain his greater disdain for elitism and his easier transition from New Wave to post–New Wave than the Fifth Generation's other two major figures Chen Kaige and Tian Zhuangzhuang who came from privileged families.

18. Chen Yan, "Zhang Yimou on *Keep Cool*," *Dianying yishu*, 256.5 (1997): 66–67.

19. Yan, "On *Keep Cool*," 66–67.

20. Mette Hjort, "Danish Cinema and the Politics of Recognition," in David Bordwell and Noel Carroll, eds., *Post-theory: Reconstructing Film Studies* (Madison: University of Wisconsin, 1996), 528–31.

21. See Luo Xueying's interview with Zhang Yimou in her book *Red Sorghum: The Real Zhang Yimou* (Beijing: China Film Press, 1988), 51.

22. Luo, *Red Sorghum*, 51.

23. Chen, *On Zhang Yimou*, 295.

24. See Robert Sklar's article "Becoming a Part of Life: An Interview with Zhang Yimou," *Cineaste*, 2.1 (Winter 1993): 28.

25. See the domestic picture box-office chart of 1997 compiled by *Dianying yishu*, 260.3 (1998): 1–2.

26. For detailed discussions on Chinese New Year film see my essay in the same book, "New Year Film as Chinese Blockbuster: From Feng Xiaogang's Contemporary Urban Comedy to Zhang Yimou's Period Drama."

27. Zhao Yuezhi traces the first official use of the term "soft power" to the "Report of the Party's 16th National Congress" (2002), in a section titled "Cultural Construction and Cultural System Reform." The document, Zhao reports, called for "the development of 'comprehensive national strength' (*zonghe guoli*) — that is, both economic power and cultural or 'soft power' (*ruan shili*) in a competitive global context." Zhao Yuezhi, *Communication in China* (New York: Rowman & Littlefield, 2008), 108–9.

28. Zhao Yuezhi, *Communication in China* (New York: Rowman & Littlefield, 2008), 164. See also Evans Chan, "Zhang Yimou's Hero — The Temptations of Fascism," www.filmint.nu/netonly/eng/heroevanschan.htm (cited in Zhao, *Communication in China*).

29. For a brilliant alternative reading, see Shelly Kraicer's review online at http://www.chinesecinemas.org/hero.html.

30. For a good account, see Gina Marchetti's review of a Dai Jinhua's book *Cinema and Desire*, online at: http://www.ejumpcut.org/archive/jc46.2003/marchetti.dai/index.html.

31. Tian came from a privileged family. His father served as the head of Beijing Studio, and his mother the head of the Children's Studio. Both of them were well-accomplished film actors.

32. Howard Feinstein, "Filmmaker Tian Zhuangzhuang Cuts Loose with 'Kite'," *New York Newsday*, April 10, 1994, E2.

33. Wang Zhihong, "Tian Zhuangzhuang with Messier Hair," *Zhongguo yinmu*, 3 (1996): 20–21.

34. See Xia Shangzhou's interview with Tian published in *Dianying yishu*, 266.3 (1999): 17–20.

35. See an interview with Tian conducted in 1994 by Philip Lopate, "Odd Man Out: Tian Zhuangzhuang," *Film Comment*, 30.4 (1994): 60.

36. Lopate, *Odd Man Out*, 60. I include a few relevant passages here:

Tian: "But after I finished *Horse Thief*, there was a period when I didn't make any films; this had a lot to do with censorship issues. Anyway, I began to question my own films. I realized the kind of film I was making before could only create sensations in people by evoking a mood. At the time I was quite happy with this. But I gradually realized that there was something emotional lacking in *Horse Thief*. Perhaps it was the portrayal of humans — the humans are too simplified. See, when I first started making films I was interested in the ideological problems of China as a whole. Gradually I became more interested in the people surrounding me and their psychology."

Lopate: "But, for instance, the camera seems more distanced in *Horse Thief*, and there are more shots that seem there just for their formal beauty. It's a more formalistic work. In *Blue Kite*, the camera is closer, more middle-distance, and every shot advances the story. Would you care to comment?"

Tian: "I can only say I agree with all the things you've said so far. It was only after I made *Horse Thief* that I came to an understanding of this problem. It's not a problem of myself only, but my whole generation. We were pursuing something that was on the surface. We were formalists. Looking for formal beauty. A beautiful story, a beautiful environment, very beautiful colors, beautiful sound. Almost like an exhibition."

37. Hong Kong made *Concubine* its entry for the foreign film Oscar when the Chinese government refused to allow it to enter the competition.
38. Nicholas D. Kristof, "China Bans One of Its Own Films; Cannes Festival Gave It Top Prize," *The New York Times*, August 4, 1993, E4.
39. For a detailed report on the making of *Concubine* see Jianying Zha, *China Pop* (New York: The New Press, 1995).
40. Zha, *China Pop*.
41. Michael Dwyer, "Silent Movies," *The Irish Times*, January 29, 1994, E5.
42. See the report "Chinese Revolution," *World Press Review*, March 1993, 47.
43. The last change was condemned by the critics in Hong Kong as mainland China's usual denial of the colony's location as a space of new order. Yet being from Taiwan where traditional Chinese culture was even more carefully preserved than on the Mainland, I suspect that Hsu would be particularly concerned with Hong Kong's subject position under the British shadow.
44. John Stanley, "Director Chen Kaige's Big Step," *The San Francisco Chronicle*, October 24, 1993, E2.
45. See "Chinese Revolution," *World Press Review*, March 1993, 47.
46. Zha, *China Pop*.
47. Easter Yau, "Yellow Earth: Western Analysis and a Non-Western Text," in Chris Berry, ed., *Perspectives on Chinese Cinema* (London: BFI, 1991), 62–79.
48. See Stephen Holden, "A Bloodthirsty Unification of China," *The New York Times*, December 17, 1999, E2.
49. Michael Porter, *The Competitive Advantage of Nations* (New York: Free Press, 1990).
50. Hjort, *Danish Cinema*, 520–32.

51. For a discussion of Zhang's blockbuster turn see Ying Zhu's chapter in this volume, "New Year Film as Chinese Blockbuster: From Feng Xiaogang's Contemporary Urban Comedy to Zhang Yimou's Period Drama."

CHAPTER 10

1. "Butterfly" literature was a form of popular literature in the early Republican years, and can encompass such sub-genres as romances, detective, and martial arts stories. From 1921 to 1931, that is, almost all the years before the emergence of leftist films, many of the Chinese films made involved Butterfly writers. One Butterfly writer, Bao Tianxiao, wrote screenplays and novels at the same time. He was hired by Mingxing studio as a scriptwriter in 1924, and wrote seven screenplays.

2. One significant exception was *Spring Silkworms* (*Chuncan*, 1933), based on a story newly published by Mao Dun and developed into a screenplay by Xia Yan. This was the first time that a literary work in the May Fourth tradition was adapted.

3. Examples include *Mother and Son* (*Mu yu zi*, 1947), based on Russian playwright Alexander Ostrovsky's play *Innocent as Charged*, and *Night Inn* (*Yedian*, 1947), based on Maxim Gorky's play *The Lower Depths*. Both films tell Chinese versions of the Russian stories.

4. See Wang Taorui, "Beiyingchang wenxue mingzhu gaibian gaiping" (Overview of the accomplishment of the Beijing Film Studio's adaptation of literary classics), *Dianying yishu*, 11 (2005): 85–93.

5. The practice of injecting "correct" and "modern" messages had already been prevalent before 1949 when filmmakers dealt with traditional Chinese literature.

6. *Little Flower* (*Xiaohua*, 1979) is a good case of extracting lyrical elements from a Cultural Revolution novel written in 1972.

7. See Ying Zhu, "Cinematic Modernization and Chinese Cinema's First Art Wave," *Quarterly Review of Film and Video*, 18.4 (2001): 451–71. These new films have simple plots, sparse dialogues, and rich visual images, while traditional Chinese films often rely heavily on dialogues.

8. Mo Yan, *Hong gaoliang* (Red Sorghum) (Beijing: Zuojia chubanshe, 1995), 39.

9. See Rey Chow, *Primitive Passions: Visuality, Sexuality, Ethnography, and Contemporary Chinese Cinema* (New York: Columbia University Press, 1995). Chow links film with other means of "exhibiting ethnic culture," saying that film "therefore serves as a major instrument for making the visuality of exotic cultures part of our everyday mediatized experience around the globe. Because of this, film belongs as much with disciplines such as anthropology and ethnography as it does with literature, women's studies, sociology, and media studies" (27).

10. Yingjin Zhang, *Screening China: Critical Interventions, Cinematic Reconfigurations, and the Transnational Imaginary in Contemporary Chinese Cinema* (Ann Arbor, Mich.: University of Michigan Press, 2002), 227.

11. Wendy Larson, "Zhang Yimou: Inter/National Aesthetics and Erotics," in Soren Clausen, Roy Starrs, and Anne Wedell-Wedelsborg, eds., *Cultural Encounters: China, Japan, and the West: Essays Commemorating 25 Years of East Asian Studies at the University of Aarhus* (Aarhus, Denmark: Aarhus University Press, 1995), 227.

12. Liu Heng, *Fuxi, Fuxi*, collected in his *Gouri de liangshi* (The God-damned grain) (Beijing: Zuojia chubanshe, 1993), 16, 108.

13. Zhang Yimou, interview, "Wei Zhongguo dianying zouxiang shijie pulu" (Pave the

road for Chinese films to go to the world), in *Zhang Yimou* (Changsha: Hunan wenyi chubanshe, 1996), 386.

14. Quoted from Wendy Larson, "Displacing the Political: Zhang Yimou's *To Live* and the Field of Film," in Michel Hockx, ed., *The Literary Field of Twentieth-Century China* (Honolulu, Hawaii: University of Hawaii Press, 1999), 193.

15. Rey Chow, *Ethics after Idealism* (Bloomington, Ind.: Indiana University Press, 1998), 124.

16. Mayfair Yang, "Of Gender, State, Censorship, and Overseas Capital: An Interview with Chinese Director Zhang Yimou," in Frances Gateward, ed., *Zhang Yimou: Interviews* (Jackson, Miss.: University Press of Mississippi, 2001), 40.

17. Zhang Ming, ed., *Yu Zhang Yimou duihua* (Talks with Zhang Yimou) (Beijing: Zhongguo dianying chubanshe, 2004), 49.

18. See ibid., *Yu Zhang Yimou duihua*, 149.

CHAPTER 11

1. Shuqin Cui, "Working from the Margins: Urban Cinema and Independent Directors in Contemporary China," *Post Script*, 20, nos. 2–3 (Winter/Spring/Summer): 77

2. Gu Changwei, who served as cinematographer for most of Zhang Yimou's films, cannot be labeled new generation. However, *Peacock*, Gu's debut as a director, tells a coming-of-age story.

3. Wang Xiaoshuai, Jia Zhangke, and Zhang Yang, together with other young directors, are the leading figures of the new generation. They embody a similar historical past, but their films, especially their early ones, reflect personal marks and different styles. The recent return to historical investigation indicates a collective posture of returning to the center.

4. Janet Wolff, "The Global and the Specific: Reconciling Conflicting Theories of Culture," in Anthony D. King, ed., *Culture, Globalization and the World-System: Contemporary Conditions for the Representation of Identity* (Minneapolis: University of Minnesota Press, 1997), 161.

5. Stuart Hall, "The Local and the Global: Globalization and Ethnicity," in Anthony D. King, ed., *Culture, Globalization and the World-System: Contemporary Conditions for the Representation of Identity* (Minneapolis: University of Minnesota Press, 1997), 34.

6. Kevin Lee, "Jia Zhangke," *Senses of Cinema* (February 2003), http://www.sensesofcinema.com/contents/directors/03/jia.html.

7. Daniel Jewesbury, "tourist:pioneer:hybrid: London Bridge, the Mirage in the Arizona Desert," in David Crouch and Nina Lübbren, eds., *Visual Culture and Tourism* (Oxford and New York: Berg, 2003), 229.

8. Ibid., 229.

9. David David and Nina Lübbren, "Introduction," in Crouch and Lübbren, eds., *Visual Culture and Tourism*, 11.

10. Manohla Dargis, "Caged in Disney in Beijing, Yearning for a Better Life," *The New York Times*, October 11, 2004, B5.

11. The character introduces himself as "Little Sister" and is addressed as such. The explanation for why the young man carries a girl's name lies not simply in the fact that his mother expected a girl; the name also reflects the migrant's loss of identity.

12. Eric Faden, "The Cyberfilm: Hollywood and Computer Technology," *Strategies*, 14.1 (2001): 79.

13. "Cyberspace" refers to the various information resources available through computer networks and the Internet. It also includes "communities" electronically connected via such resources. It distinguishes the digital, or computer-based, world from the physical world.

14. Shelly Kraicer, "Review of Jia Zhangke's Platform," *CineAction*, 54 (Spring 2001): 67.

15. Shuqin Cui, *Women through the Lens: Gender and Nation in a Century of Chinese Cinema* (Honolulu: University of Hawaii Press, 2003), 51.

16. Kang Liu, Kang, *Globalization and Cultural Trends in China* (Honolulu: University of Hawaii Press, 2004), 78.

17. Hilary Lapedis, "Popping the Question: The Function and Effect of Popular Music in Cinema" *Popular Music*, 18.3 (October 1999): 370.

18. *Little Flower* (*Xiaohua*, 1979) is a sappy drama that integrates sentiment with a war theme.

19. Raj Kapoor's *Awaara* (1951), known as *Liulangzhe* (*Drifter*) in Chinese, was a popular foreign film in Mao's China. Its melodramatic narrative and song/dance numbers exposed ordinary Chinese to an Indian or Bollywood imagination. Viewers from that generation still hum the theme song from *Awaara*.

20. Jacques Attali, *Noise: The Political Economy of Music*, trans. Brian Massumi. (Minneapolis: University of Minnesota Press, 1985), 3.

21. Thomas Swiss, John Sloop, and Andrew Herman, eds., *Mapping the Beat: Popular Music and Contemporary Theory* (Malden, MA: Blackwell, 1998), 18–19.

22. Michel Chion, *Audio-Vision: Sound on Screen*, trans. Claudia Gorbman (New York: Columbia University Press, 1990), 38.

23. The "Hainan Incident" refers to the collision between a U.S. EP-3 (an intelligence-gathering aircraft) and a Chinese F-8 military jet over Hainan, China, in 2001. The incident raised tensions between the two governments on the issue of international security and the use of air space.

24. Manuel Castells, *The Network Society* (Oxford: Blackwell, 1996), 6.

25. Michael Taussig, *Mimesis and Alterity* (New York: Routledge, 1993), 16.

26. The Three Gorges Dam Project has remained a socio-political controversy and enormous economic undertaking. The project, imagined almost a century ago and idealized under Mao's regime, will complete construction by 2009. The ultimate consequences include the forced migration of millions of people and the flooding of hundreds of towns and villages as well as historical and cultural sites. For further reading, please see Deirdre Chetham, *Before the Deluge: The Vanishing World of the Yangtze's Three Gorges* (a personal account) and Dai Qing, *The River Dragon Has Come? The Three Gorges Dam and the Fate of China's Yangtze River and Its People* (a collection of essays by Chinese scholars).

27. Liu Xiaodong, an oil painting artist and faculty member at the Central Academy of Fine Art, has created series of art works on the subject of Three Gorges Migrants. The pieces that Jia Zhangke documented in *Dong* and cited in *Still Life* are part of the field work titled "Wenchuang" (Warm bed). The first part focuses on the migrants in the Gorges and the second centers on a group of sex workers in Thailand. Liu appeared as the lead character in Wang Xiaoshuai's directorial debut, *The Days*, 1993.

28. Shelly Kricer, "China's Wasteland: Jia Zhangke's *Still Life*," *Cinema Scope* (2007): 29.

29. Robin Visser, "Spaces of Disappearance: Aesthetic Responses to Contemporary Beijing City Planning," *Journal of Contemporary China*, 13–39 (May 2004): 277.

30. Hung Wu, *Transience: Chinese Experimental Art at the End of the Twentieth Century* (Chicago, Illinois: The David and Alfred Smart Museum of Art & The University of Chicago Press, 1999), 80.

31. Jia Zhangke's documentary *Dong* captured a heartbreaking sequence, where Liu Xiaodong travels to a village to locate the family of a migrant who has been killed by falling rubble. After viewing the documentary, it is troubling to see how Jia uses the image of the dead body for his "created hero."

32. Media and print sources in China responded immediately to the exhibition of Liu Xiaodong's works and the screening of Jia Zhangke's films on the Three Gorges. Most of the discussions centered on the significance of the works. For various critical comments and a discussion of new realism, please see Zhu Zhu, "The Three Gorges: Myth and Elegiac of the New Realism," http://news.artron.net, 2–27, 2007.

Chapter 12

1. The Hong Kong film, *Kung Fu Hustle* (Stephen Chow, 2004), came in second in box-office return. See the blockbuster chart in *Dianying yishu*, 3 (2005).

2. For a detailed discussion of the evolution of Hollywood blockbuster films see Steve Neale, "Hollywood Blockbusters: Historical Dimensions," in Julian Stringer, ed., *Movie Blockbusters* (London: Routledge, 2003).

3. Justin Wyatt, *High Concept: Movies and Marketing in Hollywood* (Austin: University of Texas Press, 1994)

4. The opening day of the New Year season has been gradually pushed back from Christmas Eve to early December to take advantage of many group screening activities paid for by big companies as part of their pre–New Year employee's appreciation efforts.

5. In a similar fashion, Hollywood event films are distinct for the simple reason that they often announce themselves as such.

6. Wyatt, *High Concept*, 165.

7. On a budget of $1.3 million, the film is a domestic hit, taking in 43 million RMB ($5.3 million) at the box office, the second-highest grossing film in China at the time.

8. The film reaped in 50,000,000 yuan at the box office.

9. The film broke box-office records and raked in $6.4 million (a large number by Chinese standards), finishing ahead of the hit Hong Kong movie *Infernal Affairs III* at the box office.

10. For a detailed discussion of "metacinema" in Feng Xiaogang's film practice see Jason McGrath, "Metacinema for the Masses: Three Films by Feng Xiaogang," *Modern Chinese Literature and Culture*, 17.2 (2005): 90–132. See also Carlos Rojas's essay, "A Tale of Two Emperors: Mimicry and Mimesis in Two New Year's Films from China and Hong Kong," *CineAction*, 60 (2005): 2–9.

11. Five other New Year films of the same year including Zhang Yimou's *Happy Times* have all absorbed private financing.

12. See Wendy Kan, "Big Shot; Doesn't Win Over Locals," *Variety*, 387.2 (May 2002): 8.

13. Robert McKee, *Story: Substance, Structure, Style, and the Principles of Screenwriting* (New York: Regan Books, 1997), 43–47.

14. Stanley Rosen observed the same pattern in Feng's cinematic evolution in his chapter in the same volume, "Chinese Cinema's International Market."

15. The film set all-time box-office records in Beijing, earning more than $1.23 million in receipts. Only *Titanic* outperformed the film in Beijing.

16. Guanping Wu, "I Am a People's Filmmaker" (Woshi yige shimin daoyan), *Film Arts*, 2 (April 2000): 44–48.

17. The Chinese have yet to operate in the "supersystem" of multimedia marketing that spins a web of commercial exploitation around contemporary movie franchises.

18. "Screening date for film '*No Thieves*' scheduled," *Shenzhen Daily*, November 8, 2004, http://english.sohu.com/20041108/n222880065.shtml (accessed June 5, 2007).

19. According to Geng Yuejin, vice president of Huayi, the film's distributor, the movie had a four-day gross of 5 million yuan (US$600,000) in Beijing alone. In Shanghai and Sichuan, box-office receipts tripled that of *Cell Phone* for the same period. Even in Hong Kong, the daily tally has reached HK$400,000, which is a record for this season.

20. Erwei Li, "Jump Start the Chinese Martial Arts Blockbuster," *Face to Face with Zhang Yimou* (*Zimian Zhang Yimou*) (Beijing: Economic Daily Press, 2002).

21. For a detailed discussion on Zhang Yimou's cinematic transition see Ying Zhu, *Chinese Cinema during the Era of Reform: The Ingenuity of the System* (Praeger, 2003), 39–70.

22. "Zhang Yimou on '*House of Flying Daggers*'," *Future Movies*, http://www.futuremovies. co.uk/filmmaking.asp?ID=100 (accessed June 5, 2007).

23. Weiping Zhang, "Can *House of the Flying Daggers* Surpass *Hero*?" *Popular Cinema*, 6 (2004): 34–35.

24. Li, *Jump Start*, 323–24.

25. Leilei Jia, "Market Hero, Black Martial Art" (*Shichang yingxiong, heisewuxiao*), *The History of the Chinese Martial Arts Films* (*Zhongguo wuxiaodianyingshi*) (Beijing: Culture and Art Publishing House, 2005), 188–89.

26. Jia, "Market Hero," 188.

27. *Night Feast* is also translated as *The Banquet*. It lost its bid to Zhang Yimou's new historical epic *Curse of the Golden Flower* as the Oscar contender from the PRC. Instead, Feng's picture is selected to enter the 2007 Oscar competition as a Hong Kong film.

28. Xiaohua Sun, "Zhang stabbed by his '*Dagger*'," *China Daily*, August 28, 2004, www. chinadaily.com.cn/english/doc/2004-08/28/content_369678.htm (accessed June 5, 2007). (The survey also found that Feng Xiaogang's films are genuinely liked by many.) Against the overwhelming criticism, Tong Gang, director of the Film Administration Bureau, was vocal in his praise for *Daggers*, saying that in the fierce competition with imported blockbusters, the movie safeguards the dignity of locally made movies and shows the confidence and strength needed for locally made movies to enter the international market. Tong adds that the media should be more tolerant and create a favorable media environment for movies like *Daggers*. Zhang has been on good terms with the government.

29. As I commented in my earlier work on Zhang Yimou's film career, Chinese filmmakers are more attuned to the critical reception of their films than their Western counterparts. For a detailed discussion see Ying Zhu, *Chinese Cinema during the Era of Reform: The Ingenuity of the System* (Praeger, 2003).

30. Attentive to criticism as usual, Zhang focused on a good story and good screenplay for his most recent film, *Curse of the Golden Flower*, which came out to critical and popular acclaim in September 2006 when the film had a limited screening in Beijing to qualify as an Oscar contender.

31. Jason McGrath argues that the metacinematic elements contributed to the popular appeal of Feng's films. McGrath, *Metacinema*, 90–132.

32. Liz Shackleton, "Feng Xiaogang's Banquet news," *Screendaily*, July 18, 2005, http://www.screendaily.com/story.asp?storyid=22784 (accessed June 5, 2007).

33. It is reported that Charles Rivkin, the newly appointed chief executive officer of the award-winning U.S. animation studio Wild Brain, Inc. wrote to the Chinese State Administration of Radio, Film, and Television, expressing his dismay that China's submissions to the Oscars for the past five years were historical and martial arts dramas. See the Chinese online report, "Sprint towards Oscar," Sina.com, http://ent.sina.com.cn/m/c/2006-09-28/01301266335.html.

Filmography

English Title	Chinese	Pin Yin	Director's Name	Date
Three Monks	三个和尚	*San ge he shang*	Ah Da	1980
Ding Jun Mountain	定军山	*Ding Jun Sha*	An Zhanjun	1905
Spring River Flows East, The	一江春水向东流	*Yi jiang chunshui xiang dong liu*	Cai Chusheng	1947
Dream of the Emperor, The	皇帝梦	*Huang di meng*	Chen Bo'er	1947
Emperor and the Assassin, The	荆轲刺秦王	*Jinke ci qinwang*	Chen Kaige	1998
Farewell My Concubine	霸王别姬	*Bawang bieji*	Chen Kaige	1993
King of the Children	孩子王	*Haizi wang*	Chen Kaige	1987
Life on a String	边走边唱	*Bian zou, bian chang*	Chen Kaige	1990
Temptress Moon	风月	*Feng yue*	Chen Kaige	1996
Together	和你在一起	*He ni zai yiqi*	Chen Kaige	2003
Yellow Earth	黄土地	*Huang tudi*	Chen Kaige	1984
Snake Boy, The	上海男孩	*Shanghai nanhai*	Michelle Chen	2001

* Thanks to Katherine Chu for compiling the Filmography, Bibliography, and Index.

English Title	Chinese	Pin Yin	Director's Name	Date
Red Lantern, The	红灯记	*Hongdeng ji*	Cheng Yin	1970
Fighting North and South	南征北战	*Nanzheng beizhan*	Cheng Yin & Tang Xiaodan	1952
Fighting North and South	南征北战	*Nanzheng beizhan*	Cheng Ying & Wang Yan	1974
Kung Fu Hustle	功夫	*Gong fu*	Stephen Chow	2004
East Is Red, The	东方红	*Dongfang hong*	Collectively Directed	1965
Regrets	失足恨	*Shizu hen*	Dan Duyu	1932
Along the Railroad	铁路沿线	*Tielu yanxian*	Du Haibin	2000
No. 16 South Barkhor Street	八廓南街16号	*Bakuo nanjie 16 hao*	Duan Jinchuan	1997
Secret of My Success, The	拎起大舌头	*Linqi da shetou*	Duan Jinchuan	2002
Catch the Turtle in a Jar	瓮中捉鳖	*Weng zhong zhuo bie*	Fang Ming	1948
Spring in a Small Town	小城之春	*Xiao cheng zhi chun*	Fei Mu	1948
Assembly	集结号	*Ji jie hao*	Feng Xiaogang	2007
Banquet, The	夜宴	*Ye yan*	Feng Xiaogang	2006
Be There or Be Square	不见不散	*Bujian busan*	Feng Xiaogang	1998
Big Shot's Funeral	大腕	*Dawan*	Feng Xiaogang	2001
Cell Phone	手机	*Shouji*	Feng Xiaogang	2003
If You Are the One	非诚勿扰	*Feichang wurao*	Feng Xiaogang	2008
Party A, Party B	甲方乙方	*Jiafang yifang*	Feng Xiaogang	1997
Sigh, A	一声叹息	*Yisheng tanxi*	Feng Xiaogang	2000
Sorry Baby	没完没了	*Meiwan meiliao*	Feng Xiaogang	1999
World Without Thieves, A	天下无贼	*Tianxia wuzei*	Feng Xiaogang	2004
Fiery Years, The	火红的年代	*Huohong de niandai*	Fu Chaowu, Sun Yongping & Yu Zhongying	1974

English Title	Chinese	Pin Yin	Director's Name	Date
Zhou Enlai and Diplomatic Storms	周恩来外交风云	*Zhou Enlai waijiao fengyun*	Fu Hongxing	1997
Big Tree Village	大树乡	*Dashu xiang*	Hao Zhiqiang	1993
Warriors of Heaven and Earth	天地英雄	*Tiandi yingxiong*	He Ping	2003
Searching for Lin Zhao's Soul	寻找林昭的灵魂	*Xunzhao Lin Zhao de lingyun*	Hu Jie	2004
Snipe-Clam Grapple	鹬蚌相争	*Yu bang xiang zheng*	Hu Jinqing	1983
Leave Me Alone	我不要你管	*Wo buyao ni guan*	Hu Shu	2001
King of Lanling, The	兰陵王	*Lanling wang*	Hu Xuehua	1995
Dog Invites Guests	狗请客	*Gou qing ke*	Huang Wennong	1924
Postmen in the Mountains	那山那人那狗	*Na shan, na ren, na gou*	Huo Jianqi	1999
Platform	站台	*Zhantai*	Jia Zhangke	2000
Still Life	三峡好人	*Sanxia haoren*	Jia Zhangke	2006
The Unknown Pleasure	任逍遥	*Ren xiaoyao*	Jia Zhangke	2002
World, The	世界	*Shijie*	Jia Zhangke	2004
Xiaowu	小武	*Xiaowu*	Jia Zhangke	1997
Devils on the Doorstep	鬼子来了	*Gui zi lai le*	Jiang Wen	2000
In the Heat of the Sun	阳光火灿烂的日子	*Yangguang canlan de rizi*	Jiang Wen	1994
Other Bank, The	彼岸	*Bi an*	Jiang Yue	1995
This Happy Life	幸福生活	*Xinfu shenghuo*	Jiang Yue	2002
Great Earthquake, The	大地震	*Da dizhen*	Jiang Yue & Wen Pulin	1988
There's a Strong Wind in Beijing	北京的风很大	*Beijing de feng henda*	Ju Anqi	2000

English Title	Chinese	Pin Yin	Director's Name	Date
Join the Army	当兵	*Dangbing*	Kang Jianning	2000
Infernal Affairs	无间道	*Wu jian dao*	Andrew Lau & Alan Mak Xiu-fai	2002
Eat Drink Man Woman	饮食男女	*Yin shi nan nü*	Ang Lee	1994
Lust, Caution	色·戒	*Se, Jie*	Ang Lee	2007
Wedding Banquet, The	囍宴	*Xi yan*	Ang Lee	1993
Crouching Tiger, Hidden Dragon	卧虎藏龙	*Wohu canglong*	Ang Lee	2000
Dancing with Myself	和自己跳舞	*He ziji tiaowu*	Li Hong	2002
Out of Phoenix Bridge	回到凤凰桥	*Huidao Fenghuangqiao*	Li Hong	1997
Sparkling Red Star	闪闪的红星	*Shanshan de hongxing*	Li Jun & Li Ang	1974
Stolen Life	生死劫	*Sheng si jie*	Li Shaohong	2005
Counterattack	反击	*Fanji*	Li Wenhua	1976
Blind Shaft	盲井	*Mang jing*	Li Yang	2003
Lost in Beijing	苹果	*Pingguo*	Li Yu	2006
Green Pine Ridge	青松岭	*Qingsong ling*	Liu Guoquan & Jiang Shusen	1973
Summer Palace	颐和园	*Yi he yuan*	Lou Ye	2006
Kekexili: Mountain Patrol	可可西里	*Kekexili*	Lu Chuan	2004
Night Pearl	夜明珠	*Ye ming zhu*	Man zhou ying hua xie hui	1942
56 Years History	五十六年痛史	*Wu shi liu nian tong shi*	Nanjing zhong yang da xue dian hua jiao yu xi	1935
San Yuan Li	三元里	*San Yuan Li*	Ou Ning & Cao Fei	2003
Generation After Generation Never Stop	生生不息	*Sheng sheng bu xi*	Qian Jiajun	1942

English Title	Chinese	Pin Yin	Director's Name	Date
Happy Peasants	农家乐	*Nong jia le*	Qian Jiajun	1940
Hunger of the Old, Stupid Dog, The	老苯狗饿肚记	*Lao ben gou e du ji*	Qian Jiajun	1941
People and Two Hands	人与双手	*Ren yu shuang shou*	Qian Jiajun	1947
Spotted Deer	九色鹿	*Jiu se lu*	Qian Jiajun & Dai Tielang	1981
Why Crows Are Black	乌鸦为什么是黑的	*Wu ya wei shen mo shi hei de*	Qian Jiajun & Li Keruo	1955
Haixia	海霞	*Haixia*	Qian Jiang, Chen Huai'ai & Wang Haowei	1975
Red Army Bridge	红军桥	*Hong jun qiao*	Qian Yunda	1964
Tunnel Warfare	地道战	*Didao zhan*	Ren Xudong	1965
Fearless	霍元甲	*Huo Yuanjia*	Ronny Yu	2006
Myriad of Lights	万家灯火	*Wanjia denghuo*	Shen Fu	1948
Tiananmen	天安门	*Tiananmen*	Shi Jian	1992
Wild Rose	野玫瑰	*Ye meigui*	Sun Yu	1932
White Gold Dragon	白金龙	*Bai Jinlong*	Tang Xiaodan	1933
Mine Warfare	地雷战	*Dilei zhan*	Tang Yingqi, Xu Da & Wu Jianhai	1962
Conceited General, The	骄傲的将军	*Jiao ao de jiang jun*	Te Wei & Li Keruo	1956
Where Is Mama?	小蝌蚪找妈妈	*Xiao ke dou zhao mama*	Te Wei & Qian Jiajun	1960
Feeling from Mountain and Water	山水情	*Shan shui qing*	Te Wei, Yan Shanchun & Ma Kexuan	1988
Three Modern Women	三个摩登女性	*San ge modeng nüxing*	Tian Han	1933
Blue Kite, The	蓝风筝	*Lan fengzheng*	Tian Zhuangzhuang	1993
Go Master, The	吴清源	*Wu Qingyuan*	Tian Zhuangzhuang	2006
Horse Thief	盗马贼	*Daoma zei*	Tian Zhuangzhuang	1986

English Title	Chinese	Pin Yin	Director's Name	Date
Imperial Eunuch, The	大太监李莲英	*Da taijian Li Lianying*	Tian Zhuangzhuang	1990
On the Hunting Ground	猎场札撒	*Liechang zhasa*	Tian Zhuangzhuang	1985
Rock 'n' Roll Youth	摇滚青年	*Yaogun qingnian*	Tian Zhuangzhuang	1988
Springtime in a Small Town	小城之春	*Xiaocheng zhi chun*	Tian Zhuangzhuang	2002
Tea-Horse Road Series: Delamu	德拉姆	*Delamu*	Tian Zhuangzhuang	2004
Chairman Mao Inspects the Red Guards	毛主席检阅红卫兵	*Mao zhuxi jianyue Hongweibing*	Unknown	1966
Good Fate	镜花缘	*Jing hua yuan*	Unknown	1925
Great Wall, The	望长城	*Wang changcheng*	Unknown	1991
Speaking of the Yangtze River	话说长江	*Huashuo Changjiang*	Unknown	1983
Young Boy's Adventure	少年奇遇	*Shao nian qi yu*	Unknown	1924–25
Go to the Front	上前线	*Shang qian xian*	Wan Chaochen	1938
Little Hero, The	小英雄	*Xiao ying xiong*	Wan Chaochen	1953
Wang Laowu Became a Soldier	王老五去当兵	*Wang Laowu qu dang bing*	Wan Chaochen	1938
Zhu Bajie Eats the Watermelon	猪八戒吃西瓜	*Zhu Bajie chi xi gua*	Wan Guchan	1958
Uproar in Heaven I	大闹天宫（上）	*Da nao tian gong*	Wan Laiming & Tang Cheng	1961–64
Havoc in Heaven II	大闹天宫（下）	*Da nao tian gong*	Wan Laiming & Tang Cheng	1961–64
Princess Iron Fan	铁扇公主	*Tie shan gong zhu*	Wan Laiming & Wan Guchan	1941
West of the Tracks	铁西区	*Tiexi qu*	Wang Bing	2001
Fierce Battles: True Records of the Korean War	较量：抗美援朝战争实录	*Jiaoliang: kang Mei yuan Chao zhanzheng shilu*	Wang Jinduo	1995

English Title	Chinese	Pin Yin	Director's Name	Date
Anti-War Slogans Cartoon	抗战标语卡通	*Kang zhan biao yu ka tong*	Wang Laiming, Wang Guchan, Wang Chaochen & Wang Dihuan	1937
Anti-War Songs Collection	抗战歌辑	*Kang zhan ge ji*	Wang Laiming, Wang Guchan, Wang Chaochen & Wang Dihuan	1937
Blood Money	血钱	*Xue qian*	Wang Laiming, Wang Guchan, Wang Chaochen & Wang Dihuan	1934
Citizens, Wake Up	同胞速醒	*Tong bao su xing*	Wang Laiming, Wang Guchan, Wang Chaochen & Wang Dihuan	1931
Dance of the Camel, The	骆驼献舞	*Luo tuo xian wu*	Wang Laiming, Wang Guchan, Wang Chaochen & Wang Dihuan	1935
Dog Detective	狗侦探	*Gou zhen tan*	Wang Laiming, Wang Guchan, Wang Chaochen & Wang Dihuan	1933
Filial Son Kills His Father, A	小子弑父	*Xiaozi shifu*	Wang Laiming, Wang Guchan, Wang Chaochen & Wang Dihuan	1931–36
Leak, The	漏洞	*Lou dong*	Wang Laiming, Wang Guchan, Wang Chaochen & Wang Dihuan	1934
Locusts and Ants	蝗虫与蚂蚁	*Huang chong yu ma yi*	Wang Laiming, Wang Guchan, Wang Chaochen & Wang Dihuan	1931–36
Motherland Is Saved by Aviation, The	航空救国	*Hang kong jiu guo*	Wang Laiming, Wang Guchan, Wang Chaochen & Wang Dihuan	1931–36

English Title	Chinese	Pin Yin	Director's Name	Date
National Sorrow	民族痛史	*Min zu tong shi*	Wang Laiming, Wang Guchan, Wang Chaochen & Wang Dihuan	1936
New Tide	新潮	*Xin chao*	Wang Laiming, Wang Guchan, Wang Chaochen & Wang Dihuan	1936
Sudden Catastrophe	飞夹祸	*Fei lai huo*	Wang Laiming, Wang Guchan, Wang Chaochen & Wang Dihuan	1931–36
Tortoise and Rabbit Have a Race	龟兔赛跑	*Gui tu sai pao*	Wang Laiming, Wang Guchan, Wang Chaochen & Wang Dihuan	1932
Typewriter for Chinese by Shu Zhendong, The	舒振东华文打字机	*Shu Zhendong hua wen da zi ji*	Wang Laiming, Wang Guchan, Wang Chaochen & Wang Dihuan	1922
Tumult in the Studio	大闹画室	*Da nao hua shi*	Wang Laiming, Wang Guchan, Wang Chaochen & Wang Dihuan	1926
United Together	精诚团结	*Jing cheng tuan jie*	Wang Laiming, Wang Guchan, Wang Chaochen & Wang Dihuan	1932
The Year of Chinese Goods	国货年	*Guo huo nian*	Wang Laiming, Wang Guchan, Wang Chaochen & Wang Dihuan	1931–36
Ne Zha Conquers the Dragon King	哪咤闹海	*Ne Zha nao hai*	Wang Shuchen, Yan Dingxian & Ah Da	1979
2046	2046	*2046*	Wong Kar-wai	2004
As Tears Go By	旺角卡门	*Wangjiao kamen*	Wong Kar-wai	1988
Chungking Express	重庆森林	*Chongqing senlin*	Wong Kar-wai	1995
Days of Being Wild	阿飞正传	*Afei zhengzhuan*	Wong Kar-wai	1990

English Title	Chinese	Pin Yin	Director's Name	Date
In the Mood for Love	花样年华	*Huayang nianhua*	Wong Kar-wai	2000
Red Cliff	赤壁	*Chi bi*	John Woo	2008
At Home in the World	四海为家	*Sihai weijia*	Wu Wenguang	1995
Bumming in Beijing: The Last Dreamers	流浪北京：最后的梦想者	*Liulang Beijing: Zuihou de mengxiang zhe*	Wu Wenguang	1990
Chinese People	中国人	*Zhongguoren*	Wu Wenguang	1988
Jiang Hu: Life on the Road	江湖	*Jianghu*	Wu Wenguang	1999
Goddess	神女	*Shennü*	Wu Yonggang	1935
Two Skeletons	浪淘沙	*Langtaosha*	Wu Yonggang	1936
Heroic Sons and Daughters	英雄儿女	*Yingxiong ernü*	Wu Zhaodi	1964
Guerrillas on the Plain	平原游击队	*Pingyuan youjidui*	Wu Zhaodi & Chang Zhenhua	1974
Big Li, Little Li and Old Li	大李、小李和老李	*Da Li, xiao Li he lao Li*	Xie Jin	1962
Boulder Bay	盘石湾	*Panshi wan*	Xie Jin	1976
Girl Basketball Player No. 5	女篮5号	*Nülan wuhao*	Xie Jin	1957
Herdsman, The	牧马人	*Muma ren*	Xie Jin	1981
Hibiscus Town	芙蓉镇	*Furong zhen*	Xie Jin	1986
Legend of Tianyun Mountain	太原山传奇	*Tianyunshan chuanqi*	Xie Jin	1980
Stage Sisters	舞台姐妹	*Wutai jiemei*	Xie Jin	1964
Chunmiao	春苗	*Chumiao*	Xie Jin, Yan Bili & Liang Tingduo	1975
Early Spring in February	早春二月	*Zaochun eryue*	Xie Tieli	1963
Taking Tiger Mountain by Strategy	智取威虎山	*Zhiqu Weihushan*	Xie Tieli	1970
Deer Girl, The	鹿女	*Lu nü*	Yan Dingxian & Lin Wenxiao	1993
Happy New Year	过年	*Guo nian*	Yang Zuotao	1924

English Title	Chinese	Pin Yin	Director's Name	Date
Red Cherry	红樱桃	*Hong yingtao*	Ye Daying	1995
Zhang Side	张思德	*Zhang Side*	Yin Li	2004
Box, The	盒子	*Hezi*	Ying Weiwei	2001
Pioneers, The	创业	*Chuangye*	Yu Yanfu	1974
Clever Duckling, A	聪明的鸭子	*Cong ming de ya zi*	Yu Zheguang	1960
Iron Monkey	铁马骝	*Tie ma liu*	Yuen Woo-ping	1993
One and the Eight, The	一个和八个	*Yige he bage*	Zhang Junzhao	1983
Mulan Joins the Army	木兰从军	*Mulan congjun*	Zhang Shankun	1939
Burning of the Red Lotus Temple	火烧红莲寺	*Huoshao hongliansi*	Zhang Shichuan	1928–30
Codename Cougar	代号美洲豹	*Daihao meizhoubao*	Zhang Yimou	1988
Curse of the Golden Flower	满城尽带黄金甲	*Mancheng jindai huangjinjia*	Zhang Yimou	2006
Happy Times	幸福时光	*Xinfu shiguang*	Zhang Yimou	2000
Hero	英雄	*Yingxiong*	Zhang Yimou	2002
House of Flying Daggers	十面埋伏	*Shimian maifu*	Zhang Yimou	2004
Keep Cool	有话好好说	*You hua, hao hao shuo*	Zhang Yimou	1997
Ju Dou	菊豆	*Ju Dou*	Zhang Yimou	1991
Not One Less	一个都不能少	*Yige dou buneng shao*	Zhang Yimou	1999
Raise the Red Lantern	大红灯笼高高挂	*Da hongdenglong gao gao gua*	Zhang Yimou	1992
Red Sorghum	红高粱	*Hong gaoliang*	Zhang Yimou	1987
Riding Alone for Thousands of Miles	千里走单骑	*Qianli zou danqi*	Zhang Yimou	2005
Road Home, The	我的父亲母亲	*Wode fuqin muqin*	Zhang Yimou	1999
Shanghai Triad	摇呀摇到外婆桥	*Yao a yao, yao dao waipo qiao*	Zhang Yimou	1995

English Title	Chinese	Pin Yin	Director's Name	Date
Story of Qiuju, The	秋菊打官司	*Qiuju daguansi*	Zhang Yimou	1992
To Live	活着	*Huo Zhe*	Zhang Yimou	1994
Mama	妈妈	*Mama*	Zhang Yuan	1991
Crows and Sparrows	乌鸦与麻雀	*Wuya yu maque*	Zheng Junli	1949
Deer and Bull	鹿和牛	*Lu he niu*	Zou Qin	1996–99

Bibliography

2008 Research Report on Chinese Film Industry. Beijing: China Film Press, 2008.

"1997 Film Market Report." *Chinese Film Market*, May 1997: 4–5.

"A Chart of Ten Domestic Blockbusters." *Film Art (Dianying yishu)*, 3 (1996): 4.

"A House Even Ghostbusters Can't Help." *The New York Times*, October 22, 2004: B20.

"Banned Chinese Film Takes Top TriBeCa Prize." *The New York Times*, May 2, 2005: B2.

"Beijing Film Studio" (Beijing dianying zhipianchang). In *China Encyclopedia: Film*, 30–31.

"Bianzhe nahan" (Editor's cries). *Xin yinxing* (Silverland), 3 (1928): 49.

"*Big Shot* on Commercialism." *China Daily*, December 20, 2001 (online).

"Caozong shijie de dianying" (The movie made world). *Xin yinxing*, 14 (September 1929): 14.

"Censorship against Paramount." *Motion Picture Herald*, January 2, 1937: 29.

"Changchun Film Studio" (Changchun dianying zhipianchang). In *Zhongguo Dakaike Quanshu Zongbianji Weiyuanhui "Dianying" Bianji Weiyuanhui*, edited by China Encyclopedia: Film (Zhongguo dabaike quanshu: dianying). Beijing: China Encyclopedia Press, 1998.

"Chuangkan zhi hua" (Inauguration remarks). *Haolaiwu zhoukan* (Hollywood Weekly) (1938): 1.

"Dang Kaige zaoyu Hu Ge" (When Kaige encountered Hu Ge). Cover story in *Zhongguo xinwen zhoukan* (China Newsweek), 8 (March 6, 2006): 20–32.

"Dianyingyuan zhan Hu yule jie shouxi" (Movie houses led other entertainment establishments). *Yule zhoubao* (Entertainment Weekly) (1935): 1: 21.

"Domestic pictures blockbuster chart in 2004" (2004 nian guochan yingpian piaofang paihangbag). *Dianying yishu*, 3 (2005): 4–5.

"Er shi si niandu waiguo yingpian jinkou zonge" (The total number of imported films for 1935). *Dian sheng* (Movietone), 5: 17 (May 1936): 407.

"Film Exhibitions and Market — China." *Commerce Reports* (February 1917): 713.

"Guochan dianying de jinbu" (The progress of domestic productions). *Shanghai yingtan* (Shanghai cinema forum), 1: 3 (1943).

"He Tingran jun zhi dianying tan" (T. J. Holt comments on film). *Shenbao*, August 8, 1926, reprinted in *Zhongguo wusheng dianying* (Chinese silent cinema), edited by Zhongguo dianying ziliao guan (China film archive), 99–100. Beijing: Zhongguo dianying chubanshe, 1996.

"Hong Kong Letter." *The Straits Times*, February 21, 1931: 6.

"Jinying feizhan yingpian" (The ban on anti-war films). *Dianying huabao* (Movies), 7 (1934): 11.

"Meiguo yingjie zhi jinghua yundong" (The sanitization movement in American film industry). *Dian sheng*, 3: 11 (1934): 208.

"Meizhou tanhua" (Weekly talk). *Haolaiwu zhoukan* (Hollywood weekly), 4 (1938).

"Miami Vice Bags Chinese Star." *Screen International*, April 1, 2005, 3.

"Our Films Disillusioning the East." *Library Digest*, 90: 26 (August 1926).

"Screening date for film '*No Thieves*' scheduled." *Shenzhen Daily*, November 8, 2004. http://english.sohu.com/20041108/n222880065.shtml.

"Shanghai dianying guanzhong de yiban taidu" (The general attitude of Shanghai's movie goers). *Dianying zhoukan* (Movie Weekly), 27 (March 1939): 904.

"Shanghai Film Studio" (Shanghai dianying zhipianchang). In *China Encyclopedia: Film*, 46.

"Shanghai zhipianye zhi qiongtu moyun" (The desperate film industry in Shanghai). *Dianying zhoukan* (Movie Weekly), 76 (April 1940): 5.

"Shui duo le guopian shichang" (Who takes the audience away from domestic films). *Yule zhoubao*, 1: 3 (1935): 76.

"The Girl Guides." *China Weekly Review*, November 7, 1936: 343.

"The Hong Kong Motion Picture Trade." *Commerce Reports*, October 29, 1923: 713.

"The Movies and China." *China Weekly Review*, November 8, 1930: 360.

"The Opening Statement of United Film Exchange" (Lianhua xuanyan). *The Evening of Shanghai* (*Shenzhou gongshi Shanghai zhiye*), 4 (1926): 39.18.

"Xingqi zaoshang dianying shi ertong men de" (Sunday morning show belongs to children). *Qingqing dianying* (Chingching Cinema), 5: 17 (1940): 3.

"Xuanzui mei de waiguo dianying nannü mingxing" (Voting for the most beautiful foreign film stars). *Yinmu zhoubao* (Screen Weekly), 16 (1931): 6.

"Ying guangda shimin zhengyi yaoqiu, Hu dianyingyuan ju ying Meipian, ge bao tongshi ting zai Meipian guanggao" (Yielding to the demand of the citizens, Shanghai's cinemas stopped showing American films and newspapers advertisements). *Wenhui bao*, November 16, 1950.

"Yingshi suibi" (Casual remarks). *Dianying huabao* (Movies), 22 (1935): 14.

"Yuejing" (Monthly tidbits). *Dianying shijie* (Movie World), 2 (1934): 8.

"Zhang Stabbed by His 'Dagger'." *China Daily*, August 28, 2004 (online)

"Zheng da youjiang" (Soliciting correct answers with reward). *Yule xinwen* (Entertainment News), 1 (June 1949).

"Zhipian ye yaoqing fangying ye taolun duifu waipian banfa" (Film producers invited exhibitors to discuss ways to deal with foreign films). Shanghai Municipal Archive, S319-1-20, dated May 1948.

"Zhong Mei dianying guanxi" (The reel relationship between China and the U.S.). *Dianying zhoukan* (Movie Weekly), 83 (May 1940): 12.

Adorno, Theodor W. "Culture Industry Reconsidered." *The Culture Industry: Selected Essays on Mass Culture*. London: Routledge, 1991 [1975].

Alestron, Inc. "Warner Bros. Fights against Pirated Film DVD in China." *Comtex China*, February 28, 2005.

Alleyne, Mark D. *International Power and International Communication*. New York: St. Martin's Press, 1995.

APEC. "An Introduction to China's Intellectual Property Protection." APEC Competition & Law Database, sponsored by Fair Trade Commission. Chinese, Taipei, 2007. www.apeccp.org.tw/doc/China/ Comlaw/cniss01.html.

Attali, Jacques. *Noise: The Political Economy of Music*, trans. Brian Massumi. Minneapolis: University of Minnesota Press, 1985.

Bai, Da. "Biaozhun nanzi de zhuanbian" (The change in the notion of ideal man). *Beiyang huabao* (Northern Pictorial), 24: 1160 (1934).

Bai, Jingsheng. "Throwing away the Walking Stick of Drama," In *Chinese Film Theory*, edited by George Semsel et al., 5–9. New York: Praeger, 1990.

Bao, Jigui. "China's First Animated Short, *Tumult in the Studio*." *Hong Kong Film Archive Newsletter*, 12 (May 2000): 6–7.

———. "China's First Animated Sound Film, *The Dance of the Camel*." *Hong Kong Film Archive Newsletter*, 13 (2000): 11–12.

Barboza, David. "A Leap Forward or a Great Sellout?" *The New York Times*, July 1, 2007, Arts and Leisure section: 7.

Berry, Chris. "From National Cinema to Cinema and the National." In *Theorising National Cinema*, edited by Paul Willeman and Valentina Vitali, 148–157. London: British Film Institute, 2006.

———. "Independently Chinese: Duan Jinchuan, Jiang Yue, and Chinese Documentary." In *From Underground to Independent*, edited by Paul Pickowicz and Yingjin Zhang, 109–122. Lanham, MD: Rowman & Littlefield, 2006.

———. "Market Forces: China's 'Fifth Generation' Faces the Bottom Line." In *Perspectives on Chinese Cinema*, edited by Chris Berry, 114–124. London: BFI, 1991.

———. *Postsocialist Cinema in Post-Mao China: The Cultural Revolution after the Cultural Revolution*. New York: Routledge, 2004.

———, ed. *Chinese Films in Focus: 25 New Takes*. London: BFI, 2004, 2008.

Berry, Chris and Mary Farquhar. *China on Screen: Cinema and Nation*. Columbia University Press, 2006.

Berry, Michael Berry. *Speaking in Images: Interviews with Contemporary Chinese Filmmakers*. Columbia University Press, 2005.

Bing, Hong, "He duzhe tanhua" (Heart to heart with readers). *Xin yinxing* (Silverland), 4 (December 1928): 48.

Bing, Mei and Zhu Jingjiang. *Zhongguo duli jilu dang'an* (Records of China's independent documentary cinema). Xi'an: Shaanxi shifan daxue chubanshe, 2004.

Biskind, Peter. *Down and Dirty Pictures: Miramax, Sundance, and the Rise of Independent Film.* New York: Simon & Schuster, 2004.

Bloomberg News. "Anonymous Web Piracy a $7.1-Billion Threat to Hollywood Filmmakers," *Financial Post* (p.FP7), April 19, 2008, *National Post's Financial Post & FP Investing* (Canada).

Bordwell, David. *Planet Hong Kong: Popular Cinema and the Art of Entertainment.* Harvard University Press, 2000.

Boyle, James. *Shamans, Software, and Spleens: Law and the Construction of the Information Society.* Cambridge, Mass.: Harvard University Press, 1996.

Braester, Yomi. *Witness against History: Literature, Film, and Public Discourse in Twentieth-Century China.* Stanford: Stanford University Press, 2003.

Brent, Willie. "China to Raze the Red Tape, Centralize Studios," *Variety,* May 13–19, 1996: 44.

Bristow, Becky. Untitled talk, 2006 International Animation Artists Salon, Wuhan, November 3, 2006.

Browne, Nick, Paul G. Pickowicz, Vivian Sobchack, and Esther Yau, eds. *New Chinese Cinemas: Forms, Identities, Politics.* Cambridge University Press, 1994.

Bruzzi, Stella. *New Documentary: A Critical Introduction.* London: Routledge, 2000.

Callick, Rowan. "China's Censorship Syndrome." *The Australian,* May 14, 2008: 2.

Castells, Manuel. *The Network Society.* Oxford: Blackwell, 1996.

Chai, Yeow Kai. "*Tiger*'s Triumph Opens Doors." *The Straits Times* (Singapore), April 1, 2001: 6.

Chan, Evans. "Zhang Yimou's *Hero*: The Temptation of Fascism." *Film International,* 2: 8 (March 2004).

Chen, Dabei. "Beijing dianying guanzhong de paibie" (The classification of Beijing's movie goers). *Zhongguo dianying zazhi* (China screen), 8 (1927), reprinted in *Zhongguo wusheng dianying* (Chinese silent cinema), edited by Zhongguo dianying ziliao guan (China film archive). Beijing: Zhongguo dianying chubanshe, 1996, 607.

Chen, Huangmei, ed. *Dangdai Zhongguo dianying* (Contemporary Chinese cinema). Beijing: Zhongguo shehui kexue chubanshe, 1989.

Chen, Lifu. "Wo guo suo xu waiguo yingpian zhi biaozhun" (Criterion for selecting foreign films). Quanguo dianying gongsi fuzeren tanhuahui jiniance (Proceedings of the symposium of Chinese film industry leaders). Nanjing, 1934.

Chen, Muo. *Anthology of Chen Muo's Film Criticism.* Nanchang: Baihuazhou Art and Literature Press, 1997.

———. *On Zhang Yimou.* Beijing: China Film Press, 1995.

Chen, Yan. "Zhang Yimou on *Keep Cool.*" *Dianying yishu,* 256:5 (1997): 66–67.

Cheng, Jihua, Li Shaobai, and Xing Zuwen, ed. *Zhongguo dianying fazhan shi* (History of the development of Chinese film), 2nd ed. Beijing: Zhongguo dianying chubanshe, 1981.

Cheng, Qingsong. *Kandejian de yingxiang* (Films permitted for watching). Shanghai: Sanlian shudian, 2004.

Cheng, Qingsong and Huang Ou. *Wode sheyingji bu sahuang: xianfeng dianying ren dang'an — shengyu 1961–1970* (My camera doesn't lie: documents on avant-garde filmmakers born between 1961 and 1970). Beijing: Zhongguo youyi chuban gongsi, 2002.

Cheng, Scarlet. "Director with a Midas Touch." *Los Angeles Times*, January 2, 2007: E1, 2.

Cheng, Xian. "Shoudu de dianying guanzhong" (Film audience in the capital). *Chen bao*, October 6, 1932.

Chi, Robert. "The New Taiwanese Documentary." *Modern Chinese Literature and Culture*, 15:1 (Spring 2003): 146–196.

China Daily. "Net Piracy Still Poses A Challenge." January 18, 2008. http://www.chinadaily.com.cn/china/2008-01/18/content_6402839.htm.

China Film Archive, ed. *Zhongguo dianying dadian: gushi pian, xiqu pian, 1977–1994* (Encyclopedia of Chinese films: feature films, theater films, 1977–1994). Beijing: Zhongguo dianying chubanshe, 1995.

China Telecom. "China Number of Internet Users for 2000 to 2005, and Number of Broadband Users for 2002 to 2005, and Both through June 2006." February 2007, 14(2): 1, TableBase™ Accession #161119240.

Chion, Michel. *Audio-Vision: Sound on Screen*, trans. Claudia Gorbman. New York: Columbia University Press, 1990.

Chow, Rey. *Ethics after Idealism*. Bloomington, Ind.: Indiana University Press, 1998.

———. *Primitive Passions: Visuality, Sexuality, Ethnography, and Contemporary Chinese Cinema*. New York: Columbia University Press, 1995.

———. *Sentimental Fabulations: Contemporary Chinese Films*. Columbia University Press, 2007.

Chu, Henry. "*Crouching Tiger* Can't Hide from Bad Reviews in China." *Los Angeles Times*, January 29, 2001: A1, 10.

Chu, Yingchi. *Chinese Documentaries: From Dogma to Polyphony*. London: Routledge, 2007.

Clark, Paul. *Chinese Cinema: Culture and Politics since 1949*. Cambridge: Cambridge University Press, 1987.

———. *Reinventing China: A Generation and Its Films*. Hong Kong: The Chinese University Press, 2005.

———. *The Chinese Cultural Revolution: A History*. Cambridge University Press, 2008.

Cochran, Sherman. *Inventing Nanjing Road: Commercial Culture in Shanghai, 1900–1945*. Ithaca: Cornell University Press, 1999.

Cook, Pam. *Fashioning the Nation: Costuming and Identity in British Cinema*. London: British Film Institute, 1996.

Coonan, Clifford. "China Outgrows Mom & Pop Era." *Variety*, March 12–18, 2007: A2.

Crough, David and Nina Lübbren. "Introduction." In *Visual Culture and Tourism*, edited by David Crouch and Nina Lübbren, 1–20. Oxford and New York: Berg, 2003.

Cui, Baoguo, ed. *2007 nian: Zhongguo chuanmei chanye fazhan baogao* (Report on development of China's media industry 2007), 290–308. Beijing: Shehui kexue wenxian chubanshe, 2007.

Cui, Shuqin. *Women through the Lens: Gender and Nation in a Century of Chinese Cinema*. Honolulu: University of Hawaii Press, 2003.

———. "Working from the Margins: Urban Cinema and Independent Directors in Contemporary China." *Post Script* 20, nos. 2–3 (Winter/Spring/Summer): 77.

Cui, Weiping. "Zhongguo dalu duli zhizuo jilupian de shengzhang kongjian" (Space for the growth of the independent documentary in mainland China). *Twenty-First Century* (Hong Kong), 77 (June 2003): 84–94.

Dai, Jinhua. "Order/Anti-Order: Representation of Identity in Hong Kong Action Movies." In *Hong Kong Connections: Transnational Imagination in Action Cinema*, edited by Meaghan Morris, Siu-Leung Li, and Stephen Chan, 81–94. Hong Kong: Hong Kong University Press, 2005.

———. *Xingbie Zhongguo* (Gendering China). Taipei: Rye Field, 2006.

Dargis, Manohla. "Caged in Disney in Beijing, Yearning for a Better Life." *The New York Times*, October 11, 2004: B5.

Davis, Darrell William and Emilie Yueh-yu Yeh. *East Asian Screen Industries*. British Film Institute, 2008.

de Grazia, Victoria. "Mass Culture and Sovereignty: The American Challenge to European Cinemas, 1920–1960." *Journal of Modern History*, 61 (March 1989): 53–87.

Desser, David. "Session: Trends and Concepts in Chinese Cinema." *Quarterly Review of Film Studies*, 10 (April 1989): 358.

Dianying jiancha weiyuanhui gongzuo baogao (The work report of the national film censorship committee). Nanjing, 1934.

Dianying yishu (Film Art), 1.1 (1932): 8.

Ding, Yaping. *Yingxiang Zhongguo: Zhongguo dianying yishu, 1945–1949* (China on screen: cinema art between 1945 and 1949). Beijing: Wenhua yishu chubanshe, 1998.

Donald, Stephanie Hemelryk. *Public Secrets, Public Spaces: Cinema and Civility in China*. Lanham, Boulder, New York and Oxford: Rowman and Littlefield, 2000.

Du, Yunzhi. "Wuxia pian yu xiayi jingshen" (Wuxia film and the spirit of chivalric righteousness). *Xianggang yinghua* (Hong Kong Movie News), February 1968: 62–63.

Dunch, Ryan. "Beyond Cultural Imperialism: Cultural Theory, Christian Missions, and Global Modernity." *History and Theory*, 41 (October 2002): 301–325.

DVD Statistical Report. 8th edition, 2005, 3. Los Angeles: Corbell Publishing.

Eckholm, Erik. "Leading Chinese Filmmaker Tries for a Great Leap to the West; Will a Zany Satire Be a Breakthrough for a Popular Director?" *The New York Times*, June 21, 2001: E1.

Ehrlich, David and Jin Tianyi. "Animation in China." In *Animation in Asia and the Pacific*, edited by John A. Lent, 7–29. Sydney: John Libbey, 2001.

Elley, Derek. "Asia to *Tiger*: Kung-fooy." *Variety*, February 5–11, 2001: 1.

———. "Comedy Hit Banks on Crossover." *Variety*, March 25–March 31, 2002: 26.

Ellwood, David W. and Rob Kroes, ed. *Hollywood in Europe: Experiences of a Cultural Hegemony*. Amsterdam: Vu University Press, 1994.

Entertainment Merchants Association (EMA), *2006 Annual Report on the Home Entertainment Industry*. www.entmerch.org.

Faden, Eric. "The Cyberfilm: Hollywood and Computer Technology." *Strategies*, 14:1 (2001): 79.

Fan, Jianghua, Mao Yu, and Yang Yuan. "Report on Film Market in 1996." *Chinese Film Market*, 1 (1997): 4–7.

Fan, Ping. "Domestic Pictures in 1997 Dare Not Entertain Bill-Sharing." *Chinese Film Market*, 8 (1997): 7.

Fang, Fang. *Zhongguo jilupian fazhan shi* (History of the development of Chinese documentary cinema). Beijing: Zhongguo xiju chubanshe, 2003.

Fei, Mu. "Guopian guanzhong" (Domestic film audience). *Dianying huabao* (Movies), 36 (1936).

Fei, Shi. "Li Zhuozhuo dui Zhang Yi buman" (Li is unhappy with Zhang). *Ying wu xinwen* (Movie and Dance News), 1:2 (1935): 5.

Feinstein, Howard. "Filmmaker Tian Zhuangzhuang Cuts Loose with '*Kite*.'" *New York Newsday*, April 10, 1994: E2.

Feng, Wu. "Lun Zhongguo dianying wenhua yundong" (On Chinese film culture movement). *Mingxing yuebao* (Star Monthly), 1: 1 (May 1933), reprinted in *Zhongguo zuoyi dianying yundong* (Chinese leftist cinema movement), 64. Beijing: Zhongguo dianying chubanshe, 1993.

Feng, Zixi. "Wo zai Pingan dianyingyuan ershi nian de jingli" (My twenty years at Pingan theater). *Tianjin wenshi ziliao*, 32 (1985): 213–222.

Fenghuang weishi (Phoenix Satellite TV), ed. *DV xin shidai 1* (DV New Generation 1). Beijing: Zhongguo qingnian chubanshe, 2003.

Fleming, Charles. *High Concept: Don Simpson and the Hollywood Culture of Excess*. Doubleday, 1998.

Fleming, Michael. "H'Wood on Li Spree." *Daily Variety*, March 30, 2005: 1.

Foreman, William. "*Crouching Tiger* Is an Example of Greater China's Hidden Power." *Associated Press*, March 26, 2001.

Foroohar, Rana. "Hurray for Globowood." *Newsweek*, May 27, 2002.

Fu, Poshek. *Between Shanghai and Hong Kong: The Politics of Chinese Cinemas*. Stanford: Stanford University Press, 2003.

———. *Passivity, Resistance, and Collaboration: Intellectual Choices in Occupied Shanghai, 1937–1945*. Stanford University Press, 1993.

Fu, Poshek and David Desser, eds. *The Cinema of Hong Kong: History, Art, Identity.* Cambridge University Press, 2002.

Gao, Bohai. "Tianjin Jigushe ji Jigushe zidi ban" (The Jigu society in Tianjin). *Tianjin wenshi ziliao xuanji* (Selected historical documents), no. 17, Tianjin (1981): 178–189.

Gao, Weijin. *Zhongguo xinwen jilu dianying shi* (History of newsreels and documentaries in China). Beijing: Zhongyang wenxian chubanshe, 2003.

Gellner, Ernest. *Thought and Change.* London: Weidenfeld and Nicolson, 1964.

Gilsdorf, Ethan. "Chinese Animation's Past, Present, and Future: The Monkey King of Shanghai." *Animato* (Winter 1988): 20–23.

Goldstein, Patrick. "Brand Blvd." *Los Angeles Times*, January 11, 2005: E1, 4 and 6.

Gong, Jianong. *Gong Jianong congying huiyilu* (Gong's film career: a memoir). Taibei: Zhuanji wenxue chubanshe, 1980.

Gu, Jianchen. "Zhongguo dianying fadashi." *Zhongguo dianying nianjian* (Chinese film year book, 1934). Nanjing: Zhongguo jiaoyu dianying xiehui, 1934.

Gu, Zhonli. "Jiajin guochan dinying de shengchan, tigao yingpian de zhi he liang" (Speed up the production of domestic films and improve their quantity and quality). *Dazhong dianying* (Popular Cinema), 1:7 (September 16, 1950): 12–13.

Guangming ribao (Guangming daily), January 31, 1974: 2.

Gui, Fengbo. "Dui jinhou zhipianye de jianyi" (My advice to film producers). *Da gong bao*, June 12, 1935.

Guider, Elizabeth. "H'Wood's Global Warming." *Variety*, January 3–9, 2005: 1.

Guo, Youshou. "Wo guo dianying jiaoyu yundong zhi niaokan" (An overview of educational film in China). *Jiao yu xue yuekan* (Teaching and Learning Monthly), 1:8 (1936): 2.

Guo, Zhenzhi. *Zhongguo dianshi shi* (History of Chinese television). Beijing: Wenhua yishu chubanshe, 1997.

Hall, Stuart. "The Local and the Global: Globalization and Ethnicity." In *Culture, Globalization and the World-System: Contemporary Conditions for the Representation of Identity*, edited by Anthony D. King, 19–40. Minneapolis: University of Minnesota Press, 1997.

Harris, Dana. "Zhang Pulls 2 Cannes Films, Blames West." *The Hollywood Reporter*, April 21, 1999 (online).

Hayes, Dade and Jonathan Bing. *Open Wide: How Hollywood Box Office Became a National Obsession.* New York: Miramax Books, 2004.

Hedetoft, Ulf. "Contemporary Cinema: Between Cultural Globalization and National Interpretation." In *Cinema and Nation*, edited by Mette Hjort and Scott MacKenzie, 278–297. London and New York: Routledge, 2000.

Hjort, Mette. "Danish Cinema and the Politics of Recognition." In *Post-theory: Reconstructing Film Studies*, edited by David Bordwell and Noel Carroll, 528–531. Madison: University of Wisconsin, 1996.

Hoberman, J. *Review of Hero*, by Yimou Zhang. *Village Voice*, August 23, 2004.

Holcomb, Mark. "Once Upon a Time in the East: A Chinese B Western." *Village Voice*, September 7, 2004: 58.

Holden, Stephen. "A Bloodthirsty Unification of China." *The New York Times*, December 17, 1999: E2.

Hu, Chang. *Xin Zhongguo dianying de yaolan* (The cradle of New China's films). Changchun: Jilin wenshi chubanshe, 1986.

Hu, Yunshan. "Yin xiang zagan" (Casual comments on the film industry). *Lianhua huabao*, 5:8 (April 1935): 13.

Huang, Andrew C. C. "Marshaling the Comic Arts." *Los Angeles Times*, April 10, 2005: E6.

Huang, Zongzhan (James Wong). "Suo wang yu Zhongguo dianying jie" (What I hope the Chinese filmmakers would do). *Silverland*, 11 (1929): 14–16.

Hubei shengzhi (Hubei provincial gazette). Wuhan: Hubei renmin chubanshe, 1993.

Hunt, Leon. *Kung Fu Cult Masters, From Bruce Lee to Crouching Tiger*. London and New York: Wallflower Press, 2003.

IIPA. "2006 Special 301 Report: People's Republic of China (PRC)." February 13, 2006. http://www.iipa.com/countryreports.html (2006SPEC301PRC.pdf, February 23, 2006).

———. "2008 Special 301 Report: People's Republic of China," 2008. http://www.iipa. com/countryreports.html.

———. "Copyright Industries Release Report on Piracy in 68 Countries/Territories and Press Their Global Trade Priorities for 2006," IIPA press release, February 13, 2006. http://www.iipa.com.

———. "Intellectual Property Protection as Economic Policy: Will China Ever Enforce Its IP Laws?" IIPA 2005. www.iipa.com/2005_May16_China_CECC_Testimony.

———. "USTR 2005 'Special 301' Decisions on Intellectual Property based on IIPA's 2004 Estimated Trade Losses Due to Copyright Piracy (in millions of U.S. dollars) and Piracy Levels In-Country," 2005. http://www.iipa.com.2005_Apr29_USTR_301_DECISIONS.pdf.

Jaffee, Valerie. "'Everyman a Star': The Ambivalent Cult of Amateur Art in New Chinese Documentary." In *From Underground to Independent: Alternative Film Culture in Contemporary China*, edited by Paul G. Pickowicz and Yingjin Zhang, 77–108. Lanham, MD: Rowman & Littlefield, 2006.

Jarvie, Ian. *Hollywood's Overseas Campaign: the North Atlantic Movie Trade, 1920–1950*. Cambridge: Cambridge University Press, 1992.

Jewesbury, Daniel. "tourist:pioneer:hybrid: London Bridge, the Mirage in the Arizona Desert." In *Visual Culture and Tourism*, edited by David Crouch and Nina Lübbren, 223–240. Oxford and New York: Berg, 2003.

Jia, Leilei. "Market Hero, Black Martial Art" (*Shichang yingxiong, heisewuxiao*). *The History of the Chinese Martial Arts Films* (*Zhongguo wuxia dianyingshi*). Beijing: Culture and Art Publishing House, 2005.

Jian, Yang. "Wenhua dageming de Hongweibing xiju" (Great Cultural Revolution Red Guard plays). *Xiju* (Drama), 3 (September 1999): 51–64.

Johnson, David, Andrew J. Nathan, and Evelyn S. Rawski. *Popular Culture in Late Imperial China*. Taipei: SMC Publishing, 1987.

Johnson, G. Allen. "Worldwide, Asian Films Are Grossing Millions. Here, They're Either Remade, Held Hostage or Released with Little Fanfare." *San Francisco Chronicle*, February 3, 2005 (online).

Johnson, Matthew David. "'A Scene beyond Our Line of Sight': Wu Wenguang and New Documentary Cinema's Politics of Independence." In *From Underground to Independent: Alternative Film Culture in Contemporary China*, edited by Paul G. Pickowicz and Yingjin Zhang, 47–76. Lanham, MD: Rowman & Littlefield, 2006.

Kan, Wendy. "*Big Shot* Doesn't Win Over Locals." *Variety*, May 27–June 2, 2002: 8.

———. "Comedy Hit Banks on Crossover." *Variety*, March 25–31, 2002: 26.

Kay, Jeremy. "2007 Review: Hollywood Looks for Local Heroes." Screendaily.com, December 21, 2007. http://www.screendaily.com/2007-review-hollywood-looks-for-local-heroes/4036400.article.

Kay, Jeremy. "Kung Fu Hustles North American Audiences." *Screen International*, April 22, 2005.

Kehr, Dave. "*Postmen in the Mountains*." *The New York Times*, October 22, 2004: B12.

Klein, Christina. "Is *Kung Fu Hustle* Un-American?" *Los Angeles Times*, February 27, 2005: M2.

Klein, Christina. "Why Does Hollywood Dominate US Cinemas?" *Yale Global Online*, August 17, 2004. http://yaleglobal.yale.edu/content/why-does-hollywood-dominate-us-cinemas.

Kong, Haili and John A. Lent, eds. *100 Years of Chinese Cinema: A Generational Dialogue*. Eastbridge Press, 2006.

Kraicer, Shelly. "China's Wasteland: Jia Zhangke's *Still Life*." *Cinema Scope*, 2007: 29.

———. "Review of Jia Zhangke's Platform." *CineAction*, 54 (Spring 2001): 67.

Kristof, Nicholas D. "China Bans One of Its Own Films; Cannes Festival Gave It Top Prize." *The New York Times*, August 4, 1993: E4.

Lao, Mei. "Domestic Films: Dawn and Shadow" (*Guochan dianying: shuguang he yinyang*). *Film Art* (*Dianying yishu*), 2 (1996): 44.

Lapedis, Hilary. "Popping the Question: The Function and Effect of Popular Music in Cinema." *Popular Music*, 18:3 (October 1999): 370.

Larkin, Brian. "Technology and the Domain of Piracy." Paper presented at "Contested Commons/Trespassing Publics: A Conference on Inequalities, Conflicts and Intellectual Property." New Delhi, India, January 6–8, 2005.

Larson, Wendy. "Displacing the Political: Zhang Yimou's *To Live* and the Field of Film." In *The Literary Field of Twentieth-Century China*, edited by Michel Hockx, 178–197. Honolulu, Hawaii: University of Hawaii Press, 1999.

———. "Zhang Yimou: Inter/National Aesthetics and Erotics." In *Cultural Encounters: China, Japan, and the West: Essays Commemorating 25 Years of East Asian Studies*

at the University of Aarhus, edited by Soren Clausen, Roy Starrs, and Anne Wedell-Wedelsborg, 215–226. Aarhus, Denmark: Aarhus University Press, 1995.

Lash, Scott and John Urry. *Economies of Signs and Space*. London: Sage, 1994.

Lee, Ken-fang. "Far Away, So Close: Cultural Translation in Ang Lee's *Crouching Tiger, Hidden Dragon*." *Inter-Asia Cultural Studies*, 4:2 (2003): 281–295.

Lee, Kevin."Jia Zhangke," *Senses of Cinema* (February 2003). http://www.sensesofcinema.com/contents/directors/03/jia.html.

Lee, Leo Ou-fan. "Urban Milieu of Shanghai Cinema." In *Cinema and Urban Culture in Shanghai, 1922–1943*, edited by Yingjin Zhang, 74–96. Stanford: Stanford University Press, 1999.

Lent, John A. and Xu Ying. "Animation in China Yesterday and Today — The Pioneers Speak Out." *Asian Cinema*, 12:2 (Fall/Winter 2001): 34–49.

———. "China's Animation Beginnings: The Roles of the Wan Brothers and Others." *Asian Cinema*, 14:1 (Spring/Summer 2003): 56–69.

Levy, Emanuel. *Cinema of Outsiders: The Rise of American Independent Film*. New York: New York University Press, 2001.

Leyda, Jay. *Dianying — Electric Shadows: An Account of Film and the Film Audience in China*. Cambridge, MA: MIT Press, 1972.

Li, Daoxin. *Zhongguo dianying shi, 1937–1945* (Chinese film history, 1937–1945). Beijing: Shoudu shifan daxue chubanshe, 2000.

Li, Erwei. "Jump Start the Chinese Martial Arts Blockbuster." *Face to Face with Zhang Yimou (Zimian Zhang Yimou)*. Beijing: Jingjiribao chubanshe, 2002.

Li, Suyuan and Hu Jubin. *Zhongguo wusheng dianying shi* (A history of the silent Chinese cinema). Beijing: China Film Press, 1996.

Li, Yaxin. "Zhonglu Huana yiyahuanya daoban dian mai zheng ban, zheng ban DVD mai 10 yuan" (CAV Warner play the piracy game by selling legitimate DVDs in piracy stores, legitimate copies are sold for ten renminbi). *Diyi caijing ribao* (First Financial Daily), December 13, 2006, tech.tom.com/2006-12-13/04B5/8605965/.htm/.

Li, Yu, ed. *Zhongguo dianying zhuanye shi yanjiu: dianying zhipian, faxing, fangying juan* (Research on Chinese film specialist history: film production, distribution and screening). Beijing: Zhongguo dianying chubanshe, 2006.

Liang, Jianzeng and Sun Kewen, ed. *Dongfang shikong de rizi* (Days with the Eastern horizons). Beijing: Gaodeng jiaoyu chubanshe, 2003.

Liang, Jianzeng, Sun Kewen, and Chen Meng, ed. *Shihua shishuo* (Speaking in earnest). Beijing: Gaodeng jiaoyu chubanshe, 2003.

Link, Perry. "Introduction." In Kang Zhengguo, *Confessions: An Innocent Life in Communist China*. W. W. Norton, 2007.

Liu, Heng. *Gouri de liangshi* (The God-damned grain). Beijing: Zuojia chubanshe, 1993.

Liu, James. *The Chinese Knight-Errant*. Chicago: University of Chicago, 1967.

Liu, Joey. "Film Banned after Footage of Uncut Version Put on Net." *South China Morning Post*, January 5, 2008: 5.

Liu, Kang. *Globalization and Cultural Trends in China*. Honolulu: University of Hawaii Press, 2004.

Liu, Melinda. "Crouching Tiger, Shooting Star: Zhang Ziyi Can Kick, Swing a Sword and Throw Jackie Chan; No Wonder Hollywood Loves Her." *Newsweek*, February 26, 2001.

Liu, Xu. "Xiandai nüxing xinmu zhong de yinmu duixiang" (Modern women's most desired men — a response to screen images). *Furen huabao* (Women's Pictorial), 31 (1935): 49–50.

Liu, Yu-Zhu, ed. *Wenhua shichang shiwu quanshu* (Overview of cultural market practice). Beijing: Xinhua, 1999.

Lu, Feii and Chris Berry, eds. *Island on the Edge: Taiwan New Cinema and After*. Hong Kong University Press, 2005.

Lu, Sheldon. "Tear Down the City: Reconstruct Urban Space in Contemporary Chinese Popular Cinema and Avant-Garde Art." In *Chinese Cinema and Society at the Turn of the Twenty-first Century*, edited by Zhang Zhen, 141. Duke University Press, 2007.

———, ed. *Transnational Chinese Cinemas: Identity, Nationhood, Gender*. Hawaii: University of Hawaii Press, 1997.

Lu, Sheldon and Emilie Yeh, ed. *Chinese Language Film: Historiography, Poetics, Politics*. Hawaii: University of Hawaii Press, 2005.

Lü, Xinyu. *Jilu Zhongguo: dangdai Zhongguo xin jilu yundong* (Documenting China: The New Documentary Movement in Contemporary China). Beijing: Sanlian shudian, 2003.

———. "Ruins of the Future: Class and History in Wang Bing's *Tiexi District*." *New Left Review*, 31 (2005): 125–136.

Luo, Man. "Kiss manhua" (Casual remarks about kissing). *Dianying* (Movies), 14 (1932): 8.

Luo, Xueying. *Red Sorghum: The Real Zhang Yimou*. Beijing: China Film Press, 1988.

Ma, Qiang. "The Chinese Film in the 1980s: Art and Industry." In *Cinema and Cultural Identity: Reflections on Films from Japan, India, and China*, edited by Wimal Dissanayake, 165–173. Lanham: University Press of America, 1988.

Maige erfeng (a pseudonym meaning Microphone). "Yueyu pian de guoqu weilai" (Cantonese cinema: its past and future). *Dianying shijie* (Movie World), no. 2, Hong Kong, August 5, 1950.

Marchetti, Gina and Tan See Kam. *Hong Kong Film, Hollywood and the New Global Cinema*. Routledge, 2007.

Market, 8 (1997): 7.

May, Larry. *Screening out Past: The Birth of Mass Culture and the Motion Picture Industry*. Chicago and London: The University of Chicago Press, 1983.

Mazurkewich, Karen. "Killing Two Markets with One Movie — Columbia Shoots for Cross-Border Success." *The Asian Wall Street Journal*, January 25, 2002: W1.

McCarthy, Todd and Derek Elley. "Zhang's Political Exit Apolitical After All." *Variety*, April 22, 1999: 30.

McGrath, Jason. "Metacinema for the Masses: Three Films by Feng Xiaogang." *Modern Chinese Literature and Culture*, 17:2 (2005): 90–132.

———. *Postsocialist Modernity: Chinese Cinema, Literature, and Criticism in the Market Age*. Stanford University Press, 2008.

McKee, Robert. *Story: Substance, Structure, Style, and the Principles of Screenwriting*. New York: Regan Books, 1997.

Merritt, Greg. *Celluloid Mavericks: A History of American Independent Film*. New York: Thunder's Mouth Press, 2000.

Mertha, Andrew C. *China's Water Warriors: Citizen Action and Policy Change*. Cornell University Press, 2008.

———. *The Politics of Piracy: Intellectual Property in Contemporary China*. Ithaca and London: Cornell University Press, 2005.

Merz, Charles. "When the Movies Go Abroad." *Harper's Monthly Magazine*, January, 1926.

Mingxing banyue kan (Star Bi-Weekly), 1.2 (June 1933): 3.

Minns, Adam. "Foreign Language Films Take on Popcorn Crowd." *Screen International*, October 15, 2004: 9.

Mitchell, Robert. "Out of Hiding: Foreign Films Flying in UK." *Screen International*, March 11, 2005: 25.

Mo, Yan. *Hong gaoliang* (Red Sorghum). Beijing: Zuojia chubanshe, 1995.

MPAA. "Internet Piracy." 2005. www.mpaa.org/piracy_internet.asp.

Munoz, Lorenza. "Art House Films Go In-House." *Los Angeles Times*, April 6, 2005: C1, 5.

Nanjing, No. 2 Historical Archives, 12 (2)-2258, dated 1936.

Nanjing, No. 2 Historical Archives, 2(2)-268, dated July 1934.

Neale, Steve. "Hollywood Blockbusters: Historical Dimensions." In *Movie Blockbusters*, edited by Julian Stringer. London: Routledge, 2003.

Ni, Zhen, ed. *Reform and Chinese Cinema (Gaige yu Zhongguo dianying)*. Beijing: China Film Press, 1994.

Nichols, Bill. *Blurred Boundaries: Questions of Meaning in Contemporary Culture*. Bloomington: Indiana University Press, 1994.

———. *Introduction to Documentary*. Bloomington: Indiana University Press, 2001.

Nornes, Abé Mark. *Forest of Pressure: Ogawa Shinsuke and Postwar Japanese Documentary*. Minneapolis: University of Minnesota Press, 2007.

O'Dwyer, Jack. "Crouching Tiger Gets PR Buzz." *Jack O'Dwyer's Newsletter*, January 17, 2001.

Ong, Bao, and Sarah Schafer. "DVD's: 'Traveling' to China." *Newsweek*, June 20, 2005.

Ou, Ouwai. "Zhonghua ernü mei zhi gebie shenpan" (Assessing the beauty of Chinese women). *Furen Huabao* (Women's Pictorial), 17 (1934): 12–16.

Ouyang, Yuqian. *Since I Started My Acting Career (Wode yanyi shengya)*. Beijing: China Drama Press, 1959.

Page, Janice. "Heroic Journey." *The Boston Globe*, August 22, 2004: N9

Palan, Ronen. "Trying to Have Your Cake and Eating It: How and Why the State System Has Created Offshore." *International Studies Quarterly*, 42:4 (December 1998) 625–644.

Pan, Lujian. "Aside from *Red Cherry*'s Commercial Operation" (Hong Yingtao zai shangye yunzuo zhi wai). *Film Art (Dianying yishu)*, 3 (1996): 6.

Pang, Zichun. "Meiguo yingpian de midu" (The poisonous American films). *Chenbao*, October 4, 1932: 8.

Patterson, Richard Jr. "The Cinema in China." *China Weekly Review*, March 12, 1927: 48.

Pearson, Margaret M. "China's Integration into the International Trade and Investment Regime." In *China Joins the World: Progress and Prospects*, edited by Elizabeth Economy and Michael Oksenberg, 161–205. New York: Council on Foreign Relations Press, 1999.

Pickowicz, Paul. "The Theme of Spiritual Pollution in Chinese Films of the 1930s." *Modern China*, 17:1 (1991): 38–75.

Pickowicz, Paul and Yingjin Zhang, ed. *From Underground to Independent*. Lanham, MD: Rowman & Littlefield, 2006.

Plaks, Andrew H. "Towards a Critical Theory of Chinese Narrative." In *Chinese Narrative: Critical and Theoretical Essays*, edited by Andrew Plaks, 309–352. Princeton, New Jersey: Princeton University Press, 1977.

Pomfret, John. "A 'Tiger' of a Different Stripe; America's Favorite Chinese Film Is a Flop in Beijing." *Washington Post*, March 22, 2001: C1.

Ponte, Lucille M. "Coming Attractions: Opportunities and Challenges in Thwarting Global Movie Piracy." *American Business Law Journal*, Volume 45, Issue 2 (Summer 2008): 331–369.

Porter, Michael. *The Competitive Advantage of Nations*. New York: Free Press, 1990.

PricewaterhouseCoopers. "Global Entertainment and Media Outlook: 2005–2009." NY: PricewaterhouseCoopers LLP, 2005. www.pwc.com/e&m (pwc_outlook2009.pdf, April 30, 2006), 7.

Quiquemelle, Marie-Claire. "The Wan Brothers and Sixty Years of Animated Films in China." In *Perspectives on Chinese Cinema*, edited by Chris Berry, 175–186. London: British Film Institute, 1991.

Rafferty, Terrence. "Screams in Asia Echo in Hollywood." *The New York Times*, January 27, 2008: AR 13.

Rao, Shuguang. "A Sketch of One Hundred Years of Chinese Market" (Bainian Zhongguo shichang saomiao). In *China Film Yearbook Centennial Special Volume (Zhongguo dianying nianjian bainian tekan)*, edited by Zhongguo Dianying Bianjibu, 493–509. Beijing: China Yearbook Press, 2006.

———. "Three Questions about Chinese Cinema" (Guanyu Zhongguo dianying de san ge wenti). *Contemporary Cinema (Dangdai dianying)*, 2 (2006): 57–58.

Rayns, Tony. "Screening China." *Sight and Sound*, 1, No. 3 (July 1991): 28–29.

———. *King of the Children and the New Chinese Cinema*. Boston: Faber and Faber, 1989.

Reynaud, Bérénice."Dancing with Myself, Drifting with My Camera: The Emotional Vagabonds of China's New Documentary." *Senses of Cinema* (Australia), 28 (September–October 2003). http://www.senseofcinema.com/contents/03/28/chinas_new_documentary.html.

Robinson, Bruce. "Chinese Mainland New Era Cinema and Tiananmen." *Asian Culture Quarterly*, 2 (1992): 38.

Rodriguez, Hector. "Hong Kong Popular Culture as an Interpretive Arena: The Huang Feihong Film Series." *Screen*, 38:1 (Spring 1997): 1–24.

Rojas, Carlos. "A Tale of Two Emperors: Mimicry and Mimesis in Two New Year's Films from China and Hong Kong." *CineAction*, 60 (2005): 2–9.

Rosen, Stanley. "Priorities in the Development of the Chinese Film Industry: The Interplay and Contradictions among Art, Politics and Commerce." Paper presented at the Conference on "Locality, Translocality, and De-Locality: Cultural, Aesthetic, and Political Dynamics of Chinese-Language Cinema." Shanghai University, July 12–13, 2008.

———. "Quanqiuhua shidai de huayu dianying: canzhao Meiguo kan Zhongguo dianying de guoji shichang qianjing" (Chinese cinema in the era of globalization: prospects for Chinese films on the international market, with special reference to the United States). *Dangdai dianying* (Contemporary Cinema), 1 (2006): 16–29.

Ryan, Michael P. *Knowledge Diplomacy: Global Competition and the Politics of Intellectual Property*. Washington, D.C.: Brookings Institution Press, 1998.

Schamus, James. "Guest Column." *Variety*, February 12–18, 2001: 7.

Scott, A.O. "Fanciful Flights of Blood and Passion." *The New York Times*, December 3, 2004: B21.

———. "The Invasion of the Midsize Movie." *The New York Times*, January 21, 2005: B1, 22.

Screen Digest. "China Yet to Realise Video Potential: Piracy Undermines Growth as New Formats Emerge." Volume 37, February 2005, TableBase™ Accession # 132539205.

———. "Chinese Broadband Market Booms: China Claims World's Second Highest Broadband Subscriber Total." May 2008, TableBase™ Accession #180228785, October 8, 2008.

———. "International Box Office Surges: China Is the World's Fastest Growing Theatrical Market." Volume 36, February 2005, TableBase™ Accession # 131960249.

———. "World DVD Growth Slows to Crawl." *Video Store*, "Exclusive Research." January 18, 2004, 26(3), TableBase™ Accession # 122623925.

Seabury, William Marston. *Motion Picture Problems: The Cinema and the League of Nations*. New York: Avondale Press, 1929.

Sek, Kei. "Mancheng jindai huangjin jia guguai" (The bizarre *Curse of the Golden Flower*). *Mingpao*, December 27, 2006.

Semsel, George. "China." In *The Asian Film Industry*, edited by John A. Lent. London: Christopher Helm, 1990.

Shackleton, Liz. "Feng Xiaogang's *Banquet* news." *Screendaily*, July 18, 2005. http://www.screendaily.com/story.asp?storyid=22784.

Shan, Wanli. *Zhongguo jilu dianying shi* (History of Chinese documentary film). Beijing: Zhongguo dianying chubanshe, 2005.

Shan, Wanli, ed. *Jilu dianying wenxian* (Compendium of documentary studies). Beijing: Zhongguo guangbo dianshi chubanshe, 2001.

Shanghai Animation Film Studio, *Shanghai Animation Film Studio 1957–1987* (Shanghai: Shanghai Animation Film Studio, 1987).

Shanghai dianying zhi (A gazette of Shanghai cinema). Shanghai: Shanghai shehui kexue chubanshe, 1999.

Shao, Mujun. "Chinese Film amidst the Tide of Reform." In *Cinema and Cultural Identity: Reflections on Films from Japan, India, and China*, edited by Wimal Dissanayake, 199–208. Lanham, MD: University Press of America, 1998.

Shen, Ada. "Slipping under the Wall: Warners Hopes to Crack China with Low-Cost DVDs." *Variety*, 298, no. 2 (2005): 5.

Shen, Ziyi. "Dianying zai Beiping" (Film in Beijing). *Dianying yuebao* (Film Monthly), 6 (1928), reprinted in *Zhongguo wusheng dianying* (Chinese silent cinema), 182–186. Beijing: Zhongguo dianying chubanshe, 1996.

Silbergeld, Jerome. *Body in Question: Image and Illusion in Two Chinese Films by Director Jiang Wen*. Tang Center for East Asian Art, Princeton University, 2008.

———. *China into Film: Frames of Reference in Contemporary Chinese Cinema*. Reaktion Books, 2000.

Siwek, Stephen. "Copyright Industries in the U.S. Economy: The 2004 Report." International Intellectual Property Alliance, 2004. www.iipa.com/2004_SIWEK_FULL.pdf

Sklar, Robert. "Becoming a Part of Life: An Interview with Zhang Yimou." *Cineaste*, 2:1 (1993): 28.

Smith, Anna. "Big Shot's Funeral." *Time Out*, November 13, 2002.

Smith, Sean. "Invasion of the Hot Movie Stars: Chinese Cinema Has Brought New Fun, Glamour, Humor and Sex Appeal to Hollywood." *Newsweek*, May 9, 2005.

Snider, Mike. "Video Slips as DVD Market Matures." *USA Today*, January 3, 2006. http://yahoo.usatoday.com/tech/news/2006-01-03-dvd-ces_x.htm?esp=.

Snyder, Gabriel. "Box Office Winners and Sinners." *Premiere*, February 2005: 62–64, 123.

Solinger, Dorothy J. *From Lathes to Looms: China's Industrial Policy in Comparative Perspective, 1979–1982*. Stanford: Stanford University Press, 1991.

Squire, Jason, ed. *The Movie Business Book*, 3rd edition. New York: Fireside, 2004.

Su, ed. *Yingtan bai xing ji* (Who is who in Hollywood). Tianjin: Da gong bao she, 1935.

Sun, Jianqiu. "Sound and Color in Sun Mingjing's Silent B/W Films: The Paradox of a Documentary/Educational Filmmaker." *Asian Cinema*, 17:1 (Spring/Summer 2006): 221–229.

Sun, Shaoyi and Li Xun. *Lights! Camera! Kai Shi! In Depth Interviews with China's New Generation of Movie Directors*. Eastbridge, 2008.

Sun, Xiaohua. "Zhang stabbed by his '*Dagger*'." *China Daily*, August 28, 2004. www. chinadaily.com.cn/english/doc/2004-08/28/content_369678.htm.

Swiss, Thomas, John Sloop, and Andrew Herman, ed. *Mapping the Beat: Popular Music and Contemporary Theory*. Malden, MA: Blackwell, 1998.

Tang, Weiqi. "Zhongguo dianying haiwai piaofang bu wanquan tongji" (Incomplete statistics on the box office overseas of Chinese films). *Dianying shijie* (Movie World), 9/10 (2007): 25–29.

Tanzer, Andrew. "Tech-Savvy Pirates." *Forbes*, 162, no. 5 (September 7, 1998): 162–165.

Taussig, Michael. *Mimesis and Alterity*. New York: Routledge, 1993.

Teo, Stephen. *Hong Kong Cinema: The Extra Dimensions*. University of California Press, 1998.

––––––. "Wuxia Redux: Crouching Tiger, Hidden Dragon as a Model of Late Transnational Production." In *Hong Kong Connections: Transnational Imagination in Action Cinema*, edited by Meaghan Morris, Siu Leung Li, and Stephen Chan, 191–204. Hong Kong: Hong Kong University Press, 2005.

Thiers, Paul. "Challenges for WTO Implementation: Lessons from China's Deep Integration into an International Trade Regime." *Journal of Contemporary China* 11(32): 413–431.

Thompson, Kristin. *Exporting Entertainment: America in the World Film Market, 1907–34*. London: British Film Institute, 1985.

Tian, Jingqing. *Beijing dianyingye shiji, 1949–1990* (Historical events in the Beijing film industry). Beijing: Zhongguo dianying chubanshe, 1999.

Time Warner. "Warner Home Video Announces Historic Joint Venture with China Audio Video to Become First U.S. Studio to Establish In-Country DVD/VCD Operation in China," February 24, 2005. www.timewarner.com/corp/newsroom/pr/ 0,20812,1030960,00.html.

Tu, Wei-ming. "Cultural China: The Periphery as the Center." *Daedalus*, Vol. 120, No. 2 (Spring 1991): 1–32, 23.

U.S. Department of Commerce. "Protecting Your Intellectual Property Rights in China: A Practical Guide for U.S. Companies." *China Gateway 2003*. www.mac.doc. gov/China/Docs/ BusinessGuides/IntellectualPropertyRights.htm.

Variety. "The Internet Re-oriented." 411.11 (August 4, 2008): 3.

Vasey, Ruth. "Foreign Parts: Hollywood's Global Distribution and the Representation of Ethnicity." *American Quarterly*, Vol. 44, No. 4. *Special issue: Hollywood, Censorship, and American Culture* (December 1992): 617–642.

––––––. *The World According to Hollywood, 1918–1939*. Madison: University of Wisconsin Press, 1997.

Video Business. "Growing Disc Dominance." August 22, 2005, 25(34), TableBase™ Accession #135903944, 1.

Visser, Robin. "Spaces of Disappearance: Aesthetic Responses to Contemporary Beijing City Planning." *Journal of Contemporary China*, 13–39 (May 2004): 277–310.

Voci, Paola. "From the Center to the Periphery: Chinese Documentary's Visual Conjectures." *Modern Chinese Literature and Culture*, 16:1 (Spring 2004): 65–113.

Walker, Susan. "Westerns Is Eastern, Horses Are Camels, 6-Guns Are Swords." *The Toronto Star*, October 1, 2004: D4.

Wallace, Bruce. "The Geisha, in Translation: In Rob Marshall's *Memoirs of a Geisha*, with Chinese Stars and a Pan-Asian Cast, Will Some Essence Go Missing?" *Los Angeles Times*, March 6, 2005: E1, 10–11.

Wang, Baisou. "Yeshi jiaoyu" (It is also educational). *Minguo ribao*, March 7, 1931: 3.

Wang, Ban. "Documentary as Haunting of the Real: The Logic of Capital in *Blind Shaft*." *Asian Cinema*, 16:1 (Spring/Summer 2005): 4–15.

Wang, Jing and Tani Barlow, ed. *Cinema and Desire: Feminist Marxism and Cultural Politics in the Work of Dai Jinhua*. London: Verso, 2002.

Wang, Ruifeng. "Zhongguo dianying zuijin zhi xin de qingxiang" (New trend in recent Chinese films). *Yingmi zhoubao* (Movie Fan Weekly), 1:8 (1934): 130.

Wang, Shujen. *Framing Piracy: Globalization and Film Distribution in Greater China*. Lanham, MD: Rowman & Littlefield, 2003.

Wang, Taorui, "Beiyingchang wenxue mingzhu gaibian gaiping" (Overview of the accomplishment of the Beijing Film Studio's adaptation of literary classics). *Dianying yishu*, 11 (2005): 85–93.

Wang, Weici. *Jilu yu tansuo: 1990–2000 dalu jilupian de fazhan yu koushu jilu* (Document and explore: The growth of documentary in mainland China and its related oral histories, 1990–2000). Taipei: Guojian dianying ziliao guan, 2001.

Wang, Yiman. "The Amateur's Lightning Rod: DV Documentary in Postsocialist China." *Film Quarterly*, 58:4 (Summer 2005): 16–26.

Wang, Zhihong. "Tian Zhuangzhuang with messier hair." *Zhongguo yinmu*, 3 (1996): 20–21.

Watson, Burton. *Records of the Grand Historian of China*. New York and London: Columbia University Press, 1961.

Wei, Taifeng. "Da guangming dibuguo Nanjing, Migaomei xinpian shouyingquan yizhu" (Grand was defeated by Nanjing, MGM's premiere right changed hand). *Yinghua* (Movies), 11 (1934): 268–269.

Wenhua bu Beijing bianzhe kan, ed. *Jingju xiandaixi guanmo yanchu dahui jiemudan (heding ben)* (Programmes of the modern-subject Peking opera performance convention). Beijing, 1964.

Wilonsky, Robert. "Kung Fu'd: Or, What Does Miramax Have against Asian Films?" *Dallas Observer* (Texas), January 29, 2004 (online).

Wolff, Janet. "The Global and the Specific: Reconciling Conflicting Theories of Culture." In *Culture, Globalization and the World-System: Contemporary Conditions for the Representation of Identity*, edited by Anthony D. King, 161–174. Minneapolis: University of Minnesota Press, 1997.

Wu, Guanping. "I Am a People's Filmmaker" (Woshi yige shimin daoyan). *Film Arts*, 2 (April 2000): 44–48.

Wu, Hung. *Transience: Chinese Experimental Art at the End of the Twentieth Century*. Chicago, Illinois: The David and Alfred Smart Museum of Art & The University of Chicago Press, 1999.

Wu, Pang. *Wo yu Huang Feihong* (Wong Fei-hung and I). Hong Kong: Wu Pang, 1995.

Wu, Weihua. "Independent Animation in Contemporary China." *Cartoons*, 1:2 (Winter 2005): 21–25.

Wu, Yonggang. *Wo de tansuo yu zhuiqiu* (My exploration and pursuit). Beijing: Zhongguo dianying chubanshe, 1986.

Wu, Yu. "Yinse de feng" (Silver wind). *Dianying zhoukan* (Movie Weekly), 26 (1939).

Wyatt, Justin. *High Concept: Movies and Marketing in Hollywood*. Austin: University of Texas Press, 1994.

Xiao, Guo. *Zhongguo zaoqi yingxing* (Movie stars from early Chinese cinema). Guangzhou: Guangdong renmin chubanshe, 1987.

Xiao, Zhiwei. "Nationalism, Orientalism and an Unequal Treatise of Ethnography: The Making of *The Good Earth*." In *From Gold Mountain to the New World: Chinese American Studies in the New Millennium*, edited by Susie Lan Cassel, 274–290. Alta Mira Publishing Co. 2002.

———. "The Expulsion of Hollywood from China, 1949–1951." *Twentieth Century China*, vol. 30, no. 1 (November 2004): 64–81.

Xin, Leng. "Rendao xiandu guangan lu" (Preview comments on Humanity). *Da gong bao*, May 14, 1932.

Xin, Ping. *Cong Shanghai faxian lishi, 1927–1937* (Discovering history in Shanghai), 38–44. Shanghai: Shanghai renmin chubanshe, 1996.

Xu, Gary G. *Sinascape: Contemporary Chinese Cinema*. Rowman and Littlefield, 2007.

Xu, Lin and Zhang Hong. "The Crisis of Literature and the Humanist Spirit." *Shanghai Wenxue*, 6 (1993): 65–66.

Xu, Ying. "Animation Film Production in Beijing." *Asian Cinema*, 11:2 (Fall/Winter 2000): 60–66.

Yan Dingxian. "The Cultivation of Animation Talents through Practice." Paper presented at 2006 International Animation Artists Salon, Wuhan, November 2, 2006.

Yang, Haizhou, ed. *Zhongguo dianying wuzi chanye xitong lishi biannianji (1928–1994)* (Chronology of the film materials industry system). Beijing: Zhongguo dianying chubanshe, 1998.

Yang, Mayfair. "Of Gender, State, Censorship, and Overseas Capital: An Interview with Chinese Director Zhang Yimou." In *Zhang Yimou: Interviews*, edited by Frances Gateward, 35–49. Jackson, Miss.: University Press of Mississippi, 2001.

Yao, Zhiwen. "Some Suggestions on the Development of the Chinese Film Industry" (Dui Zhongguo dianying chanye fazhan de jidian jianyi). *Journal of Zhejiang*

Institute of Media & Communications (Zhejiang Chuanmei xueyuan xuebao), 6 (2006): 14–16.

Yau, Esther. "Yellow Earth: Western Analysis and a Non-Western Text." In *Perspectives on Chinese Cinema*, edited by Chris Berry, 62–79. London: BFI, 1991.

Ye, Longyan. *Taiwan dianying shi* (A history of cinema in Taiwan). Taipei: Chinese Taipei Film Archive, 1994.

Yeh, Emilie Yueh-yu and Darrell William Davis. "Re-nationalizing China's Film Industry: Case Study on the China Film Group and Film Marketization." *Journal of Chinese Cinemas*, 2.1 (May 2008): 37–52.

———, eds. *Taiwan Film Directors: A Treasure Island*. Columbia University Press, 2005.

Yi, Lang. "Mei ziben jingong Zhongguo dianying jie hou zenyang tupo muqian de weiji" (How to make breakthrough after the invasion of Chinese film industry by American capital). *Dianying yishu* (Film art), 3 (1932), reprinted in *Zhongguo zuoyi dianying yundong*, 92–93.

Yin, Hong and Zhan Qingsheng. "Notes on the Chinese Film Industry, 2005" (2005 Zhongguo dianying chanye beiwang). *Film Art* (*Dianying yishu*), 2 (2006): 14, Table 2.

Ying, Xiong. "*On Shanghai Triad.*" *Dianying yishu*, 248:3 (1996): 8–10.

Young, T. S. "The Girl Guides." *China Weekly Review*, November 7, 1936: 343.

Yu, Mo-wan. "Swords, Chivalry and Palm Power: A Brief Survey of the Cantonese Martial Arts Cinema 1938–1970." In *A Study of the Hong Kong Swordplay Film* (1945–1980) (5th Hong Kong International Film Festival catalogue, 1981), 99–106.

Yu, Peter K. "From Pirates to Partners: Protecting Intellectual Property in China in the Twenty-First Century." *The American University Law Review*, 50 (2000): 131–199.

Yu, Sen-lun. "*Zhang Side* Dominates Top Chinese Awards." *Variety*, October 29, 2006 (online).

Yu, Yang. *Since I Started My Acting Career* (*Wode yanyi shengya*). Beijing: China Drama Press, 1959.

Zeng, Guangchang. "Chinese Early Animation." *Jiangsu Film*, December 1992.

Zhai, Jiannong. *Hongse wangshi: 1966–1976 nian de Zhongguo dianying* (A red past: 1966–1976 Chinese film). Beijing: Taihai chubanshe, 2001.

Zhang, Huilin. *Ershi shiji Zhongguo donghua yishushi* (20th-century Chinese animation art history). Shangxi: Peoples' Art Press, 2002.

———. "Some Characteristics of Chinese Animation." *Asian Cinema*, 14:1 (Spring/Summer 2003): 70–79.

Zhang, Jianghua, ed. *Yingshi renleixue* (Visual anthropology). Beijing: Shehui kexue wenxian chubanshe, 2000.

Zhang, Ling. "Buneng wangji de meili Xiang Mei" (The unforgettable beauty, Xiang Mei). *Meizhou wenhui zhoukan* (Wenhui Weekly, North American edition), January 10, 2004: 63.

Zhang, Ming, ed. *Zhang Yimou duihua* (Talks with Zhang Yimou). Beijing: Zhongguo dianying chubanshe, 2004.

Zhang, Tongdao. "A Retrospective of Chinese Cinema in 1995" (Kuayue xuanhua: 1995 nian Zhongguo dianying huigu). *Film Art* (*Dianying yishu*), 3 (1996): 23.

Zhang, Weiping. "Can *House of the Flying Daggers* Surpass *Hero?*" *Popular Cinema*, 6 (2004): 34–35.

Zhang, Xianmin and Zhang Yaxuan. *Yigeren de yingxiang: DV wanquan shouce*. Beijing: Zhongguo qingnian chubanshe, 2003.

Zhang, Xiaotao. "Mainland Films 2005" (*Dalu dianying 2005*). *Arts Criticism* (*Yishu pinglun*), 1 (2006): 63–66.

Zhang, Xudong. *Postsocialism and Cultural Politics: China in the Last Decade of the Twentieth Century*. Durham, NC: Duke University Press, 2008.

Zhang, Yimou. "House of Flying Daggers." *Future Movies*. http://www.futuremovies. co.uk/filmmaking.asp?ID=100.

———. Interview, "Wei Zhongguo dianying zouxiang shijie pulu" (Pave the road for Chinese films to go to the world). In *Zhang Yimou*, 385–412. Changsha: Hunan wenyi chubanshe, 1996.

———. "Sing a Song of Life." *Dangdai dianying*, 13:2 (1988): 81–88.

Zhang, Yingjin. "A Centennial Review of Chinese Cinema." http://chinesecinema.ucsd. edu/essay_ccwlc.html (accessed May 12, 2008).

———. *Chinese National Cinema*. New York: Routledge, 2004.

———. "My Camera Doesn't Lie? Questions of Truth, Subjectivity, and Audience in Chinese Independent Film and Video." In *From Underground to Independent*, edited by Pickowicz and Zhang, 23–45. Lanham, MD: Rowman & Littlefield, 2006.

———. *Screening China: Critical Interventions, Cinematic Reconfigurations, and the Transnational Imaginary in Contemporary Chinese Cinema*. Ann Arbor: Center for Chinese Studies Publications, University of Michigan, 2002.

———. "Styles, Subjects, and Special Points of View: A Study of Contemporary Chinese Independent Documentary." *New Cinemas* (UK), 2:2 (2004): 120–121.

———. "Thinking Outside the Box: Mediation of Imaging and Information in Contemporary Chinese Independent Documentary." *Screen*, 48, no. 2 (Summer 2007): 179–192.

Zhang, Yingjin and Zhiwei Xiao. *Encyclopedia of Chinese Film*. Routledge, 1998.

Zhang, Zhen. *An Amorous History of the Silver Screen: Shanghai Cinema, 1896–1937*. Chicago: University of Chicago Press, 2005.

———. "Bodies in the Air: The Magic of Science and the Fate of the Early 'Martial Arts' Film in China." In *Chinese-Language Film: Historiography, Poetics, Politics*, edited by Sheldon Lu and Emilie Yeh, 52–75. Honolulu: University of Hawaii Press, 2005.

Zhao, Yuezhi. *Communication in China*. New York: Rowman & Littlefield, 2008.

Zheng, Junli. *Xiandai Zhongguo dianying shilue* (An outline of modern Chinese cinema). Reprinted in *Zhongguo wusheng dianying* (1996): 1410.

Zheng, Wei. "Jilu yu biaoshu: Zhongguo dalu 1990 niandai yilai de duli jilupian" (Documenting and expression: mainland Chinese independent documentary since 1990). *Dushu* (Beijing), 10 (2003): 76–86.

Zheng, Yimei. *Yingtan jiuwen — Dan Duyu he Yin Mingzhu* (Memories of the film world — Dan Duyu and Yin Mingzhu), 20. Shanghai: Shanghai wenyi chubanshe, 1982.

Zheng, Yongzhi. "Sannian lai de Zhongguo dianying zhipian chan" (China motion picture studio in the past three years). *Zhongguo dianying* (Chongqing), 1: 1 (January 1941).

Zhong, Ying. "Jinyibu fazhan nongcun dianying fangying wang" (Further develop the rural film projection network). *Hongqi* (Red Flag), June 1975: 50–53.

Zhongguo dianying nianjian 1981 (China film yearbook). Beijing: Zhongguo dianying chubanshe, 1982.

Zhongguo dianying ziliaoguan and Zhongguo yishu yanjiuyuan dianying yanjiusuo, ed. *Zhongguo yishu yingpian bianmu, 1949–1979* (Catalogue of Chinese art films). Beijing: Wenhua yishu chubanshe, 1981.

Zhongyang dianying shencha weiyuanhui gongbao (The central film censorship committee: news bulletin), 1: 10 (1934).

Zhou, Shixun. "Yingxi tongyu" (Scathing comments about film). *Dianying zazhi* (Movie Magazine), 1: 3 (1932).

Zhou, Tiedong. "Overview of the 2007 Chinese Film Industry." Talk presented at the conference "Chinese Film at 100: Art, Politics and Commerce." University of Southern California, April 24–26, 2008.

Zhu, Rikun and Wan Xiaogang, ed. *Duli jilu: duihua Zhongguo xinrui daoya* (Independent records: interviews with Chinese cutting-edge directors). Beijing: Zhongguo minzu sheying yishu chubanshe, 2005.

Zhu, Ying. *Chinese Cinema during the Era of Reform: The Ingenuity of the System.* Westport, CT: Praeger, 2003.

———. "Cinematic Modernization and Chinese Cinema's First Art Wave." *Quarterly Review of Film and Video*, 18.4 (2001): 451–471.

———. "Commercialism and Nationalism: Chinese Cinema's First Wave of Entertainment Films." *CineAction*, 47 (1998): 56–66.

———. "Feng Xiaogang and Chinese New Year Films." *Asian Cinema*, 18: 1 (Spring/ Summer 2007): 43–64.

———. "The Past and Present of Shanghai and Chinese Cinema," *New York Times* China Studies Website (April, 2006): http://www.nytimes.com/ref/college/coll-china-media-001.html (accessed December 22, 2008).

———. *Television in Post-Reform China: Serial Dramas, Confucian Leadership and the Global Television Market.* Routledge, 2008.

Zhu, Ying and Tongdao Zhang. "Sun Mingjing and John Grierson, a Comparative Study of Early Chinese and British Documentary Film Movements." *Asian Cinema*, 17:1 (Spring/Summer 2006): 230–245.

Zhu, Zhu. "The Three Gorges: Myth and Elegiac of the New Realism." yachnagartnet: http://news.artron.net, accessed on February 27, 2007.

Zhu, Zisheng. "Nannü qinghua zhinan" (A guide for courtship). *Beiyang huabao* (Northern Pictorial), 25 (February 1935): 1210.

Index

Breinigsville, PA USA
10 March 2011
257367BV00006B/1/P